P9-AEU-157

SURVIVAL THROUGH DESIGN

SURVIVAL

RICHARD NEUTRA

THROUGH DESIGN

New York · OXFORD UNIVERSITY PRESS · 1954

Printed in the United States of America
By The Haddon Craftsmen, Inc.,
Scranton, Pa.

TO COLUMBIA, the university which in two hundred years has grown up in the midst of the world's most teeming and technologically advanced community. 1754-1954

PREFACE to a loose and yet linked cycle
of writings collected over almost a lifetime.

The designing of structures, if we take
it 'not in the abstract,' concerns, above all, labor for human
beings, and *with* them. Human beings must be served and
they are reached by design not only as ultimate consumers;
in the process they must be won over as co-performers and
working crew. Every step must be acceptable, understand-
able, convincing, so as to enlist the necessary co-operation,
and the final solution must be appealing, both rationally and
emotionally. It must be as comprehensive as possible to avoid
manifold friction and collision; the range of individual re-
sponses must be foreseen.

Animals of lesser brain equipment have no such problems.
They are not engaged in convincing each other. And for the
most part they leave things alone which to touch would be
fatal. Man is different; he is a tinkerer. He tinkers with his
habitat, while other animals hold their peace with it. They
survive by adjusting themselves to natural change during long
biological ages—or they perish. Man may perish by his own
explosive and insidious inventions. For an adjustment to
them he leaves himself precious little time, and progressively
less as his technological wizardry runs wild and rushes on.
If he is to survive at all, it cannot be through slow adjust-
ment. *It will have to be through design* more subtly consid-

ered and circumspect, through more cautious planning in advance.

The author feels keenly indebted to the men of literary and philosophical gifts who have illuminated cultural history and our own scene by an understanding of the past. When we speak of the past or the present we do not mean sections of abstract time. We mean, of course, processes that occurred within them. And of technical processes especially we can say that they unroll now faster and faster, so that present and future become more sharply and progressively different from the past. Parallels and comparisons turn out bewilderingly unreliable.

In this book the author occasionally quotes scientists, known for their original research, who after their professional custom would hesitate to draw too hasty conclusions from as yet incomplete findings. His own arguments do not stand on any pretense of sharing all the systematic thoroughness of science. He only had the deep desire to point out how much aid to safety in design has come to him from contemporary sciences that have observed organic functioning on closest range and thus to point out how profoundly the entire realm and the fateful art of design can be benefited. Answers in the light of a current knowledge of this kind cannot be brief and handy, as perhaps abstract speculation of the past would have summed them up. But it is very stimulating to see answers foreshadowed even though qualifications will have to follow upon each other as long as observation deepens and progresses.

The reader, like all of us, is a consumer of physical design, of designed products, and of a planned and constructed environment as a whole. Any efforts at clarification will tend ultimately to help him and us with our consumer problems. We all are in need of certain criteria to judge and to be judicious, to accept and to reject.

As it is, humanity all over the globe, ever more artificially supplied and thus often victimized, appears now at the mercy

of a rampant, over-advertised industrial technology which is flooding us off our physiological bearings and, it may sometimes seem, is threatening to drown the entire race like a litter of defenseless kittens.

Perhaps we have come thus far because of a *dualism*, separating our production and design into the utilitarian and non-utilitarian. This dualism is more than a misuse of words. *It simply has no real basis or simile either in outer nature or in our own physiology.* Such strangeness to real nature makes it more than suspect of being destructive.

Involved in his own practical work, the author has been forced to ponder this all-important subject for many years. He could not have struggled through life if it had not been for his faith that in a modest way he could, as an architect, contribute a little toward the preservation of human kind and existence—something of objective value. There is a growing number of us who are convinced that generally valid scales and gauges for judging design in this sense can be found and must be applied. To deny it would seem nihilistic.

Like memoirs carried over decades of a mind's development, a crop of thoughts may here be harvested to be helpful; they somehow sprouted from the daily labors of design, and often from those numerous and necessary conversations with clients about its acceptance through conviction and confidence.

Sincere thanks are due to the many who have given me aid and comfort, although sometimes, over the years, my memory fails to recall even their names or their exact words that impressed me. I wish I were able to assemble a full list of stimulating sources or a complete bibliography of what I have been allowed to absorb deeply but often beyond lasting awareness. It would turn into something like an autobiography, and remain incomplete, as autobiographies always are.

<div align="right">R. N.</div>

Los Angeles, California
June 1953

ACKNOWLEDGMENTS

The author's thanks are here expressed to his dear life companion, Dione Neutra. She, with her cheerful labors, and others have helped him through the many years of preparing the manuscript and bringing it into final form: Regula Thorston, Eva Heymann, and John Blanton, who also waded through the galley proofs. Oxford University Press, especially John Begg, has given much needed and appreciated cooperation.

SURVIVAL THROUGH DESIGN

The NATURAL ENVIRONMENT IS DOCTORED UP
CONTINUOUSLY and warped by the acts of the
human brain.

1

Nature has too long been outraged by
design of nose rings, corsets, and foul-aired subways. Perhaps
our mass-fabricators of today have shown themselves particu-
larly out of touch with nature. But ever since Sodom and
Gomorrah, organic normalcy has been raped again and again
by man, that super-animal still struggling for its own balance.
There have been warners, prophets, great floods, and new
beginnings.

What we here may briefly call *nature* comprises all the
requirements and characteristics of live organisms. This en-
tire world of organic phenomena is, in the escapades of our
still obvious immaturity, often treated against 'the natural
grain' and contrary to the 'supreme plan'—that of biological
consistency and requirement. In former ages it was a sin to
do this and for such failings the deity threatened to liqui-
date the sinners. We may now have dropped—perhaps too
carelessly—the moral accent. Yet to us, too, the issue is still
one of survival by virtue of wholesomeness, or damnation
and death through our own default.

In human design, we could conceivably see *organic evolu-
tion continued*, and extending into a man-shaped future. At
any rate, that phenomenally intensive development in the

3

multi-layered cortex of the human upper brain has not yet with certainty been proved a blind alley or a dismal failure. To be sure, this distinctly human brain harbors trouble, but it also may furnish some as yet untried survival aids. We have been laggards in calling upon all our potential powers and resources to arrange for us in a bearable manner an individual and communal living space. The toxic trash piles of our neglects and misdeeds, old and fresh, surround us in our physical environment. The confused wreckage of centuries, unrelated to any current practical purpose, is mixed in a most disturbing manner with our often feeble, often arbitrary, attempts at creating order.

Organically oriented design could, we hope, combat the chance character of the surrounding scene. Physiology must direct and check the technical advance in constructed environment. This setting of ours is all powerful; it comprises everything man-made to supply man, from the airy storage compartment of our toothbrush to the illumination of a speedway interchange, or of the neighborhood day-care center for toddlers.

A great deal of what has been vaguely called beauty will be involved in this proposed new and watchful scrutiny of man-made environment. It will come into question perhaps far more often than anybody could imagine in our current drab disorder. But the sort of beauty we speak of here will have given up its now too precarious grounds of self-defense. Designers will recognize that gradually but surely they must underbuild their proposals and compositions with more solid physiological foundations rather than with mere speculative conversation or sales talk. An eternal residuum of mystery may always lie deeply buried in this field, and yet the realm of research, testing, and provability increases from day to day.

All our expensive long-term investments in constructed environment will be considered legitimate only if the designs have a high, provable *index of livability*. Such designs must be conceived by a profession brought up in social responsi-

bility, skilled, and intent on aiding the survival of a race that is in grave danger of becoming self-destructive.

Design is the cardinal means by which human beings have long tried to modify their natural environment, piecemeal and wholesale. The physical surroundings had to be made more habitable and more in keeping with rising aspirations. Each design becomes an ancestor to a great number of other designs and engenders a new crop of aspirations.

There were many failures in the past. Cities such as Rome have been called eternal only to become monuments, less of stability than of a continuing need for being remade. Rome and many of its buildings have been cruelly rehandled by inner and outer barbarians. The Eternal City bears striking testimony to the shipwreck of a multitude of plans and designs that have forever remained frustrated fragments. In the present, things may be different from what they were in the past, perhaps, but certainly not better. The controversial, calamitous character of contemporary towns, from 'modern' Mexico, Milan, Manila, back to Middletown, U. S. A., is known to all of us when we but cross the street from our office building to where we have parked the car.

Through the mental work of design, which is supposed to improve our lives, the race appears generally to stray farther and farther from the natural scene. The paradisical habitat of earliest man is considered a myth today and his natural situation may originally have posed him harsh enough problems. Yet those of our man-designed, man-constructed environment are often more trying and more severe tests to our natural resistance.

Man's own cramped-together creations, anything from underground sewage systems and subways to a badly hemmed-in sky overhead, irritatingly criss-crossed by a maze of electric wires, should not prove as inescapable as fate. Lightning and the plague, once so formidable, have been countered by proper measures; must we then here find ourselves helpless? Must we remain victims, strangled and suffocated by our own design which has surrounded us with man-devouring

5

metropolises, drab small towns manifesting a lack of order devastating to the soul, blighted countrysides along railroad tracks and highways, studded with petty 'mere-utility' structures, shaded by telephone poles and scented by gasoline fumes?

Design, the act of putting constructs in an order, or disorder, seems to be human destiny. It seems to be the way into trouble and it may be the way out. It is the specific responsibility to which our species has matured, and constitutes the only chance of the thinking, foreseeing, and constructing animal, that we are, to preserve life on this shrunken planet and to survive with grace.

Such survival is undoubtedly our grand objective, according to an innate pattern of feeling. It is a matter of urgent concern to everyone—from the loftiest philosopher to the most matter-of-fact businessman. Design to contribute to survival of the race is more than design as a long-hair luxury or as a lubrication of bigger and better trade.

Never have the opportunities for general and integrated design on a world-wide scale been as breathtaking as they are today. The Second World War has left huge areas of destruction in its wake but promptly a clamor rose, from Le Havre, France, to Agana, Guam, that things should be rebuilt in the 'old way.'

Yet pitiful attempts at resurrection of what is bygone are not the best we can do to honor the past. Also, naïve parochial outlook needs supplementation by global forethought, experience, and contemporary know-how. With all sincere respect for regionalism, there does exist now a cosmopolitan 'joint responsibility' for reconstruction anywhere. Human planning cannot really remain compartmental or sectional in an age of mutually braced security. Vast regions, which were formerly colonial, are awakening to their own contemporary participation with needs and supplies enormously stepped up. Technological progress in advanced centers is spreading and forcing a changed way of life even on the far-away, backward portion of the globe. And under the pressure of this

progress if it is to be integrated, conscientious design is needed everywhere.

What sort of design? What are its governing principles and on what objective foundations can it be based? Is there anything to rely on behind all that bewildering multiform activity of ours? Is there anything which eloquent philosophers could put into words?

The writer has long felt tempted to put into words the fact that at this day and age no speculative philosophy, no deductive method alone, no talking-it-out can yield us all the principles of design. In our time new instruments and obligations have come to us from research penetrating into life's performance. Physiology is a pursuit and a science which opens the door to broad and intensive application. We begin to wield tools which will enable us to do the patient spadework which must be done. It will be fascinating because it is so novel.

With knowledge of the soil and subsoil of human nature and its potentials, we shall raise our heads over the turmoil of daily production and command views over an earth which we shall have to keep green with life if we mean to survive— not cramped full with all the doubtful doings of a too thoroughly commercialized technology. Tangible observation rather than abstract speculation will have to be the proper guide. And drifting will no longer do.

2

Is drifting really a matter of the past, or is there some speculative philosophy left to justify it? Can we really plan anything, or are we only laboring under an illusion that we can?

In order to be effective and even possible, design presupposes some kind of operative choice on the part of man, which has been called a *free will*. We know it has been gravely doubted, not least perhaps, because it conflicts inconveniently with our tendency of mere drifting through the world.

And a second philosophical question, strange perhaps to an architect, has actually been posed again and again. This sixty-four-dollar query is whether there is such a thing at all as an 'outer world.' Is there really something outside of us to be man-handled and man-made-over, or is all this around us perhaps only a figment of the mind? Great thinkers have aired their scruples about the subject. Yet it seems plain enough that something real *would* have to be out there if we were able to exercise the leverage of our decisions on it.

The doubts linger on: Are we free to act, is it real sense to plan, or are we simply surrounded by our own illusions? Certainly, the writer gathered from his experience of chairing a State Planning Board that to date this entire business

8

of planning is still obnoxious to many. Thus a little probing into such doubts should prove truly useful.

First then, the concept 'man-made' is one which has been endlessly questioned by suspecting philosophers as well as by the simply faithful. Was not everything, with all its consequences, created and just readied to unroll, so that man cannot even lift his hand on his own accord? Has he actually that free will, so much cherished by his self-respect or arrogance—a choice to make anything, or remake it? Is he master of his destiny to shape his career and to choose his way over the earth and perhaps beyond individual death up to a lasting security? Can he go to heaven by his own power?

People of traditional conscience have been puzzled for ages about all this. But even in most modern dress the same questions have been asked. Is planning a white hope—or just a political creed of soulless totalitarians? Is it a pretentious delusion which disturbs natural processes—nothing but a clever invention to feed a parasitic bureaucracy of busybodies? Also the free-lance fraternity of planners, architects, and designers is hardly ever lucky enough to find an all-out support. Acquiescence with their doings is often but half-hearted and coupled with a strange deep-down doubt whether things can really be managed by anticipation and plan. On the other hand, there is much wishful thinking that things will work out by themselves, that one could well cross out from the budget the tedious expense item of planning or design—and just muddle through, let things happen.—

Quite related to the scruples we speak of is still another, the troublesome one: Is man really separable from the world at large so that he can act upon it? Or are he and all around him just ONE?

The religious thought of ancient India strikingly expresses this idea in the Upanishads, which may be soothing to some, revolting to others. 'All that out there *is* you, yourself (Tatvam asi!).' Outer and inner world, environment and you are fully meshed, not separable, not truly different from each other. The busy passion for extraneous design, for making

things and keeping them moving, is all foolish and evil. Fakirs, philosophers, and hermit saints wisely content themselves to exercise the innermost being, nothing else. It is the world anyway. They love solitude, despise and detest the villages, the city, and all physical 'constructs.' Theirs is an old indictment of civilization as a whole, especially the brand, crowded with machinery and animated by a mechanical rush, which the Occident has come to favor.

Tomes would be necessary merely to outline the ever-recurrent and ever-qualified treatment that has been administered to this double dilemma: Here, *individual independence* of any outer setting—or on the contrary, inextricable oneness with it; and there, *free will* hopefully to design, redesign this setting of ours—or else, determinism, fate.

We may just as well admit: A bothersome quandary since the dawn of the race, it is *apparently innate and rooted in our mental structure*, and thus hard to ignore. The question 'Are human plans a good thing, or are they basically evil?' has been speculated about for as long as 'Can we in the long run win out with our wit before the sphinx and her puzzles?' Do we really ever succeed with plans? Or are all our designs just wishful dreams? If we want to convert minds to planning, it is at any rate instructive to remember how long people have worried about its merit. Perhaps a little retrospection into past troubles of the mind may rid us of our own.

It has seemed to generations that God's grace alone, not man's petty doing, could salvage and save. More than thirteen hundred years ago, at the Synod of Ephesus, this principle gloriously defended by St. Augustine won out against Pelagius, perhaps quite characteristically a Britisher, who represented the other conviction. He claimed that man *can* design his conduct and mode of living, that he can win survival *by his own effort*, and immortally ascend to the circle of the blessed. Stamped a heretic, poor Pelagius could to this day be the patron of the planners who themselves are still so often exorcised.

It seems these two attitudes, self-confidence and trust in

providence, cannot really be segregated from each other even in a single mind. René Fuelöp-Miller has pointed out that not only are these opposed convictions held by different people or argumentative philosophical factions but that there is a fundamental demonic, never-ending combat between the two trends, *to plan* or *not to plan*, to be provident or to let things happen. And both of these tendencies, I feel, are really lodged in every one of us. They have, as I see it, their turns with the ebbing or rising of our vitality. When we are lucky and feel strong, we want to take things firmly into our hands, plan ahead, even arrange the most distant future. When we are stricken by sickness, loss, and failure, our plans shorten desperately. Then they are reduced to the next week, the next day. During a heart attack we only plan for a mere second or two—for reaching the chair in front of us. At last, composed, we say, 'What's the use? Things come as they must.' And we stretch out relaxed, resigned. Physiological tonus is more valid than philosophical claim.

Even the great Augustine himself, like the rest of us, may, during the ups and downs of outer life and inner vitality, have been somewhat undecided in his being, and occasionally perhaps uncertain in his expression; otherwise it would be hard to understand how for one and a half thousand years to come, people were able actually to quote his words in the defense of both sides!

The Reformation, with the bitter determinist Calvin in the lead—as well as the Thomists, the Dominicans, and later the Jansenists within the mother church itself—developed considerable wrath against *men of action by plan* such as Ignatius of Loyola. We can see in this vigorous saint and exemplary organizer something like the sixteenth-century representative of practical reflexology. His was the careful and systematic knowledge of *conditioning and re-molding minds*—a subject always close to the problems of design as we shall presently try to follow them.

Ignatius indeed turned out to be the prototype of an efficient trainer for plan, action, and results. His order had a large tool chest that contained, among other instruments,

rich, expressive art and architecture. There was then waged a long, bitter, and fundamental *feud against the will triumphant* with the Jesuit order standing for it. European cabinets, bristling universities, and armies were on both sides of the fence and the bloody battlefield. Finally, all was left undecided by the decree of a Pope who justly longed for peace. We can well feel with him.

The following two centuries saw the amazing rise of science, and a new sort of determinism, a faith in an all-comprising 'causality,' seemed once more on the verge of winning out. A man of progress like Voltaire felt with some justification that he could now don a wholesome sneer at those antiquated, ever more quaint quarrels of the clerics. Yet again, two hundred years later, we find that eternal twin problem being discussed with endless qualifications and re-qualifications in our own contemporary literature. Of course, the vocabulary has changed.

That entire concept of *environment versus the organism* now seems to experts an abstraction,[1] perhaps altogether off-key and certainly often impractical to operate with. Neither physically nor biochemically nor sociologically can the individual really be segregated or isolated as a separate entity. 'The organism permits no severing of the *hereditary* from the *environmental*. Indeed, every cell is the environment of the other cells, and every group of cells is part of the environment of the cells of another organism.' Biochemist Henderson points out that through the process of respiration the organism is chemically so united with its environment that the two can be separated only in the abstract way in which we separate the water of two tributaries which have flowed together into a common river bed. Organisms are immersed to fusion in their chemical as well as their social setting; they *literally live on and in one another. 'The isolation of the individual from his fellows is neither a biochemical nor a social fact.'*

[1] Murphy & Newcomb, quoting Henderson: *Experimental Social Psychology*, Harper & Brothers, New York, 1937, p. 28.

Only a very little earlier, however, the famed and strict 'environmentalist' theory, we know, had innocently taken such abstractions as most concrete facts. Now it commands full credit no longer. Planners, as well as practical men in hard-boiled traffic with 'outer facts,' will get a little confused about how hard, fast, and 'outer' these facts really are.

Also in the findings of leading physiologists, such as G. E. Coghill, the theory of a decisive environment is declared to be 'grossly inadequate.' He ascertains through many minute observations on growing embryos that there is such a thing as behavior which is 'spontaneous,' meaning: *not caused from the outside*. This behavior is 'expressing the inner dynamics of the organism as a whole.' And indeed Coghill speaks of such things as 'spontaneity, autonomy, or *initiating* as factors in behavior.'—All these things could make an old-fashioned materialist, environmentalist, and determinist shudder.

And then Erwin Schroedinger. He, a great man of contemporary physics, seemingly first accepts that everything in our lives is presettled.[2] This is surprising to many who have heard of the 'undecided behavior' of particles in the atomic nucleus. Yet, Schroedinger says: 'To the physicist I wish to emphasize that in my opinion, and contrary to the opinion upheld in some quarters, *quantum indeterminacy* plays no biologically relevant role.' Further, he thinks, every unbiased biologist would be a determinist if there were not the well-known, unpleasant feeling about 'declaring oneself to be a pure mechanism. For it is deemed to contradict Free Will as warranted by direct introspection.' At least for an instant, Determinism, a tight, causal meshwork, again seems to be tops here, despite all the individualistic behavior of those atomic particles.

But then Schroedinger's reader is startled by something like a magnificent somersault. The great physicist suddenly proclaims *free will* not only a pleasant assumption, as he had mentioned before, but something by inner evidence

[2] Erwin Schroedinger, *What Is Life?* Cambridge University Press, 1951, p. 89.

quite indisputable. And he has another shock in store: ' "I"—am the person, if any, who controls the "motion of the atoms" according to the laws of nature.' It sounds like strong mystic language to be used these days—and by a physicist at that—but there it is.

Schroedinger also speaks up against what he calls 'plurality.' Plurality means to him that only seeming separation of the 'I' from the 'you.' In reality, however, all is one—and a most modern scientist serenely joins here the most ancient sages. The Indian concept of *Maja*, which he praises, does not really permit such an idea as an outer environment. Therefore the somersault has been turned into a double one and here, bewilderingly, it is again, after all is said and done, 'We,' in a philosophical analysis, cannot do anything whatsoever about 'it.'

Well, perhaps we 'cannot,' but we MUST.

It is time for us to lose our patience with all these speculations. We had thought it fair and appropriate, perhaps necessary, to inquire whether our proposition has meaning, before proposing such a thing as planning, before suggesting new ways of designing human destiny and its instrumental surroundings. Charles Beard, the great historian, when reading this manuscript shortly before his death, strongly suggested that I should check whether planning was really possible.[3]

I have tried my best. Philosophical thinking of the past and leading minds of our own historical moment have now been considered. The problem has actually been discussed for thousands of years, and it appears, no final solution has ever been found. Perhaps our brain structure inherently prevents us from finding it. Yet, there remains an urgent inescapable problem staring us in the face; today more than

[3] From a letter, 23 Dec. 1947, by Charles Beard: 'Fess up, now, Brother Richard, just what do you, in a final showdown, believe about the deterministic influences of environment on human beings, as biologic creatures.'

ever we seem confronted with the anxious question as to whether the human race is fatefully self-destructive and thus destined to perish from the earth, or whether by our own design we may attempt and assure our survival.

What are the means of willful design and what are its ends, provided we can make these means work? To use ancient language for a new and still somewhat repetitive situation, do we hopelessly face a new flood as heaven has turned away from us? Apart from all dire dilemmas and panic reactions, the flood simply *is* upon us. It is threatening to overtake us right now in this world of gigantic industrialized production which hardly knows any bounds set by biological wholesomeness.

There seems really one thing left to do; that is to by-pass speculative issues quietly, take heart, organize the procedure, and confidently attack the stupendous ubiquitous problem of design, as far as feasible, with an eye on tried inductive method. And never must we lose a sincere, enlightened interest in the ultimate consumer—our species as a whole.

Whatever those theoretical convictions may be in which we sometimes like to indulge, for all practical purposes we seem *born* and *built to make anticipations*. Equipped with brains, as we are, we *must* plan and design. We cannot leave our salvation up to the old-fashioned brand of *Kismet*, nor to a new-fashioned one either.

If the advocate of planning, who faces many opponents, can gather very little definite support from philosophy, is there such support in current science which, after all, itself lays *plans* for research and has shown brilliant successes? A conviction in favor of unavoidable causality has never in the past lamed science; it rather has helped its initiative.

Moreover, modern science does not look at the causal point of view as the only possible one. 'Modern science,' to quote the renowned mathematical physicist, Paul S. Epstein, 'has developed another, the statistical, standpoint, which is just as logical and self-consistent and is in far better agree-

15

ment with the experimental facts as they are at present known.'[4]

In this new attitude nothing really has been decided either for or against free will and initiative. Yet, one very important characteristic of modern thinking in physics stands out and seems very pertinent to our argument for planning man's environment on a really large scale. The intrinsic error of observation (the reason for 'indeterminacy') has been found comparably unimportant for large bodies and significant only for small particles. Human intellect could, therefore, give a valid prediction of the motion of planets and other celestial bodies for a long period of time, but, in the case of atoms and electrons, in their individual singular conduct, simple calculations may fail.

The way we live in emotionally tinged expectations seems to reverse exactly this cooler, sounder prognosis in regard to feasible results of foresight! By necessity, every individual *does* some petty planning for his small-scale individual career and *warmly believes in it*. But if wholesale planning 'of large bodies,' such as communities, or regions, is proposed, it is frequently and readily pooh-poohed by a solid block of rugged individualists who decry such an undertaking as a chimera, a perilous illusion. Still, we should remember our lesson that *probability and the statistical point of view are partial to it*, favor it, and *promise us much more security in wholesale planning* than in the design of individual circumstances and careers.

[4] P. S. Epstein, 'Physics and Metaphysics,' *The Scientific Monthly*, July 1937.

MANKIND PRECARIOUSLY FLOATS TO ITS POS-
SIBLE SURVIVAL on a raft, rather make-shift
as yet, and often leaky: Planning and Design.

3

In the center of the problem that faces
us next, once we have taken a fortified decision against yield-
ing to predestination or to chance, there seems to loom the
question, 'Can we successfully separate Sunday from six
times as many weekdays?' Can we have two kinds of con-
duct, two kinds of design, one, a somewhat dwarfish set for
Sabbath consumption and dedicated to beauty, ideals, good-
ness and truth; another, a vast work-a-day set, meant for sup-
posedly *practical utility*, with ugliness, shoddiness, and a new
brand of barbarism rolled into it, and permissible by general
consent?

In a religious community of old, only a despicable cynic
could have pronounced such a two-pronged idea of 'useful-
ness' versus righteousness. At once he would have been
spotted as possessed by the devil; his utility would have been
recognized as the utility of hell.

Today, can we any more, and from any point of view,
accept such double-talk and dual set of standards? We have
been led by science to recognize a fundamental *unity within
ourselves*. While man is now known to have vastly more
sense receptors than the traditional five, all of them together
still deliver one combined message of a world truly indi-

visible. Among the many senses, formerly unheard of and recently discovered, there is no sense of 'beauty,' nor has a separate one for 'utility' been spotted. The current physiological view of our being makes man *one*, unless he is diagnosed a pathological schizoid. It is also *one* world we shall have to face with our designs.

If any design could be split into beauty on one side and utility on the other, as now many of us so readily assume, it would not be akin to the organic life *in* us or *around* us, which most certainly has no such divisibility. And yet people have had to live, especially these last two centuries, amidst a multitude of designs conceived and executed in just this mistaken spirit and be profoundly affected by it. Factories, railway depots, office buildings, cheap mass-housing schemes, and city plans which were first thrown together or engineered for utility and then dressed up for beauty demonstrate daily that they have painfully little kinship to life and in fact are fairly foreign to it. They cannot really sustain it. From designs like these only meager crumbs can possibly be picked up for the purpose of vital assimilation and sustenance. On the contrary, toxic influences penetrate from them into us every day, every hour, every fraction of a second.

In contrast to this, our time is characterized by a systematic rise of the biological sciences and is turning away from oversimplified mechanistic views of the eighteenth and nineteenth centuries, without belittling in any way the temporary good such views may once have delivered. An important result of this new way of regarding the business of living may be to bare and raise appropriate working principles and criteria of design.

In conversation with his clients the designer finds that likes and dislikes often are held to rule supreme. They are an armor proverbially impenetrable by argument. In spite of loose aesthetic verbalizations and speculations, acknowledged principles to support design must yet emerge and be acted upon. So far all seems to depend only upon incidental persuasive improvisations.

It must be emphasized how important, how broad an issue

is dealt with here, because clients are not just a few people who want their penthouses decorated or their beach houses built in nice shapes. They are not only capricious television stars with spending money, but also, for example, city fathers who dispose of staggering tax revenues extracted from all of us. 'Clients' include executives of huge industries, mail-order houses, and railroads; also politicians and bureaucrats who pass on a big, mixed bundle of designs for speedway systems, city halls, schools, projects for hundreds of thousands of families, and on plans to develop entire regions, states, or nations. It is not at all a figment of the mind that untold billions of dollars have already gone into such constructions and many more will follow in a perpetual procession.

Meanwhile, the spread of carelessly caused decay, waste of natural resources within and about us, destruction and blight, approach a most alarming and desperate magnitude.

And yet there are those among us who retain their contagious skepticism about the possibility of any valid criteria applicable to these matters and, therefore, of grand planning schemes altogether. They dislike being stampeded into action and feel that history has been full of false alarms, as if action were necessary. Is it safe to say: Experience has shown that things will right themselves after a while and there is no use worrying? That things have been out of gear so often in the past; and the danger shouldn't be exaggerated? If man has muddled through again and again, can it now be as bad as all that?

The great conquistadores of olden times maneuvered a handful of armed men and horses, and the famous ancient explorers navigated a small ship with slow speed. Their maps were rough and inaccurate; they possibly could afford that. Is this true as well for a fleet of airborne troops, for huge invasion armies of today, for a rocket ship to the moon, or even for one of those modern airliners speeding along almost as fast as sound? A plane like this needs the most exacting preparation of its course, a true map, a minute plan of procedure, a guiding beam, or else all may be atomized in a sort of crash quite unknown to the ancients.

Contemporary civilization, for better or worse, evidently operates on a new level. It is engaged in such high velocities in the handling of such staggering masses that good old trial-and-error, always a little obnoxious and seemingly at no time an ultimate method, now often reaches most urgently its replacement stage. Of unavoidable necessity are more precise and pertinent data, preventive and constructive programs, blueprints. Those data will have to concern above all proved and clarified common human potentials. If our designs are to hold water, we not only must have a technological and commercial horizon but we must more truly know man, the consumer, and his 'physiological purchasing power.' To plan for him we must know his characteristics. The terrifying magnitude of energies, speeds, and masses invested today have created a biological situation without precedent. The early treatment through tradition, or the later lawless laissez-faire, seems now out of the question.

And the mass production of the post-Victorian generation of only yesterday was child's play. It was a rehearsal for the breath-taking show we are going to face now, in the midst of this high-geared yet unevenly spreading planetary industrialism of the second half of the twentieth century, where war and postwar periods hold hands when it comes to fantastic figures of consumption. Condemned, bombed-out boroughs, cities and regions are to be reconstructed because of war damage as well as for an obsolescence due to severe inner blockages. The thought cannot vanish from our attention that while there is an immense, a staggering demand for design and for plans all around the globe, really workable, broadly fundamental, and generally acceptable criteria for this gigantic design activity are lacking.

Are there reliable values which are at least sharply silhouetted against the horizon of the future? Can we define such values beyond those which are commercially advertised? Can we make these values more soundly founded or defensible? How is the knowledge of these values to be obtained with a degree of assurance?

To worry about such objective criteria and to find them is anything but gray theory. They drastically affect the economics of communities and nations. In fact, without objective criteria, without well-founded principles to carry on, plan, and design, we cannot prove anything to councilmen, taxpayers, administrators, boards, or the people.

We must not, we cannot even afford to doubt the valid existence of these principles and criteria. They can be based on nothing but a perpetuation of the species, which we aspire to insure—on the needs for survival of the human race.

The entire organic evolution which had seemed to culminate in the social and physical structure of human culture must not come to a dead end. It must not stop in cataclysm and a new sort of chaos simply because humans cannot learn to control, by the brain, the constructions and multiform products of the brain.

If design, production, and construction cannot be channeled to serve survival, if we fabricate an environment—of which, after all, we seem an inseparable part—but cannot make it an organically possible extension of ourselves, then the end of the race may well appear in sight. It becomes improbable that a species like ours, wildly experimenting with its vital surroundings, could persist.

But perhaps we have not yet given ourselves our full or last chance. In fairness, we beg for it.

There have been times when speculative thought on this and other subjects was almost unchallenged. What George Lundberg has in general pointed out for sociology, a science of all human affairs, is equally true for the foundations of wholesome design: mere speculation will no longer suffice. It is not so much that new systems or styles will be 'thought out,' but all will have to be underbuilt with painstakingly sifted, observational, and experimental material.

In this crucial period of ours, we can no longer hope for any short-cut. If we have any hypotheses, they must be working hypotheses recommending certain paths of research that lead to objectively verifiable results.

We must not jump to conclusions and we shall not light-heartedly promise proof. But in the end, we hope to stimulate trains of fascinating inquiry and investigation; the sort that, through all our practical work, we have found truly needed in order to outline a basis of design and to make a sound, justified, and successful bid for its acceptance.

FROM A BABY CARRIAGE TO A METROPOLIS, our man-made surroundings, top-heavy with technological trickery, have become our mold of destiny—and a source of never-ending nervous strain.

4

In periods of war or severe social and economic stress, sweeping pessimistic statements are made concerning the self-destructiveness of the human species. Our civilized life, even at its 'normal' pace, may well inspire such pessimism. Certain hopes set on science during the last two centuries have proved illusory and the results ambiguous. Indeed, despite its spectacular achievements in specialized fields, systematic science does not seem to be applicable to the whole of man's complex affairs.

Yet the construction of a contemporary scene which would gratify human needs instead of frustrating them, which would further the smooth functioning of man's nervous system instead of imposing an intolerable strain on it, is a problem that will most certainly not be solved by lucky accident.

The human habitat—originally the primeval forest or the grassland of prairie and pampas—has become more and more man-made. And with us, it is perhaps 90 per cent the work of human hands and—we must hope—brains. Civilized men pass their lives in or between structures. These structures,

23

and the spaces between them, urgently require sound and integrated design. They are the more in need of it because they are static and permanent, unlike the campfire sites of the nomads, which could be befouled and then easily abandoned once they became uninhabitable. Yet primeval nomadic recklessness often still characterizes our dealings with the physical environment. Also, the human species, more numerous on the planet than ever, is crowded, cramped, and harassed by density. A great part of the world has been transformed into congeries of slums.

In spite of technological progress, or perhaps because of its spottiness, our man-made environment has shown an ominous tendency to slip more and more out of control. The farther man has moved away from the balanced integration of nature, the more his physical environment has become harmful. Nervous friction and wreckage have multiplied in the metropolitan type of surroundings. Frightening statistics remind us of this.

Although human beings no longer live in natural jungles, they inhabit jungles of their own making—jungles such as are beheld from the windows of automobiles moving through our towns, be they large or small. We see endless stretches of wilderness from New York trains crossing through Harlem or from the Chicago 'El.' Miles upon miles of 'fronts' and 'backs' which are now grimly neglected and old, but which never were young, line the tracks passing Albany and Syracuse, entering Detroit or Los Angeles. One does not have to be an out-and-out environmentalist to be concerned about the baleful influence of such man-made surroundings. They envelop the child, the adolescent, and the adult like an inescapable fate.

The nursery in which a child spends its first formative years, the bathroom in which it is taught the essentials of modern cleanliness, the house containing these rooms, the street in which this house stands, the neighborhood to which the street belongs, with its schools, places of work, worship, amusement, recreation—all are part of what may be called our constructed environment. It can be friendly

or hostile (for the most part hostile) to the human organism on which it perpetually acts and reacts.

Our deep and unconscious responses lend the environment demonic powers over us.

Early in life we spend much time floored baby-fashion, perplexed, most curious. As a two- and three-year-old, I often sat on the parquet of my parents' apartment, studying the raised, splintery grain of the worn hardwood and the warped boards. The cracks between the boards were filled with a compact something which I liked to dig out with my fingers. To grown-ups the floor is distant. Had they stooped to examine what I produced from this quiet resting place of open parquetry joints, they would have called it dirt. Magnification could have shown it to be a teeming microbiotic world. I tested it by the toddler's ancient test—put it into the mouth and found it 'no good.'

Strange as it may seem, my first impressions of architecture were largely gustatory. I licked the blotter-like wallpaper adjoining my bed pillow, and the polished brass hardware of my toy cupboard. It must have been then and there that I developed an unconscious preference for flawlessly smooth surfaces that would stand the tongue test, the most exacting of tactile investigations, and for less open-jointed, and also more resilient flooring. I recall, that scantily dressed or naked as I was, I became uneasily aware of the surface on which I sat and moved.

It was then, also, that I first experienced the sensation of towering height by looking upward to the carved top of a Victorian dresser. I was more awed and impressed than, later, by the gigantic columns that support the vaults of the cathedral of Milan or the roof of the Temple at Luxor.

The idea of shelter is associated in my mind with a feeling that took root in me during those days. Our parlor ceiling was uncomfortably high, and so I used to sit and play under the grand piano. The low headroom under our piano provided me the coziest place I knew. Many likes and dislikes must have taken shape in the child I was, as they do

in every child. At night there were dark, inaccessible, mysterious spaces—such as that frightening area back of the olive-green upholstered love seat, placed 'catty-corner' into the room. I still shudder at the memory. And I still loathe the waste of space behind furniture.

Those many childhood experiences taught unspoken lessons in appreciation of space, texture, light, and shade, the smell of carpets, the warmth of wood, and the coolness of the stone hearth in front of our kitchen stove.

Later our college lectures on architecture never touched on such basic sensory experiences, or on the subtle relationship between physical structures and man's nervous behavior. I did hear, though, a great deal about good taste and beauty. So-called beauty was an outworn abstraction, which did not advance my understanding, and so-called taste was a vague term with no definite meaning. Both seemed conceived as if they could simply be added to what otherwise would be merely 'practical.' There was a flavor of non-essential luxury about this taste-and-beauty 'supplement.'

Our environment called for a more integrated evaluation, especially that crucial part which man himself constructs and continues reconstructing from age to age.

The natural scene—the precultural environment—has undergone only minor changes throughout the long formative period of our species. The process of early man's adjustment to this environment was largely automatic. Man-made environment, however, is subject to far more rapid changes. There is no time for slow biological adjustment to novelties which at any moment may become technologically feasible. The velocity differential of these two processes is fraught with dangerous friction. Experts in organic requirements and reactions must help us steer clear of precarious maladjustment.

The fact that our surroundings have become ever more alien to life and its needs has been clear enough for a long time. But accompanied by a fortissimo of technical-industrial activity, we have listened to the siren song of 'progress.'

The physical surroundings, the expression, the looks of a

period like the Middle Ages could not well be understood without sympathetic insight into the common faith and the peculiar scholastic quirks of the minds that shaped it. Similarly, we ourselves have long been possessed by a popular faith. It was a faith which ambitions and superstitions firmly linked to a mechanistic brand of scientific outlook and to the mass impact of industrial output. This faith begot our present metropolitan turmoil. To gain a relative understanding of our present status, its background and potentials, it may be useful to review, very briefly, a sequence of mental attitudes that have evolved during the last two hundred years.

5

No single one of the sciences or arts has an entirely independent record of development. Mutually conditioned they become part of the general wealth of mankind. Architecture of today is not a solitary offspring of modern society; its intellectual pedigree is complex. Thus, a glance at the broad cultural background implicitly related to design will be of value. Unlike automotive and other engineers, architects have been trained to keep an eye on the precedents of a distant past. They have long been accustomed never to discuss even the most novel development of the future without a grain of retrospection. In our brief survey, therefore, without any claim to exhaustive treatment, we shall try simply to highlight the historical background of current views.

Rationality has in some measure been applied to the everyday operations of man and his designs during the last hundred thousand years. The origins of the modern scientific approach may be traced back to antiquity or the Middle Ages. By the eighteenth century, the achievements of scientific inquiry and mathematics had been very successful and quite distinguishable from the results of earlier modes of thinking. This success gave rise to the belief that everything

in the world could sooner or later be rationally explained, and that human life could (and should) be organized on the sole basis of 'reason.'

This eighteenth-century trust in reason turned into a new faith, as well as a fashion, and finally into a deep-rooted social movement. It spread through court society and down into the educated middle class, which aspired to political influence commensurate with its growing economic power. Rationalistic slogans were used in the struggle against the privileges of aristocracy and clergy. Yet actual scientific research was still primitively organized. Infinitesimal mathematics or involved astrophysics were understandable to only a handful of people. Nevertheless, the new ideas were widely appreciated for their paradoxical brilliance.

Before the middle of that century, La Mettrie, a French physician, wrote a book entitled *L'Homme-machine*. The idea that man was a machine, even if it could not be proved in detail, seemed like a splendid slogan to witty *raisonneurs* who enjoyed annoying the Church. And there were earnest hopes that this notion could actually be proved, at least later on. At that time, the comparison with a machine did not imply contempt for man; on the contrary, intricate clockwork or other machinery was the exciting novelty of the day. While the educated classes were infatuated with rationalism, the broad masses of Europeans had still not progressed beyond a belief in witchcraft; and emotions that had previously been associated with magic were now readily transferred to the machine, the much admired *automaton*, the amazing homunculus of the new age.

What contributed most to the spread of rationalism among the masses was not, however, its pleasantly shocking or fashionable aspects, but its deeper revolutionary implications. One of these was the gradual replacement of the qualitative by the quantitative approach in science.

Earlier philosophy had been based on the concept of quality. 'Qualities' were regarded as irreducible essences. This concept was bound up with the hierarchical structure of society. A 'quality' was something that by definition could be

discerned only by the especially endowed, not by the common man. Whether the qualities in question were spiritual or material, only a person of privileged view could assess them. In fact, there were no material qualities; for even these, such as shape, color, or rhythm, seemed to hold mystical significance.

The new, post-medieval science of nature adopted a quantitative approach. Science was inseparable from mathematics; its progress depended on the development of increasingly more accurate methods of measurement with finer and finer scales. There was promise that mystical qualities would be universally resolved into understandable quantitative terms. Society began to realize the democratic implications of such a development. The common man had had no legitimate access to those long-enthroned and puzzling qualities; he had been kept out of the secret, and had been denied corresponding rights. The common people had always been the majority; but only now did the majority become important: the new science, based on mathematics and measurements, seemed to imply the glorification of numbers. How could it fail to appeal to masses of people, now 'enlightened' by revolutionary literature?

Moreover, it was amply demonstrated by the new industrial technology that science really 'worked.' It did not matter that only a few people knew how. The mere fact that it did work and produce—while its inventors obligingly explained that it was no secret magic but the outcome of plain, quantitative computation accessible to all—was startling to the common man. He began applying reasoning power to a good many venerable social and political institutions, even though they derived their authority from the will of the crown which, in turn, claimed to act by the grace of God. Rationalism was no longer a mere fashion.

While some philosophers of the Enlightenment, in a remarkable spirit of childlike seriousness and optimism, drew up comprehensive plans for reforms, the physical setting in which they lived remained largely unchanged. Pictures of the rooms and buildings where the Encyclopedists met, or a por-

trait of Voltaire with his elaborately curled wig, show that these ardent reformers continued to cherish old-fashioned physical surroundings, to furnish them, and to dress themselves in a manner hardly compatible with their rationalistic creed. The compartmentalism in man's mind breaks down slowly—this accounts for the amusing contrast between attire and conviction.

Ideas of reform received a new and powerful stimulus after that calculating social idealist and militant sentimentalist, Jean Jacques Rousseau, had stirred up a passion for broad, radical readjustment. His followers thought that it would be a simple matter to find the way back to what he called a natural mode of life and social order. People, simple minded and most plainly dressed—*sans culottes*—ultimately made so bold as to storm the Bastille. They went so far as to behead the king, who formerly was thought to possess mysterious and unaccountable qualities different from the rest. Accountable quantities were now victorious.

A new era, calling for wholesale replanning, redesigning for a total reconstruction of the pattern of life, seemed to be at hand, as an inevitable consequence of the great political revolution. Inveterate and obsolete conventions were to be analyzed radically and liquidated *en masse*. Industrialized technology clamored for expansion and consumers. The society of the future was to be modeled on Rousseau's social contract. It was also to be based on the tabulated judgment and vote of the many. Numbers obviously had succeeded in solving so many questions, even the most intricate scientific problems.

The new society was to be democratic. Before the American Revolution, sizable democracies had existed only in ancient Greece and Rome. Greco-Roman patterns of life and artistic expression were therefore promptly revived to serve and symbolize the new order. The rationalist-minded society of A.D. 1800 made a strenuous effort to assume the outward forms of antiquity—which in itself was hardly rational or in any way compatible with the dawning machine age. Americans built banks in the form of Greek temples, hundreds of

mansions donned Greek pediments. In the United States, rainier than Hellas, nearly flat roofs, although covered with new-fangled sheet metal, proved permeable to the moisture of melting snow, and wet spots left their mark on the ceilings below. The porticos and colonnades were less majestic than those at Selinus in Sicily. The symmetrical Greek face often imposed a rigid floor plan that made homes of this kind stylish but hardly practical. Rationalism in science and social philosophy had evidently failed to find an adequate architectural expression of its own, and succeeded only in producing another fashion, one that was curiously divorced from the requirements of real life.

The pendulum swung back. Public taste soon replaced the rigid surface-Hellenism by a more flexible combination of forms patterned on the supposed architecture of the Middle Ages and other periods. The ideal of an integrated environment, which was to be the programmatic expression of a new order, seemed forgotten. It was as though the sneering predictions uttered by the aristocrats as they ascended the guillotine had proved right. The populace, that mob of bourgeois, had proved unable to create new cultural patterns and live up to them. From Louis Philippe to Queen Victoria, the middle classes, political victors though they were, kept on rehashing and diluting the forms of the *ancien regime* that they had upset.

Revolutions make many promises, but their fruits ripen slowly. The eighteenth-century palace with its lackeys and flunkeys is perhaps only now being replaced as a subconscious ideal in the minds of the middle classes, who were the conquerors of 150 years ago. It is being slowly supplanted by a taste for informal, self-service dwellings designed for the masses of small consumers. The prophecies of eighteenth-century revolutionary thinkers who strove to end the feudal curbs on industry and enable everybody to enjoy its products are beginning to come true in building matters only today. The change in attitude has taken a long time to crystallize and is not yet clearly defined, if one may judge from

the Georgian residences still under construction in real-estate developments named 'Bel Air' or 'Sans Souci.'

Throughout the nineteenth century, while the art of design remained tradition-bound, science and technology forged ahead. Constructive thinking continued to develop behind the controversies among stylistic schools. Rational organization of social life also became the object of a new science, undaunted by bloody revolutions and the political reactions that followed.

But while nineteenth-century thinking was largely stimulated by mechanized industrial progress, and furthered by the development of physics, the new science of biology made it increasingly evident that every living organism must be adjusted to its environment, and that species and genera had indeed been molded by their environment through millions of years. The public became aware of the Lamarckian and Darwinian theories of evolution. Originally these were strictly biological hypotheses; but, almost suddenly, speculations on the all-powerful role of natural constellation and circumstantial pressure became as fashionable as rationalism had been in the eighteenth century. Later, just when the factual foundation on which the original theories were based began to be questioned by scientists, vulgarized versions of them had a heyday in all kinds of contexts.

Although abrupt mutations had not yet been explained by the theory of de Vries, and evolution was still believed to be slow and gradual and to become noticeable and effective only over hundreds of thousands of years, evolutionary terminology was glibly introduced into the interpretation of man's comparatively fast-moving history. Socio-economic disorders were comfortably ascribed to allegedly biological causes. The laws of heredity and of environmental influence were invoked as a neat justification of exploitative practices that conflicted gravely with earlier Christian ethics. It became possible to be complacent about unpleasant social realities. The industrial proletarians, living in shockingly crowded slums with their hordes of sickly and neglected children, the weak and unadjustable individual, the criminal, and all the characters

on the margin of established society became 'comprehensible'—sometimes with a shrug of the shoulder. But the same century saw the emergence of social psychology, sponsored by Cesar Lombroso in Turin, as well as the patiently fact-finding and systematic 'experimental and physiological psychology,' initiated by William Wundt in Leipzig.

European newspaper readers in the 'seventies and 'eighties seemed again reasonably sure that they were on the verge of not only comprehending the human and social fabric with all its intricacies but possibly even of establishing a rational social order and organizing the globe in a most satisfactory fashion, with all the remaining savages transformed into successful colonials. Although there were different schools of thought, an optimistic outlook was predominant.

While big enterprise and empire builders forged ahead, socialism and trade-unionism had entered the domain of practical politics. Civilization promised to spread speedily over the map as well as into the depth of society. The discovery of the laws of natural development and human conduct seemed around the corner. The progressives of the day hoped that the social order which was so largely based on tradition, and which had originated in primitive mystical ideas, would soon be supplanted by a new one based upon science. Everything in life, it was proclaimed, must be governed by recognized natural necessity.

Perhaps not quite everything as yet. Certain important and very specific aspects of life continued to follow conventional lines and conflict with natural necessities, but few social thinkers paid critical attention to such anomalies. The architects of that period gave a new and permanently unwieldy shape to the significant metropolises of the world and the day. In Paris, Vienna, Berlin, the edifices and streets became jumbles of the most disparate elements. They did not recognize the rule of any natural necessity.

Camillo Sitte, one of the first theoreticians of city planning, who found an audience during the industrial boom that followed the depression of the early 1870's, seemed almost exclusively interested in producing impressive groups of

showy public buildings or representational façades. An important and gifted leader in monumental thinking, he did not seem to mind the fact that one of those buildings might boast a front in supposedly French-Gothic style, and others in Italian Baroque or in Periclean Greek, while all of them were planned and erected within the same decade and around the same city square. Nor did he waste time, as young Engels had done a generation earlier, on investigating whether slums were indeed a natural necessity. These slums had sprung up on the outskirts of almost every large community into which a greedy industrialism had crowded the laboring population—in Glasgow, Manchester, Breslau, Boston. Sir Patric Geddes has named this reckless, crude era the paleotechnic age.

To us these slums would perhaps seem much more urgently related to an improved planning of dwellings or communities than to novel writing or picture painting. But for some reason—probably that of least resistance—the sequence of historical developments was exactly the reverse. Naturalism in literature and painting preceded by three or four decades a comparable naturalism in architecture and planning.

In the Paris of the 'seventies, when the new French republic was ambitiously carrying forward the construction of the imperial boulevards and building an impressive row of façades inaugurated by Baron de Haussmann, literature developed initiative in a quite different direction. It went into the slummy back streets and studied them with a realistic passion for facts and for social justice. Pseudo-historical compilation and facial treatment were banned from at least a few of the arts which now took the lead, and some writers even began to call upon the architects to follow their example. But most architects of that day apparently did not read modern literature, or failed to understand its message.

Emile Zola shocked his contemporaries by writing a novel entitled *L'Assommoir*, the slang term for a cheap saloon; then he went further and wrote *Nana*, the story of a prostitute, which conservatives considered pure pornography and which, in partial corroboration of their opinion, sold a hun-

dred thousand copies. Actually *Nana* had been planned as one of a cycle of novels, which their author conceived as objective studies based on the laws of heredity and environment. His intention was to portray the impact of environmental factors on various branches of a family, in fact, on French society. Zola himself proclaimed this sort of fiction writing to be scientific on the ground that it dealt with hard realities on the basis of objective research. He and his followers, watched by the rest of Europe, founded and drew up the program for the naturalistic school in literature. This movement was somewhat paralleled in painting. The artists walked out of the academic studios in protest and began to paint outdoors, striving to render the natural effects of light and air. Impressionists and pointillists who were trying to come closer to the realities of nature were inspired by a spirit of scientific experimentation.

Disregarding the various manifestos and proclamations, we may define Zola's naturalism as a movement which expressed a reaction against the romantic tendency to escape from the present into remote situations and periods. The naturalists tried to counteract the influence of Musset and Hugo, with their picturesque settings and fictitious treatment of life. 'Real life' was to be scrutinized with passionate attention. Even vulgarity and banality were recognized as an ingredient—almost an ornament—of realism. The underlying idea was that the subject matter of real nature must be 'studied' and presented 'scientifically,' with the help of all the tools available to contemporary investigation. The naturalistic novelist availed himself of systematic biology, realistic psychology, and, a little later, political economy. He introduced into literature a phony parallel to scientific method of observation and speculated about the application of the newest theories to his own field.

In brief, naturalism advocated a return to nature, by the most up-to-date means. Nature was to be recaptured by 'scientific' methods. It was not a sentimental or romantic back-to-nature movement. Zola's conception of nature was worlds apart from that of the idyllic poets. A regularly

scheduled Victorian railway train was taken into the natural scene—lyrical promenades or picturesque Neapolitan donkey rides were done for.

Thus Emile Zola wrote his stories about a strike in the mines of the northern industrial district, and photographed with his pen, or should we say daguerreotyped, the population of a backward rural area. Woven into all of this was his genealogical report of that French family, the Rougon-Macquarts. With respect to form, Zola's clustered composition may have been modeled somewhat after the Comedie humaine of Balzac's methodic genius. But now a definite and extra-personal scientific system became the backbone of this new literary cycle.

In the course of time, naturalism and the scientific approach to literature were superseded by other movements and fashions, while science plodded on patiently, less concerned with short-lived utopias, than with long-term results. Best-sellers that promised to solve the riddle of the universe by a short cut or in ten easy lessons remained incidental diversions.

The sciences often progress at an uneven pace; some make great strides, while others lag behind. For example, it took quite a while before the organic chemists or bacteriologists picked up their parcel of higher mathematics. But unevenness in development is only temporary; for all the sciences have become interrelated, and no part of the advancing front line may for long remain far ahead of the others. Needless to say, the actual pace of scientific progress was rather slower than suggested by the blurbs of so-called scientific novels; yet, there was steadiness of direction, and progress became less and less accidental.

As if in contrast to such systematic integration, the human mind has also, we said, an innate tendency to remain divided into tightly separated compartments. Emile Zola, like Voltaire before him, was not free of such a peculiarly split outlook. He courageously advocated a consistent interrelation of all things, adherence to nature, indifference to conventions,

and realistic logic. Ultimately he embraced socialism as a doctrine that promised to achieve a rational organization of the human community. But when he came to build his own house in Meudon or furnish his apartment in the Rue de Boulogne, he certainly did not act like a champion of progress. His self-chosen physical environment was quite at variance with the spirit of his radical pronouncements.

One might expect to find this leading proponent of back-to-nature-by-scientific-method sitting at a clean-cut, modern writing table in an airy, well-lighted, almost empty room, simple but psychologically gratifying in design and color scheme, so conceived as not to interfere in any way with crystal-clear thought. In such austere surroundings we might imagine Zola, frugal, full of sympathy (as much sympathy as a scientist can afford, of course) for the exploited miners, working hard and systematically at his daily 2500 words of *Germinal*. Here he would create that bitter mass drama of a strike, a tragically frustrated attempt at self-help in the new and troubled industrial age.

How he actually furnished his 'new' apartment we know from the following enthusiastic description of a contemporary:

> A large room into which the light penetrates with difficulty. . . The big windows are reduced to small dimensions by use of broad Bonne Grace window hangings of blue plush on which flower embroideries, cut out from antique Italian chasubles, are sewn. Curtains of white lace and double curtains of red crepe-de-chine increase the dimness of the room and render it severe and lugubrious. The cabinet de travail (this is the work-room) is furnished with objects from every epoch, every style, every country. The work table of Dutch origin, heavy and massive, dates from Louis XII; the huge writing chair of solid rosewood dates from Louis XIV and came from Portugal. There are two small bookcases of the Louis XVI period, a little Louis XV table, a piano and two magnificent Persian vases, containing bunches

of lilac. Above one of the doors is a kind of scallop from an Italian altar hanging, embroidered with Venetian beads, dating from the seventeenth century. There are numerous pictures on the wall, for the most part of the impressionistic school, including the famous portrait of Zola by Manet, and landscapes by Cézanne, Monet and Pissarro.

What we face here is lusty mid-Victorian eclecticism at its wildest, surrounding a new sunrise of impressionist painting and naturalist writing. But we step farther into the apartment of the revolutionary.

The bedroom is the most curious of all. The walls are hung with antique tapestries from the Chateau d'Amboise. The windows are of stained glass of different periods, ranging from the twelfth to the seventeenth century.

Between the two windows is a huge coffer of carved wrought iron. There is an antique Preston cupboard, some superb Majolica pottery, and a tall and massive bed of the Louis XIII period ornamented with hangings made from a chasuble of Genoese velvet.

Strange as it may seem, the author of L'Assommoir and Germinal worked in a study encumbered with antiques and slept in a Louis XIII bed in an air-tight compartment of antique Genoese velvet. And we must keep in mind that Zola's books were not only written but also read from Bucharest to Saint Louis in the midst of just such furniture set in similar rooms and settings.

Zola's modern biographer, Josephson, from whom the foregoing quotation is taken, tells us that when Flaubert was led by the gleeful Zola into that extraordinary bedroom, he sat on the majestic bed and stared about him with his great wondering child's eyes, ravished. He thought of one of his own romantic tales of the Middle Ages. 'Why, it is the bedroom of my Saint Julien, the Hospitaler,' he whispered rapturously. And so it was—or nearly so.

The apartment in the Rue de Boulogne, in the Paris of 1877, was furnished to have what the romantic pre-Zola literature considered medieval flavor. Zola, who had deliberately wrecked the literature of the preceding period, busily indulged in its furnishings, architecture, and superannuated gimcracks. The pictures adorning the walls were for the most part of the radical *plein-air* impressionistic school, which Zola had championed and promoted. Did he fully grasp their message? He undoubtedly *hung them dead* on his over-decorated walls. We may well conjecture why Cézanne, a genius of much greater stature, became estranged from his old friend who lived surrounded by all this confused clutter and bric-a-brac picked from all the latitudes and longitudes of history. I do not know whether Cézanne's bedroom had a window large enough to admit a bit of *plein air* for his eyes and lungs, but we do know that he did not die from suffocation in a hermetically sealed sleeping chamber. Zola actually did. I was a child at that time, but I still remember the big headlines. My parents seized this opportunity to explain to me the dangers of gases emanating from poorly vented fireplaces and stoves, and then conversed on the new creed of sleeping with a window open.

Today, Zola's novels may seem long-winded; but parts of them remain historically instructive. His mind was a sensitive instrument accurately recording the tendencies of his period; he is representative, not accidental. His naturalistic program was in revealing contrast to the style of his writing desk, his working chair, his bedroom. It is a real and poignant tragedy that the sincere popularizer of straightforward science-for-life's-sake succumbed to a shortage of oxygen and an excess of gingerbread.

There was no proto-surrealistic plan whatever to his combination of altar candles on the desk and sexual psycho-dissection in the manuscript. Zola was unaware of his own double standards. His doctrine of naturalism was one thing; his apartment was another. He lived and died at the hands of the vigorous interior decorators of his age.

The new ideas were not yet strong enough to form their own physical shell. Such a process takes time.

What recently and for a while has been called the new architecture was new only as architecture goes; in fact, it was a belated camp follower of 'naturalism' which, in those earlier days, was to revolutionize only the literary compartment.

But similar ideas have come home to us. Forty years later we again witnessed the revival of a movement advocating a return to nature by way of modern science. We were assured that we must not be afraid of such a trivial object as a bathroom soil pipe exposed freely on the exterior of a building. It might even have propaganda value for realism and matter-of-factness. Once more the objective was to conquer sentimental romanticism which again was spotted as nihilistic and showing no loyalty to the possibilities of our own time!

Zola and his literary friends had followed this line of thought; LeCorbusier evidently felt quite similarly inspired by the Paris of half a century later, but the focus of interest had now shifted to planning and 'toward a new architecture.' LeCorbusier had come home from Vienna, where he had met Adolf Loos, the architect, who shook the Philistines of his time with proposals for new modes of living, while Oscar Wilde only shocked them with parlor witticisms. By the end of the century the aspiration for a radical change had abated in literature but invaded the field of physical design.

Earnest reform may every so often be interrupted by caprice; much of arbitrary eclecticism might still be adopted as a 'spice.' Plastercast caryatid virgins, rococo chairs, and Victorian cartouches reappeared between the world wars in the penthouses of Paris, London, New York, and the gigantic Brazilian gambling casino of Petropolis. 'New Empiricism' and 'Neo-Romanticism' can in certain places be granted title as authentic movements. But the main and primary current of developmental progress in building design can now be deflected less easily. At all events, it is no longer as isolated as it had been before. Architects have begun to be interested in other branches of human endeavor. The consciousness of

the broad relationship of design to life has been recognized in some measure. An over-all integration and clear direction should prevail over all petty cross currents.

The blunt pose of mere reaction against naïve romanticism, however we may choose to define it, has subsided. The superficial desire to indulge in banal and ostentatious crudities intended to frighten the Philistines, may have been as fashionable in 1925 as it was in 1880; it is so no longer. The essential core of design emancipation has never been merely a fashion destined to die when the next spring model comes out.

Sentimental retrospection and the hunt for sheer novelty may often seem to dominate the scene. Yet another attitude has come increasingly to assert itself in everyday design at its best. It is an attitude of rather sharpened, objective, all-around observation before wielding the pencil. It is creatively systematic, sometimes meticulously statistical, undogmatic, but not irresponsible. Altogether it is different from classical precedents—however great and venerable these may be. And in spite of such flagrant differences there is no reason to suppose that an intensive human art cannot thrive in this new atmosphere, or that the end of all real pleasure in life is in sight.

6

After naturalism, many movements followed one another in swift, sometimes confusing succession. But a 'scientific' ambition, inaugurated by the naturalists in literature and the impressionists in painting, had become one of the artists' permanent drives. Instead of interpreting romantic subjects, late nineteenth-century painters decided to set these aside and tried to render the natural phenomena of light and color, to paint according to scientific optics. They were selective recorders and most patient experimentalists, like Seurat, the inventor of pointillism. It was only fifty years later that mathematical physicists began wondering whether strictly speaking the observer and his very means of observation do not affect what he sees.

When color and light in nature were no longer a fascinating novelty to the artist with his modern searching mind, his interest shifted to the study of 'pure form and color,' of 'the new media and materials,' or of the artist's 'ego and his subconscious.' The results of such inquiry and research were what he painted and carved. In whatever devious currents post-impressionistic painting divided itself, art never again reverted to the bygone innocence. Scientific aspiration per-

43

sisted. More especially, a scientific-sounding terminology, loosely borrowed from various sciences, now seemed necessary to many artists and critics. Although they were not scientists themselves, they depended on the language of science, almost as much as the medieval artists—who were no saints—had depended on the language of their Christian faith. Thus in the first quarter of the twentieth century, it was, for instance, the psychoanalytic terminology that inspired many artists and their public. Despite their enthusiasm, both had often only a faint idea of what it was all about.

As a young man I was befriended by Professor Freud's sons and had the chance to observe on social visits in his home that the great man himself was indifferent, if not hostile, to the then current expressionistic art, fraught with 'depth psychology.' Sigmund Freud was a connoisseur but kept aloof from consciously revolutionary, controversial, and programmatic novelties. They did not attract him as did Cretan jewelry, Greek statuary, and Hellenistic painting.

Science, fascinating because it was beyond the layman's grasp, or popularized with questionable accuracy, imprinted itself on art manifestos, but often to the annoyance of the scientist.

While the old romantic approach was being shunned for a time by the artists, science itself consolidated its inductive method and preferred operational concepts to the handy package labeled 'eternal truth.' Even philosophy, as far as it survived, began to be permeated by this matter-of-fact attitude. In America, pragmatism and behaviorism attracted wide attention. Following James, Dewey and instrumentalism proclaimed that an idea was true if it worked.

If a thing had truth because it worked, it now also had beauty because it functioned. A hundred years ago the American sculptor Horatio Greenough declared that the structural form created by man must follow function, just as was the case for living organisms, according to the new science of biology. Dr. Giedion has most interestingly re-

corded less well-known predecessors of these ideas among French designers and writers.

An impressive literary precedent is Gottfried Semper's wise and voluminous book *The Style*. Semper, a contemporary of Greenough, practiced architecture in Dresden, Zurich, and Vienna, and his writing was translated in part into English by John Wellborn Root, the greatest architect of Chicago's 'pre-Columbian' period. Semper's programmatic statements: 'The solution of modern problems must be freely developed from the premises given by modernity' and 'Any technical product is the result of use and material,' were undoubtedly known to Louis H. Sullivan and cherished by him. But however radical the ideas of Gottfried Semper and his French counterpart Viollet-le-Duc may have been, these men never abandoned traditional formalism in practice.

It was Sullivan who in 1892 decided to house Pullman cars and locomotives at the Chicago World's Fair in a Transportation Building of nontraditional form; and it was Otto Wagner who, simultaneously, built two or three dozen stations of the Vienna subway and elevated rapid transit lines in the new style of the time. The same issue was dealt with on similar terms by one man in Central Europe and another far away in the Middle West of North America, where forty railroad companies had begotten a metropolis which was slowly to emerge from grimy chaos.

I know from my early and frustrated attempts to get Sullivan's writings into print that publishers, only a generation ago, failed to realize the revolutionary significance of Sullivan and the interest his consistent 'Kindergarten Chats' would finally arouse. Perhaps he did not state in so many words the relation between *morphology*, the science of organic shapes, fabrics, and textures on the one hand, and *physiology*, the discipline of life functions on the other. Yet the very idea of this interdependence certainly permeated his profound conversations which inspired and comforted me. Greenough's articles of 1850 probably had remained unknown to Sullivan. At least I do not recall hearing him mention these articles to me.

45

Assuredly, in every piece of constructed machinery (and why not of building engineering, too?) form seemed to follow function, and perfect functioning seemed to be a criterion of perfect form. Beauty was due for a re-definition by the engineer as well as by the biologist.

The rebirth of aesthetics on a 'scientific-naturalistic' basis seemed to be at hand. A universal solution for all aesthetic problems had all at once been proclaimed, a monopoly of interpretation, and a rule of action seemed established: Investigate the functions of a proposed construction, give it adequate functional form, and it will be a 'beautiful' form— whether or not it fits into our traditional scheme of shapes. Design no longer had to comply with social convention; rather, it was computable through a critical analysis of the available materials and determining requirements. Design-result could be almost automatic. This was a point of view quite unfamiliar to Palladio and Vignola.

What Louis Sullivan, as a saddened and dying man, was kind enough to tell me, a young tyro, about the changed functions of today's building, as well as the need for developing new and fitting formal solutions for them—these were ideas which reflected the general trend of thought of the closing nineteenth century. He was the ingenious recipient of the ideas of his time, destined to formulate these general and fundamental beliefs in specific application to building design.

Possibly in some former periods architects occasionally played the part of pioneers and educators by introducing original ideas of their own. But in the 1890's, the geniuses Wagner and Sullivan distinguished themselves mainly by their relatively higher receptivity to already current thought. Their great merit was to be far ahead of petty-minded colleagues and of their profession, which in general was arrested in its development and impervious to the demands of modern life.

Architecture was now expected to become a real and significant part of current existence instead of remaining the archeological game into which it had degenerated. The

straggling architect had finally caught up with his time. An integrated environment seemed really just around the corner. But soon the very biased concept of 'utility' was rashly coupled and popularly confused with the much broader one of function. This led to a distortion of Sullivan's thoughts and paved the way for a reaction.

The ancient idea of Democritus and Lucretius that forms of life developed by an automatic natural selection of suitable elements (while the nonsuitable ones disappear in a cosmic wastebasket) had had its celebrated comeback in the biological philosophy of Darwin. By way of the short formula of the survival of the 'fittest' it had penetrated into the socio-economic neighborhood of the designer. *Pressure of circumstance* which molds a solution was now recognized and honored.

Routine practice in architecture, which throughout the the nineteenth century had not fully acknowledged technological progress and indulged in eclectic play with shapely morsels and tidbits from all by-gones and the nooks, islands, and continents of the globe, was in need of a shake-up. The shock came from the new evolutionist doctrine. It was now a credo that everything truly alive at a particular time had to be a *fitting* expression of contemporary needs and means.

To progressive minds in architecture, Greek columns and other symbols of the mystically tinted statics of the past were atavisms. Vestigial organs, such as the vermiform appendix, no longer function and, therefore, it was reasoned, must disappear. It was felt they should vanish by atrophy or else be speedily cut out lest they cause trouble. At an earlier stage of development, such organs might have been fine and useful, but now they were being carried along as a pointless and even harmful burden turned toxic by disuse.

The question arose: Can such dead matter be at all 'beautiful'? According to the newly formulated functional definition of beauty, the answer was no.

Beyond doubt, these Greek columns had lost a good deal of their prime appeal since they had been moved from Sicily or from Cape Sunion—which serenely looks over the

wine-colored Mediterranean—to LaSalle Street of the noisy Chicago 'Loop' or Wall Street in Manhattan, crowded with a quite different sort of life and looks. These columns now served to camouflage a new technique foreign to them, and often a whole pile of stories towered above their sorely befuddled epistyles. It all became an arbitrary collection of senseless, accidental props, while originally these forms had been revered as invented by gods to play a noble, exclusive role in their system of structural symbolism.

Greek columns had perhaps been fluted to give them the expression of resilient, strong members of fibrous organic material, and they showed a pronounced swelling at the lower part of their shaft to indicate something like a visible capacity of elastic compression under load. They were carefully 'proportioned' and enriched with symbolic accents, as is the ritual dance that has come a long way from primitive society.

But their careful proportions and symbolic accents did not really fit these ancient paraphernalia into the dry logic of an office building which stands or falls with its concealed modern steel skeleton, whereas the Parthenon actually stood and fell with its exposed truly supporting Doric columns.

Symbolism in structural members, aiming to dramatize their static function, was probably in order at a time when traditional faith and experience, all initiated by a god-teacher, guided the construction crew. The glorified customary proportions of the load-bearing members were sufficient to convince the beholder that the structure was secure, which fact could, after all, then only be guessed and suggested, not mathematically computed. The symbolic detail reminded him of mystical wisdom which, as a protective force, stood behind it all.

However, symbols of strength were now deflated by exact computations of strength which supplanted them. The La-Salle Street bank or office building was thoroughly 'figured' by people with engineering degrees who ascertained the structural capacities of framing members and their fabricated connections. Other accredited engineers as representatives of

48

the public interest checked the computations, and only then did the city building department pass on them. Nothing here was aesthetically proportioned, but dimensions and safety factors for every part were prescribed by regulations and ordinances and chosen without any due mysticism.

Once a steel column was thus computed and dimensioned, nobody could proportion it differently; common sense forbade it and the law was strict. In consequence, the architect divorced the rational engineer and, all by himself, conceived and gave birth—as though by parthenogenesis—to a dream column, quite independent of the structural one. This latter column was to be the *beautiful* one. Apart from the intrinsic steel-skeleton, it was made of false, inflated masonry and faced with conventionally fluted terra cotta. This symbol of an ancient golden age still rises quite casually over the parked cars of the uninitiated—and the very uninterested.

The divorce of 'beauty' from 'utility' can only puzzle the consumer. One must not be surprised that this supernumerary beauty never deeply touched the souls of the people in Cleveland or Buffalo. In such context, it would hardly have touched anyone in Periclean Athens either. For a while it really was enjoyed by the professionals. The man in the street was merely impressed by the historical prestige of these façades and by the luxurious waste of a startling investment in surplus make-up.

This superficial application of beauty, borrowed from the past, turned into an elaborate curse. It was taught by an erudite caste of intellectuals and carried out by humdrum draftsmen, all of whom, as Sullivan felt, lacked confidence in their own age and failed to appreciate its lively possibilities and vital needs.

Although these building designers were officially bound and pledged to historical precedent, on many occasions they indulged in a playful good time, rather like the Marx brothers. They juggled all sorts of historical items and amusingly divested them of any original meaning. Truly the boys of the architectural fraternity were far from tragic or historically serious. If it had not so often been stupid rou-

tine, it might have been downright fun to kick the *Petit Trianon* on top of a twenty-three-story hotel and call it a penthouse.

In the new camp, however, which professed the doctrine of an inevitable development determined by environment, there did reign a kind of almost tragic fatalism. The amusing game of making an arbitrary patchwork quilt was superseded by the grave pursuit of integration.

In the eighteenth century, Herder, young Goethe's admired older friend, advanced the theory that the character of the songs or literature of a given people is determined by the living environment. It was another hundred years before men consciously found architecture, too, was part of their environmental destiny. Sullivan detested the flood of architectural old-world imports as a tedious hangover from which American design was to be freed, and posed the question: Does not life itself discard its past forms?

The wide, uninterrupted span of necessity with its tragic flavor was dear to Louis Sullivan. Despite his essential optimism he was fascinated by this same tragic and continuous wide span in the modern music of his beloved Richard Wagner, which had overshadowed the easy coloratura tricks and carefree compilations of a Rossini or Donizetti. No longer were borrowings to be made from old *bel canto*, because its charms, whether in music or in architecture, simply could not be borrowed without badly fading out.

But Sullivan had additional good reasons for opposing the adaptation of old forms. These forms had been inaugurated in the architecture of priestly castes, absolute sovereigns, and feudal aristocracies. The America of the railroad age was very different from the diminutive Greek democracies, half slave, with their very limited class of free full-fledged consumers.

Modern life and production were, on the contrary, determined by the machine and based on a mass consumership. Sullivan was the first architect to see American masses, as Walt Whitman had seen them, a grand, far-flung nation of American men and women. In actual fact, however, modern

50

industry and its consumership were broadening to international dimensions, more international than the Roman Empire or anything that had ever existed.

Once upon a time, the material specifications had been short and simple. For the Parthenon they were marble, quarried in the neighborhood. This was the only material employed from flooring to roofing. Now, the material specifications, not only of a huge monument but even of a little roadside service station could easily fill a heavy tome if they were to be pounded out on a typewriter. There are fire-enameled sheet metal and glazing and structural steel, conduits, wires, pipes, plumbing installations, sash, roofing, plated hardware, and what-have-you. Countless finished products of complex industries which are located in many sections of the country—of the globe—make up the 'raw materials' of even the smallest building.

The glorious 'unity of material' was a thing of the past. The 'raw materials' were no longer raw, but themselves end products of long drawn-out and widely scattered manufacturing processes. The new builder and designer quarried his material from *Sweets*, the great annual building material catalogue. And *Sweets* began to stand on shelves in Mexico City, Shanghai, Melbourne, and Johannesburg. The quarry was anything but local. Just as cars were shipped from Detroit to all points of the compass, so structural steel and sacks of cement found their way from a low-wage industrial country like Belgium to distant Singapore and Rio. American fixtures filtered into many regions of the planet. The building market had become cosmopolitan.

Materials and building supplies, traveling around the earth, were purchased from agents and distributors who knew little about the qualities, composition, or manufacturing processes of their merchandise. Nevertheless, the so-called quality specification still lingered on in now empty phrases such as 'good workmanship and material.' Brunelleschi may have well used this language in fifteenth-century Florence to admonish the dependable craftsmen who built his Segrestia Vecchia. Now it became more sensible to say: 'Everything

according to the standards of the American Society for Testing Materials.'

Today, apart from specialists, nobody in the building trade knows much about how billet steel is best made, or what its qualities are. Most material and supply items are innocently purchased over the telephone. Common knowledge of materials in the old sense is gone. Such knowledge has become far too involved to be accessible to the ordinary consumer, or even to his building attorney, the architect. This unavoidable ignorance dims the value of pronouncements on sheer quality.

Also in neighboring fields, quality specifications have been replaced by performance specifications, that is, by a description of the performance capacity and operational objective. These are the criteria according to which a turbo-generator, or a sewage-disposal plant, is actually purchased. Similarly, the buyer of an automobile seldom knows what is inside the engine housing, nor does he hire an expert to find it out. He may come to the showroom for the gloriously advertised style, but what he wants to know or asks about, besides the retail price, is the mileage per gallon of gas and the endurance record of a particular make. And he wants to venture a reasonable guess about when the major repair bills will begin pouring in on him. What is actually given him or what he asks for from the supplier's agent is a performance guarantee. All the incidental talk about quality in itself seems now to be recognized, at least by the enlightened buyer, as vague and unverifiable sales talk.

Qualities can be explained only by a craftsman, not by a salesman; but performance can be guaranteed to the consumer by the manufacturer or his distributor. Thus the functional concept, the pragmatic concept of commercial values, gradually came into being—and the more mystical concept of quality faded away because it was too nebulous to offer security.

Industrial technology had begun to flavor all concepts, from security to beauty.

QUALITY ONCE WAS RARITY—in an industrial-
ized age, however, quality is no longer aris-
tocratic, and 'Beauty' is now on two fronts
in battle: with the monster of monotony, and
all the novelties of salesmanship.

7

The earlier consumer of handicraft
products—an average man buying, say, a piece of cloth in
sixteenth-century Nuremberg—had, through long ages of un-
changing production methods, developed acquaintance with
the properties of the few established kinds of consumers'
goods. But at the time when Mark Twain engaged in his
humorous description of the period following the Civil War,
he found a great American topic to joke about. Machine
technology spent its youth in a wild jungle of 'bluff.' Mental
balance was impaired. Advertising was perfected to flood the
defenseless public and trap it into useless purchases.

An earlier standardization had broken down. It needed to
be re-established in order to restore security to civilized life.
By bitter experience the consumer of our civilization learned
that he had no means of judging alleged qualities; he could
judge performance only.

If 'beauty' did not clearly follow function, 'value' certainly
seemed to follow it. Fascinating manufacturing processes
might be extolled in sales talk to buyers, but who could un-
derstand them all? Only users could assess true value.

Fraudulent publicity had been so interlocked with the business that first sprouted from machine production that the machine itself was branded by some writers as a curse. It threatened to obliterate fine qualities in human beings as well as in their products. The retrospective kind of romanticists warned that the end of the world was at hand and advised return to the good old crafts. A hundred years ago, Ruskin, a man of lofty intellect, traveled all over England in a stagecoach, which he dug up from some old barn or museum, in order to demonstrate against the quaint steam locomotives of his time, which he hated and despised. The threat of mechanization is still very much with us, but our urgent hope of countering it has undergone changes.[1]

At any rate, the good old qualities could not be preserved, still less arbitrarily revived. The machine age called for the creation of a new sort of life and a new type of quality. They were being created while much else was undoubtedly being lost.

In periods of the past, the excellence of a product was closely associated with its singularity or even uniqueness, like some silken handkerchief or lacquer piece, especially worked by an outstanding craftsman for the Chinese emperor. But now the axiom 'Quality equals Rarity' became meaningless. Some of the new quality goods, such as electric bulbs, developed a tendency to migrate to the shelves of dime stores, thus demonstrating that despite their excellence they were anything but unique. On the contrary, they were so 'excellent' that almost unlimited quantities of them could be easily sold every day. Needless to say, the term 'excellence' no longer had the old connotation of uniqueness when applied to products that proudly displayed their brand and standard. But standardization must not be lamented as vulgarization. Mass distribution is simply the essential prerequisite of continuous improvement toward a machine-made perfection. The refinement of the *post-aristocratic quality type* is completed only

[1] Cf. Lewis Mumford, *Technics and Civilization*, Harcourt, Brace & Co., 1934. Siegfried Giedion, *Mechanization Takes Command*, Oxford University Press, Inc., 1948.

when commodities, tested through performance, can be produced in mass because they are sold at a nominal price.

The electric bulb, its uses and appearance, would have been marveled at by the ancient connoisseurs of Chinese silk and lacquer. Its metal filament has qualities of fineness far beyond the comprehension of any educated layman. It was developed in hundreds of laboratories, and it contributed to the emergence of a new science, colloidal chemistry; it was perfected by the tremendous apparatus of intricate research, through thousands of resourceful and highly trained brains. The production of such articles, the indispensable machinery and equipment, requires a preliminary investment which could not possibly be made by a single individual, whatever his financial status. The purchasing power of modern masses tops that of the Chinese emperor. It is the potential and the actual market of a-billion-a-day users of electric bulbs that brought into existence this new type of quality, a quality difficult to understand in itself, but easily appreciated in a standard performance.

Standardization and a functional concept of what a thing *is* or rather how it ought to perform are unavoidable in an industrialized world. They alone have proved that such a world, no matter what its drawbacks, must not perish in fakery and confusion, and in the obliteration of quality *per se*.

In the half-industrial and half-handicrafts methods of today's petty building business—half free of sweaty chores and half slave to them—there is still reflected a good deal of that initial insecurity which earlier characterized, in general, incipient industrialization, with all its deficiencies. Many who have trusted in twenty subcontractors to build their home shudder at the memory.

It was the organized quantity buyer, not the retail consumer, who first awakened to the new requirements. He was anxious to put an end to insecurity, accident, and fraud and soon proved himself capable of imposing rules. First, the great American railway companies in the 'seventies of the last century, and later the United States government,

purchasing per annum values up to several hundred million dollars, staggering at that time, showed organized initiative. They laid down standard specifications, always focusing their interest on performance. The triumphs of transportation and even of armament pale beside this greater victory over consumers' insecurity, which was incidentally brought about. Even before the First World War, American research work, aiming at industrial standardization, low-cost production, and increased security of the purchaser, may have amounted to eight or nine millions yearly, and probably to very much more if all unofficial efforts are taken into account.

And yet, when the idea emerged to evolve creative standards for such an important branch of human activity as housing ninety per cent of the population—an activity in which, on an industrialized basis, billions of dollars could and should be soundly invested—sentimentalists raised the cry of 'Danger.' They blithely overlooked other, more imminent and real threats to social security. Design resisted the trend to standardization in the name of so-called Individualism. But the individual interpretations of architectural beauty, which are assembled along the streets of Hollywood and elsewhere, the curious jumble of French chateau, English half-timbered Tudor, Spanish, Moorish, Mediterranean homes, apartments, and bungalow courts, were not built according to individual background or the respective historical standards of craftsmanship. These were merely mimicked; a common flimsiness was genuinely of our own speculative age. What modern industry contributed was hastily milled, second-grade, shrinking, and warping lumber, and black paper and chicken wire to cover the roughly nailed carpentry frame and serve as the base for a thin coat of cracking stucco. Cracks seemed only to add to the charm of this quick-turnover traditional architecture, which aspires to look venerably antique.

Galloping depreciation and what may be called 'obsolescence praecox' kept this type of enterprising construction in ever-new demand. The advocates of variety at any price (even the lowest) failed to see the ugly waste. If they criticized it

at all, their censuring was mild compared with their denunciations of the dreadful monotony that would result from industrial standardization in architecture.

They contended that the American suburban developments, those gems of variety, would simply perish in a deluge of uniformity. They prophesied that 'beauty' would not survive industrial uniformity of structural elements and systems. The home catalogues of mail-order firms showed more models and variable trimmings than the company could handle economically; and sales correspondence was carried on in plain envelopes, lest the purchaser be found out by his neighbors and taunted for acquiring a house that was not individually built. But would such have meant a specific fit?

Even wholesale housing projects were doctored up to achieve a spurious individualistic variety. This was achieved not by means of a truly sensitive site plan, a 'human' grouping of homes, and creative landscaping, but simply by superficial architectural recitations of one kind or other. There was general fear that uniformity might spread over the globe and destroy the joy of living. At any price, the monster monotony was to be kept at bay, even by far-fetched means.

This writer has traveled extensively and owns a collection of photographs of remote villages in Europe and Asia, from Kwangtung, Southern China, to Wallis, southern Switzerland, and the Carpathian Mountains in Slovakia. The appearance of each of these places is most often one of a natural uniformity, and not of a wild variety of production methods. Identical roofing material in a given region naturally calls for an identical roof slope. Modes of fenestration, sash, door, and wall construction within one locality are almost exactly the same all the way through. A standard which the villagers know is most in keeping with their requirements and tools is bound to imprint harmony upon the total picture. All the dwellings are oriented in the same direction, because the sun is known to rise for everyone on the same side of the valley, and everyone is anxious to get

the same kind of exposure, because it has been found to be the most suitable.

The Swiss village has the same repetitive sort of charm seen in the fir woods on the hills behind. Each tree there looks like its neighbors because they all root in the same soil, receive the same radiation from the sun during its daily and yearly course, bear the same snow-loads, and resist the same winds from identical directions.

Countless tourists have spent millions of dollars to enjoy seeing such restful and appealing uniformity, without ever thinking of monotony. Recurrence, unity of elements, and consistency really make for harmony.

Across the Pacific, on the islands of Japan, an entire nation has been living in minutely standardized dwellings for a thousand years. It is a kind of mass standardization of housing far beyond anything ever attempted or conceived in the industrialized age. Japanese towns have been the delight of crowds of American visitors, yet these towns consist of houses, and the houses of rooms, which are all strictly dimensioned according to a basic area standard, the Japanese floor mat of three by six feet. Neatly joined together, these mats fully cover the floor of each room, which is thus a multiple of the standard measure. Millions of houses are the neat aggregates of such basic rooms, and there is not even a strong difference between urban and rural districts so pronounced in Europe. All sliding partition panels of exterior and interior enclosures are three feet wide. They line up with the floor mats, and so do the Tansu or drawers in which are stored the folded and pressed kimonos made of cloth which, throughout the realm, is woven on looms, again three feet wide. Thus, the cloth the Japanese wear and the storage drawers for this cloth have established the basic dimensions for rooms and building craft.

Such a standardization of the dimensions of sliding doors and partitions, of built-in drawer sets, of roof construction, balcony railings, and wooden bathtubs enabled the planner-builder-carpenter to sketch his layout in the simplest way. Standards settle structural details, and they give shape to

living. All activities are subtly and organically integrated with the shell in which they are housed and the stage on which they play. This is equally true of the stationary, noiseless Japanese dance on padded floors, and the chirping, short-range music and songs which, within an enclosure of light non-resonant partitions of paper stretched to dull tension, require no reverberation. Just as the plan and the building standards fit this form of dancing and music, so does the typical *Tokonoma*, the visual 'joy-niche' of the living room, accommodate a tenderly brushed roll picture which hangs neatly in dominant isolation behind a vase with a plum twig. Everything is typical, from the focal distance and light suitable for the scale and painting technique of the picture, to the arrangement of the knick-knacks and the flowering branch. The buildings are designed to serve this refined ritual of life.

Naturally, when conditions change, cultural standards become inadequate and break down. Men who must run up and down the stairways of elevated railways—in metropolitan Tokyo—or pedal bicycles, or step on the gas throttles of little cars get into the habit of wearing close-fitting leather shoes and European clothes, less dainty than the old Japanese garb. Thus the flooring of their houses must no longer be mats designed for feet in padded socks; Western clothes must be hung in closets, not laid in drawers; doors swing on hinges and are no longer simple sliding panels, independent of our complex hardware. Heavy pianos are carried in and placed on a shaking floor, now too lightly constructed. The foreign-trained player sits down on a stool, high for a Japanese and unknown to tradition, and raises a tender ceiling with the crashing chords of Liszt and Rachmaninoff. He bursts like a bull into the china shop. To avoid a public nuisance, insulation becomes necessary, and reverberating walls are required for a desired brilliance of acoustics which the Japanese instruments could ignore.

Bathtubs and walls are made now from materials other than wood, and their surfaces must be glazed to keep in step with imported ideas of sanitation. The old carpenter-

builder is puzzled by it all and loses face; he is crowded out by a dozen subcontractors of specialty trades. Ancient unity yields to a bewildering variety. New standards and newly adjusted judgment seem, for a while, merely a vague promise of the future.

This East Asiatic example deals with only one of many civilizations similarly consistent in all its elements and similarly disintegrating when these elements begin to disappear. Design is closely linked with the survival of over-all social patterns.

Regional uniformity in planning the vast majority of human dwellings existed all over the globe before the rising pressure of importation made itself felt. It was a uniformity that served human beings long before modern industry, uncurbed by distance and the limitations of local supply, rushed in, disturbed men's minds, and made possible such things as artificial slate, tile, thatched, metal, and paper roofs, all on one and the same street.

Expanding industry and building activity have not created uniformity; on the contrary, they have tended to destroy a wholesome measure of uniformity which had existed earlier. A restoration of things in common, so profoundly needed for mental comfort because of better human grasp and 'in-feeling,' will obviously require much effort and cost a high price. Nevertheless, it is a humane program. The natural objective for neighbors is frankly to admit common denominators instead of being victimized by a variety, often introduced by mere salesmanship.

When Marco Polo, who had grown up in medieval Venice, first walked through Canton in Southern China, he certainly must have found it very different from his home town. But after all, both places were built and equipped according to the principles of handicraft which then were essentially similar all over the globe. There is no such consistency to connect the half-timbered barn, designed and nailed together as the garage of an American's 'English cottage,' and that other pride of his, the newest model automobile housed in

that barn. Here is merely a weird juxtaposition grown into a senseless habit. The car, the highly polished end product of an intensive and extensive industrial production process, is much more of a stranger in its own barn-garage than the Venetian Polo was in Chinese Canton.

Lost unity must be restored. Can it possibly be done now on another basis than that of machine production, which nobody really considers avoidable, or would personally wish to do without?

Human life, actually a function of human nervous systems, cannot remain split. It cannot survive astride a demarcation line which separates the qualities of a new production reality from a crude and flimsy, imitative, and far-fetched stage setting. Dignity or warmth cannot be borrowed from a fictitious 'past.' More and more eyes were beginning to see the ridiculous incongruity of driving *this* car into *that* garage. Reversions to counterfeit innocence cannot last. Faked infantilism too often ends in an infantile fake.

If an adult uses or pretends to use baby talk, we cannot very well feel for him the warm tenderness we have for children. If he crawls on the floor, he is awkward to look at, he is no longer charming like a baby. We might like an old English barn, but we do not really enjoy seeing it aped by a two-car garage on Floral Heights.

If the community was to regain mental comfort, 'beauty' would have to be based, as it was in some of the most significant periods of the past, upon the broad acceptance of standards of its own mental and technical age, fully harmonized. Common practices, and ever-recurrent types, are characteristic by no means only of an industrialized age.

Twenty-odd huge temples were built in a standardized style on the Acropolis of a Sicilian town, and extensive colonnades, repeating identical forms, accompanied the main highways leading to Syrian Palmyra and many other Hellenistic cities in quite different sections of the Old World. Over and over again the same typical, tested, and acknowledged patterns were repeated. In the course of years people had learned something about columns and about the 'classical orders.'

Persistent repetition and gradual improvements had refined not only the product but also the layman's and consumer's capacity to discriminate.

Hectically changing fashions are indigenous to and perhaps justified in the ladies'-apparel business, with new models coming out every spring and fall. In building, where long amortization periods are of the essence, such fashionable changes first bewilder the consumer and eventually repel him, make him sick and tired of it all. Hardly has he had time to read up on Norman, Colonial, and Tudor, when Mediterranean, French chateau, and modernistic became the vogue—to his greater confusion. He well knows he 'cannot judge these things'; he has no basis on which to found his judgment. In the end, kaleidoscopic novelty itself becomes the standard.

To combat this nuisance, 'architectural control' was adopted in some quarters as the battle cry of the enlightened land subdivider. What it often amounted to was merely to save buyers the trouble of worrying themselves about the props that do or do not fit into a given masquerade party.

But other masquerades were going on simultaneously and competitively, and no integrated style could be achieved by such impositions. If all the people cannot be fooled all the time, there is also no single kind of fooling and masquerading that will do for everybody in the long run. Finally a few scattered reformers, opposed to shifting real-estate fashions, held out a hope for a return to sincerity which would yield a sound, consistent whole. Individuality is at last surmised to be not a matter of superficialities but the outcome of profound physiological traits that are not honored by just random diversity.

Only with STANDARDS AS ANCHOR could the typhoon of insecurity be weathered when industrialism broke loose over the world. Earlier, eternity had been cherished, and it called for quite different standards than does a calculated period of amortization.

8

In our discussion of standards we have pointed out some of their mental and physical benefits for the consumer—but the producers are interested as well. A wise standardization reduces production problems and the number of individual 'set-ups' and operations. Speed in training of personnel will also save costs and worry.

At least until the competitor has caught up, standards mean a larger margin of profit; and later, when installations and specific tools have been amortized and thus are available without additional expense, further financial benefits will accrue. Distributors, for their part, welcome the reduction of the number of items to be stocked and the fact that they need handle only a few 'lines.' In the long run, however, standards cannot be successfully dictated by sellers, distributors, or producers. Nor can they, in a society like ours, be as static as in a tradition-bound tribe. Today, standards must be sensitively tuned to the times, by never-tiring, systematic awareness of requirement. The socio-economic aspects and implications of each technical feature and, above all, ever

better *biological fitness* of design are worth studying before mass production is warranted. Standards must not be permitted to degenerate into reflecting only the vested interests of a minority, such as the producers.

During the early phases of manufacture aided by machines, the idea of common standards advanced slowly. The strange logic of competition lured each producer to adopt his own special and monopolistic measurements, sizes, and often bogus systems of grading. All of this befuddled the buyer.

America, after industrialism in its primitive, 'paleotechnic' form had taken root, first went through her anarchic period of insecurity and fraudulence; but she had the good fortune to discover effective remedies at a relatively early date. The vast national market favored the growth of quantity production methods, and the development of uniform technological qualities. Because industry could draw on a continent-wide purchasing power, the United States seemed predestined to play a leading part in the industrial realization of a new environment. A quarter of a century ago, this writer predicted an American bumper crop in contemporary building design, although little had been done at the time to justify his optimism. But his thesis that design of and in our day will wax, feeding on a broad subsidiary industrial output, is now well borne out.

Creative concepts are always essentially operational and they are stimulated by specific materials at hand. The best ideas on timber construction would have been of little use in treeless Babylonia; consequently, we may well assume that no Babylonian ever had them. There were no forests in the Euphrates valley, and that is why nobody there even dreamed of log cabins or frame structures.

In our century, the so-called raw materials for building are actually industrial end products. They are rarely supplied from near-by natural sources, but are accessible thanks to a far-flung transportation system. Today cargo and freight tariffs aid or hinder design, and the economic geography of transportation influences our imagination to create things in this or that region.

We have seen that the annual advertising catalogue of America's vast building material and supply industry inspires the contemporary designers—just as stone quarries inspired the neolithic Indians of Peru, or the presence of timber stands the carpenters in the Carpathian Mountains. But the most 'naturally' stimulated development can be strangely stunted. The human brain functions under certain compulsions. Designers follow patterns of the past even in contradiction to facts in hand, and their prejudices are usually encouraged by vested interests and already acquired long-practiced skills. These may or may not aid living. They may make progress irrational. Lydian and ancient Greek builders, compelled by this mental mechanism—variously described as sentimental association or sacred inertia—continued a timber tradition while shaping structural members of stone, which had replaced their earlier building material. According to Pausanias, the Baedeker of the classical world, the original wooden columns of the venerable shrine at Olympia one by one were replaced by stone columns; but these, and even the later Hellenic temples, while actually built of stone, were still *formally* conceived in wood.

The same property of the human mind may drive us to make a steel-built home or the concrete university buildings in New Mexico appear like so much piled-up adobe. As we shall discuss later, there is distinct comfort for the human nerves in following habits. Our creative effort is adulterated by the comfort of adopting the habits of others and reviving traditions, and by codifying habits into laws, sacred or secular. We have mentioned the incident of a speculative real-estate subdivider who, once having invested in a particular brand of aesthetics, tries to cut his worries. He institutes some sort of 'Architectural Tract Restrictions' in order to freeze design and arrest development to rigid unity and powerful permanence.

Still there are stronger forces than those of a tract deed which enforces by whim the perpetuation of some structural infantilism. An 'adult' steel-built house may prove very economical and practical because it holds in store less damp-

ness and rheumatism. It cannot so easily be rejected even though it does not happen to look like an early Californian adobe ranch. Restriction of a stylistic kind might in fact cause land sales and values to fall off. Tracts thus restricted may later collapse commercially unless property owners awaken and band together in revolt to lift the restrictive covenant that makes them early Californians or Cape Cod fishermen.

While even laymen readily understand that, basically, construction must govern appearance, there is reasonable doubt that steel-built houses would sell well from the start if they actually looked like what they are.

Acceptance is a measure of the consumer's neuromental adaptation. When all is said and done, brain physiology will have to interpret all such sociological effects and phenomena. A process of learning, of transformation of habit, is required on the part of the user. However imperfectly at first, nervous adaptation will eventually follow suit to meet practical conditions, if they are biologically feasible.

The floor plan and the external appearance of a steel house might be restricted to a type of regularity greater than is customary in order to simplify shop preparation and fabrication at a distance. If these rigid rules are cumbersome, there are compensations. A slender steel frame permits liberal openings into the outdoors, while a bearing masonry or adobe wall does not lend itself safely to more than a few minor windows. Yet because such features are in conspicuous contrast to custom, they call into play a 'defensive reaction'; the prospective buyer tends to oppose them. In order to cushion the shock, the seller resorts to cover-up and mimicry, and his half-measures are often very unfortunate. 'Appearance' is composed of direct sensory stimulation plus an important package of diversified mental associations elicited in the beholder.

The picturesque, irregular grouping of the building bodies, the sloping roofs, the haphazard fenestration which seem to make for the charm of some old types are incompatible with the new system of construction; they cause unnecessary

trouble, which is expressed in excess costs to the builder and, in turn, to the consumer. The industrial trend has naturally been toward increased work in the shop and decreased work in the field. What once may have been a pleasing agglomeration of accidental irregularities, harmless because they were naturally and easily taken care of by the men right on the job, turns into an artificial, undue complication where every bolt hole is punched in advance according to blueprinted details. When an imitation of carefree rusticity is offered under the greatly changed procedure of a precisely scheduled and machine-tooled production, everything becomes involved and costly.

Above all, it becomes ridiculously false. Every type of construction, whether ancient or recent, has its inherent mode of handling. The technique modifies the problem and fits the solution to available means. Penalties of many kinds must be paid as soon as one deviates from this rule.

A construction in adobe, for example, not supplemented by wood will naturally produce large wall areas and heavy wall cross sections because this material has little strength in compression, shearing, and bending. If wood or other structurally superior materials are added to strengthen an adobe wall that has been weakened by window perforations, joints between the disparate materials will often open as a result of unequal shrinkage, and the precarious plaster coating will crack. If the designer disregards the innate possibilities of a structural type, he produces one lacking in homogeneity and exposed to rapid disintegration.

The Pueblo Indians did not mistreat their adobe dwelling construction, or force it to a performance beyond its natural range. They contented themselves with air and light through the door alone; window openings difficult to span were few, narrow, or nonexistent. The primitive builder, ignorantly or wisely, dodged many of our troublesome details.

But the primitives enjoyed still other advantages. Each spring, on a certain moon-determined date, their squaws performed the ritual of adobe repairs. Such repairs, befitting the material, were *fully anticipated*. Maintenance had no accent

of nuisance to neolithics, nor were they staggered by water-proofing bills. Fixing up the pueblo was a festival like spring sowing. *Periodic maintenance was a revered ritual.*

To us, recurrent repair costs are a damnable item in our running budget. We feel and know that the remedies for leaks in enclosures, plumbing, and what not, are annoyingly expensive in a commercial order of things. We are in no festive mood to give honor to the godly forces of nature when water seeps through our basement wall, the linoleum and wallpaper peel off, the windows stick, and the exterior door butts corrode. Our attitude toward maintenance has changed since ancient rituals and economics have both passed on, one linked to the other.

In short, the aesthetic potentialities of design at a certain historical moment are not vague abstractions that can be easily borrowed and manipulated at will. The satisfactions possible from designed environment are profoundly dependent on the structural means just then available and on their economic and psychological implications, all of which are inseparable.

The antique metropolis of Babylon, according to Herodotus, was spread out thinly. A huge and very populous place, it covered an area almost as large as that of New York City, about 300 square miles, but communication must have been even more cumbersome, without subways, crosstown buses, and taxicabs. In that Mesopotamian mass of public and private structures, there was scarcely an interior as large as a moderately sized living room of today. Ten feet of ceiling span was an engineering feat in Babylon. And even considerably later, the palace of the mighty Sargon in Khorsabad, a colossal group of structures, had only three open spaces in a labyrinth of corridor-like rooms and narrow interstices between very heavy walls. The open spaces were courts. If a spacious room was needed, an unroofed court, perhaps covered by an awning at certain hours, was the only answer within the limited structural possibility of that period.

It is obvious that a great civilization like that of Mesopo-

tamia, excelling in agriculture, hydraulic engineering, astronomy, arts, law, and literature, must have been essentially affected, as regards social life, by this significant absence or scarcity of even moderately spacious and naturally lighted interiors. Interiors made spacious by means of trusses, girders, joists, or steel-reinforced concrete slabs, with an array of ceiling constructions ready to take formidable bending stresses— all this has modified our daily life. Structural technique has a deep influence on human behavior and social patterns.

Because crude clay cannot withstand the attacks of the climate, and because it offers extensive unbroken wall areas to these attacks, the Babylonian architects must have searched for a durable skin to cover their royal structures. The problems of surfacing and, incidentally, of surface decoration were solved by burnt and glazed tile.

A development like this makes for a significant progress in attitude. There is mental comfort in permanence. Undoubtedly, all human beings harbor an ideal of it. But while a primitive people, such as the Pueblo Indians, express this aspiration in a recurrent ritual of rebirth, which is more dramatic than piecemeal, current upkeep, advancing civilizations generally tend to build durable structures that do not require periodic maintenance. The aim is to secure godlike eternity to initial form and color concept.

Yet the mythology of permanence is manifold. Minds must be differently conditioned to restore buildings every spring or every generation, or to follow an even more involved scheme, as is the case with the thousand-year-old double Shinto temple of Ise, built in wood, of which one or the other twin is always under complete and minute reconstruction as a matter of ritual.

Man, the householder, is constantly in quest of freedom from chores. Nervous energy freed from the task of perpetually rebuilding the stage of the physical environment is made available to enact the drama itself, the multiform drama of a civilized society. Thus *permanence without maintenance* becomes the ideal or perhaps the illusion. At any

rate, in one form or other, it is deeply related to a general nervous satisfaction and also to a specific aesthetic gratification.

In Egypt, common domestic architecture must have been crude and temporary, like that of Babylon, or like the mud huts of the present-day Fellahin. But when monumental structures were built for the dead and the immortal gods, higher sites were chosen, outside the fertile area of periodic inundation where daily living took place. And up there, the gods and the dead were entitled to permanent building materials of their own—limestone, basalt, porphyry. Unlike Iraq, Egypt had rock formations that supplied these hard materials, some of them more enduring than the Mesopotamian glazed artifacts. While the bulk of our architectural expression today concerns the living, in Egypt the realm of obsolescence (which is that of life) was evidently not considered worthy of gerat effort and of such permanent building material as could be quarried on the rock banks along the Nile valley. Eternity without maintenance was here the aspiration.

Thus the most precise stone cutting and stone masonry of all time served the static, mummified dead and the deities. Those gigantic ashlars and column drums would not have been cut and moved and lifted with such persistent pooling and forcing of labor if the buildings had been planned only for use by mere living men—who are short-lived at that. Since the occupants were undying gods and preserved dead, their housing had to be made to last over millenniums; the intended amortization period was eternity itself. And the sweat, blood, and misery wrought into these sacrificial buildings added essentially to their mystical value. Design served survival after life. Pictures of monuments reflecting this mentality occupy a prominent place in our illustrated textbooks. For many years they have been before the eager eyes of apprentices in building design and still continue to influence the popular concept of architecture.

Today it would be possible to build the Cheops Pyramid by means of electric derricks and other labor-saving ma-

chinery within a scheduled time. But such a structure would be meaningless, utterly lacking the original halo of sacrifice and the flavor of superhuman exertion. Building for the eternal must be done under a supreme stress of all capacities and even under a painful sacrificial overstress.

Yet ambition for literal permanence becomes anomalous at a further stage of social and mental development. The will to construct a static environment for eternity may originally derive from a basic nervous urge to avoid continual readjustment to new stimuli. But static peace, slipping out of the chain of ever-new events into a life of stable 'facts,' is an ideal we cannot possibly entertain. To our science, interrelated *events in time* compose the universe. The Heraclitean view of 'everything in flux' has again become true, and design is acclimatized to this mood. Our environmental structure is acknowledged to be transitional, and our buildings are built for anticipated finite periods of duration or deterioration. Sacrifice is no longer sought for any magic attempt to overpower eternity, which to us means not a few thousand years but more than billions. This ambitious attempt, always futile, has finally been abandoned in realistic resignation.

We now like to see temporal building for masses of the living. Any new monumentality is concerned with the pulsating life of the community. And we want to build with less and less perspiration; we can do it more easily, more comfortably. Passers-by enjoy seeing a 6o-ton built-up girder, ten feet deep and fifty feet long, blithely hoisted to the sixth-floor banquet hall ceiling of a hotel under construction. It is done in a matter-of-fact manner by the combined action of cleverly placed, slender derricks. A few qualified workmen turn levers with their gloved hands and up goes the colossus. It tickles loafing sidewalk superintendents to watch the huge letters of the fabricator's sign on the rising girder's web grow smaller and smaller.

No slaves are lashed; there is no sweat, no bloodshed. All is ease instead. Is the satisfaction gained from such a procedure and from avoiding those more gloomy concomitants of

ancient construction in an essential relationship with the aesthetics of the finished product? If aesthetic satisfaction is a matter of brains and nerves, the finished product and its mode of production—perceived or remembered—are closely linked. Must not design for a wise gratification and as a true aid to life recognize this powerful dependence? The method of creating a thing colors its value for us. 'Beauty' is not an absolute—static, and standing alone. Our minds and nerves intimately relate it to the living dynamics of producing and consuming.

While 'BEAUTY' IS PROCLAIMED TIMELESS, RELEGATED TO AN OCCASIONAL PEDESTAL, AND THERE HONORABLY MAROONED, civilization is liable to turn into blight.

9

If a hotel is built with the help of labor-saving devices, the resulting economy will, of course, be reflected in the price charged for a room. But financial considerations cannot fully account for the satisfaction of watching such devices in operation. A similar economy could be achieved by the use of cheap labor and backbreaking working methods, such as were customary, for instance, in colonial metropolises like Shanghai.

Mere financial considerations are beside the point in question. The way a thing is produced seems to matter a great deal in our evaluation of the result, even though we ourselves may not be the exploited slaves, or foot the bill. But in its psychological effect upon us or in its aesthetic appeal the ultimate product is not independent of an implicit interpretation of the processes that brought it about.

As to pure form, there is great similarity between the scroll of an Ionic column, carved in limestone, and the spiral of a thin steel spring which, because of its material characteristics, perfectly and speedily rolls up by itself. The two spiralic lines may be equal, but the formative process auto-

73

matically contributes different psychological accents to each of these products, and the distinction is felt by the beholder.

Aesthetic gratification, seemingly concerned with form in space only, deals with implications of development in time, unless this form is lifted out of practical context for the sake of simplified theory.

We seem physiologically made to see things always in a genetic time perspective. Moreover, we unconsciously look at things as if they had been produced by a human maker; we tend to sense at work a creative being with nervous equipment and behavior similar to those of man. This naïve, anthropomorphic attitude is natural. It, too, is physiologically determined, because any creative experiences that we can possibly have ourselves are correlated with our own nervous reactions, such as accompany our labors to produce a thing.

Viewing hand-formed pottery, or the lines of a draftsman, or the lettering of a calligraphist, we unconsciously identify ourselves with their makers: We seem to follow vicariously the imagined muscular exertion in the nervous experience of the craftsman, as if experiencing it ourselves. In the same way, our tongue is slightly innervated when we only think of a word; our muscles tighten while we watch a wrestler or a tightrope walker, however comfortably we ourselves may be seated. Our emphatic experience of the pains of creation, unconsciously inferred when we look at a product, may add or detract, heighten or reduce, our enjoyment of it.

Precision—that is, minimum deviation from the theoretical aim—has at all times been a major human aspiration; in fact, as we shall see, it has been considered the object of a basic urge. For thousands of years, precision of production could be achieved only by laborious methods. Our attitude toward precision has thus been closely linked to the idea of a slow, long, and painstaking process, and, as already noted, the quality of precise workmanship has in turn become associated with the characteristic of rarity, sometimes even of uniqueness.

The Chinese emperor would send for a famous craftsman in a distant province, and give him unlimited time to pro-

duce a lacquer bowl with twenty coats, smoothly ground, or a handkerchief of exquisitely spun and woven silk, or a miracle of ceramic glaze. This work, and the craftsmanship required to produce it, would become a legend for millions. Such admiring appraisal goes far back to primitive society.

The Stone Age collection of the anthropological laboratory at Santa Fe, New Mexico, contains specimens of amazingly perfect rotational pottery, made *without* a turning wheel, a contraption that originated in a later period. The ideal of perfect shape and texture was present in human hearts much earlier. It corresponded to a need of the nervous system which existed long before tools were invented to satisfy it. In fact, the ambition for perfect form, or the nervous pressure toward it, must have *led* to the invention of the potter's wheel. Yet, today, in the bazaars of Santa Fe, tourists are offered artificially misshaped, bumped-up pottery as charmingly primitive souvenirs. The truth is that perfect roundness was a perhaps rare but well-recognized desideratum even in the most ancient pueblo.

With the coming of machines, however, the concept of quality has undergone a profound change, as far as our nervous responses are concerned. The productive processes have often become puzzling, and we can no longer vicariously share in them. The formative background, the *genetic perspective*, is now blurred and clouded. This is like traveling in an unfamiliar country. If all empathy has its original precedent in reading facial expressions and thus experiencing the motives behind them, this ability seems to fail us when we are among the natives of an utterly strange place. Our customary clues no longer fit. Precision in workmanship meant one thing when the work was done by craftsmen; it means another when it is inhuman, done by strange machines.

Mechanical precision was initiated in the munitions industry, which was also one of the first to use mass-production methods. Munitions must be produced in enormous quantities, since consumption here frequently approaches the level of complete waste, even from a military point of view. The

exact fitting of projectiles to gun barrels required great mechanical precision in the shop and made operation on the battlefield more foolproof. This precision was later extended for similar reasons to other mass manufactures. Automobile production is perhaps the most striking example.

But here another important factor had to be taken into account. Although the motor car was made as foolproof as possible to allow for careless and wasteful handling by drivers ignorant of mechanical exigencies, unavoidable repairs on the road had to be foreseen and facilitated. This problem was solved by the interchangeability of parts. Worn-out pieces of the engine can be easily replaced by substitute parts, which are stocked in thousands of far-flung depots. The necessary repairs are made without hand-fitting and without too much dependence on the worker's skill. The new part cannot easily be misplaced even by a poorly trained mechanic, or despite fidgety human nerves.

In order to achieve interchangeability of parts, the highest degree of accuracy became imperative in the production of good automobiles, and only the minutest dimensional deviations from the norm could be tolerated. As early as the 1920's, the margin of error in the production of some cars could not exceed: 1/1000 of an inch for 5000 processes; 1/2000 of an inch for 1200 processes; 1/4000 of an inch for 300 processes; and 1/10,000 of an inch in bearing balls.

All this precise workmanship was marshaled to produce not a refractor for astronomical use, but a common, almost ubiquitous article. The concept of rarity or uniqueness is as foreign to this new type of precision as it is to this new type of quality. The entire issue grew into a matter of broad popular impressiveness; it thoroughly re-educated us and re-conditioned our attitudes. Precision, formerly a luxury, has turned into a prerequisite for economical production and maintenance, because the possible market, the scope of consumption, depends on it.

As precision became commonplace in an industrialized civilization, however, it inevitably lost much of its charm and mysterious prestige. Those uniquely balanced innerva-

tions in a master craftsman were here no longer required, nor could they be admiringly re-experienced by the consumer.

It was within the very historical decades which produced machine precision that precision itself lost face and was arbitrarily abandoned for 'beauty's' sake. Precision was discredited; it seemed vulgar, and was combated by various romantic antidotes. For instance, contrivances such as *Jazz-plaster*, or picturesque false ceiling beams, crudely surfaced, began to infest American domestic architecture. This was also the time when wheel-turned pottery was kinked out of shape just to make it look primitive. Precision was equated with coldness, imperfection with warmth; exactness of detail was discarded, and haphazard 'rustic' forms were introduced by the speculative psychologists of the real-estate market.

Moreover, these introductions proved to be cheap, wherever lingering remnants of neat handicraft could be abandoned. While formerly a plasterer had to serve a long, exacting apprenticeship, now—especially in a temperate climate like that of California—any laborer seemed capable of doing a plasterer's job quickly and, of course, for less. While in bygone days paint had to be applied with skill in flawlessly uniform coats and tones, now wild irregularities and accidental discolorations became an asset of the Hollywood bungalow.

It is true that the machine has ruined handicraft. This, however, did not come about because, as Ruskin and Morris sadly noted, the first machine products were crude and primitive, but rather because the machine soon proved superior in precision, the quality that craftsmen had proudly regarded as their prerogative for thousands of years and that had inspired consumers with awe. The machine introduced an entirely new psychology of precision, by changing, and sometimes directly reversing, the accents. Thanks to it, irregular, imprecise forms have become *unusual*, and almost morbidly attractive.

In abstract aesthetics, the method of producing an object may possibly be ignored as a factor of evaluation. But the

practical situation and the daily workings of our brain are never so purely one-track. Whenever we are confronted by a product, our attitude toward it is more or less consciously motivated first by considerations of performance and consumption. How is the form of the object related to the manner in which it operates? Is there any obnoxious discrepancy between appearance and immediate function? Secondly, considerations enter concerning the genesis of this form. How was it produced? How did it grow and reach this particular materialization? How far is the consumer able to follow? Can he at least vicariously, nervously, *empathically* share in the production process?

The first group of questions is concerned with functional significance, and the second with the 'constructivistic' background, with constructive procedures, sensed behind the appearance. Any appraisal of design, then, has these two vital aspects: the constructivistic—how is it made? how can it be fabricated?—and the functionalistic—how will it operate and be used?

Also, the concrete beauty of an organism, say a plant, is not understood as just a static non-operational phenomenon, looming in space. Here, too, a dynamic time perspective is indispensable and unavoidable. In our minds, beauty is related, on the one hand, to the process by which this organism seems to have grown to its present state and, on the other, to the manner in which it will function to fulfill its obvious biological requirements. Much of this can be intuitively perceived without analytical knowledge, and even erroneous judging does not alter the principle. If we look at a pine tree bent by the wind on a coastal bluff, the concept of it does not remain within the bounds of *mere sensual impressionism*. The fused conductive structure of our own mental-nervous apparatus, its rich operation as an integrated whole, makes this impossible.

Sensory perception merely ushers in an automatic process of higher brain activity. The entire associative machinery of the mind is bound to be set in motion. From beginning to end our emotions are co-activated. We feel in a flash those

struggles our tree has had with storms. The genetic past, the present function in relation to external forces, the telling expression of *functional preparedness*—the tree bracing itself in the direction of prevailing winds—all this is hardly separable from what we look upon as the form and beauty of a grown tree. Any doctrinaire division of the total concept into the aesthetic and the non-aesthetic aspect would be artificial and cloud rather than clear the insight into this truly unified phenomenon. No such division is possible from a physiological point of view; and no other view, we feel, could be valid today.

In animals, or in human beings who are underdeveloped or who have regressed, the activity of the higher brain centers is limited, associations are of lesser scope. But it is absurd to reduce aesthetics for normal human beings to the level of animals or morons.

We shall consider the undoubtedly existing primitive aesthetic comfort of birds and insects equipped with exquisite sense apparatus. But there can be no doubt that the human nervous equipment, through the associative powers of the forebrain, has developed incomparably more differentiated demands and solutions.

It is an unfortunate roaming of theory that favors a separation, even an antithesis, of beauty and utility, and places an accent of additive extravagance and uselessness on the first of this pair. Once such a contrast has been established, the self-respecting adult, the practical man, cannot but vote for 'utility first,' with perhaps a few occasional self-conscious concessions to 'beauty' second.

An artificial, abrupt contrast has been set up where, by nature, oneness and an uninterrupted continuum are true to fact. Where does the utility of a tree stop and its beauty start? Our dualism has dangerously harmed, not helped, an understanding of design and of the architecture of a well-integrated environment. The direct result is that harmful turmoil we know so well, that disintegration conspicuously spreading and sprawling around us in so-called civilized areas which are biologically blighted.

79

NATURE'S FORMS GROW QUITE DIFFERENTLY
but they often are models for those designs
which man produces, accepts, and, before
long, strangely tires of.

10

Whatever we perceive as 'beauty' in nature is never, and in no way, an *addition* to what we perceive as 'utility.' All organic shape and detail depend clearly upon structure itself, and never can they be looked upon as decorative adjunct. Natural forms and colors are not added or superimposed, but intrinsic, immanent, integral.

But the process of natural growth is different from that of human 'con-struction.' In nature, growing and functioning are inseparable, mutually determined, and *simultaneous* life processes. The seed, the seedling, the plant, function continuously during all the infinitesimal stages of well-fused growth. In human creations, being produced and functioning always follow upon each other, and full harmony between the two is really never accomplished.

We first build a factory, and only after the building is up do we use it. During the planning period, we merely try to anticipate future use requirements and endeavor to bridge mentally the decisive gap between the phase of construction and the phase of function. Nevertheless, the practical operation begins only after various errors may already be petrified

in ferro-concrete. Some later constructions will be required to incorporate the experience of usage.

The essential time interval between the phase of production and that of function expresses itself also in applied aesthetics. Beauty is added to a thing which first is practically conceived, then manufactured, and finally used by human beings. Those who plan a house are often mentally engrossed in the mode of its construction. Only after this problem is solved does imagination free itself to behold the occupants in their responses of daily life. It is difficult to bring simultaneously into focus the images of structural and functional requirement, and melt them into one. A distinction between a *constructivistic* and a *functionalistic* aspect in nature would be a theoretical segregation of what in fact is a concrete unity: growth. But in human production, this division is by no means theoretical; it is most real and can never be fully overcome.

There is another important difference between natural organisms and the products of man. Calves born with two heads are rare, and if born, they have no survival value or chance of reproduction. In nature the magnitude of change is comparatively restricted. Man, on the contrary, is the creator of fairly permanent atrocities, which surround us 'for the duration' and beyond.

Natural selection of survival values consists in automatic elimination of mutations that show lesser fitness for life. Similar principles may in the long run apply as well to human production and to the construction of human environment. Here, however, survival value is a more complex concept.

Primarily, our concern may be with the assured and continued existence of a product or commodity itself. It must survive on the open market, prove its mettle against competition. But then our man-made surroundings, our human products will in the last analysis and over long periods have to demonstrate their wholesomeness not only for the individual consumer but to aid the survival of the race itself.

Plants and animals can survive only if they are adjusted to their physical environment. Man, unlike plants and animals, is a tinkerer and has the capacity to transform his physical environment by most fateful additions. Leo Balet [1] has stated that intellectual spokesmen of the eighteenth century, the era of political absolutism, indulged in the general doctrine of complete mastery and the knocking down of resistances. The reversion of natural properties into their exact contraries, the replacement of nature's forms by artificial ones, was triumphantly interpreted as the Mastery of Nature. The foliage of trees was cut to look like straight walls, cubes, spheres, birds, or what not. Painted faces, powdered coiffures, courtly furbelows attested that it was possible to conform nature to the will of the absolute sovereign. It was against this unnaturalness, or anti-naturalness, that the rising power of the middle class was soon to react in words and deeds. This protest was then lodged largely on moral ground. Nature was drafted as an ally in the revolution against the godless rule of the prince and the arbitrariness of his political and artistic henchmen.

Today perhaps we no longer regard this as a moral issue, but may still rather agree with those protestants as well as the Biblical prophets who saw the wrath of the Lord rise against perversion. We have learned to think of the laws of nature as inexorable and never violated without severe penalty. To the biologically minded, mastery of nature does not mean reckless perversion of her forms and processes, but rather the art of attuning man's ways to her order.

Our creed as designers should make peace with a creation which long preceded our own. Yet in recent times the specifically human capacity of troubling nature has increased way beyond all the artificialities of the *ancien régime*. With the help of alpha particles and gamma rays, we can influence even the innermost chromosomatic base of the species and cause heretofore unheard-of mutations. The atomic bomb

[1] 'Die Verbuergerlichung der deutschen Kunst,' *Literatur und Musik im 18. Jahrhundert*, Leiden, 1936.

has popularized spectacular dangers of this kind, but there are many less conspicuous ones. Dr. Beadle produced mutations with seemingly harmless ultra-violet light, and certain chemicals have similar effects, although we may for a time be unaware of them. Nevertheless we place these potent agents in our immediate environment.

Man constructs tools, and with these tools more tools to change increasingly natural surroundings, and each product has its own incidental cluster of by-products. It is through this comprehensive activity that houses, road networks, cities—an entirely new environment—are created. The man-made setting reacts through an infinite number of stimuli upon the nervous system of every member of the community. More than that, today design may exert a far-reaching influence on the nervous make-up of generations.

The claim of Dr. Sonneborn of the University of Indiana that newly discovered cell plasm genes in protozoa can transmit to a next generation acquired characteristics of, for example, higher temperature resistance, implies that things are not as fixed as we thought only recently. Conceivably far-reaching influences on the future of a species can be exerted through design. Out of ignorance, we permit our instrument, human design, to operate accidentally, and it may bring about mutations more fateful than nature's.

Modern biological research, then, has somewhat shaken the theory that acquired characteristics, or inflicted impairments, mean nothing to descendants. This return—since early Darwinian days—to a belief that the inheritable substance itself can be molded, adds a great deal to the prestige and significance of design. But, even assuming that acquired traits do not endure through generations, it still remains true that the individual, the 'phenotype,' must have its opportunity of development so as to realize inherited characteristics. And thus we still would have to worry a great deal about man-made environment and its possible obscure dangers to the human community, even if we set aside all ominous considerations about how, through design, we tamper daily with the precious inheritable substance itself.

There are numerous threats in those unheeded by-products of human inventions. We may mention, for instance, the fact that there are two hundred known carcinogenic substances, that is, substances that favor the incidence of cancer. One of these is ordinary soot, the effect of which has been studied on ailing chimney sweeps in England. Another is the hydrocarbons, such as are contained in the kerosene drippings from seemingly harmless little body stoves, which Hindu women have been carrying too close to their skin, with fatal results. Many industrial processes have been investigated for the purpose of determining such noxious influences. But the entire urban surroundings of our age, which are so completely permeated by technological processes, need to be combed for trouble.

In the cases mentioned above, the victims long remained unaware of their plight. The disease struck insidiously. There had been a sensory adaptation, an accommodation of the skin, to the particular poison, the presence of which might otherwise have been noticed. Sickness, often followed by death, came without much advance warning. Many of the victims were stricken before reaching adult age, before reproduction of the species was realized. For survival, we cannot always depend on our senses. They often fail to report danger in the smallest dose, which sometimes is the most dangerous.

An amazing observation was related to this writer by Dr. Frederick Crescitelli of the University of California. It concerns animal subjects which were brought to convulsive action by exposure to a certain sound, a note of particular frequency. The effect of this sound was manifested even long after the subject had fully adapted itself to it as an acoustical, sensory stimulus. While this sound was scarcely perceived, it could still produce violent contortions!

The fact that a man does not realize the harmfulness of a product or a design-element in his surroundings, does not mean that it is harmless. We need other, more objective, criteria than mere opinions or custom and habit. We may become used to the sight of a telephone pole in front of

our window and may claim that we can ignore it, but it still might be proved detrimental to visual and thus general well-being.

Nature has endowed us with minute pain receptors, devices that alarm us in case of injury. They also signal over-fatigue, and thus help to head it off. These pain receptors function successfully in natural situations. To insure the perpetuity of this elaborate apparatus—for the benefit of our survival—nature has made it non-adaptive, i.e. pain does not become less perceptible if it persists. Nobody can really get used to painful exhaustion and just work harder and harder. On the contrary, these alarm signals get more and more piercing and loud if we do not heed them. But it seems that some 'unnatural,' man-made stimuli, while eliciting response from other receptors, happen not to cause direct pain, and in such cases repeated stimulation results simply in an accommodation to it. From then on, we are left without any warning.

The adjustment of human beings to man-made environment is a much more complex process than biological adjustment to a natural habitat. It is a process involving rapid readjustments; new frictions and nervous 'arrhythmias' are continually produced, and efforts are continually made to alleviate them. All this internally mirrors, in fact physologically constitutes, the endlessly ramified process of civilization. The pace of this process is much speedier than that of adaptation through long, biological ages. Every new technological invention results in urgent new demands on the human nervous equipment.

Through a tedious learning process, this nervous apparatus, naturally limited in scope and speed, tends to approach again and again a balance of the bearable; but we have it even more in our power to change our physical surroundings and to step up once more the multitude of stimuli.

We know all this from suffering under an avalanche of unassorted so-called progress. Harsh neon signs, for example, in certain technically limited color combinations are splashed all over a commercial street. Their quick succession as we

pass them in a fast-moving, motor-driven vehicle would have been terrifying to people even one short generation ago. They may be nerve-wrecking to us, whether we know it or not.

It has become imperative that in designing our physical environment we should consciously raise the fundamental question of survival, in the broadest sense of this term. Any design that impairs and imposes excessive strain on the natural human equipment should be eliminated, or modified in accordance with the requirements of our nervous and, more generally, our total physiological functioning. This principle is our only operational criterion in judging design or any detail of man-made environment, regardless of how difficult it may seem to apply the principle in specific cases.

We must keep in mind that in nature even minor deficiencies in adaptation have in the long run obliterated entire species. Obscure, seemingly insignificant elements of our man-made environment may produce disastrous effects if given sufficient time. A systematic illumination of the danger in our present scene should be the order of the day. Our muddling through in a perniciously and neglectfully constructed environment must no longer be taken for granted; its perils must not be ignored.

Man-made mutations, in the realm of technique and culture, loom large in proportion to the structures of yesteryear which we may have learned to deal with. Effects of change here are often so violent that they quickly annihilate the *status quo.* This strange disruptiveness is a specifically human factor in patterns of development.

Many of our cultural changes—often the more conspicuous ones—are accounted for not by a steady positive evolution but by a negative factor, *fatigue.* It is a phenomenon which seems to occur on many organic strata, from the exhaustion of a bit of unarticulated plasma to that of a complex human brain.

Mere tiredness of existing forms may overpower us. We may want to get rid of it all. We need a clean-cut change.

At times, being tired of what exists may obscure other important issues and turn into a primary motive of human action. Nevertheless, over long periods at least, evolution can never become exempt from that simpler and broader principle that establishes the survival of what is physiologically most fit.

Perhaps one could venture to subordinate the first principle of fatigue to the second principle. One can fuse both by stating that especially for the more highly developed human neuro-mental system a static changelessness seems especially unfit. Dissatisfaction with a static unchanging environment also increases with the complexity of our cultural structure. It is certainly much less noticeable or prevalent in a primitive tribe than it is in a more civilized society.

Our fatigue may concern the shape and color of our automobile, furniture, or house, the texture of upholstery fabrics, the smell of our carpet, the tunes of popular music. We may become tired of a socio-economic order or a political administration. It is such tiredness that can account for novel fashions and extravagances in ladies' apparel, hats, handbags, hair-dos. It reflects a need for new stimuli, which is characteristic of civilization on higher levels and indicative of their perpetual physiological unbalance and lack of stable adaptation. We must keep in mind that the quest for diverting novelties to counteract boredom tends toward a rank overgrowth. It may obliterate or warp the basic, long-range evolutionary progress of human production and creativeness. In nature this urge for diversity for its own sake has no clear counterpart. There is well-motivated variety but no petty arbitrariness indulged in only to relieve fatigue.

In spite of all these differences between generally natural and more specifically human developments and production processes, it must not be overlooked that nature outside of the human realm has amply served as a model for human constructive efforts.

A strict imitation, however, often seems to end in sterile failure. If two 'equal' forms are produced by unequal proc-

esses, or in unequal materials, they are not of an equality that satisfies the highly developed human brain. Human minds evolve from a childish stage where shallow similarity is taken for identity to ever-higher levels of differentiation.

Yet, striking similarities between things that are incongruous occur in nature also. Simple color adaptation to surroundings, static as with a grasshopper, or changeable as with the chamaeleon, develops into fantastic cases of *pseudomorphism*. Certain plants of very different families become similar in appearance to such a point that grazing animals mistake them for each other. A butterfly, or a caterpillar, may, for visual protection, closely mimic a plant leaf on which it lives. This shows that a quirk of functional circumstances may indeed bring about similarities quite different from and independent of structural similarities. But such cases remain anomalies. They are incidental or even in contrast to the main fertile current of biological progress which evidently has much more fundamental determinants than such occasional mimicry.

Many man-made imitations, however deceptive, have only a superficial and ephemeral appeal to the senses and often only to some of them, not to all. They are not 'omni-sensorial' and not well related to a fully active mind. Although we may become habituated to dull imitation, it can never be truly fertile. A machine-made Persian rug means to us very much less than the original meant to the Asiatic peasant craftsman and user.

Of course, we must not confuse the repetition of a productional process, in which the same technique and materials are used as in the original process, with pseudomorphic imitation. Such repetition is compatible with sound productional tradition—be it in weaving, wood joinery, or ceramic glazes. What we call pseudomorphism is the achievement of superficial similarity, but by different structural means, as in the case of a cast-iron wastepaper container that is shaped like a cut-off tree trunk.

A constructed building that looks 'as if grown' is pseudomorphic, no matter how engagingly true to life the word

'grown' may sound. A dynamic plant that grows from roots which absorb moisture and nourishment from the soil is one thing; a static structural weight resting on waterproofed concrete footings is another. If these should be conceived as roots, they are dry and dead roots indeed. The sham similarity does not contribute in any way toward a better understanding or a deeper enjoyment.

By the same token, articles that superficially imitate the workmanship of a bygone day are *ipso facto* pseudomorphic. In 1640 a fisherman built a house on Cape Cod for his bride. Resurrected near Hollywood in 1940 by lump-sum contract work from the architect's blueprints and for the use of a motion picture producer, the same pattern is pseudomorphic, without any generating potency. It seems about as close to its original as marbleized linoleum is to genuine crystalline limestone. Only for a brief sensual perception may these houses possibly appear similar; so as not to disturb this sort of similarity, any further cerebration would have to be cut off. Fortunately, it cannot be fully cut off by an architect. Even the knife of a brain surgeon will fail to do that because life could not last beyond such major butchery.

The roots of imitation are deep. It aims to reproduce a desired pattern of stimuli, which has earlier elicited one's response. Nature has modeled for imitative man, who wanted to be her equal. There is an original human craving for repetition, and imitation plays an important part in the history of design; we cannot shrug our shoulders at it.

Since Tarde's *Laws of Imitation*, in 1890, this subject has often been investigated, but much remains to be clarified. Musical cicadas have a drive to repeat their own call and imitate the sounds of their fellow insects. Children below a certain age and morons tend to repeat speech and action. The phenomenon is known in psychopathology as echolalia and echopraxia. According to anthropologists Novakovski and Jochelson, certain Siberian populations, when depleted in energy by their winter hardships and starvation, break out in a strange epidemic of senseless imitation.

It obviously takes energy *not* to imitate. It is very natural to repeat what another person does or says. McDougall and his school of psychology saw in imitation—along with suggestion and sympathy—a primary psychological force. But imitation, like other primary forces, can easily become a scourge to life.

NATURALNESS CAN BE REGAINED when the acceptance of design is guided physiologically and not just commercially pushed.

11

Acceptance of design must turn from a commercial into a physiological issue. Fitness for assimilation by our organic capacity becomes a guiding principle for judging design because such fitness aids the survival of the individual, the community, the race itself. Design must be a barrier against irritation instead of an incitement to it. The everyday insight in this matter is more rudimentary than we would think because of the weight of habit. A diet is not necessarily healthful because it is habitual. The fact that someone is used to smoking opium, even craves it, does not make opium a harmless drug. An element of design may be habit-forming and thus attractive but still incompatible with the requirements of our constitutional system. Designers of the future will neither cater to harmful habits nor gratify arbitrary desires. Their decisions will abide by ever-increasing physiological information.

In many countries the buyer of food or drugs is, to some extent, protected by law against products that might prove damaging to health. But things must not necessarily be swallowed to bring harm. External stimuli in our physical surroundings must not be underestimated and left untested. Beauty commissions, whose opinions are controversial, solve

little and might find meager support when they dared deviate from public taste. As for the producer's claims and propaganda, it is obvious that they cannot be taken at face value.

Let us analyze an example of a common builder's supply item—linoleum called marbleized. First, a look at the productional aspect. Flawlessly plain surfaces are harder to produce than mottled ones, and thus the latter are found to cost less. 'Beauty' enters the picture as an afterthought, when the manufacturer accidentally discovers that his product has a possible visual likeness to marble. This is what we describe as pseudomorphism. The manufacturer exploits the similarity by advertising his linoleum as marble-like and marbleized; and then he suggests also a functional plus of his article: 'dirt does not show.' The cheaper product is made acceptable to the consumer because it is 'beautiful and practical.' In one strange mathematical sum, two abstract concepts of rather different class and order are added up.

Now we may disregard the seller's biased advertising and consider the consumer's side; for instance, the manner in which a kitchen counter or any work surface may affect our nervous system. There are possible three clearly distinguishable cases of stimulation originating at the surface of an object:

1. Continuous, *smooth and even* distribution of stimuli over this surface.
2. *Rhythmical* distribution of stimuli
3. *Irregular* distribution of stimuli.

We can test our sense receptors in experimental arrangements, and this testing will actually have to be done to arrive at anything but an arbitrary decision. Experiments will yield data about fatigue of the mainly affected sense receptor, the visual sense, through exposure to the test surface for definite and measured periods. Then the total nervous system, not only the eye, will have to be checked under the influences of the particular surface in question for general tenseness or lack of relaxation, for increased or reduced receptivity to

additional stimuli, for such effects as glandular and digestive secretion, for modified metabolism, et cetera. The investigations will further compare normal responses of the test person in a passive state with response conditions when the subject is engaged in specific tasks over the surface being tested. Also the range of individual differences will be interesting.

If we propose predictability and scientific reliability before hastily speeding a newly invented commodity into production or permitting production to flood the market, we simply must not go by likes and dislikes, so easily and often so irresponsibly evoked. Nor can we lightly assume that a matter is insignificant because it is small. Science has indeed taught us to appreciate the importance of very small things like minute irritations and sub-microscopic viruses.

Although we have as yet no experimental data to prove that irregularly textured (jazz) plaster or marbleized linoleum is under certain conditions unpleasant to the tactile or visual senses, we know that throughout history man has shown a certain preference for smooth and even surfaces. Neolithic flint implements are polished beyond immediate practical requirement. A neurological interpretation, or at least the securing of factual data, will come from pertinent experimentation on animal and human subjects.

Over an even surface, our tactile and our visual senses can move without abrupt changes in innervation, just as a skater glides over smooth ice. Bumps or holes in the ice make skating less pleasant, because sudden and irregular nervous adjustments become necessary. If such external obstacles to steady nervous processes occur at rhythmic intervals, however, their effect seems more pleasant than that of irregular and haphazard interruptions.

Without delving into these quasi-kinesthetic problems, we should like here only to point out that something of 'beauty' or 'pleasantness,' or the lack of them, in marbleized linoleum is not beyond physiological testing. Perhaps we could even come to interpret why one type of mottled effect is less offensive than others.

As for the 'practical' merits of a product, we must again resort to an associative evaluation. The idea that dirt does not show on marbleized linoleum is similar to that of painting a butcher shop red because blood splashes on a red wall do not bother the eye.

Cleanliness has been put on a level with godliness and morality. It contains also what used to be considered potent aesthetic ingredients, and altogether a vast background of associations extending into the depths of consciousness. For reasons of this involvement, the idea of cleanliness changes with time, place, and setting, and becomes another instance to prove the insufficiency of an aesthetics, pure, simple, and timeless.

To us, cleanliness is not merely a matter of visual appearance, as it was, for example, in the past to the Japanese. Under their spotless floor mats, the *tatami* on which they eat and sleep, small refuse could accumulate for months and feed vermin. In the shiny hollow hairdress of Japanese geishas, artfully constructed around a core of silk and paper (*negake*) and riveted together with many *Kanzashi* and *Kushi* (pins and combs), there gathered a week's dust. These hair sculptures were so laboriously contrived that they were preserved for many nights, and during sleep the heads, thus adorned, were supported by little wood bridges instead of being permitted to sink into pillows. An ornamental mode of living is often unfavorable to a regular regime of cleaning.

As borne out by odors in a poor but neat Japanese house, the sense of smell for instance can be markedly much less involved in the concept of cleanliness. Here cleanliness is purely visual, while a Hindu may conceive it mostly in spiritual terms. In India, thousands of the faithful cleanse their ailing bodies by submerging them in waters that seem polluted to Western tourists.

Our own concept of cleanliness, imparted in kindergartens and elementary schools, through parental admonition and pamphlets of public health departments, is neither merely visual nor spiritual. It has a biological basis and is conceived almost as a scientific survival aid. We often act to protect

ourselves against agents of uncleanliness which cannot be detected without a microscope. In no case are we really satisfied with merely concealing dirt. From this point of view, a surface that shows clearly any undesirable accumulations of dirt is superior to one that does not. Maximum imperviousness and absence of open joints are preferable on this count as well as on the count of labor saved in cleaning. It is true that the cost of suitable materials may at first be high as it is in the case of all innovations; but if such materials are in increasing demand, a way is found to manufacture them at reasonable prices. Such demand is the all-powerful motivation of an industrialized civilization. Enlightened consumers will only have to pose correctly the problem of easy removal of dirt from lived-in interiors and especially from surfaces, imperviously finished.

Polished marble, for example, a very ancient product, possesses just this quality to a high degree, while thin gauge linoleum, the first material of this sort to introduce a phony marbleization, had a surface clearly afflicted with the pronounced unevenness of its burlap base. The producer's claims concerning the practical merits of marbleized linoleum depended on a fallacious association: Marble is easily cleaned; marbleized linoleum resembles marble, and so it is clean and cleanable. And if in fact it is much less easily and perfectly cleaned, well, at least it does not show the dirt. A clever pseudomorphic substitute is introduced with the intent to satisfy one sense, the eye (rather dulled that eye must be), while those of its qualities that are important for hygiene, such as minimum porousness and chemical imperviousness, are disregarded. Textured plaster, rolled 'figured' glass, ornamental cast iron, 'jazzily' discolored paint coats, et cetera, could be similarly analyzed for commercial rationalization of defects.

The manufacturer's notion of practicality then can be trusted as little as his notion of beauty, so profitable and easily advertised; his is a very biased beauty and biased utility. His ideas as a specialist in the mechanics of production should be fully honored; but the consumer must be

guided by experts other than the manufacturer alone if he is to evaluate products in the light of his own deeper interest. What he needs is not clever sales talk, but reliable investigations. Conditions closer to our natural wants can be regained in our constructed environment if productions are physiologically probed.

NATURE'S WORKINGS, SO INSPIRING TO MAN,
were imitated by him and then PRODDED
WITH A LITTLE MAGIC.

12

There appears a millionfold complexity
of the cause-and-effect relationship in natural phenomena. It
is a meshwork utterly impossible to disentangle, to grasp, or
to account for in full. Only fragmentary interpretations have
emerged. Human intellect tends to make up a world picture
of causes and then, by analogy to its own constructive effort,
makes it over into one of aims and purposes. Purposeful de-
sign has been interpreted to underlie a unified world ma-
chine.

The concept of a universal order by planned intent seems
especially satisfying to the human mind. Abstracted from
comparatively few observations of supposedly understood
natural events, it was stretched and elaborated.

The picture of an *ordered operating cosmos* is a useful staff
or reassuring crutch for the difficult obscure road through
the chaos of incomprehensibility. The ancient idea of a
world wisely ordered to function affords an emotional grati-
fication that has shown eminent and long-tested survival
value. It is the inspiration for all planning and designing.

A teleological or purposive evaluation of natural processes
appears very early in human history and has persisted as a
simplified contentment of the mind, so much in need to

maintain its balance. As man's abstractive capacity developed, everything in existence and in operation began to seem geared to everything else in sight. The ancient astrological doctrine of the correlation between terrestrial and celestial events is a striking precedent for the scientific postulate of a universal context.

Except perhaps on the levels of lowest magnitudes, as in the orbits of atomic particles or the mutations of organic matter, an abundance of causal ties are conceived by our mind which seem to make possible operation and functional sequence. We do not think in terms of static, isolated, or independent occurrences in nature. Nothing stands and persists by itself like a solitary monument, unaffected by neighbors. Everything seems meshed into an over-all context, which has its dynamic functional character.

For a million years, the evolving human mind found in the natural environment an immediate spur to imitation of this functionalism. It seemed only in need of adaptation to man's own purposes and tasks. Successful approximation of nature's unfailing functionalism, however, calls for protracted periods of persistent experimentation, and such effort has always been hampered by the circumstance that the individual life span is short. A man perfected a tool, reached his limits, then died. After a pause his son or even his great-grandson might go on perfecting.

The creations of man are imperfect when seen in the light of the functional integrity that prevails in nature. Human products are static, i.e. not self-regenerative or self-adjusting, even when changing conditions flagrantly demand such an adjustment of function. Every step forward calls in turn for renewed effort and initiative on the part of the human creator. Man's mental economy, his physiological liability of periodic as well as final exhaustion, make temporary contentment mandatory—often long before he can realize the goal of functional perfection he sets for himself. At the same time he remains conscious of the imperfection or faulty functioning of his product and is perturbed by it. He seeks to compensate the physical deficiency at least by psychological

means. The more primitive the product, the greater perhaps is the urge toward such 'supplementation.'

For ages, the supplementation consisted in adding the instrumentality of magic. This involves the ability and the urge simply to identify things with names and attach to them powerful imaginary attributes. The magic supplement may be found in a symbolic sound, a symbolic shape, an amulet, a mystically potent substance—either very pure or a concoction of strange ingredients, ritually processed.

A tool or a weapon such as a bow and arrow may be fairly well fashioned to purpose, but nevertheless may prove in some degree functionally imperfect. Its efficacy seems capable of being heightened by spoken conjurations, by charms inscribed upon it, or by powerful symbolic ornament. This assumption depends on a mental mechanism similar to the one that performs the identification of a rock with a powerful demon, a tree with a nymph, friendly or hostile, or the magic by which a child transforms an old towel into a cherished doll.

Man tends also to ascribe by sheer mental power a function where he is actually incapable of observing it. Even with contradicting evidence at hand, he is likely to find alibis to support the decrees of his mind. We should be more nearly correct if we called this magic an extrafunctional supplementation. At least there is no palpable physical function to it.

The functional parts of a building can be augmented in this same manner by means of symbolism in shape, detail, and color and, as mentioned, by the sacrificial and therefore magic effort vested in its construction.

On the one hand, the purely functional design of a human product follows precedents found in nature, however crude the approximation. A reinforced concrete framework, based on intricate computations of internal stresses, rightly reminds us of the skeletal structure and bone texture of a vertebrate, in both design and function. The slender concrete shell of a dome by the great engineer Dischinger, spanning a planetarium or large market hall, exemplifies the same

laws of statics as the paper-thin but amazingly stress-resistant shell of a snail or crustacean.

On the other hand, the magic supplementation that is intended to compensate for imperfect function has no such analogy or precedent in nature; it is one hundred per cent of human origin. Yet frequently it may borrow and super-impose formal images from nature, in whole or in part—as when shapes of fishes, birds, phalluses, eyes, mouths are painted or carved on arrows, boats, temples, helmets. Such applied images are fundamentally divorced from any natural functioning. Nevertheless, they allude to it symbolically, and thereby become operative, if not in the objective world, at least in man's wishful thinking.

MAGIC WANES AS TECHNOLOGY ADVANCES but
some of the 'old' is saved as ornament to
warm the heart.

13

Gradual increase of functional perfection in design seems to be accompanied by a proportionate decrease of extrafunctional supplementation. Here emerges a psychological law of human production.

Primitives as well as moderns try first to realize their purposes through technological inventiveness and functional design. Then, not completely gratified by the result, they supplement the slow and laborious satisfactions of imperfect instrumentalism with wishful magic and symbolic imagery. Where rationally purposed design falls short, a presentation, irrational but suggestive of function, may bolster our confidence, our feeling of security. But as we attain greater functional efficiency in design, we can gradually find a purely naturalistic approach, dispensing with supernatural augmentation. Our designs then tend to acquire in some measure the differentiated complexity as well as the economy of the unimpeachable functionalism that impresses us in nature. Our productions gradually lose that dualistic character, compounded of the rational and the irrational, which is so typical of early human endeavor. The handling of our technical problems becomes more matter-of-fact, less involved in ritual, charm, or prayer. Lighting a fire for warmth and

brightness was once a grand act; today it is no longer fraught with symbolism—we simply turn a knob or press a button.

The symbols associated with that ritualistic attitude, however, tend to linger on long after the psychological need that brought them into existence has passed. Originally man thought to make sure of obtaining his aims by means of magic; the succeeding ages have retained a residue of magic simply through force of mental inertia.

Doubtless we have here one of the main sources from which ornamentation springs. It flows on by conditioning in infancy and formed habit. Ornamentation cannot well be rationally invented and applied in cold blood, and current arbitrary decoration lacks the initial emotional impetus, the authentic purpose, of gratifying a deep primordial urge. It also does not endure and so it is quite unlike old ornamentation that has served through many generations.

Nevertheless, even shallow, unemotionally conceived decorative treatment, attached without profound faith or magic implications, has been used throughout the ages. It has appeared again and again, probably preying on ancient custom, and sometimes merely for the purpose of covering up surface imperfection. For example, when cast iron was first offered for nineteenth-century consumption, after the mold was removed plain surfaces were often found disfigured by little sand holes. As a remedy, Renaissance foliage was superimposed to improve the appearance. Whenever the potential inherent beauties of a new material are not recognized because production techniques are insufficiently developed to present it in perfection, the decorative artist is called in to sugarcoat the pill and to divert attention from deficiencies. Unlike the ancient sage of true ornamental wisdom, his feeble descendant, the decorationist of our day, seems to die young; certainly his creations are short-lived, barely surviving from one season to the next. The value of his makeshift contribution is nullified by fascinating technological advances, which finally offer in its stead the satisfaction of flawless surfaces. In the end, pure, unadorned forms appear, sensitively conceived in the new material, with nothing imposed on it.

A real rose needs no painting or decorating. Lively colored plaster coating of marble was used by the Greeks in an early period. Later, when marble was treated more expertly as a fine material, such a practice would have seemed infantile or characteristic of arrested development.

In discussing decoration, we must mention the fear of emptiness. The blank often makes us shudder; the horror of it seems ingrained in our mind structure, a mental *horror vacui*. From earliest time man has striven for perfection, for elimination of disruptive imperfections; but his mind seems to shrink from the ultimate perfection and uninterruptedness, the plain, which threatens him as a void. In general, he feels prompted to fill a vacant space with pattern. Children are fairly impelled to scrawl on a blank wall.

What an undeveloped mind perceives as blankness, however, may strike a more mature mentality not as a vacancy incapable of assimilation but as a meaningful element in a larger composition. An untrained person, for example, may see a wall, an area of color, a piece of plain furniture as an isolated entity, and rebel against its bareness. A trained person can conceive it as a part of a room and enjoy a juxtaposition or play of contrasts that completely eludes the first observer. To the connoisseur, the over-all composition becomes alive. The accent of quiet achieved by an interval of emptiness may mean delight, not revulsion. It is an outstanding example of how more complex cortical activity may reverse an earlier affect of emotional brain centers. A phenomenon as basic for design evolution as this deserves full attention.

Before the invention of canvas and paper and the popularization of easel paintings, artists—beginning with the prehistoric hunter in his cave—must have been badly pressed for sufficient surface space on which to paint according to their heart's desire. If they chose the wall of the cave or, later, of a building, the intention was not always to improve the wall itself—just as a Shakespearean sonnet was not written in order to improve the paper. Truly creative paintings, including murals, cannot be regarded as intended just

to embellish the base on which they are superimposed. They are not decor, or features merely added to something else. Rightly or wrongly, they are conceived quite independently of their physical setting. A pianist playing a Chopin nocturne is not concerned with acoustically adorning the living room. On the other hand, soft music emanating from a continuous record player is actually something like an acoustical decoration. Even though there is an abuse of the pieces thus played, it may be granted that such an audio device *does* something to the setting and to the hearer.

We have sketchily dealt with symbolic ornament and decorative surface treatment. There is another category of, strictly speaking, non-functional material we tend to retain in our environment. This might better be characterized as *no longer functional*, but as still charged with lingering associations suggesting actual use and comfort, and must be differentiated from the void-filling kind of decoration and from the survivals of magic emblems mentioned above. It is to be said, however, that this clinging to the shadow of bygone usage may in itself easily acquire the accent and flavor of a magic formula.

Fossilized forms remaining from an obsolete technological situation often continue to provide a certain strange mental comfort, even though the gratification they yield could now be obtained in an entirely different manner. Thus we derive pleasure from installing fireplaces in houses that have heat-radiating floors. Heavy door and window jambs appropriate to thick walls are found where actually cork or Fiberglas insulation may permit the use of much thinner enclosures. Conspicuous light fixtures or chandeliers have been retained when indirect, wholesomely diffused light could be or is being supplied; decorative wrought-iron window guards have been favored, although burglar insurance policies are in the bank safe and could obviate them.

Such old standbys now serve merely to symbolize our assurance that warmth and light can be produced and security maintained *as of old*. At a later stage of development, these

feats are taken for granted and bits of surplus design are dropped as no longer psychologically necessary. Ultimately, even the switch controls needed to operate lighting, heating, air-conditioning, and burglar-alarm systems come to be regarded as too conspicuous, visually and acoustically, and are masked from sight and hearing. Design interest has at last attached itself to other matters and ceases to assure or to demonstrate what needs no assurance or demonstration.

But in general, forms and ideas associated with past modes of living or with earlier attitudes hold a peculiar attraction for man. This is only in small part to be accounted for by habit. The conscious revival of interest in long-buried cultural treasures has little relation to persistence of habit or of the particular living traditions connected with them.

It may be that the sentimental attraction of documents representing vanished stages of human history is linked with the nostalgia for a golden age or that 'happy past' complex. Or perhaps we seek a pleasant feeling of superiority, such as the one we enjoy in a kindly condescending conversation with a child.

At any rate, it seems somehow pleasing to see the primitive and the modern side by side; it stimulates the mind. An old piece of furniture in a modern house may serve as a window, opening up a perspective from one age into another, an outlook from our own enclosed little moment onto the broad landscape of history.

Most people know that Martha Washington 'home-made' candy is produced on some sort of assembly line. It is not purveyed with a gracious social gesture but in brusque competition with the 'home-made' candy trading on the name of Dolly Madison, which also reaches us through hundreds of chain-store outlets. Nevertheless, we must find those names and 'colonial' wrappings somehow heartwarming, as otherwise they would not have been invoked by master minds of salesmanship.

Although people may go on camping trips in streamlined trailers, or soon helicopters, of the latest model, they feel like pioneers when they build a log fire on which to heat the con-

tents of a tin can bearing the endearing label, 'Old-Fashioned Bean Soup.' Then follows a course of delicious pancakes, from a box on which the beaming face of 'Aunt Jemima' symbolizes the culinary magic of a slave mammy of the 'old South.' Finally night falls, the butane-gas heater is turned off, the aluminum-framed Pullman beds are unfolded, and the party of 'old-timers' goes to sleep on foam-rubber mattresses.

Old is a 'warm' word—it seems good to have it around. An old baroque curve or a Victorian curlicue in some otherwise contemporary design may cater to the same appetite or add the spice of contrast. But the original object or a reproduction of it can never recover the function of genuine nourishment. It can never again be a staple food; its function has shrunk to that of an imported tidbit.

'FUNCTIONALISM' CAN TURN INTO A SUPER-
FICIAL CREED for extroverts, but it can also
be guided to honor the functions within our
skin and the innermost life.

14

We have seen that at the end of the
nineteenth century functionalism undertook to establish an
objective criterion of aesthetic judgment. It promised to
supersede all arbitrary historical formalism in design. Yet Sul-
livan's splendid rule of no exceptions, the principle 'Form
Follows Function,' unfortunately does not hold the handy
answer to all problems of design motivation. The point may
perhaps be illustrated by a deliberately exaggerated example.

The game of billiards is played according to certain rules
and with a certain technique. Both rules and technique call
for specific playing equipment. The functional design of this
equipment seems simple. There is a level table, with elastic
side guards, covered with a deep-colored felt cloth on which
the balls can roll smoothly. The balls must be perfectly round
and polished, and of a bright color to insure maximum visi-
bility against the background of the table. All that seems
requisite in a billiard ball is that it be a round, smooth, clearly
visible perfect sphere, resilient to a degree.

To Sullivan—and the writer concurs in this heartily—such
a ball would have appeared satisfying in its sheer simplicity.
Any decoration of it would not be called functional. Mil-

lions of billiard balls of this simple form have been produced and used. They are little wonders of essential beauty in Victorian pool halls and on tables with grossly ornamental legs.

Now let us assume that we have a billiard ball embellished with the portrait of Abraham Lincoln. At first glance, this appears to be a flagrant instance of nonfunctional decoration, and its apparent offensiveness should give all the advantage to the orthodox functionalist point of view.

If it could be readily shown that the decoration has no functional justification, we might serenely subscribe to the theory that all human products can be clearly divided into two kinds, the functional to be approved and the nonfunctional to be condemned. The first kind is identified with beautiful simplicity, like the clean ivory ball; the second is characteristic of much of our environment, cluttered as it often is with decorative accretions that have no functional meaning. The future designer could be easily advised which path to choose.

Unfortunately, the situation is not so simple. The benefit to be derived from neatly isolating the black sheep is tantalizing; it is seemingly placed in our reach but it cannot be sustained against all argument. Consider the billiard ball bearing the Lincoln portrait from the point of view of the man who ordered this adornment. He, like that other fellow who smokes a pipe with Teddy Roosevelt's face on it, says that he loves a great president. But our man adds another claim and swears that the sight of Lincoln's kindly, reassuring features helps to improve his game of billiards.

At first blush this sounds a bit far-fetched, but it has innumerable and much more impressive parallels. A famous writer may allege that he must have a certain painting hanging over his writing desk; otherwise he cannot write. Moreover, the desk must be a Louis-Philippe desk, or it must be of light birchwood. The collection of bric-a-brac on Zola's writing table, mentioned earlier, seemed to him as functional as a velvet beret was to Richard Wagner, who could not compose when he was not wearing this headgear.

Our problem now appears to turn on the factor of nervous conditioning. None of these items is in itself functional but as a result of the conditioning of the user they have become functional in a sense.

Let us assume that the owner of the billiard ball, surface-treated with the likeness of Lincoln, is a successful elderly Negro whose parents were slaves. As far as we can gather from the man's own testimony, his nerve tonus improves and his faculties are stimulated to expand when he thinks of the great and gentle emancipator. His self-confidence is increased when he sees Lincoln's face. His innervations and muscular co-ordination become more precise, his arms, his fingers, and his eyes work with greater steadiness. If he bases all these claims on inner evidence and, even more, on his quite measurable scores in the game, how could we safely refute him?

If a man orders a functionally meaningless decoration, it evidently is not functionally meaningless to *him*. All ornamental nuisance, all arbitrary formalism can thus be justified by devotees who claim that they feel better if they have what they like—and, exasperated, we are back where we were before Greenough or Sullivan stated their great principles.

It is all well to say that form follows function, but unfortunately this does nothing for the form purification of wash-bowls or architecture, as so many of us ardently hoped it would. It is a striking slogan, but it does not give us a practical leverage for changing the curlicue-burdened condition under which the human race suffers.

This suffering and widespread trouble are obvious enough. Yet if anything truly constructive is to be accomplished, the threat of a million formal impositions on our lives must be proved in factual detail by intensive laboratory work. Only observation down to the most minute detail will disclose the physiological principles on which we must base a reformation of design. Strangely stratified but fusable nervous responses are really our problem. The task of reconditioning us from harmful addictions will be arduous; predilections, as they pile

upon and against each other, solidify and are hard to dislocate. If we do not guard against unwholesomeness, it grows up about us and seems to become functional, or at least strongly habitual. It is not easy to keep the two concepts of the habitual and the functional apart, or to illuminate their interrelation.

FUNCTION MAY ITSELF BE A FOLLOWER—for example, when form and color excite sex in courtship.

15

The precept that form follows function is based on the observation of nature. Some phenomena of organic life, however, seem to contradict this principle, unless by means of sophistry we succeed in putting the cart before the horse.

Granted that appearance and aesthetic appeal are usually in the train of functional circumstance. This certainly seems true of the scraggy growth and the impressive branching of a tree under prevalent wind pressure. Yet suppose we can find other examples in nature where, on the contrary, aesthetic appeal is something that does not merely *follow*, where appearance is no consequence but obviously also a cause. Then form may in turn serve to release important functional sequences; the faith in 'functionalism' is shaken and its unqualified version becomes untenable at least as a universal mode of explanation.

The shapes and colors of flowering plants that depend on insect fertilization have, as we know, developed through natural selection. Colorful forms are an important gear in the wondrous, ever-busy world mill, and the billions of visiting insects are another gear. Gears function by fitting into one another, by interlocking. But just how does each individual

tooth of the first gear activate or put into motion an individual tooth of the second one? In other words, what does actually make a wild azalea attractive to a bee? Admittedly, the shape of the azalea's sex organs fits the bee's proboscis. The color of the flower is white (not red, which the bee's retina would fail to register distinctly), and the scent—well, the scent attracts and 'pleases' the bee. Why does the whole proposition *please* the bee? Why does this flower please *us and* the bee? Have we really progressed with our functionalist explanation? What makes objects pleasant and attractive to us is still a puzzle.

It is evident that, physiologically speaking, the bee is equipped with such receptivities that the azalea can offer to it a definite sequence of stimulations, optical, olfactory, and tactual. But it is exactly this combination of much-desired stimulations that used to be called aesthetic appeal. And such appeal appears to be operative in us as well as in the bee. What, then, has been basically gained by this novel interpretation?

Again granted, the flowering plant could not exist, would never have evolved, without that still mysterious appeal and it is functionally dependent on it. What interests us is the bee's endowment with a *primary positive receptivity*. This phenomenon seems similar to a tropism, a basic responsiveness to light, or moisture, or gravity. Perhaps, if we cannot further penetrate to the core of the mystery, we can at least gain from pointing out its specific character.

First: If the phenomenon described depends at all upon something like aesthetic appeal, we must conclude that aesthetic appeal is *not* based on the absence of interest and desire as specified by some puristic philosophers.

Second: In the case of primary attraction, such as that of the bee to the flower, there is something elementary at work which may not necessarily be present in the more involved gratification a human mind derives from perceiving a form integrated with function. Such a 'higher' gratification is man's prerogative and depends on his formidable upper brain equip-

ment, which permits all kinds of complex rapid-fire associations.

This sort of satisfaction is undoubtedly widespread in human life. But there remains a marked 'plus' in that primary enjoyment of the flowering plant. This must be discussed and is of great differential significance. The appeal here seems to rest on quite other grounds than the logic of function. It certainly does not help an over-all understanding to close one's eyes and deny the flagrant, more elementary peculiarity of sheer aesthetic stimuli. The problem is stratified and must justly be tackled on various levels.

A fish is streamlined and is covered with a waterproof and flexible armor of scales. The adjustment to a liquid medium is so perfect that we are delighted to behold it. Even as the fish lies still and dead on a boat's deck planks, we can easily imagine its living movement through the water; and if we had never seen a fish swim, we could probably reconstruct its function from its form.

It may readily be admitted that through such natural forms man has learned a great deal about what constitutes 'beauty' to him. And he has applied what he has learned to his own production; the streamlining of our automotive vehicles was the result of such a lesson in formal know-how.

Still, we do not for a moment see in the shape of a fish something that was evolved to provide aesthetic appeal for humans. Clearly this kind of beauty is a by-product.

If a streamlined form is attractive to us, the azalea is in a different and much more primary way attractive to a bee. Obviously, the flower presents stimuli definitely addressed to the bee. The striking thing is that this attraction is quite comprehensible even to us on the very same sensual grounds on which it operates for the bee. We are evidently not the original addressee, but we, too, respond to the message.

The appeal that the fish form has for us is based on its obvious functional appropriateness, to which after brief cerebration we respond emotionally. The azalea appeals to us not because of miraculous adjustment to insect life or any other functional considerations. Higher brain centers are not

involved, and the appeal evidently reaches the bee in the same manner, since this insect is altogether devoid of such higher centers. We humans have added through growth impressive top layers to our nervous equipment and are capable of intricate satisfactions. Still we have retained the ancient bottom layers of the structure as well, and their primary functions. The study of the anatomy of the nervous system shows that the emotional tract connects with each level of this stratified and well-communicating structure.

Emotional response and aesthetic appeal of the primary sort appear, for instance, in the courting activities of animals. Animal courtship not only serves the purposes of sexual selection but also provides the stimulation that leads to the excitement necessary for mating. In lower mammals, this stimulation is brought about by seasonal inner secretion. But even in the case of salamanders, birds, and so on, the stimulus to excitement must also be supplied from the outside, especially by the male partner. His means are highly varied but in many cases they unmistakably include elements of what deserves the term aesthetic appeal. Not only the birds but human bystanders as well, sexually unengaged and indifferent as they are in this case, readily recognize this appeal, no matter how convinced we may be that the courtship phenomenon fits intimately the general functional scheme of nature. Here is simply that salient specific 'plus,' that already mentioned primary aesthetic element which in most other natural phenomena is not observable. *Exciting form here becomes cause.*

Some Empididae flies when courting present the female with small insects they have snared. The gift is wrapped in silk spun by the male, or in a large glistening balloon composed of bubbles secreted by the lover who carries this marriage gift.[1] If colored paper is strewn near the males, they will put it in their balloons. The cellophane-wrapped gift

[1] Wells and Huxley, *The Science of Life*, Doubleday, New York, 1931.

114

package and the gleaming perfume bottle have their pre-human, phylogenetic precedent.

Stickleback fish turn an iridescent red color in sexual excitation, and their appearance seems to be the stimulus that in turn excites the females.

The male newt wears a magnificent nuptial dress and performs a courtship dance in which he prances with arched back before the female while his tail wafts toward her the odorous secretion of certain glands. It is this that excites her to pick up the sperm packet he drops and to insert it herself into the oviduct.

According to Elliot Howard, the male warbler builds the nest, then the female joins him, and the courtship begins. The male spreads his wings and his tail, and bristles up the feathers on his throat and his head to thrill the female.

Again to quote Wells and Huxley: 'Most people have seen a peacock displaying his train, perhaps the most sheerly beautiful sight in nature. The bustard inflates his throat, throws back his head and overts his wings so that he may strut before the hen like a surprising giant-white chrysanthemum.'

The argus pheasant has perhaps the most striking ritual of all. The long brown wings, their pattern of light spots so wonderfully shaded that they look like solid spheres, are spread out and thrown forward like the bell of a great flower. His long tail plumes wave up and down and from under one wing an eye peeps out to keep the hen in view and to watch the 'aesthetic effect' on her.

The male Australian bower birds construct peculiar bowers which are quite different from their nests. The bower often consists of a short tunnel of twigs; at its entrance the bird deposits shells, bones, berries, and bright objects. This collection, comparable in appeal to Victorian bric-a-brac, appears to be a substitute for courting plumage; the display of the male consists of driving the female through the bower, and drawing her attention to his exhibit.

In all these cases, function obviously seems to follow form. It is consequent to the display and perception of form, color, movement. In some cases, function is provoked by a light

signal, by a stunning illumination, such as that produced by certain night-mating fireflies. This beautiful light goes out when the sexual act, which it helped to spark, is accomplished. The function, so to speak, effaces the form when it is no longer needed as a stimulus.

Thus the functionalist slogan might often be neatly reversed: Appearance precedes and clearly seems to evoke an operational event. *Function follows form.* Form here is primary, a motivating force, as it has always seemed to old-fashioned aestheticists who listened to music or looked at jewelry.

As the physiologist knows, sense receptors have through many millions of years grown in ability to perceive many forms and colors. It must be admitted that they have come to develop a selectivity for some preferential stimuli or their combinations. There is no use denying that certain stimulations arouse emotional responses by a short circuit, while others do not.

If we are correctly interpreting this sort of response, however, which seems so independent of intellectual cortical appreciation of function, we must evaluate it as belonging to a relatively early evolutionary stage, in dominance when cerebro-neural equipment had not yet reached human levels. If we wish to judge stimuli and responses, we must understand clearly how our organic endowment has evolved its present multilevel complexity, and now responds accordingly. Nothing is gained and comprehension seems lost if we try to blanket with one aesthetic formula two types of response, involving operation on different physiological levels. We should, rather, like to distinguish them more sharply.

A tree in springtime bloom elicits immediate sensory reaction and powerful biological events in linked-together insect and plant life; a dead tree may, because of its shape, interest a sensitive artist or a philosopher. To speak of both trees as beautiful, to maintain that their beauty or their type of effectiveness for response be covered by the same blanket rule, is only to cloud or confuse matters. The color and form appeal

of vernal bloom is more universal, more basic because it operates in us on a relatively deeper and broader physiological level. The enjoyment of the dead-tree form is strictly human and not even foreshadowed in pre-human animal nature. The difference is best described by a corresponding difference in the characteristic neural happenings which actually involve different regions and specific capacities of the brain.

Several of the animal species mentioned in our examples have only a very rudimentary nervous system as compared with man's. They thus function perfectly and normally without certain brain activations, many of which are in fact quite out of their reach, though common to us.

Certain of their responses, however, still have their counterpart in the human nervous life, which is in some respects more developed than theirs. Brief and direct responses that exclude highly evolved and refined cortical activities, such as *differentiation, association,* and *abstraction,* are quite normal in animals, but such short circuits may well be called subnormal when they predominate in man. Even imbeciles, except those of the very lowest grade, react more complexly than animals.

We like to remember that any attempt to relegate pure aesthetic appeal to a subhuman level, or to put all problems of beauty on a subnormal level of psychic activity, would be an erroneous approach to the whole issue. Subhuman aesthetics cannot possibly be regarded as the *right* thing and as merely polluted by the admixture of human upper-brain action. The notion that intellectual activity as a component of aesthetic response is an undesirable or even harmful adulteration has become untenable. On the contrary, such activity is a normal constituent factor in the chain of our neuromental processes. In the light of current physiological knowledge, the idea of purity and impurity must be yielded.

Our neurological entity must be recognized. It is indivisible and, though operating on several levels, it always remains a whole. Thus human judgment of environment, whether we call it aesthetic or something else, will simply *have* to have its full share of cortical ingredients. There will

then be many thought associations, especially admixture of appreciation concerned with functional and genetic aspects. All these are, so to speak, articles handed down from the top rung of the ladder. Not indigenous to animals, upper-brain action belongs inevitably to our stage of development and to the human picture of the world. It is in this more complex world, as we see it in the light of current organic research, that the coming designer must operate, not in the pure aesthetics of a bygone brand of speculation.

For our responding nerves DESIGN IS ALWAYS
INVOLVED IN TIME—from sudden shock to a
great steadiness of appeal.

16

In the examples from animal life given
in the preceding essay responses that are elicited by a
'primary' appeal have one common quality: they are sea-
sonal, and their duration is very brief. As momentary excite-
ments, they are communicated, for instance, from one indi-
vidual to its mating partner. Bright plumage is a stimulus
for a special occasion; it is often tucked away in normal life
and only during courtship is it brought suddenly into play.
The appeal seems designed to come almost as a shock, in the
sense that it abruptly deviates from everyday appearance and
behavior.

In human conduct, too, direct sexual appeal is a departure
from the ordinary, the humdrum, the continuous. When
overt and forceful, it can scarcely be reconciled with habitual
decorum. It contradicts the rules of stable daily life. Sexual
appeal shocks into excitement, although it may sometimes
come in tiny quanta, as a mere tickle. Any attempt at mo-
notonous routine would soon wear it off; it would be shock-
ing no longer. Courtship behavior is only one case of express-
ing and arousing emotion, and non-sexual excitation may
induce something similar.

Dr. George Murray Levick, in *Antarctic Penguins*, re-

119

counts that sexually excited penguins present stones as nest-building materials to their females. The appearance of humans near their rookeries seems to induce a comparable excitement; sometimes a bird approaches such a stranger instead of its mate, and solemnly drops a stone at his feet. Dr. Levick was quite embarrassed the first time he was a recipient of this tender attention. Thus, while display, exhibitionism, and appeal of this sort seem related in the first place to sexual excitation, they may also be prompted by individuals other than the mate, or even by lifeless objects. But characteristic of related aesthetic phenomena are *excitement, brief duration, exceptionality*. The flowering of plants, too, is a short seasonal outburst in the course of a year, or, as in the case of century plants, at even longer intervals.

Excitation is imparted like a shock to insects co-operating with the flowering plant. The biologist Von Frisch has described the ecstatic 'dance' of the honey-gathering worker bee upon her first return to the comb from a locale where some species of flower, rich in nectar, has just opened into bloom. The other workers crowd around the dancer to catch the scent and then, guided by their olfactory equipment, eagerly swarm out to the new 'strike.'

The kind of appeal we are discussing here is essentially linked to novelty, surprise, departure from the usual; by its very nature it cannot be continual. Blooming and mating are intermittent; such excitation cannot be constantly maintained if the organism is to survive. There must be nervous counter-currents, an inhibitive mechanism to prevent the exhaustion that would result from endless repetition of reflex responses. Without fatigue and the useful awareness of it as warning signal, muscular or sexual energy, or biological capacity in general, would be fatally depleted.

This primary aesthetic appeal, then, can stimulate activity for a limited time only. The principle of function following form operates in nature within a time limitation. On the other hand, the principle that form follows function is not thus restricted. It shows the *stability* typical of upper-brain vintage and deals with those hardier, lasting cortical prod-

ucts, which are called abstracted concepts and occur only in humans. Such concepts may guide us through a lifetime. Their satisfactions are comparatively steady.

The cells of a honeycomb are constructed to function the year round. Our human response to the 'functional beauty' of their stress-balanced hexagonal structure is as stable as this structure and its function are. The satisfaction here has nothing to do with sudden shock. It takes a more highly developed brain equipment to appreciate the operational form and structure of the honeycomb, and derive lasting gratification from it, than it does to enjoy the sweetness and scent of honey, which constitute a more primary but short-lived satisfaction. The sensations caused by taste and scent strike us at first like a pleasant shock, then dwindle from second to second.

This brings us to a general consideration of the *time element in aesthetic appeal*. It is evident that the factor of duration varies according to the neural level on which the stimulus is processed and the response is formed. The level on which complex associative operations are elicited is much higher than that of merely sensory reaction, but what particularly interests us here is that the responses on these differing levels differ also in stability. Speeds of obsolescence and fatigue phenomena play their role everywhere.

The idea of aesthetic appeal must be divested of a quality of timelessness or eternity often attributed to it in the past. Such appeals are subtly stratified as to neurocerebral reception and assimilation and thus in regard to physiological time in which these organic processes unfold. There are certain basic shapes that have almost constant appeal, coupled with a certain steady mental economy. Other aesthetic stimuli operate on a fluctuating sensory level. But all appeals should be graded with respect to their duration or rather *the duration of our receptivity* to them. Each has, so to speak, a definite amortization period.

Musical form, configuration of sound and rhythm, can, through repetition, be vested with stability as a stimulus. For the most part, however, its impact is strictly instantaneous.

The same may be said of certain forms in space, such as the shape of a whiplash or a lasso in action, or of a lightning flash. The 'shock appeal' of such a form vanishes when the attempt is made to perpetuate it, say, on a photographic plate or to reproduce it in a static medium. The grin of a comic actor is immortalized to no avail in the bronze statue of his tomb. Appeal here may even turn into repulsion.

An improvised joke or phrase patterned for primary appeal may be rich in shock value, but if we have to hear it repeatedly, its effectiveness wears off. The construction of a quip intended for ephemeral newsprint is quite different from that of a passage written for a book that is expected to retain favor for many years or centuries.

By this token *design of form should be governed by the criterion of the anticipated duration of exposure and appeal.* Here we undoubtedly have a basic rule for creative practice.

A billboard poster, a book, a tombstone—each has different amortization periods; very different approaches to form and arrangement of letters or typographic standards will therefore become appropriate. Ladies' apparel may be designed to last only for a season. It would be a sorry mistake to be similarly carefree or arbitrary in designing a house, since it represents a much greater investment on the part of the consumer, who may have to take twenty-five years to pay it off.

Neglect or disregard of the relevance of the time factor in design is a frequent and yet a fatal sin. It is responsible for a permanent cluttering of our constructed environment with elements that at best are enjoyable or endurable for only a relatively short time. We may not be able to stand them any longer, but they persist.

122

17

In our everyday life we are assailed
continuously by a chaotic complexity of forms, shades,
colors, smells, noises. But a differentiating, abstracting, and
then synthesizing process takes place, until the chaos around
us is somehow articulated into more or less distinct objects
and organized entities. This mastication of an outer world
in individual bites, followed by a suffusing of all particles
into a digestible world picture, is a device not unlike chew-
ing, salivation, and digestion for the assimilation of physical
food. Our mind seems bent on processing the amorphous
intake of the senses by means of a specific secretion of its
own—namely, order. Design depends on this ordering ac-
tivity of the mind, and contributes to it.

Plato ascribes a solemn mystical significance to abstract
ideas, to simple numerical relations and geometrical pat-
terns. Mental economy evidently favors what can be easily
conceived, visualized, memorized, and communicated. Thus,
a square, a circle, or an equilateral triangle is more readily
defined, envisioned, and recalled than a figure of irregular
shape and anomalous proportions.

We are somehow equipped so that we can record our con-
sumption of nervous as well as of muscular energy. Emo-

tionally we seem conscious whether the exertion required for a given task will be great or small. This inner awareness constantly colors our outlook and all our mental undertakings.

Experiments have shown that bees seem able in some way to determine the number of their wing beats or the consummated flight effort and thus the distance they have flown from the hive. Effort and strain are somehow self-measuring by inner sensations.

Our speech center records energy expended while we repeat rhythmically rolling verse or a sample of bumpy, chopped-up prose. Verse and prose have different values especially in the light of brain-physiology. In a similar way the visual center differentiates between the effort involved in following a steady curve as a guideline, and that required for jumping in space from point to point.

Kinesthesia deals with the feeling we experience in moving members of our body or any small part of it, such as the eyeball. There is a sort of kinesthetic constancy in the gliding or, more correctly, rhythmically jerking of our eye along a straight line. Something like a 'plus-effort' seems to occur at any point where such a line is interrupted or where it changes direction. In a zig-zag or in irregularly broken lines, the volleys of nerve impulses also become irregular and have to be multiplied.

With such inner evidence of energy expended or of economy achieved, we subconsciously put a high value on regularity or order. We are even induced to ascribe such order of our own making to natural phenomena which, of course, are independent of the economics of our perceiving and conceiving and for the most part devoid of simple patterns and proportions. Nature, beyond our own limited grasp, is impartial to simple numbers and complicated fractions. Numerology is a very human invention, queerly projected into the universal scene. In spite of all the ingenious endeavors of the Jesuit scholar Wachsmann, and many others, the proportions of the golden mean have not been proved to prevail in nature. By contrast the Ludolphian number π, expressing

the ratio of the circle to its diameter, plays an important role in the physics of the universe, although 3.1415 . . . is anything but a simple, round number, easily memorized.

The experience of apprehending or remembering something with ease is accompanied by a pleasurable feeling of lowered tension, and thus is cherished. Conversely, our mental economy, as well as Platonic aesthetics, is in general negatively disposed to forms that are difficult to grasp or retain.

Occasionally, however, positive value is ascribed also to elements that supply a titillating taste of contrast to a prevailing regularity. Certain deviations from common proportion or rhythm do just that. A bit of syncopation, a slightly startling dissonance can enliven a conventional musical score. Irregularity is a spice in the Platonic dish.

But even the greatest irregularities deliberately created by humans are trifling as compared with the endless complexities of nature. Nevertheless we have seen that nature can be interpreted by human brains as functional and orderly. The Hellenic concept of the cosmos actually equates the universe to a great, beautiful harmony or order. In this view, on this level of mental functioning, all the phenomena of nature seem purposefully interrelated. But sometimes we feel we must temporarily abandon the effort to understand the world in such terms. Then, for an interval, we experience a peculiar mental relaxation. We resign ourselves to the amorphousness around us, as though we were listening to a conversation in a foreign tongue that we have given up trying to understand.

We may sit serenely on the bank of a stream that rushes along between boulders and numerous little wooded islets. The sound of the current fills the air with diffuse and subtle reverberations from rocks and foliage. Purposes are forgotten; a few rudimentary ideas of cause and effect may, for moments only, flicker in our consciousness. We have ceased to place much value on cause and consequence or on simple forms and ideas.

The creek in a rocky canyon may cause such and such an erosion. It may be understood to have produced through the

ages a resounding hollow. And now the boulders and pebbles in its bed make the bodies of water vibrate in their much distorted movements so that the surrounding air transmits a multiform, complex acoustical phenomenon. Well and good, but causes, beginnings, and ends are forgotten. To us, all has turned into a purposeless, yet pleasing, gurgling and tinkling polyphony. A listener in leisure enjoys the voices of nature as something casual, carefree, lacking any intention, without that order or form which dominates human routine. If he were listening sharply, certain sounds would seem to be repeating themselves lawfully; the same rocks and boulders cause the same deflections of the current over and over again. There are sometimes baritone and again soprano strata distinguishable to the ear. In the mood he is in, he perceives no rhythmic laws or differentiated notes, but merely sound agreeably diffused.

In their continuous transitions, their lack of cut scale, these sounds violate all the simple rules of classical, orderly, man-made music. Even if it were possible to distinguish a pattern, it would prove much too intricate to induce the kind of response elicited by plain Platonic order. The sound remains gently confusing, pleasantly bewildering, undefined, and the perception is melted together with a host of other half-conscious sensations. The olfactory impressions caused by the moist surroundings, the visual stimulations arising from the manifold light reflections, blinding, mirroring, dancing, and disappearing on the ripples and waves of the water, the drafts of cool air over the skin—all this cannot be as precisely apprehended or communicated as, say, the image of a clearly conceived circle. Such a static abstraction, a product of our upper brain, is much more stable than those fleeting impressions.

If we find such landscape surroundings attractive and beautiful—restful beyond words—it certainly cannot be because of order. There is no trace of Platonic regularity. In terms of geology and botany or of philosophical speculation the scene might perhaps be interpreted as an expressive part of the admirable world mill that operates without end. Our

gratification in such an environment, our relaxed vacation spirit, however, derives from no intellectualized approach, but rather from the circumstance that we have been hypnotized by incomprehensible irregularity, have given up our usual effort to distinguish, our attempt at individuation, and have a leave of absence from all human filing systems. We do not perceive each boulder, each ripple of water, each tuft of moss, each cloud overhead as a cog in that great machine or attribute a distinct functional existence to each of them. In a mood of mental inactivity, emotionally at ease, we expend a minimum of neural energy.

If we should start to examine our surroundings, organic and inorganic elements would at once again take on 'individuality' and a separate operative existence despite all essential interdependence. Each of them becomes or appears to become forthwith endowed with its own life, function, or purpose. It is as though a huge crowd of people were suddenly articulated into a number of distinct personalities in interplay but each demanding special recognition. Thus at any moment we may look into a cosmos articulated by our own making and everything emerges at once from the chaotic vagueness that we faced while relaxed.

Whenever we are in pursuit of a program, mental economy impels us to find, establish, and maintain order. This may then tend to be an order of the Platonic variety. But even beyond that, our propensity to discern organized entities, recognizable arrangement in what our senses perceive, is at work in many ways.

There is nothing in itself more chaotic than the infinite space of the heavens above us at night, filled with remote celestial bodies rushing and whirling at inconceivable speeds and distances. Our early ancestors projected it all into one ceiling, and made it over into the 'peaceful tent of the starry sky.' They grouped stars in simple constellations of approximately equal luminosity. To these groupings they gave strangely associative names—the Scorpion, the Lion, the Huntsman. They found mental comfort in this ordering of

a chaos not otherwise comprehended. Here we have another early instance of the practice of mental economy, derived from simplified 'Gestalt.'

Mental activity on this level is no longer fully relaxed as in abandonment to chaos. It is also at ease, but after another fashion; we feel different from the way we feel within a setting of geometric regularity. Rather it is a state of the mind corresponding to the state the Hindus call chit, or chee-ta, in which associative images follow each other in a dream-like flow. They are very often illogical, unsifted, uncontrolled, but for this very reason they represent an economy of nervous energy. A dream yields its own kind of gratification and saves nervous output. The ability to attack problems on the high and strenuous level of controlled mental exercise and operating inhibitions developed late in the evolution of human thinking; mythologies, easily associating those dream-like images, came first.

Emotional gratification often reflects a profit-transaction in expenditure of nervous energy; frustration reflects a loss-transaction. How these problems are met, and whether the approach is more that of primitive let-go, of mythological imagery, of Platonic regularity, or of sharp operational discrimination, is instrumental in shaping the man-made environment of the time. Design has often reflected a strange mixture of various types of mental background activity.

Still, the expenditure of certain guarded quantities of energy offers a clue to the understanding and tracing of nervous happenings on all their levels up to high mental exercise, and especially it is a clue to the vagaries of production and consumption of design.

There is no 'PURE REASON,' just as there is
no 'PURE BEAUTY.' Emotion most naturally
tinges every mind operation, be it a mathe-
matical task or creative design.

18

To the man in the street, an exact
scientist may seem a pure intellectual—the 'heart' does not
speak in his work. Closer inspection will confound that simple
picture. A mathematician as well as a schoolboy, when con-
fronted with problems of computation that really tax their
respective capacities, seems to go through certain typical emo-
tional reactions: blood circulation, glandular secretion, respi-
ration, the peristalsis of the bowels, metabolism, all are meas-
urably affected while supposedly pure reason is at work.

Let us remember our own feelings during a mathematical
examination. Can we say that our emotions remained unaf-
fected and placid? We first perceived and identified with
timidity a series of chalk marks written by the examiner on
a blackboard. We located the unknown value in the series
with a noticeable amount of tension. If we remained puz-
zled and did not know immediately from routine experience
how to start or how to continue, possibly that tension grew
and produced a feeling of despondency. Something like a
catastrophic reaction may have closed in on us, causing us
to 'flunk' the exam. Even mild panic is capable of blocking

the orderly innervations of the abstracting, differentiating, associating cerebral cortex.

But let us assume that we composed ourselves somewhat. Still embarrassed, we began to apply previously acquired methods and at once felt calmed by doing so. The words we use here obviously designate emotional, not merely intellectual, states. Through proper transpositions the equation before us may then have taken on a more familiar form; we succeeded in isolating the unknown value and grew hopeful. Suddenly the full solution dawned upon us and we felt elated. The schoolboy may loudly shout his little 'eureka,' just as old man Archimedes, overcome with emotion, jumped out of his bathtub because he had an idea that 'clicked.'

The person who chalks down the solution after having gone through considerable nervous pressure is permeated by a marvelous relaxation. He is happy; he feels a liberation of the heart, lungs, and lower viscera; excessive nervous impulses, emotional tensions have subsided. Pressure or tension, the rapids and blockages in the spread of nervous energy, are registered emotionally even in the purest of intellectual operations. There is nothing really pure or unmixed about them if we watch them in the making. Only a theory *post factum* depicts them as unemotional.

Basically we cherish relaxation and, only temporarily, nervous tension that readily can be resolved. We wish all to remain within normal bounds. There are aspects of the flow of innervations, of the nervous process itself, that are recorded as pleasurable, and others that register quite regularly as unpleasant.

A pleasure mechanism can also be assumed to operate behind the peculiar procedure of designing, which, like the enjoyment of design, is a special case of the more complex nervous transactions. The need for satisfaction, which means relaxation after a given problem has been solved, is implicit right from the start of a design effort. Such anticipation supplies us with the hopeful mood, the favorable emotional tonus, the incentive to tackle the task and invest the required initial energy. From hopelessness no inventor or artist could

ever derive either motor power or impetus. There is lodged in him, from some similar past experience of systematic approach, a hopefulness concerned with that pleasurable relaxation which comes from a well-ended nervous exertion and is its reward: the 'sabbath feel' of accomplishment.

Thus on one hand, an initial exertion is acceptable or attractive because its tension is finally resolved; on the other hand, fatigue, exhaustion, and frustration are dreaded should no happy ending be reached in the venture. The anxiety in the face of a new problem of design brings to mind the despair which, according to his own testimony, gripped Richard Wagner each time he began to labor on the composition of a new music drama destined to last four or five hours on the stage but to consume a year or more of his life in creation. The available storage of nervous energy and its consumption, subconsciously gauged, are of great significance in design decisions and procedure. A fundamental awareness of the limits of nervous capacity might conceivably be operating even prior to a completed actual experience of fatigue. It may account for the avoidance of waste in a master's supreme performance and in the restrictions he voluntarily imposes upon himself.

There is a beautiful and striking economy in the movements of an accomplished golf player, horseman, or dancer, in certain passages of Shakespeare, or in the instrumental simplicity of a Bach suite for solo flute. Whenever economy of design has been successfully brought to wide habitual acceptance within a culture, a great age is ushered in and a tradition is launched which will find admiration and yield gratification even centuries later.

It has been pointed out, however, that routine will also, by mere repetition, impart to any process the mechanical economy that goes with production followed by reproduction. Thus, even a very involved, seemingly wasteful design may long remain in force, and it does not contradict our principle if a tribe, a community, or a highly civilized nation stubbornly clings to complicated formalism. Much nervous energy is being saved by this very adherence, energy that

any change or sacrifice of pattern would unavoidably force to be expended. For people who are used to tattooing, life without it would be quite an effort.

A much-needed physiological understanding of habit and tradition in design relates them to neuromental economics. And economics, a term that sounds so quantitative and cold, is here forever mingled with fleeting emotion. Our neuromental performance is acted out on a multiple level stage, like a medieval mystery play. Emotion is near to all the levels and never exits.

Almost without exception, we may say: Whatever can be easily perceived or nervously assimilated, that is on a small budget of energy consumption, appears from the outset inviting and agreeable. Something seemingly ready for easy assimilation, however, may first be made the object of a little experimenting that deviates interestingly from the norm. There may be a show of some boldness in modifying the norm, a bit of extravagance, a vent to our exploratory play drive. Still, such occasional thrills picked up under way, as it were, must not make us forget the fundamental law. A subsequent and ultimate relaxation seems the sweetest fruit we can obtain. An intuitive awareness of our nervous energy household makes us rather timid in expending such energy too freely.

What is commonly called conservatism thus seems to be an attitude derived from a primary survival mechanism, which must not by any means be ignored or despised.

MENTAL ECONOMY IS MANIFOLD, from simple regularity to the ease that comes from even complex habit; also 'magic' shortcuts have been seen to supplement the more laborious satisfactions of the mind.

19

The ancestor of our engineer and designer was the primeval toolmaker, builder of canoes, producer of early weapons. The contraptions man designed may be found anything but perfect in their functioning, and as his wits gave out a gap still remained between reality and the goal set.

Whenever anticipation is unfulfilled, a remainder of neural tension seems to disturb the mental comfort. As the designer begins to stagger on his difficult path, in his wishful thinking he looks for a detour or jumps the track of rationality. He may slip out of his blind alley onto another level; sometimes we could say that he gropes down to an underground by-pass. The whole process then seems to play closer to the lower brain levels of quickened emotional gratification, and below the full upper brain possibilities. We have spoken of dreamlike imagery and symbolism. They enter here, also, to provide a shortcut, bringing relief and wish fulfillment where the factual solution, the product, in its physical functioning, had remained imperfect and troublesome. I have on occasion noticed similar tendencies in my own mind while laboring

on a difficult design and tiring under the strain. It is necessary for a human being to arrive at a resting place and it seems to be against the nature of a mental operation that is emotionally sustained to stop anywhere before at least a temporary abatement of nervous tension has been reached.

It is fascinating to look forward to a future in which this all-important phenomenon of inventing, and of fatiguing in the process, may be interpreted in exact terms of brain physiology. We have tried to state it from a psychological point of view. A rational approach to a design problem is followed just as long as the difficulties can be surmounted and resistive friction does not develop to such a degree that this rational inventiveness is brought to a standstill. With a standstill-before-the-solution emotionally intolerable, a substitute is sought, whether by that dive into subterranean magic or a leap from the end of the firmer path onto the flying trapeze of mystical satisfaction. Fundamentally it is emotional gratification that must be reached by fair means or foul.

There is, of course, nothing really fair or foul, nothing moral or immoral in jumping the track when its end has been reached. Within a certain historical constellation, the track of rational design is simply limited, and no designer's responsibility reaches beyond it. *Ultra posse nemo tenetur.* Incapacity sets an end to responsibility, as the Roman lawyers acknowledged.

A significant warning is in order, however. The survival of a design idea will be impaired if the track is *willfully* jumped by the designer who only makes believe that he can go no farther. Such a situation occurs when he pretends that he lives a hundred or a thousand years earlier, at a time when the track actually was blocked, owing to then prevailing conditions. In this case, the designer chooses to indulge in phony primitivism or childishness, without the excuse of emergency or true contemporary limitations, but just for fun.

Probably here *is* foul play. His crawling on the floor, referred to earlier, is not a true infantile survival aid, but

rather a futile adult pose assumed to prey on the charm of a child. It is a pose that is sterile.

With this in mind we avail ourselves of a very practical criterion to gauge and judge design, and design approach, at any historical or current moment. A Chinese junk has a well-designed prow to cut the waves. An engineering brain did ingenious work as far as it went and as far as was possible at the time. Nevertheless, deficiencies became flagrant when a typhoon blew. All the painful constructive thinking did not prevail, and could not always assure against wreckage. Therefore a means of 'mental insurance' was sought in dreamlike wishful association and symbolic links of design. A triumphant-dragon ornament crowned the prow to give victory over evil storms, and eyes were painted on to find the way through the turbulent and darkened waters.

Once mathematical computations are discovered to gauge impacts and to dimension hulls of ships for resistance, however, once radio beams guide vessels through air and over the foggy ocean, dragons and painted eyes fall gradually into disuse. They must, because they are no longer legitimate in the mentality, the neuro-energetic terms of design's current phase. A different thinking and judging is now automatically touched off by the same problem.

Today we cannot design a vessel such as an ancient Chinese junk without willfully reverting to a lower level of nervous satisfaction; and to ignore our present level is to stunt the mental potential for evolution. It means that survival is impaired by maladjustment and by a disuse of our mind, the organ that propels the race. Disuse will cause its atrophy, abuse will make its performance doubtful, its products harmful.

We see here in a nutshell a good part of the physiologically determined history of design. Through the ages one ancient economy of thinking, one earlier practice of neuromental economy, is replaced by a later one. Magic must again and again withdraw into fields not yet 'full-cortically' plowed through; and, indeed, there seems a limitless back country for ever-new retrenchments of the uninhibited, the

undifferentiated, the semi-controlled, the naïvely animisti-
cally conceived. Thinking on a level that is due to the most
recent evolution and perfection of the thinking process is
strenuous and we like to lapse into an easier, earlier practice.

Playfully, we may once in a while toy with old-fashioned
modes of association and attach to the front of our automo-
bile a symbolic radiator figure, a dim reflection of that
trusted dragon on the prow of the Chinese junk. Someone
may still place a rabbit's foot in his pocket before boarding
a transoceanic sky sleeper.

In the world of modern design-economy, the radiator figure
is a relic. To hoard gold pieces in an old stocking may have
been the proper thing in the Thirty Years' War. Nylon
hosiery filled with our kind of token currency and stuffed
into a modern Beauty Rest mattress is a sham device for
fending off financial catastrophe in our times. Such 'atavism'
is simply out of step with current economics, mental and
otherwise. Similarly, certain design conduct may, once upon
a time, have been quite well adjusted to an earlier mentality
and its economics; today it is an anachronism, which cannot
pay off in current coin.

Economy of nervous exertion, a basic principle underlying
neuromental phenomena, has consequences in form and de-
sign which are manifold and varied. They are historically
stratified and depend on the level of mental economics the
designer and his public have reached.

As minds march on, one form of economy follows another
and each affects design activity and development at their
very roots.

The primary economy of simplicity may stand near the
beginning; a simple child's story built on symmetry and
rhythmical repetition may have that sort of economy to
commend its acceptance. On the other hand, a story, a song,
a form, a color combination may be very complicated and
devious and still highly acceptable. Tribal life is full of in-
volved behavior and those formalisms which save and store
up energy once they are stereotyped. With the exception of
a few rebels man has always clung to his established econ-

omy. Rites and customs may be hotly defended against all newcomers in the field because they yield the desired nervous economy, although in quite another way than through intrinsic simplicity. Thus there exists an economy of routine that is well contrasted with the economy of simplicity. And there is also the fascinating economy of the magic short cut.

Yet when magic degenerates from a dynamic instrumentality into static, humdrum ornamentalism, or when Platonic simplicities, symmetries, 'axialities,' and rhythmical repetitions have been frozen in rigor mortis and have found eternal rest in colonnaded post offices to give chilly aid and comfort to the ever-orderly mind of the Procurement Division, survival has not really been secured but rather impaired. There is, indeed, a pleasurable, an almost libidinous accent to moments when strain is relieved and inner mental pressure depleted, *but such depletion must not gain infinite permanence.*

Simple regularity can be granted general honor among mental economy measures. It seems to have operated on a subhuman level and Gestalt psychologists have made it their point that birds and bees appreciate certain organized patterns. This animal preference stamps such features perhaps basic, but it should not purport to make them supreme on a human level of mental operation. In a way, it may even be subhuman and atavistic to let simply organized shapes govern our choice. At any rate, we must strive cautiously to appraise the physiological function of consuming, absorbing, assimilating *forms,* be they simple, organized entities, habituated complexities, magic remnants, or novel and puzzling technogen necessities—requirements of the industrialized age in which we find ourselves.

ARCHITECTURE IS ILLUMINATED NOT ONLY BY LIGHT but by sound as well; in fact it is brought into relief for us THROUGH ALL OUR SENSES.

20

Traditionally architecture has been conceived in visual terms, or in terms of visually perceptible 'Gestalt.' The human eye is much more developed and more sharply focused than the ear. Its influence on consciousness seems stronger than that of all our other sense receptors. Some of these, e.g. the sense of smell, are perhaps not only arrested on a lower level, but definitely regressed and atrophied when compared with the corresponding equipment of certain animals.

Yet we must guard against the notion that only those sense perceptions that are easily and consciously registered really count. One might say that environmental influences are only rarely granted entry to consciousness, but may become particularly pernicious when consciousness is lacking to correct or counteract them. We should therefore be interested in all the non-visual aspects of architectural environment and design even if they are not customarily in the foreground of our awareness.

The acoustics of a theater or assembly hall have become a design factor of the first order, changing shape and surface treatment in a manner that would never have been stimu-

lated through considerations of vision alone. In many cases, the intentions of what may be called the Platonic or Euclidean architect are nullified by the acoustical expert, to whom parallel or circular walls, domes, and other customary formal elements are offensive.

The classical architect, it must also be remembered, does not use the terms 'geometrical' or 'mathematical' in their modern sense, which has been complicated and revolutionized by recent generations of scientists. He may idolize mathematics but to him it means always elementary, simple, easily memorized relationships. In his eyes, even a fraction that would divide out into several decimals does not belong to comfortable mathematics. When it comes to curves, 'free shapes' have been a recent daring introduction; the Euclidean architect loved a circle or possibly an ellipse. Acoustics, at any rate, do not happen to fit into this straitjacket of simplified visual selectivity. In considering architecture as an acoustical phenomenon, however, we have more in mind than the mere audibility of a speaker on the platform or of a singer on the opera stage. Acoustics affect much more deeply the enjoyment of architecture itself and the perception of space within an enclosure, or of voids between buildings.

When we walk throuh the nave of a medieval cathedral, the impact of our steps on the stone pavement, or the reverberation of a little cough, makes possible, or even becomes in itself, a vital, essential impression of the architectural space. Such sounds acoustically elucidate also the material of their enclosure. Stone walls may echo, but velvet drapes scarcely reverberate and signal nothing to the ear. Like light, sound will bring into bright relief architectural bodies and spaces and leave portions of them in shade.

As an auditory performance, the ritual during Mass actually reveals the interior of the church to us. It is an error to think of the cathedral as only containing or housing candles, singing people, a sounding organ. The choral modulations, the booming of the basses, the diminishing pianissimos *illuminate the grand interior acoustically* just as the candles do visually. Without the light, conditioned by the stained-

glass windows, the interior would be simply nonexistent in its particular visual appeal. Similarly a design pattern that modifies sounds makes possible a great part of our architectural perception.

Because of acoustics, the error of conceiving architecture in abstract forms and of allowing its 'instrumentation' in concrete materials to be an afterthought becomes impossible.

A motion-picture set of a cathedral, constructed for mere optical consumption by the camera, is devoid of the architectural impressiveness for all our senses that a real cathedral holds. It is photographically, visually, faithful to the original and an object of pride for the stage designer. But because it is constructed in papier mâché and studio board over a flimsy wooden frame, its dull acoustical properties of reverberation are so foreign to those of the original that they place the copy on an entirely different plane of experience. Fine visual sets may be extremely untrue acoustically. In the sound picture, the acoustics of a real cathedral must be added. They are produced separately in an electrically equipped sound chamber and then dubbed in. By similar means, we can now enjoy the acoustics of Carnegie Hall in our 12′ x 12′ bedroom by turning on a radio or record player.

Some of the newly developed electrical instruments, such as the stringed instruments of Benioff, which have no resounding body of their own, may one day be made independent of the room's acoustics. This will permit us to enjoy music that has a brilliance entirely foreign to the space and enclosure in which we listen to it. It will even be possible to adjust these illusionary acoustics while the piece is being performed. In other words, it is then not merely amplification of the instrumental sound which takes place. The audible dimensions of the room may change from a small enclosure to gigantic space when the musician merely steps on a pedal while playing a given phrase. A performance of the last movement of Beethoven's Ninth Symphony is one of many striking examples of the fact that the acoustics of a room, kept constant, are an impediment to musical enjoyment. When the great chorus begins, thundering above the

still-restricted orchestra of the early nineteenth century, one feels that the ceiling ought to be raised and the walls made to recede. The future conductor may be able to effect just that. In an acoustical sense, he may actually inflate and collapse the room about his audience. This is an acoustical space mirage. It is space, visually unreal, and a merely ear-imagined architecture brought home to us by electronics.

There are deceptive, illusionary methods that a designer may employ, and certainly not only when he invests his effort in stage sets. It should be emphasized that 'illusion' is one of the designer's common instrumentalities, and that he would do well to familiarize himself with some of the serious research in this field. Possibly he could even exert a constructive influence on such research.

The well-known size-weight illusion is what Helmholtz called an unconscious inference. It is based on experiences in which several senses originally contributed to perceiving one piece of co-ordinated information. Later, only one sense may elicit the same idea or cortical response, although this may not correspond to the total facts in the case. Thus the designer can, for instance, make a structural member seem strong or heavy by giving it large apparent dimensions, although it may be composed merely of inflated surfaces around a hollow.

Experiments systematically conducted with children to test capacity for illusion have yielded well-tabulated results. For instance, a ball that never left the hand of the experimenter was 'seen' in a counted number of cases, as though it had been thrown and were traveling, and a perception initiated by a movement of the arm was often seemingly continued for the ball, while in reality that motion had not been transmitted.

Often the designer operates unconsciously, employing rudimentary illusions and suggestive devices, perhaps without even knowing it. A straight line is so strongly directional that it takes on a seeming dynamism. To the observer a line or a slender rod that runs up to a plane crossing its direction

does not really 'die out' there but gives the impression of piercing the plane. The onlooker perceives the line *as if* it were actually penetrating that surface and passing through it into some conjectural space beyond. With skill, this can be used and is being used to counteract our feeling of the space-limiting character of a wall. It is a device of designing that can make a wall into a mere screen by producing something like a subconscious supposition of void space behind a thin surface. Such a design can be called suggestive; it is suggestive of things that are not really sensed.

Since Binet's suggestibility tests dealing with false estimates of comparative lengths of lines, many observations have been made on similar subjects. Certainly, experimentation on illusive and suggestive devices in design, visual or not, would yield much useful information.

Architecture is normally a matter of composite perceptions which the designer should understand in their linkage. While he has only recently gained rational command of the acoustical means, calculated visual tricks and illusions have been his stock in trade since antiquity. They may be seen in Pompeian interiors and throughout the Italian Renaissance; Bramante's Santa Maria delle Grazie is a famous example. The false perspectives, the only optically raised domes, the artfully deepened niches and vistas of the Baroque may now perhaps find their counterpart in ingeniously widened and gratifying acoustical perspectives.

Whether we are conscious of it or not, the constructed environment either appeals to us or harms us also as a complex auditory phenomenon and is often effective even in its tiniest reverberations.

The excitement of auditory stimuli produced by the life in our constructed shell is a factor that the classical architect ignored for the glorification of a visual and static abstraction only. The designer of a physiologically conceived, constructed environment can no longer ignore it. Architecture to him is a stage for the dynamics that affect the ear as sound reverberations, the eye as light reflected, and the other senses in many forms.

The sensory phenomena which the architect anticipates in a building makes him select certain dimensions, forms, and materials to serve the consumer's comfort. Ill assembled, these sensory stimuli may also make us suffer or make us feel dull, listless, irritated.

Anyone who travels in Japan notices that Japanese speech and behavior are less noisy, more subdued than the corresponding occidental expressions. Japanese children are trained early to delicacy of sound and touch. In a Japanese interior of oiled paper and thin silk, stretched over those incredibly slender frames of cryptomeria wood, an American child would seem noisy and destructive.

Japanese privacy depends on hushed voices in rooms which can be closed off temporarily by sliding screens—rooms not acoustically insulated. Secret conversations are better held visually, in writing, as in a play by Nakamura: a few quickly brushed characters are in a mysterious way shown for a moment to a conspirator and then silently thrown into the *hiabashi*, the charcoal brazier. The Japanese home with its acoustical and other specific properties is the nucleus of a broad culture, with modes of living intricately dependent on architecture and its many sensory realities. Other structures, such as the store, the tea house, the Japanese restaurant with its *chambres particulières*, opening broadly onto lightly constructed porches and subtly landscaped yards, closely imitate domestic interiors and repeat their acoustical and other characteristics.

By way of adaptation, all Japanese living spaces are small compared with ours, proportioned to the small stature of the people. The subtlety and precision in dress, of feminine make-up, building finishes, and joinery, the daintiness of *kakemonos* and roll pictures, of cherry twigs and chrysanthemums tenderly arranged in equally tender pottery of manifold refined glazing detail—all this appears as concession, to even myopic eyes, at any rate for close-range visual enjoyment. To see a few Japanese sitting in a small, almost empty 10- or 12-mat room patiently watching the dance of *maikos*, young geisha novices in flowerlike costumes, is to realize that

they used to belong to a people of especially blessed eyes whose surroundings had been liberated by plan from visual clutter and interference.

Still, all this has its definite and significant acoustical correlate. Acoustics, too, are intimately built into this civilization. The subdued quavering, twittering sounds of stringed instruments, such as the *shamisen* and the *goto*, the vocalization of Japanese songs and lyrics, are similarly designed to carry no distance at all. Their *vibrato*, where it occurs, means something entirely different from that of the Italian *primo tenoro*. He, by straining his vocal cords, tried to reach customers in the fourth gallery of the Old Teatro dal Verme or La Scala. He actually moves stones as Orpheus did through his music, because his singing fits a structure of resounding masonry, to which the tradition of *bel canto* is coupled. The Japanese house has no such resounding quality. Its shell consists of paper membranes in dull tension. The floors are covered with thick straw mats on which the dancers' feet, in padded cotton socks, produce no audible impact. And no such impact or acoustical stimulus is intended. The dance is almost stationary, almost silent. The movements are flowing, not staccato. They do not call for rhythmical noise.

In a Japanese house, a fandango garnished with Spanish castanets would be a destructive turmoil and at the same time a frustrated performance acoustically crippled. Equally incomprehensible and puzzling would be a Japanese lyrical poem of a few short, whispery lines, recited to an American after-dinner party in a heavy fireproof apartment building with glass windows vibrating from Park Avenue traffic.

Future instruction in environmental design and architectural training will instill detailed awareness of the basic physiological actuality that the human nervous apparatus is continuously stimulated through a large number of sense receptors. Mutual interferences can cause trouble or all may be planned to serve and to function through a wholesome integration of design impacts, still largely unknown, and for much subtle pleasantness, too often ignored.

144

THE DESIGNED ENVIRONMENT CAN AND DOES
PATTERN FOR US MANY KINDS OF SENSATIONS
which derive from air currents, heat losses,
aromatic exhalations, textures, resiliences, and
from the all-pervading pull of gravity.

21

There has been an almost customary underevaluation of architectural design by a broad public. This may often be traced to the simple physiological fact that a great many individuals are visually much less endowed and developed than we are inclined to assume. An architectural environment, discussed, as usual, merely on visual grounds and treated accordingly, will, of necessity, leave these individuals indifferent or only mildly interested.

Other sensory aspects should, therefore, be further explored. The interior of the little red schoolhouse, with its cast-iron stove glowing in an unventilated room, and the classrooms of its great successor, the monumental brick box of a metropolitan school district, with its wood-trimmed blackboards and oiled or waxed floors, all had a peculiar sour smell. Generations of boys and girls have been thoroughly familiar with the schoolroom odor which attaches itself to that wooden chalk rail with a wet sponge on it, the lockers loaded with rain-drenched overcoats, and the lunch kit scented by cheese sandwiches.

Books read near high-school library shelving retain olfac-

tory accents which remain emotionally associated with these early experiences in literature. As a matter of fact, odors of school environment, as of many others, are most intimately held in memory and more quickly recognized again in later years than are visual impressions of the architecture involved.

The hygroscopic cut stone of medieval cathedral masonry has its peculiar gaseous exhalations, supported by those of moist microbiotic life, which make certain ancient interiors recognizable to a blindfolded person, more so than the flavor that distinguishes one popular cigarette from another, as advertised in a similar test.

Certain odors do not occur in well-irradiated rooms, but are indigenous to dark basements. Porous materials, such as softwood and stone, flavor interiors quite differently from those where condensations, due to temperature drops, never penetrate but merely flow off impervious surfaces, such as marbles and metals and the ancient mosaics in the tomb of Empress Galla Placidia.

The smell of a Victorian wood-paneled study might be sensorially more distinctive to us than its stylistic profiles, cornices, and moldings; and it will be different for highly polished, lacquered walnut than for waxed oak or untreated redwood or cedar.

The livability of a parlor might be more strongly affected by the smells of upholstery, carpet, and draperies than by the visual ornament of imitation Chippendale or Sheraton. The rubber flooring, the enamel paints, spar varnishes, tung oil, the banana smell of certain synthetic lacquers, even varied sorts of dust, originating locally but not very consciously recorded, yield an inexhaustible array of odorous impressions to be reckoned with in design.

Air polluted by a little cigarette smoke smells differently from that of a guard house in which tobacco pipes are kept going, and even slight traces of body perspiration (far below the saturation standards of old-fashioned barracks and dormitories) give well-marked, though often subconscious, accents to any ill-vented interior. Slums, overlooked or toler-

ated by many indifferent eyes, become repulsive to many noses—no slum is 'picturesque' to the nose. It is perhaps characteristic of the contempt in which this sense is unjustly held that even to discuss smells passes as ill-bred.

Future design of living environment may operate effectively with positive olfactory ingredients and not merely guard against the presence of the most obviously obnoxious ones.

Earlier periods used antidotes of scent in their interiors and burned incense to overpower the attack on the nose of tallow candles and chamber toilets. It remains open to question whether future designers will content themselves simply to produce nose neutrality and abstract odorlessness, if this can be achieved at all. Perhaps they will learn of the pertinent physiological effects due to the integral exhalations of their structural and finishing materials which form the enclosures of human life. They will not just add a nip or sprinkling of olfactorial refreshment from their ozonizer; and we should hardly anticipate the use of mere additive, 'decorative' smells.

Yet should hermetical air-conditioning prevail, we know that there will be no such auxiliary as an uncontrolled breeze from the garden. It will no longer help out against the monotony of the interior with an accidental precious whiff of nature's perfume, varied as the seasons unroll, thanks to the blooming lilac bush, the night jasmine, or the pittosporum in the neighbor's garden. Incidentally, it does remain a significant precedent for constructed environment that gardens at least have been sensitively designed on an olfactorial basis too, not only on visual principles.

Dogs have comparatively dull eyesight. But if they could speak up, they could tell a nose-inspired story of their millennia of domestication. After having borne with us in caves, in elevated, open, windy, neolithic lake dwellings, in the tightly walled cities of the age of the Crusades, in farm houses adjoining cow barns, and in apartments with dumbwaiters and laundry chutes, a history of architecture flavored

by smells could be revealed, a history that would be strikingly different from the one pictured in our visually conceived textbooks.

Intimately related to our reception of odors is our sense of the moisture content of the air enclosed by architectural space and of the movement of this air. The latter caters to cutaneous receptors which record lower-than-body temperature and are activated when evaporation of the moisture film on the skin is accelerated. The degree of this acceleration is sensitively perceived. It conveys to us a consciousness of the speed and intensity of air movement about us.

Air currents are forced into certain perceivable patterns by the shape of the enclosure and the locations of air vents piercing it. One can even see this pattern in a Gothic cathedral or a domed Renaissance church by watching those endlessly self-repeating forms of drifting incense smoke which quiver and change characteristically when the main entrance, or the door to the crypt, or again the door to the *sagrestia* or *battisterio*, is opened.

Every constructed interior, every architectural layout down to a simple cross-ventilated living room, is destined, and may well be designed, to have its specific pattern of air currents, which is normally perceived by our senses of temperature and of touch.

Our physiological, our nervous equipment permits us to notice the vital difference in near-by wall materials. Some of them absorb the bodily warmth; some are mirrors which seem to reflect our own heat rays and 'caloric image.' Some materials are heat gatherers, such as wood or celotex or cork, and these store warmth near our shoulders or our back or our feet; some speedily conduct it away from us and thus are cool—not only to the immediate touch but even from a certain distance.

A designer who places a built-in settee so that there is a concrete wall on one side, a glass surface on the other, and a wooden wainscot to the rear of the sitter *has established*

a definite pattern of heat loss.[1] And we must remember that various parts of our body have a varied sensitivity to heat losses; the soles of our feet and the back, or dorsal region, are more sensitive than, for example, our chest and head. The head again takes irradiation of heat quite differently from, say, the palm of our hand. Anyone who basks in the sun on the beach may painfully learn that much.

One can, from the very start, design a room, its orientation and material selection, in such a manner that temperature losses, irradiation, and air currents are salient parts of the scheme. In this manner one can achieve a differentiation richer and more pleasant than when a design is concerned merely with visual perception and ignores all other potential sensory aims.

Tactile stimuli have always been recognized as important factors in producing responses to architectural environment. Rough masonry on the front of a fireplace, crude-surfaced, porous softwood, homespun upholstery goods, coarsely woven rugs and blankets—apart from all associations with rusticity—will yield effects profoundly different from smooth, evenly polished surfaces. Material specifications have been perpetually influenced by such data of only vaguely conscious sensory experience. But detailed experimentation is needed before we shall know how certain tactile stimuli, combined with resiliencies, for example, appeal to our fingertips, to our toes and soles when we walk, to our back when we lean, and so affect our total nervous system.

Here we must not overlook that sitting on an upholstered chair, lying on a springed sofa, stepping on a padded carpet—or, for contrast, on a terrazzo stair—registers certain inner muscular perceptions that are quite different from tactile impressions. Internal strains and stresses are produced by placing our body in a certain position, by the deformation of our muscular cushions at exterior physical contact and

[1] Many years after these lines were first written, the author is very gratified to learn that studies on this subject, at least for classrooms, are under way.

where our body is supported. All such stimuli find significant response. They are first recorded by sense receptors, most numerously distributed throughout our body and varied so that some of them are stimulated by tension, some by compression of the organic fabric. (These senses are called proprioceptors, pressure corpuscles, the 'organs of Golgi.') Incidentally, the image we have of our own body depends largely on such inner and surface pressures.[2]

From infancy, our ego is much concerned with support, always missing the primary comfort of a floating manifold suspension in the uterus. Rigid firmness is evaluated quite differently from stepping, sitting, resting, or moving on supports of marked resilience. The sense of gravity is alerted, together with a large group of inner muscular senses, when we stand or walk on a mattress or springy floor covering.

Yet there may be erroneous beliefs concerning the actual lower threshold of perception in matters of resilience. Hardwood flooring or resinous tile is assumed to be more resilient than cement floors. In this case we may have filed our sense reports incorrectly. It may be proved by measured experiment, and only precise physiological experiments can prove it, that discomfort and fatigue here are caused rather by a variation in body heat lost through our feet than by differentials in resilience, which in these cases are probably far below what we can possibly perceive. It would take more than an elephant to compress and deform a hardwood floor. How could a housewife notice the difference in resiliency from that of cement? Of course, we must not confuse this issue with the possible deflection of joists under the flooring, which in a flimsy building might well give us more concern than pleasure.

It may be that much more pronounced deflections will be tolerated, in fact planned and enjoyed in a homogeneously elastic architecture of the future. At present, while we still proceed precariously to sheath elastic skeletons with crack-

[2] Paul Shilder, *The Image and Appearance of the Human Body.* Kegan Paul, Trench, Trubner, London, 1935.

ing, brittle plaster and cement, noticeable deflections are rather taboo.

In human dwelling places, complex inner stimuli derive from the design of the rooms and the articles in them with which we surround ourselves. The chair, together with the desk, determines our posture; so does the couch on which we read with a light source, either well or inconveniently placed. Or, for example, that same couch may be planned and placed in poor relationship to a magnificent window and make us crane our neck in vain to enjoy the view. The problems of posture relate a vast number of other sensory experiences to vision, which concerns and directs not only our eyes but our whole body.

It is clearly the design of a room and its furniture which call for certain habitual movements and placements of our body. The taking and holding of a posture, the going into any muscular action, in turn establish what is called a kinesthetic pattern, a pattern of successive and simultaneous inner stimuli. Important responses are then elicited by such stimuli, reflexes are touched off, conditioned by a routine usage of furniture, lighting fixtures, and a thousand little items which, in their placement and function, may be variously right or wrong. The responses mentioned are frequently not conscious ones, and in many cases not motor responses directed toward a remedial action. Often these responses are emotional but cumulative, so that lasting depressions or exhilarations may be their effect, and thus the effect of the room in which we spend our time.

The discussed kinesthetic pattern established, inside the body, is indeed in intimate correspondence with the layout and design pattern outside. Architecture, in fact, is just such a pattern, laid down about us to guide continuously the movement and straining of our eyes, necks, arms, and legs. A great deal of relaxation and emotional gratification may come from it or may be prevented by it.

We ought now to touch a little more upon our complex sense of gravity. It is this sense which, for example, makes

151

us prefer a horizontal plane on which to step. Standing and walking on a ramp or incline requires many more trickily balanced innervations than walking on a level floor. Our entire architecture, stratified as it is in level planes, is evidently prejudiced by this circumstance. The physiological determination of architecture by gravity is perhaps more worth while to note than the often glorified external and mechanical triumph over it.

It is well enough known that architects are continually dealing with the phenomenon of gravity and heaviness, and that it has been their venerable job to support lintel beams by means of posts or columns, and arches by means of pillars and buttresses. But apart from these dramatic exhibitions of resistance to the pull of the earth, the forces of gravity are brought home to all of us and to the designer much more intimately. They are continually recorded and minutely felt *within our bodies*, within all the muscles we use in balancing ourselves. We must remember, not only a tight-rope dancer is engaged in a balancing act. Our own far-reaching involvement in problems of posture derives from the salient fact that we almost never react to gravity pull alone. Primarily, of course, we do not want to slump down and are perpetually engaged in supporting our body; yet most of the time we have some additional, some second task which in our consciousness may well appear as the primary one. We wish, for example, to turn our attention to another person in the room or, if we are by ourselves, to a view window, a radio tuner, or another contraption, which we intend to operate. While we lie on a sofa and read a book by the illumination of a wall light we must find and keep a suitable support for our head in relation to the printed page. All this involves simultaneous posturing for a task and against gravity. It is not unusual to sit and try to write notes while holding a telephone receiver. During our entire life on this planet we endeavor to attend to so many things and all the while the earth is exerting its pull. Gravity is incessantly pressing certain of our organs against others as we go into this or that position. These inner pressures, though they are

in the majority not consciously perceived, produce feelings of comfort or discomfort, as the case may be. Furniture design and placement, many interior arrangements and installations of the architect must deal directly and indirectly with this mysterious pull, which endlessly reaches into all our activities, work, recreation, and rest.

Gravitational sensibility, then, deeply affects our appreciation of architectural environment. Pews in which we sit, sofas on which we lounge, tables from which we eat, desks on which we work are either 'comfortable' or distracting and fatiguing to us through a combination of sensations which respond to gravity, though indirectly. We are much more aware that our eyes are concerned with the light of a spectacular sunset over the sea or with a brightly illuminated mural than we are conscious that our many inner muscle senses are minutely reporting on gravity, even while we, reclined in a club chair, intend to relax.

We combine these inner sensations with those of our specific inner-ear organ of gravity and with our visual impressions of the up and down and of oblique perspectives in which we often happen to see our room. Finally, we are ready to pronounce our judgment on the comfort of the chair and its position in relation to the fireplace or the window which may give onto a mountain skyline up high, or a lake shore beneath our feet.

Physiological research on posture may, as pointed out, affect not only the designing of chairs, desks, and tables but also the manifold relative arrangements of space, furniture, and placement of appliances that make it so necessary for us habitually to assume certain postures. Such arrangements may occur in a vast variety of rooms dedicated to relaxation or to specific tasks—be it in the front seats of rushing automobiles or at typewriters which swivel out into supposedly handy positions.

It should again be emphasized that none of the discussed responses occurs truly independent of each other. On the contrary, they are tightly woven together in what is called

stereognosis. We have spoken of incorrectly filed sense reports; but, generally, indeed, the stereognostic cross-filing system of the many co-ordinated senses is a miracle, worth all study.

The wonders of electricity were exhibited at country fairs and dancing froglegs were viewed with amazement long before electric power was generated in giant plants. Pyrotechnics will long have been an entertainment before rocket ships take off to the moon. And so also the physiological wonders of stereognosis are demonstrated as side-shows—and wrongly interpreted by the barker to sightseers who crowd in to visit the 'Mystery House on Confusion Hill.'

The architect who designed the out-of-plumb confusion establishment off the highway for thousands of perplexity seekers had in a way a job differing perhaps only by exaggeration from the job every architect has. There is always an appeal to senses and mind in a strong interaction; an architect entertains the acquired stereognostic adjustment, strengthens it, or slightly disturbs it. In doing so he produces habitual satisfaction or novel thrill, as the case may be. The novelty on Confusion Hill might arouse sweat on the forehead, uneasiness, mild seasickness, but as usual the architect of the place is not even recognized as the troublemaker.

In more normal houses he may be innocent by sheer ignorance of the powers he wields over his victims, but in the Mystery House he turns into a calculating torturer. By plan he throws a monkey wrench into the collaborative working of the senses. The floor, walls, ceiling, although tilted, keep their usual relationship, so that the eyes are deceived and report the situation as normal. But the other up and down senses differ in their report and are here brought disturbingly out of joint with the eye. Gravity, always taken for granted, becomes a surprising phenomenon of almost painful intensity and of a direction which makes it over into something we believe we have never experienced before.

We enter with humorous skepticism the Mystery House on the hillside, on which it and its yard fence stand at a right

angle to the slope. In the patio, water seems to run upward in a slanting gutter, ping-pong balls apparently roll uphill and ignore gravity. Chairs stand on an incline, lamps hang stiffly out of plumb, as if charged with a strange magnetic force. When pushed, they swing with astoundingly wrong amplitudes, like a pendulum gone crazy. Our inner disturbance grows while we sit at a table, from which a strange power seems to pull us away. We feel we could not eat a bite in this place. We look around and notice, in a quiet seemingly ordinary room, how dizziness overcomes us. We rise, and the muscles of thighs, middle-foot, and toes strangely fail us, we totter and tumble against a wall. Fortunately the commercially well-conceived Confusion Establishment carries a liquor license and afterward can serve us a drink to counteract the secondary shock to stomach and viscera.

The whole is a striking example of how deep down the disturbance will reach if we break the co-cordination of visual experience and gravity sense in the inner ear and the many muscle-senses, which help our usual balancing act. This stereognistic co-ordination is slowly acquired from infancy and, through a network of nerve connections, governs glandular secretion, blood circulation, the rhythmic intestinal movements. Reassured feelings are related to this established harmonization of sensory clues, termed stereognosis, and other emotions arise promptly from a disharmony among them.

The compounding of sense impressions produces our generalized consciousness of the environment, be it natural or designed and constructed. Such consciousness remains emotionally tinged throughout and subtly flavored. It would be hard to speak here of pure or impure appeal in the spirit of earlier aesthetics.

Einstein seems closer to our energy-bound space-time of the senses than were classical Euclid and Newton.—'PHYSIOLOGICAL SPACE' HAS IN ITS VERY ORIGIN PRONOUNCED DIRECTION AND RANGES onto which man has later slowly planted his many meanings.

22

If architecture is an affair of many senses, the stage assigned to it, space itself, is in fact also a multisensorial product which begins to evolve for us while we are still in the uterus.

The prenatal experience of shelter, floating in the evenly warm liquid medium of the mother's womb, is a primary factor molding our later reactions to an outer world, and to the architectural compartments that we construct for our later life. That early uterine floating is, however, merely a tactile, a gravitational, a somesthetic experience, that is, one based on general body sensations. It does not yet involve all other senses, and has, for example, nothing to do with the important visual responsiveness which develops only after the eyes are opened at birth. It is with our eyes that we discern dimness and brightness related to narrow enclosure and expanse. Thus, if some of us cherish darkened cave-like interiors, often preserved in occidental dwellings, this cannot stem from the womb. Agoraphobia, the pathologically pronounced fear of open spaces, has a strong visual compo-

nent and so, too, cannot go back to the period of living blind which the embryo passes during gestation. Nor has it descended to us from the earliest anthropological stages where man freely roamed a tepid landscape and seldom sought shelter. To all appearances, it must rather be a product of later conditioning. Perhaps a memory still lingers of the protected and comforting glacial cave in the midst of frightening climatic cataclysm. Whatever it may be, the aversion against seeing a broad expanse uncurbed and space wide open has stood rigidly against many an architectural design of our day.

What the various senses bring in is by a practical lifetime's experience worked into a space concept, studded with diversified meaningful associations. It has also been badly warped and depleted by controversial social conditioning. The sense of gravity, for example, naturally and strongly contributes to our awareness of the *above* and the *below*, of the *upward* and *downward* in space. To the mind trained to follow Euclid, however, this is all a matter of indifference. To him space is nondirectional. For him all directions have equal significance and he grants no preference.

Yet physiologically conceived space in general can have no such neutrality. It has natural 'vector properties,' as a mathematician would say. Without them it could not even come into sensory existence. Stimulative impacts always originate somewhere and from *there* reach our sense receptors. This at once does away with any possibility of directional indifference. Different directions by themselves have or acquire for a living being very different meanings and specific emotional loads. Our nervous apparatus does not register anything that we could call space without these meanings and emotional overtones sounding in. They are by-products and perpetual accompanists of all our space perception.

Up and down, right and left, forward and backward, far and near—these are not geometrical terms. If we really want to fit the architecture of constructed environment to life and

so put it on a physiological basis, we must decisively step beyond and outside the abstractions of Euclidean geometry.

To the great seventeenth-century thinkers such as Newton and Leibniz, space in its own nature was absolute, always self-similar or homogeneous, not involved in any dynamic phenomena. Now, looking back from our current vantage point, we know that instead of saying, 'space in its own nature,' Newton should have said, in his *Principia*: 'Space by current definition or by a convention derived from classical geometry.'

Space had existed naturally in the most intimate experience of living organisms and particularly of man long before all those conceptual crystallizations took place. We may conveniently term space in its own original nature physiological space. It was first nothing of stray speculation, but something very intimate to the daily life of organisms as they moved, grew, and exercised their senses. Physiological space may be traced back even to the primitive experiences of the tiniest viscous cell. The osmotic exchange of gaseous and liquid substances, pressure inside or outside the enclosure of its semi-permeable membrane: these were indeed a cell's *arch experiences in physiologically related space.*

In the more recent developments of mathematical physics there is something like a return from dangerously thinned-out abstract conventions, back to our common organic base. We are closer to this base in declaring time-space inseparable, a fourfold continuum. Strange as such a statement may have sounded at first, it comes really much closer to ordinary physiological life experience than the idea of a separate space and time. This strange idea involved the arbitrary splitting of a manifold that was organically fused and inseparable in our very being.

Einstein's intimate interweaving of a spatial universe that was formerly merely geometrical with the physical universe of gravitational or accelerative fields, and with mass, light, and energy, brings it much closer to the physiological space perceived through our senses. Forces acting upon them in-

trinsically fill the universe. This natural space was recklessly left behind in the impoverishment of Euclidean abstraction and made over into a lonely, empty space. Altogether, that was a rather regrettable divorce if we consider the hapless, loveless offspring of mere formal geometry in architectural practice. These so-called classical structures, left around for us to worry about from Buenos Aires to Bucharest, are often orphans without near relations to life, each suspended in a vacuum, each isolated and aloof in its symmetrical self-centeredness.

To the lay person there may well be some strangeness in contemporary mathematical physics, in 'curved, expanding, and contracting space,' in the 'indeterminacy' or 'uncertainty' of motion, position, velocity. This strangeness comes largely from one circumstance: all those concepts have their concrete stage of action quantitatively *outside of the normal human sensory range.* Planning and designing within sub-molecular spaces is called chemistry and, on a still more elementary plane, nuclear physics. Here new ideas must fit new minimum magnitudes. On the other hand also the investigation of vast magnitudes and velocities on stellar levels, and of a correspondingly sized physical interaction, is, naturally, unfamiliar to the man in the street. All this commonly remains outside the realm of planners and architects as well as of those who use cities and houses on an ordinary macroscopic scale. Investigations far beyond daily routine could not well demonstrate to a general public how essentially near the new scientific space concept has come to our very physiological foundations.

Einstein deals only with operational concepts and the observable to bear them out, but I have admired him in his fascinating conversation and breadth of human interests. He seems much closer to pulsing life than a teacher of cool classical geometry, who deals with speculative, timeless concepts that are independent of matter and energy.

Our living space is the space into which we were born as feeling observers and from which the geometrical abstrac-

tionists and some architects of a bygone or passing day tried to expel us.

When we remember the moon high up in the zenith, and suddenly have it in front of us, skimming the hills of the horizon like a tremendous disk, it seems a different moon. Experience is needed even to identify it as the same. If we look upward in an elevator shaft, the space above us is very different from the space below us, perceived through an open floor grate of the elevator cab or a high landing platform. Climbing the stairs in the observatory on Mount Palomar, we see first the starry sky overhead; then we bend over, look deep downward, and marvel at it in the huge crystal-clear, two-hundred-inch refractor beneath. It makes a most striking, almost terrifying emotional difference to have the sky underfoot.

This difference is based on physiological circumstance and functioning. Our subtle inner perception of body position is called *somesthesis*, and that of muscular efforts to overcome weight in every moving or cantilevered member of our physique, *kinesthesis*. Both play their role when we bend forward or backward—and if we do so in order to look, we promptly combine the visual with these other perceptions. The specific gravity sense housed in the semi-circular canals of our inner ear makes its very important contribution. With all this co-ordinated equipment, we sensitively record, for example, that situation of stooping over the sky which so unexpectedly appears below our eyes. It is a situation frightfully opposed to our common over-all sensory experience. In classical geometry and its space concept, however, gravity, of course, played no role, and the vertical was not distinct from the horizontal. Nothing more removed from life could be conceived than such serene indifference.

A student of environmental design must fully and in practical detail appreciate that ten feet measured vertically is perhaps a sizable dimension when taken as the height of a room. Laterally, as the width of a room, these same ten feet suddenly appear to have another, very much reduced

magnitude. Finally, as a frontal distance—if we stand in a cell with our back to one wall and find ourselves curbed by another oppressive wall a mere ten feet away—it may be still more cramped space. All this is easily tested, but deserves minute quantitative analysis through experimental attention. Research on space perception may unroll problematics of which most people had been only vaguely aware.

Simple physiological requirements have undoubtedly been much sinned against when the design of cities and buildings was considered a mere planimetric job. The neuromental effect of a medieval town clustered around a hill crowned by a romanesque monastery, the bishop's castle, or a spired cathedral is not gaugeable in a *plan* only, and, of course, was never conceived on planimetric terms. Organic space composition transcends such terms by many ups and downs, by impressive heavinesses and soaring lightnesses.

But the mentioned distinct values attached to the vertical and the horizontal directions do not begin to exhaust the treasure of space connotations that spring from physiological grounds. When we perceive *space in front* of us, it is to us something quite different than the *space behind* us. The fact remains that the human species, like its more recent mammalian ancestors, has its eyes, its visual receptors, lodged in the front of the head, not on the sides or in the back of the skull. Nose and ears are less clearly oriented in their function; nevertheless, when stimulated, they make us turn and face the issue. Arms and hands, legs and feet are so jointed that the range of their effectiveness is greatest if we bring our body into a frontal relation to events in space. Our inner senses recording movement and posture tell us whether our body squarely faces an event to gain such effectiveness, be it facing a leaping lion or an approaching lover.

As a matter of course the meaning of 'ahead' and 'behind,' a space conception endowed with 'forward' and 'backward,' permeates our thinking and feeling. All things in front can be controlled or tackled; things behind are out of such control, but are better not left unsettled, lest they remain a source of peril, or at least suspicion. There is nothing merely

metaphorical about this. Perhaps a million years ago it penetrated into primitive reasoning, and it has given emotive color to all the *aiming* and struggling of the species and the individual. The transition from the physiological cause to sociological consequence of accepted meaning is often imperceptible.

The famous self-centered domed rotunda of St. Peter's in Rome was, according to the original conception, a purely geometrical, multiaxial, nondirectional abstraction. Yet nature slipped in again, against the wish of no lesser creators than Bramante and Michelangelo, who had planned here with ideological static purity. The Roman proverb, *natura semper recurret*, held true for the grand building of Rome. Two subsequent generations of architects, such as Maderna and Bernini, bowed to nature and labored to revive dynamic direction in St. Peter's design. A center of Christendom had proved a mere figure of speech and something of an unacceptable abstraction, as a practical and spiritual facility. The Christians of the world could not well close in from all sides and form a ring about the building. Actually pilgrims had to approach it, and through it, its tabernacle. A processional, a gradual forward movement, a *forward-facing toward the holy*, is an immortal part of all naturally founded ritual. In the end an impressively approachable altar in the background of the remodeled church interior, rather than a geometrical center, was powerfully played up to intensify this human desire *to face*. The nave was elongated forward at a later date; an 'afterthought façade' and the colonnaded foreground plaza were added to prepare for approach; everything was done to accomplish direction and so answer an organic need, a dictation of nature.

In the process, the all-around visibility of the huge dome was sacrificed, and it is now dwarfed to a mere background feature. For hundreds of years, learned aestheticists who appreciated the superb centric geometricity of the original design have regretted the changes. But physiologists may well shrug their shoulders and state that *front-back* is a biological tradition of long and powerful standing, with eye sockets

moved forward and subtle brain functions influenced by this profound fact. Even a Titan of the powers of a Michelangelo will have to operate within biological necessities, or else the chance for survival of his work will be impaired, will dwindle under the pressure of basic counterforces, stronger than the most potent human decision. Thus a symmetrical center of the world has to remain precarious theory, an idea strange to concrete feeling. The world, at least as we view and sense it, can have no hub unless it is the little ego itself. Wherever the Deity may be conceived to dwell, that ego, by its nature, would have to face it, *prostrate* itself *before* the supreme, use an actual and animated body in adoration, *bend* the head *down* in humility or *raise* eyes and hands *upward* in hope. The ritual will always conform with the tenets of physiological space, with its strong directional accents. Building design must follow suit.

If we walk along a precipice or drive a car over a road zig-zagging up a mountainside we notice a very marked difference when the steep slope is to our left and when it is to our right. In fact, the grip, strength, skill, and operational precision of our right hand is different from that of our left. Our entire nervous function seems to depend on whether we are right-handed or left-handed, and the normalcy of right-handedness has many obvious social derivatives. The officer used to carry his sword at his left for good reasons. The tools of the cobbler, the draftsman, the tailor, the window washer, the chimney sweep, are placed about these people often in a conventional and characteristic way, as are the forks, spoons, and knives of the eater at the dining table. These arrangements, originating from the normal functioning of human bodies, bluntly disparage symmetry to which the paper-planning architect so long allowed himself to be enslaved. But in fact, he even cherished it as his perpetual recipe. He would place buildings for government departments, one here, one there, symmetrical to the mall, as neatly as he would dispose the entrances to a post office, one

here, one there, no matter from which direction pedestrians were expected to come or where car-parking areas could be provided. Fortunately, he was not given power to design a motor car with the steering wheel neatly in the center of the front seat.

Altogether we are not simply symmetrically bilateral, but rather constitutionally asymmetrical. Important inner organs—say, the heart—have grown lopsidedly in our body. Even the two halves of our supposedly symmetrical face are anything but fully corresponding at birth. By later nervous and muscular function of facial expressive motility, they develop with advancing age to be more and more asymmetrical. Students of personality and expression have prepared surprising photo mountings that illustrate this point. A face is first frontally photographed and printed in the normal way. A second print is cut along the center line of the face, and then the right half is removed and substituted by the left half, which has been printed from the reversed negative. The same process is followed to produce a synthetic face from two right halves. Thus two complete faces are artfully obtained from either portion of the photograph. These faces, as now composed, are far from resembling each other and do not seem to show the same person at all, as first photographed and presented naturally. We hardly can recognize ourselves in these purely symmetrical adaptations.

Astounding at first, all this only proves again the fact, well known to an attentive observer, that we are in form and function anything but close to physiological symmetry in a strict geometrical sense. And yet, endless exhibits of symmetrical beauty and geometrical simplification—from courthouses and railroad stations to footwear—testify how designers have concentrated on this sort of abstraction and how little concerned they were with vital reality. Their products might fill a strange museum of physiological abortions and miscarriages. Nevertheless, the fact that a human foot has an array of unequal toes, of which the biggest one appears on the inner side and the others taper off to the outer

side, prevailed and Euclidean shoes of symmetry could not last. Yet they have pinched many a foot.[1]

If we position a writing desk not in the center of a room but in such a manner that the major space remains in front of it and can be seen by the person seated at the desk, or if, on the other hand, we place this piece of furniture in a way that it faces a wall with a good deal of space back of it, which thus is not visible, we have obviously developed two situations quite distinct in physiological meaning. If we place the desk with its right edge to the window, we interfere with the physiological fact of right-handedness and produce eyestrain through an irritating shadow cast by the writing hand. In other words, physiological factors or considerations have little to do with geometrical arrangement of room and furniture. Much of the time they are contradictory to it. But these elementary examples prove the importance of permeating environmental design with the use of tested data of organic significance.

A physiological concept of space, then, is needed to position the various physical objects which we require and for which we make allowances. In a bedroom, for example, the first objective may be breathing air which is replenished through well-placed window openings and passes through the interior at will. Further, there are various items we desire to have immediately within arm's reach. Other necessary things must also be readily accessible, but for some we may well allow two or three steps. Our breathing lungs, our stepping legs, our reaching arms are physiological scales and furnish modules of space.

All considerations of *spacing* derive, of course, from the basic fact that no two solids can simultaneously exist overlapping in the same space. They have to be placed outside of each other and outside of the space we allot ourselves for

[1] These remarks about shoes were written a dozen years ago and were inspired much earlier by Adolf Loos. More recently, Bernard Rudofsky (*Are Clothes Modern*, 1947) has, with humor, treated the strait-jacket of symmetry and clothing as applied to the human figure.

moving about and for using all the equipment. Any poor arrangement in this respect may become a perpetual nervous irritant in the routine of our daily life, an irritant quite similar to a bad traffic layout in a neighborhood or a community. Rush hours, jams, and parking problems loom also in a family bathroom.

But this tactile side-by-side problem is by no means the only one. Beyond and above the budgeting of space for objects and for our own bodies, there is the important aspect of pure visual space. When we open our eyes in the morning to start the day or when we return home in the evening, fatigued and desirous of relaxation, our home or bedroom might be the stage for visual conflict, friction, and irritation. No doubt the constructed environment as we actually have it is generally full of such visual collision, of turmoil to the eye, and of neglected optical litter. Nervously wholesome surroundings, spaces in which nervous balance can be found and organic life can thus be served and preserved, undoubtedly have their own laws, tuned to a common human physiology. There is that stupendous whole of a constructed environment, which, like fate, envelops civilized life. It must not be allowed to conflict seriously with those natural laws.

Physiological space must prevail in the end. It must be helped to prevail over any other arbitrary notion on space. It may have to overrule and rectify all these notions and sociological concepts of space, to which the individual humbly, often amazingly, has submitted for many generations. Sociological space after all is only what man as a social being with all his cerebral teamwork of distillings and embroiderings has derived from basic physiological space and what group life has superimposed upon it. The base must remain to bear the superstructure.

Parceling fairly level land was an early part played on this stage of the sociological space-drama. Out of it, and sprouting from the land surveyor's descriptive practice, grew the entire subsequent tragedy of Euclidean geometry inadvertently turned into creative design. We have seen it, in the

grandeur of its abstraction, often badly emasculate physiological space, even disorganize or, we should say, de-organize it. When direction, organic distance, height, depth, up and down, right and left, in front and behind were gone and forgotten, space had become denatured, amorphous.

It may now be seen, however, that this sharply consistent geometrical abstraction was only one of the multiform developments of sociological space. Many other, less logical space concepts and connotations, variegated and symbolic, conflicted with it. Many were spun from the basic physiologic fiber stretched along through the ages. Also these often confused strands tended to tie down and hamstring design until it could barely move.

There is influential meaning to the fact that the Victorian hostess sat at the table often in the only armchair, the guests on ordinary chairs *one inch lower*, while the informal California hostess in the current living room often cuddles on the carpet beside the easy chair of the guest of honor. Social space concepts may be controversial but they are of great effectiveness in environmental make-up.

Seeing a person from above is, of course, different from looking up at him. The deep curtsy or genuflection corresponded to the high baldachined throne seat or the tall tiara or crown on the prince's head. As Adolf Loos used to tell us students, everything about the venerable palace had to be super-elevated—the ceilings, the height dimensions of windows and of doors with looming *supra-porte* decorations over their tops.

The sky-is-the-limit sentiment has expressed the splendor of kingly courts as well as the power of realty-finance combines which gloried in the verticalism of skyscrapers with empire in their names as well as in the blood of their ambition. The verbal convention of narrating the histories of empires in vertical terms of rise and fall is anything but accidental.

To gain height against the eternal pull of gravity is the supreme triumph of the living; only the dead must lie level.

Their flatness is the prototype of all forced and final relaxation. They have clearly resigned all vertical aspirations. In pure classical geometry, however, common emotions which the designer evokes with steep ascents or staggering precipitousness do not count.

'Distance to be conquered' is another one of life-like admixtures which will easily adulterate a 'pure' and static space concept. As far as this concept is geometrical, there exists nothing like the idea of accessibility or of a range of control. Still, our different senses and the reach and power of our arms and legs have distinctly such ranges. Indeed, the ranges of possible control surround each individual in concentric rings. The closer ones are, of course, more easily negotiated than the farther ones. Starting from the near-by inner ring and proceeding outward through the middle reaches into the blue distance of the far and last horizon, conventionalized connotations have settled and sedimented onto these zones of distance. All distance is naturally reckoned from the sense-equipped ego in the center. In time and through civilization this entire centric space system seems to become barnacled with symbolism. Its 'sedimental pressure,' we could say, molds quite a bit the social being and its designs.

Physiological space is emotionally egotistic. Three steps taken toward us are quite different from three steps away from us, and it must not necessarily be real movement which yields this effect; it may be merely potential. When physicists debate *expanding space* versus *contracting space*, lay persons feel emotionally touched by the very words, puzzling as they may be.

Three steps almost within arm's reach again have a different significance than the same distance a mile away. There is a mental perspective of space values involved as well as a mere visual foreshortening. And, sociologically, nearness, if undesired, connotes oppression, perhaps danger, or infringement on privacy. However, if a king or superior personage chooses to step near an ordinary mortal, it means honor and flattering familiarity. When the Pope ends an

informal audience, he withdraws from intimacy a step to give his blessing. There is an accretion of rites concerned with spatial action and layout.

Space enjoyment and allotment are linked with a wealth of multiple sense reports. At low winter temperatures, we have learned to value the smallness of a room's air volume which needs only a reasonable caloric quantity to give us the pleasantness of warmth. This smallness of quarters, restricted interior distances, together with low ceilings, thus generally receive a sociological accent of coziness and economy. In contrast thereto, the tall and wide room is, as we have seen, associated with an upper societal stratum, characterized by economic independence, cool and guarded distance, and also by correspondingly measured patterns in gait and gesticulation. How differences in room size and height are appraised by the ear shall not be forgotten. If, in consequence, the voice has to be raised or can be lowered, this all has its established significance in human relations from intimacy to formality.

Again sociologically evaluated, and so in the world of design, space also has its distinctly *inward sequences* toward more and more privacy, starting from the outer entry to social living quarters, then to master suite, and finally to the master bath, which may be the most withdrawn room. Derived from the original organic fact of facing, there are within space *forward sequences* of honor ritual, of dignity, of progress, of interest in climax. We find such sequences when we proceed through the sphinx alleys, between the pylons, pass the outer and inner courts of an Egyptian temple, or wander forward under the long fugue of high floating groined vaults toward the altar triptych of a Gothic church, finally to reach the secluded seats of the respected clerical chapter, well removed from common laity. Spaces are sociologically graded by a commonly understood and accepted symbolism quite similar to that of martial parades, pageants, or religious processions, which in turn will often move through such spaces.

For periods the organic essence of space may have been denatured, diluted, and adulterated by conventional bias. In the light of a physiological understanding, space will be redeemed and recognized as a living experience instead of a pale abstraction to be filled with arbitrariness, be it novel fashion or the accretion of ages.

DESIGN AS AN AID TO SURVIVAL must always
have an intimate kinship to the life processes
it SERVES WITHIN TIME.

23

Space is the stage on which design per-
forms. But every performance is also contained in time and
its results extend within it. Design must serve physiological
and social processes. All its activity must be seen as the
human way of furthering and continuing life, the life of our
species.

If we operate with such a broad concept as survival, we
naturally need to understand the things that aid or threaten
it. It is a fundamental consideration underlying all specific
problems and concerning the organism in all its parts. The
great Verworn has stated that if physiology attempted an
explanation of vital processes, it would in the end have to
be in terms of cell physiology.[1]

[1] To take a phenomenon, considered truly elemental, basic, and gen-
eral, the normal and the varying concentration of hydrogen-ion in living
protoplasms has, until recently at least, seemed to many the cause for
an avalanche of consequences: 'Biologists of every school of thought,'
to quote Heilbrunn, 'have postulated hydrogen-ion changes to account
for practically all types of phenomena. Thus pathologists have thought
that death and certain types of diseases are due to an overactivity of
the cells; embryologists have claimed that fertilization and cleavage are
due to a change in the pH; human physiologists have, at one time or
another, insisted that the contraction of muscles is due to acidity of the
muscle cells, or that the stimulus for respiration is a change in the

If aid and detriment to survival are to serve us as the truly dependable criteria, as scale and measure for design values and for judgments on the fitness of this or that environmental detail, there is no other way but first to study what is called general physiology, and the factors that may be intrinsically involved in survival will become increasingly clear.

To be sure, various terms of survival or connotations of the concept, such as adequacy of circulation, resistance to fatigue and to infection, and capacity for recovery and regeneration are still rather sketchy. It is difficult at this time to stipulate which of the connotations is decisive. If, for example, the idea of *unstunted growth* is considered, the definition of it as 'a gradual increase of a living organism' does not suffice, because it may seem to put the accumulation of fat into the class of growth. Growth means a surplus of anabolism, of upbuilding. Yet the catabolic processes of consuming matter produce a display of energy also very characteristic of a vigorously growing specimen. In certain organisms—for example, in reptiles and fish—growth has no definite limits of space and time; it is in itself a controversial concept. Nevertheless, we should not doubt, for example, that any interference with the production of those hormones which accelerate the healthy build-up of an organism into the state of maturity would certainly be a clear-cut threat to the survival of the race.

In all circumstances, consideration of survival involves a time perspective. And characteristic of any design for living is its fundamental *temporal involvement*. Design is always meant to favor and preserve life processes and normally cannot be rigid or must not be conceived to fit static situations.

To look at time in terms of a wrist watch is basing it on a man-made mechanism. Time may also be expressed and

hydrogen-ion concentration of certain brain cells; and, to continue but not complete the list, botanists have argued that the tropism of plants is due to difference in pH.' (Heilbrunn, *General Physiology*, 1938, p. 54.) Recently the recognition of certain action of phosphate carbon protein 'buffers' has complicated some of these interpretations.

measured *naturally* by atomic decay, such as radio-activity or the million-year rock erosion due to the steady action of water. These processes can be described as extra-organic. Growing, aging, fatiguing, and recovering, however, are the physiological clocks by which we actually gauge time and by which it is brought home to us. By our own inner evidence, this concept of time is truly inseparable from life in all its phases and, therefore, from a design for life which we can grasp emotionally.

It has already been pointed out as unfortunate that a formal, abstract geometry, divorced from physiological space, has long dominated the minds and activities of designers. Now we must emphasize the precarious timelessness of classical geometry. Physiological time and geometry are strangers. But a *time-foreign* design appears to by-pass life or cripple it in its most important dimension.

One of the fundamental concepts with which designers operate is proportion. Proportion seems independent of time and also of absolute size. A large or a small design may be similarly well or badly done because the same proportions occur in both. *Similarity* is here spoken of as a term that has deeply penetrated our thinking. Geometry held a monopoly on its definition. Originally, as every school child knows, similarity was interpreted or abstractedly explained by Euclid in relation to triangles. Triangles that can be brought into a position with their sides parallel to each other and with corresponding angles of equal size are termed 'similar.' This is a static and timeless way of looking at things. It is a view eternal and at rest like the pyramids of Egypt which, also are similar to each other, large or small.

What do similarities and differences amount to in the world of the living, big and small?

A huge elephant and a little mouse are grouped together as being similar, less in formal looks than in important life functions—say, in suckling their young. With this operational feature in mind, they are designated as mammals. But we could, for the purpose of strengthening our point, even

assume that their formal similarity and parallelism are much greater than they happen to be and that the elephant looks precisely like a mouse seen through a magnifying glass. Even in this case, the physiological similarity between the two, the big and the small, would be far from full or true; there would remain a strange but vital difference on which we must dwell if we are interested in life's function.

The ratio of surface to volume in the little mouse is very different from the corresponding ratio of the elephant. This means that the heat production in the mouse has to be much more lively, granted an environment of equal temperature and conductivity. In turn, the high rate of heat production seems in the mouse to speed up all life activities as compared with those of the elephant. And so these two animals, assumed by us to be of perfect formal similarity, *live on two very dissimilar physiological time scales*. No figure will adequately describe this deep and far-reaching difference. But we may notice that the elephant's heart beats 25 to 28 times a minute, whereas the heart of the mouse beats 520 to 780 times during the same period. At this rate the mouse cannot possibly live as long as the elephant; it dies after three years or so, while the elephant, living by a time standard perhaps more 'similar' to that of the carp in the pond, enjoys 80 to 100 years.

If an architect were called upon to design zoological garden cages for a mouse and for an elephant, habitations that would conform to no more than the minimum standards these animals require for a healthy, happy life, he would have to take into consideration more than just the conventional kind of proportions. Cold, static geometry would not do where life is to be served. And thus the little mouse requires much more room for jumping about, and engages in a greater 'motility' than an elephant. To bring the problem closer to our own lives, even though a boy may be half the height of his father, it would be erroneous to apportion half the space to his bodily activities and life necessities. Again, geometry does not apply; organic considerations must prevail.

174

Through its *operational relatedness to time*, the suggested physiological view drastically combats all abstracted formalism in our setting. It becomes clear that to life and to design for life there can exist no empty, lonely space by itself, but only a space-time manifold filled with heartbeat and warmth. No frozen forms in void and emptiness, but matter-and-energy phenomena changing vividly from one form to the other—such are the things that must be accommodated by design.

Euclidean designers for thousands of years have innocently borrowed 'proportions' from a mammoth Parthenon to be passed by many human steps and to be viewed while bent over backward in awe. They have religiously reduced these proportions in order to apply them to the Doric front of a suburban branch bank, a little garden pavilion, or what-have-you. The height and width of a door, the dimensions of its ornamental moldings, may be multiplied by two or four or ten and always remain 'well proportioned' to each other. Yet even in such a monumental building as the palace of the mightiest king or in the majestic board room of the first national city bank, doorknobs and latches cannot grow to ten times their size and retain a meaning relative to gripping hands or living beings. If organic living forms truly become our prototype of design or if they are only to be placed successfully within designed settings, then what used to be identical 'proportions' often results in utter nonsense.[2]

In spite of formal similarity and cherished and retained proportions, organic *operations* may be found most dissimilar. In order to produce any similarity in and for life,

[2] The beginning of the sixteenth century was an age of rules and canons of proportions. The book that Luca Pacioli had printed in 1506 bore the characteristic title *Divina Proportione*. In 1567, Vincenzo Danti's *Trattato delle perfette proportioni* brought the old classical idea of a perfect canon to the fore. In 1584, Lomazzo's *Trattato della pittura, scoltura, ed architettura* chimed in: 'without geometry and arithmetic nobody can hope to become a painter.' 'Correct' measurements, however, were certainly not the only contribution of that classical age. Leonardo da Vinci himself, who in his *Trattato della pittura* established their theoretical foundation, wisely warned against canons of any sort because of 'the immense variety of nature.'

the emphasis on *what* has to be brought into the most suitable ratio must be shifted very significantly. A cease-fire in this abstruse combat against nature shall be advocated.

To live means being engaged in energy exchange and vital contact with the outer world. All life processes—moving about, growing, aging, fatiguing, being nurtured, or losing calories—are closely related to problems and magnitude of this contact. To those who live, there is no splendid isolation. There is give and take. These operational concerns are superior to any kind of angular equality or a mere geometrical kind of eternal proportion.

Timeless non-physiological, abstract formalism concerned with proportions of this kind has long been dangerously overstressed in its application to design and to the environment in which life can be staged successfully. It is like a foul blow to life itself, a danger threatening the vitals. There can be no comfort in a world where stupidly the columns of a little prefab's entry porch are made half as high as in a Georgian palace while the corresponding proportions of other ornamental trappings are proudly preserved to fit the reduction. Artifacts must not ignore the dynamic dimensions of life that they involve at every step. There can be no happy survival where children are dressed and treated as little grownups—poor-darling diminutive 'similes' of adults. We have had too much of this sort of fallacy.

We should perhaps return for a moment to the design implications of growth to which aging relates. Growth affects also our idea of *self-similarity*. We change, and this change away from ourselves seems pleasant enough when we are young; our faculties increase. But later on when we decline, it becomes an increasingly wistful affair.

To use the physiological word, aging, also for inorganic objects and 'constructs,' may be a loose practice. Yet, even in the case of a house, self-similarity is pretty well impaired when the various parts do not give out all at the same time but at varying speeds. It is impossible to design it so that its frame will droop at exactly the same rate as the paint wears

off. The entire structure becomes sadly and increasingly dissimilar to itself—just like a man who loses his teeth and takes on fat, while his hair turns white at the temples and disappears at the top. Thus also the reverse process of growing poses a corresponding problem. Yet it all spells a need for design with a *time implication*, design to fit a bundle of processes rather than a static state of affairs.

We are of course aware of the difference between designing shoes and pants for a rapidly growing little boy and getting footwear and clothing for a full-grown man. The little boy—like a grasshopper which changes its outer shell, the chitinous case of its 'exoskeleton,' by a series of moltings—will have to have new shoes and pants periodically. There is for this a more or less predictable rate of renewal, quite independent of wear and tear but rather dependent on the growth of his bone structure. Like anything else that keeps growing, the little boy is and *must not be thought of as one item when it comes to design, working for survival.* He is really a series of items—or what is called a 'serial structure' *in space-time.* As mentioned above, the youngster is by no means growing to self-similar shapes as if he were being seen through sets of ever more powerful magnifying glasses. While every phase of that 'boy-series' very intimately relates itself to the preceding and succeeding phases, there is no easy Euclidean similarity between the appearances of this sequence.

It is essential that the designer recognize and acknowledge this organic condition. There is, for example, the significant fact that the boy's head is relatively large at birth but grows much more slowly than his hands or feet do. Of course, the self-successive dissimilarity between what is in one moment of time and what is in the next goes way beyond mere forms. From month to month, the *functionings* of head, hands, and feet differ in their subtle relationship and coordination to each other. And this is even more important.

There are, indeed, a thousand ways in which the designer of a home, for example, can improve his design if he sees the family group of his client not as a little snapshot to be

squarely framed and fixed, but rather in that serial perspective of growing and aging. A garden architect cannot look at the plants as if they were fixed in size and mutual relationship.

Bearing in mind the intricate problem of growth to be accommodated by design, we may consider that a family group has a twofold growth. First, we refer to growth in number of children—proliferation. Yet this growth is limited and it is supplemented by another growth of the member organs or member elements. Their interrelationship develops with specific articulation of each. Similarly, a city should be organically limited in its population figure, but having reached a given numerical size, it still can grow in stature by maturing, articulating, evolving its organic parts and their relation, and all the urban living benefits that such a process can yield.

It is interesting to contemplate that a type of growth, proliferation, and articulation, characteristic for the nervous system itself, should occur similarly in the most comprehensive product of the human brain, the cultural community and the man-made outer shell of it—the city.

SEEING, LIKE OTHER SENSING, WAS DECISIVELY
TRAINED WITHIN THE NATURAL SCENE; time
is of its essence, although seeing seems to
deal only with space.

24

The Dartmouth Eye Institute has devised impressive tests demonstrating that a large part of what laymen consider a sensory occurrence may in reality involve higher mental activity and represent a performance based on many preceding purposive experiences, sedimented in us over a long stretch of time. The associative plus the emotive apparatus may play a great role through formative years in what we call seeing. Experience sets in when a baby begins to use his eyes and gradually learns to transform the surrounding chaos of colors, brightness, specular highlights, and shadows into a comprehensive perspective of 'objects,' such as we have to handle while we grow up.

As designers, we should learn to distinguish on all levels those physiological responses that are constant, not acquired, and inevitably elicited by our design. From here we shall have to proceed to the conditioned responses deriving from experience, individual training, convention, and traditional use. Our responses to color will illustrate this point.

It may be proved that certain sensory responses which we regard as acquired are really primary and innate. We perceive a color such as blue as 'receding' and a color such as

red as 'warm'; these impressions have been accounted for as merely conditioned effects and as deriving from our experience that distant mountains turn blue by air perspective and that we have seen fire full of reds. This is probably an inadequate explanation.

The experimental studies made by Dr. D. B. Harmon for Texas schoolrooms have indicated that so-called warmth in colors may not be purely 'psychological.' For his attempted establishment of brightness balance, Dr. Harmon chose colors of almost equal reflectivity and wave length—at both sides of the spectrum center [1]—colors ranging from greenish blue to light orange. He also reports that the cream, yellow, and orange hues reflected actually and measurably more heat rays than the blue-green and blue shades, long regarded as 'cool' colors.

The idea that colors apparently recede or advance simply as a matter of 'feeling' is somewhat altered if we pay attention to the fact that the eye is not 'color-corrected.' Thus only monochromatic light—that is, light of one color and wave length—can be fully focused at one moment by the lens of the eye.

Whenever the eye focuses on a white mark made on a green chalk board, now often used in schools, it acts as though it were myopic to the green color: the image of the green surface falls into focus *in front* of the retina. This makes the green seem to recede into a 'background.' A red area, on the contrary, falls into focus *behind* the retina: a red chalk board therefore would seem to advance toward the beholder instead of remaining in the same plane as the white chalk mark.

There is under these conditions another strange effect experienced: a green or a red point, because it is imperfectly focused, is also perceived enlarged as a disk, while a white pinpoint in the same plane remains a pinpoint. Here, then, are 'constants' of response that are antecedent to any experience. It is obvious how much our space, which is a product

[1] 5500 angstrom units.

of our physiological make-up, appears affected by color choice in design.

And we are confronted with still other complications when we consider the time factor. For the act of seeing occurs not only in space but also very much in time.

The focusing of the eye is by no means instantaneous. And even more significant, various successive accommodations are not equally swift, because of inadequate capacity of the muscles to reverse the process that flattens the elastic lens or, again, makes it bulge. Also, the opening and closing of the iris and the onset of fatigue are dependent on time. Let us say that a blackboard has a reflectivity factor of 9; a green chalk board one of 23; a white book page one of 70. Now, it is not at all possible to shift and accommodate in the same time interval back and forth from one of these reflective surfaces to the other. While it takes $\frac{1}{25}$ of a second to shift focus from white to black, it may take twenty-five times as long, or a full second, to return from the blackboard to the white book page. Here is something for the designer to ponder, especially since emotional reactions may accompany the processes of focusing and attempted attention.

Of course, design in light and colors by no means restricts itself to problems of acuity, the sharp focusing for identification of objects. The eye is equipped to be stimulated not only by light and color but by form and movement as well. Any discussion of form, for example, will have to take into account the aligning power of the eye. This is the specific capacity that makes it possible to distinguish the demarcation between adjacent areas. For this task of demarking the line between two shades, the visual organ is, it seems, not rigidly directed, but is kept in a rapid vibration, the amplitude of oscillations being something like 50 angular seconds. During this vibration, or relatively quick little swings of the eye, a light ray, emanating from one point of the line in question, is kept oscillating. An oscillation over one and a half typical spacings between 'rod' and 'cone' positions on the retina is perhaps a device to counteract fatigue of these microscopic receptors of the sense organ, which have been

found to tire in $\frac{1}{16}$ of a second. Considerations such as these remove any design at once from space into space-time, where we actually pass our lives.

No thorough attempt is here intended to penetrate into the quickly advancing and often changing physiological interpretation of sensory processes, which are being observed in ever-improving experimental arrangements by ingenious specialists. It must merely be emphasized that such experimental findings, rather than theoretical speculations about aesthetics, will have to govern design motivation. Through these newly developing insights we may expect to determine true physiological constants—in other words, firmer ground for our planning.

It has been generally granted that certain constants exist, such as the plain Platonic patterns, which we now are inclined to interpret in the light of neuromental economy. It is also conceded that we have, for example, a consistent preference for rhythm, possibly reflecting rhythmic processes within our body, such as those of respiration and peristalsis, pulse and heartbeat.[2] This rhythmical disposition is a factor on which any designer can count as a constant.

As to color vision and color schemes, we are often inclined to regard them as involving mostly personal taste and prerogative. But this attitude is again contradicted by another popular contention, i.e. that certain colors almost invariably have certain 'meanings' and carry a specific cargo of emotion. Serge Eisenstein, the great cinematic innovator, has discussed such convictions at length in his book *Film Sense*. However this may be, and whatever conditioning to unnatural black and white abstractions we may have experienced through a century of photography before the advent of color repro-

[2] In fact, rhythm seems rooted in 'visceral drives,' in which a school of physiologically interested psychologists wanted to see the background of practically all motivation or emotive events. Visceral processes are of a rhythmical, cyclical character, owing to the gradual and periodic accumulation of substances or to accruing deficiencies in certain parts of the body. In regular intervals, a threshold is reached and then an equally regular and repetitive reaction begins.

182

duction, color is at any rate a sensory stimulus of the very first order. Sensitive and would-be sensitive homemakers, for example, speak and worry a good deal about it—as any architect knows.

When, as a child, I occasionally overheard adults anxiously discuss color in connection with 'decorating' some interior, I often wondered why the innumerable hues in nature never seemed to clash, never seemed to tire the beholder, as the colors of man-made environment so often do.

Obviously the natural scene furnishes the first and most powerful medium and precedent for man's acquaintance with color and helps to account for his interest in it. This natural scene has gradually been enriched by a few man-added color accents. In a wide rural landscape an occasional red barn and silo may meet our eye. Eventually we find ourselves completely surrounded by colors of our own making, say, in a downtown business street or a Park Avenue boudoir. The natural scene is crowded out by artificial colors. 'Our paint covers the world,' is the formidable motto of a nationally known manufacturer, whose poster shows thick bright paint spilling over the globe and dripping down into space. Color superficially painted on is man's contribution. It is more than a practice emerging from a need for protective coating—it is a contribution by free choice and for special gratification.

We must keep in mind that color is a mere derivative of light. All cows are black in the dark, says a German proverb. Color simply does not exist independently of light, and *is* light or light reflection of varied properties.

In order to understand the color difficulties of the decorator, we might compare an outdoor scene, naturally illuminated, with an artificially lighted interior. The first illumination changes continually and dynamically from sunrise to sunset. The western sky, for example, may be deep blue with white cumuli floating in it at ten in the morning, and may be pale lemon with orange or vermillion-edged dark clouds thirty minutes after sunset. Also, these bold juxtapositions of color do not last long; they change kaleidoscopically. Yet

they are repeated on other days or in recurrent seasons. Time has a natural and important part in the experience.

When autumn comes, the natural vistas change their color breathtakingly, or pale out, as the chlorophyll decomposes more quickly than do the rest of the vegetative pigments. Every year the spreading cover of winter snow emphasizes the few remaining patches of color or darkness in the landscape before our window. This rock or that red barn stands out quite differently now than it did only two days ago, before the snow came, or two months ago, when the aspens were such a bright yellow. It is the same landscape but again not the same; sameness here is a misnomer.

In contrast to these color dynamics of the natural scene our interiors are hopelessly static. If paints wear off, the rooms merely look a little shabbier. This is almost the only change that ever takes place, unless we do something about it. And lack of change is sufficient to explain our resultant color fatigue, a fatigue that hardly ever occurs in natural surroundings.

The color receptors of the retina have been evolved and conditioned in the course of ages by the combined color stimuli of the natural scene. Static coloration can never assure enduring psychological satisfaction; it is unnatural.

If man-made color is to play its part as an aid to survival in a fully urbanized environment, it is imperative first of all to minimize static effects and rigid color arrangement.

Let us take the extreme example of a windowless, dust-proof, air-conditioned hospital ward, perhaps with measured ultra-violet irradiation to substitute for the health factor of sunshine. Its walls are painted a soothing light olive green. In the long run, such a statically set interior will, from a neural point of view, in some respects compare unfavorably even with the dungeon of old. The latter had at least one little grilled window opening, and so provided one important comfort: an ever-changing play of light and color on the walls, the floor, and the heap of straw on which the prisoner rested. The wretched man could at least watch rosy or golden

reflections and wandering shadows as the hours and months slipped by.

Any static color or color combination is, physiologically speaking, unfit. Colors should set each other off refreshingly, not only in space, side by side, but also in time, one stimulation following another. Any unchanging combination becomes unbearable for an extended period, even if the initial selection of colors seemed perfect. Color perception, like form perception, takes place in the space-time continuum. To treat it in relation to space alone is in itself a defective approach.

Modern lighting technique offers tools to serve us physiologically much better than we choose to let it. Thus future interior design may spare us the ordeal of exposure to monotonously sustained color effects. It may pull all the stops of an endless light organ, producing rheostaticaly controlled variations in illuminative intensities and color. And these changes will be planned to play refreshingly on opaque and translucent surfaces, on surfaces selected to absorb or to reflect light rays. Every partition, the ceiling, the flooring, the furniture, and the accessories will be integrated in the scheme of illumination. The play of elusive reflections and shadows cast by semi-translucent and solid objects, and growing over neighboring forms and textures, will then be no longer wholly accidental. Provision for it may become an invigorating part of creative design.

Above all, a room will be much less just one room than it is now in its rigid constancy. Even the smallest room will be less confining. The visual space that is psychologically, neurally so important shall become modifiable at will.

All this may sound rather utopian. At present, it often is difficult for a designer to induce even a wealthy client to allocate from the total investment a reasonable sum for more subtle changes of illumination or for special construction materials and furnishings that will respond planfully and sensitively to this elastic illumination. The Joneses probably have not done this in their new palatial home in Floral Manor. Perhaps they have spent a much larger sum on ama-

teurishly handwoven and unreliably dyed drapes and on pretentious antique or modernistic furniture—each piece a rigid block of color and form. They have been high-pressured into paying a fabulous sum for a fabulous loudspeaker and record player, and now possess a much-admired, individually constructed set that in tone quality and manipulative gadgets rivals their electric organ and their unusual concert grand piano. Still, the musical tastes of these owners may be not at all unusual and may not, in fact, be any better than their discrimination in regard to weaves and dyes. They have merely made their decisions about spending according to precedents prevailing in their social circle. Unfortunately, there exist few precedents for composing and rendering light and color per se, as objects of enjoyment, except perhaps for the recital instrument Clavilux, or certain crude contraptions that play with a little amber and pink and blue, yielding something similar to the color effects of synthetic syrups on a drugstore shelf. But here we speak for an integrated, illuminative space design—integrated by and in its original conception. Decorative afterthoughts are beside our essential concern.

Pioneering in dynamic illumination will probably at first need 'convinced capital.' It will, of course, at the outset play no part in the housing of the vast majority that so far lives below even minimal standards of physiological satisfaction.

But the fundamental fallacy of static color and light arrangements in our dwelling and working places is a basic offense to nature, and its remedy is by no means luxury. Once its harmfulness is exposed, experimentation will advance, constructive design will follow, improvement will spread to lower economic levels by the propelling power of growing demand and ever-broader acceptance. The manufacturers of radios and record players have proved that appreciation of fine sensory appeal can be fostered in a public that originally seemed musically inert and largely undiscriminating about acoustical qualities. A similar development in regard to illumination is not without reason.

Meanwhile, one very simple and practical principle emerges. Artificial light sources, even when of a static intensity, must at least become flexible or varied as far as placement is concerned. If we are limited in our interiors to permanently applied color coatings, we must reduce their harmful effects on the nervous system by giving these interiors as much as possible the benefit of the natural changes of illumination outdoors. As a corollary, transparency of partitions between interior and exterior becomes important. Victorian hermetic enclosure, window hangings, dignified perpetual dimness must go. With drapes open at times, closed at others, large expanses of glass aid a visually conceived plan of space for living; they add to its chances of yielding comfort, lasting over the stretches of time.

COMFORT AND FATIGUE must be understood within the picture of organic events and will limit the possible scope of arbitrary fireworks of design.

25

We have spoken of fatigue as a vast subject of vital interest and George Nelson once correctly observed that there is no reclining chair sufficiently well designed to insure comfort for a night-long bus or plane ride. It is good to get up and stretch one's legs. For refreshment the motility of our limbs and trunk must every so often be brought into play.

Even the best-designed stimulus becomes ineffective when applied incessantly. Fatigue diminishes the conductivity of nerve fibers engaged too long. The skin surface receptors, for example, become numb very quickly.[1] But fatigue does not depend simply on duration and intensity of stimulation; it might be surprisingly postponed and diminished by such a subtle device as rhythmicality.

[1] Every nervous activity (according to findings stemming largely from the experiments of Gerard and Marshall) diminishes the action potential—the conductivity and conduction velocity within the particular nerves in action, which (as measured by Downing and Hill) give off minute quantities of carbon dioxide and heat. Rather similarly to fatigue conditions, the nerves can be 'locally suffocated' by want of oxygen. This circumstance, which may, for example, be due to pressure, would also reduce or practically stop their conductive capacity or alter their rheo-base, the intensity threshold above which they go into action and

According to the fundamental discoveries of Adrian, published more than twenty years ago, the sense receptors, when stimulation occurs, discharge a series of impulses, or volleys of impulses. Each of these impulses has a minimum strength below which no action can take place. Adrian actually pronounced something like a quantum theory of sensory discharges. The intensity of the sensation depends on the rate of discharge of these individual volleys. The receptors, however, as well as the nerve fibers, have a certain accommodative capacity: when a stimulus is applied constantly, there is no corresponding continuous discharge of impulses. Only a few initial ones take place and these soon abate. This phenomenon of neural accommodation occurs quite apart from muscle fatigue but has an equally basic significance for design. It has an intriguing and practical bearing like that of the older psycho-physical law of Fechner-Weber, which taught designers something very amazing. This law exposed as error any naïve expectation that intensities of sensations will show up in direct proportion to the intensities of the wielded stimuli. They do not do so. In fact they are much smaller and are related more closely to the logarithms of the stimulus value. Certainly, to make a fortissimo sound twice as loud as a forte, to illuminate a desk twice as bright, to paint a wall twice as red become very controversial design proposals if we try to measure their brain-functional correlates and repercussions.

The reduction of sensory receptivity through accommodation means a great deal especially for the responses that our designs can conceivably elicit. If we wish to keep design 'organic,' we cannot disdain learning a little about such fun-

below which they seem to ignore any stimulus or maintain indifference to it. Likewise, their chronaxie or, differently expressed, the minimum of time they require for a stimulus to elicit their activation, may change under oxygen starvation when, for instance, blood circulation is disturbed through other nervous effects. Such effects are often caused by unfavorable posture and, as already pointed out, postures are frequently the consequence not only of furniture design, but of furniture placement, the relation of the pieces to each other, to the shape of the room, window locations, et cetera.

damental functions of the organism that we desire to respond. The consumer of our design must have his opportunity for comeback through a certain amount of rest. His minute accommodations or fatigues must at least be considered by the designer, if not actually calculated. In stimulations such as our designs provide, balance between the catabolic processes of consumption of energy and the anabolic processes of repair and regeneration must be maintained. These processes are implicit in all nervous and muscular activity to which an organism is stimulated. 'If stimulation is too strong and repeated at too brief intervals, the processes of repair will not keep pace with those of consumption, or the waste products of the functional activity are not completely removed,' as Howell expresses it.

The phenomenon of fatigue which deserves discussion also for its many social implications, may—purely from a physiological point of view—be considered in three different aspects. The first is the subjective aspect, i.e. the individual's own perception of what is taking place within him, and his emotional reaction to it. Fatigue results in secondary inner stimulations that cause sometimes vague, sometimes distinct feelings of discomfort throughout the body.

The second aspect involves what scientists call the morphological expression or the objective bodily symptom. This consists of a change in the affected parts that can actually be seen when the fatigued cells are studied under a powerful microscope.[2]

The third aspect is the functional one—i.e. fatigue may be defined as an 'impairment in the rate of performance.' Functionally, then, fatigue means depression of normal excitability; this depression can well be measured by and probably corresponds to electrochemical changes in the nerve cells

[2] In advanced stages of fatigue, a disintegration and 'chromolysis' of the so-called Nissl granules has actually been observed in these cells. These granules consist of the chromophil or stainable substance, tigroid, which seems to disappear in the process of extreme exertion. Far progressed fatigue becomes visible also when the increasing formation of vacuoles, i.e. tiny gas bubbles, is noticed within cells that are exhausted.

and their appendages, the dendrites. Fatigue and fatigue behavior as metabolic phenomena have been studied in many types of tissue. The implications of these investigations apply to the structures of the central nervous system as well. In a brain, whether rested or fatiguing, millionfold combinations continue to flash on and off, as we derive enjoyment or suffer from external configurations taken in with our senses.

Monotonous repetition of forms and motions—such as accident or designers and architects often subject us to—tire our brain and our nerves. Just what doses or what durations of exposure produce numbness or affect still-hidden inner balances adversely? It may become possible to arrive at accurate evaluations in these matters. At any rate, comfort, as a subject of physiological knowledge, dawns significantly on the contemporary horizon.

A workable understanding of how our psychosomatic organism ticks, information on sensory clues which wind its gorgeous clockwork or switch it this way or that, undoubtedly will someday belong in the designer's mental tool chest. Yet we must not indulge in mechanistic metaphors and thus oversimplify the issue of life, complex by the recurrent swelling of vitality and the ebbing into fatigue. Through more useful interpretations of our day, we have outgrown an adolescence that enjoyed itself in a gross machine materialism once considered 'so progressive.'

In 'INTERIORS' AND IN OUR URBAN EXIST-
ENCE, LIGHT AND COLOR CALL FOR A MORE
INFORMED WATCHFULNESS than eyes have
needed for a life outside in unhampered
nature.

26

Even with very moderate and simple means, it is possible to contrive interior illumination that is not static and thus fatiguing. The varying effects of daylight can be enjoyed through large windows, well shaded by exterior overhangs. The visual sharing in the outdoor scene can be moderated by means of sliding drapes that can be opened or drawn to any point as desired. At night the room need not be monotonously lighted. The illumination may be supplied from alternating directions, and from varying sources. These can be partly or wholly concealed, so that reflected light predominates.

The possibilities of directional effects may be subtly utilized. Diffused light coming from above is very different from lateral lighting. Concentrated light supplied by a source near the floor level has an emotive quality of its own. It is largely the unusual, changing light emanating from below our eyes that constitutes the charm of a fireplace. There are many modulations of direct or diffused lighting that can be intimately related to shape, surface materials, and contents of a room.

Illumination of interiors by means of pure white light, supplied from fixtures which are concealed in the roof projections over large windows, has long been a feature in my designs. It results in a pleasing effect of openness to the night. The interior space seems to be extended into an indefinite exterior space that only gradually recedes into total darkness. Thus such outer space can be drawn on even when there is no moonlight. Incidentally privacy within is secured simply by means of the *optical screen* produced by reflection on the exterior window surfaces. This arrangement does away with inside reflection on glass panes, so long as no strong light falls on them from interior sources. When exterior lighting is turned off and the interior is illuminated, this interior is promptly mirrored in the window glass. There results a feeling of being enveloped by the night. We see nothing of landscape but only the room, duplicated by reflection; this yields a very different, a phantomic extension. At other times a sense of being intimately enclosed may be enhanced by light-colored drapes to be drawn across the windows. Thus the one room affords a number of refreshingly varied experiences of *space through illumination.*

Selection of colors becomes here quite a different problem from what it is under conditions of static lighting. Contrasts of shade, intensity, brilliance, and, above all, reflectivity and luminosity often turn into paramount considerations. The detriment and significance of great differences in distribution of brightness have recently been made a subject of study. Uniformity as well as steadiness of brightness is justifiable in a space used for concentrated work over given periods. But there are benefits in change and contrast. Steady illumination can become oppressive even though it may seem attractive at first. The strong vivid colors in nature, like those of an impressive evening sky, would become hard to bear if viewed indefinitely; here the factor of fatigue appears operative. Undoubtedly, steady uniformity needs to be offset— just as seasonal change is an important element in our enjoyment of nature. We like to look forward to the brief attraction of the desert in bloom, or of hillsides miles away, flam-

ing in season with a carpet of cadmium yellow California poppies.

The brightest reds and yellows in nature are not commonly found over extensive areas, or if they are, they do not appear for prolonged periods of time. Bright xanthophyll left to color the autumnal foliage glows briefly before the leaves drop. The brilliant fall colors of sumac and maple fade in a week. Red hemoglobin may lend an emotional kick to hunting, war slaughter, and bloody murder, but it rarely drowns the entire field of vision. The great exception here is chlorophyll, which plays such a decisive role in the assimilation activity of green plants. It occurs over the landscape, all summer long, even all the year around in plants, from algae to conifers. Through countless millions of years animal and human retinas have been conditioned to tolerate immense expanses of green. Eyes have grown to relax in full view of them. A similar prevalence of bright yellow or red would indeed be unbearable.

It becomes apparent how greatly man puts himself at a disadvantage from the standpoint of nervous health when he limits the types of optical vibrations to a few in his constructed compartments and surrounds himself with fully stabilized, static color schemes. Moreover, he applies them most often in a fairly limited space, an 'interior.'

For primitive man in his semi-outdoor existence, such restricted choices for his cave or hut had no ill effects. He could put up with them, just as he put up with the obnoxious odors of his crude household, because most of the time he roamed hills and plains. For modern man, living in closed, compact, and almost constantly used interiors, static color schemes are much more detrimental to well-being. A limited field of vision forced upon us can be made sickening with color, much like the inescapable air volume with its chemical pollutions confined within our walls.

In advanced situations of civilized life, such as a teeming metropolis with bewildering traffic and disharmonious neon lights, multitudes become nervous sufferers. In 1952 nine million Americans were mental cases. This is not accidental,

194

and systematic remedial study of new irritants and physiological requirements has become urgent. In contrast thereto, life at earlier stages could and did succeed by simple, unplanned, slow natural adjustment.

If we cannot yet produce a biologically perfect interior by technological means, our decision must simply be against making an interior fully dependent on intricate technology. We must still design living space, and a current environment for the race, so that the neurologically salubrious agents of nature outside are freely admitted and kept active to as great an extent as possible.

We must not be blinded into toying with every technical invention to the exclusion of natural biological benefits, before we have made sure that we can artificially substitute for those benefits something that is essentially equivalent. For example, an electric light may illuminate a subterranean compartment without oxygen consumption. That proved a valuable novelty for an age accustomed to open-flame light sources. But humans who needed light will still find need for replenishment of air. When this air is pumped in by machines, a deficiency of air-moisture control may again make the place unfit, even for a short period of life. And the longer one tries to extend this period of artificially served existence, the more physiological factors and necessities must be considered and satisfied by carefully studied special devices.

With our mammal lungs we might dive deep into water and survive for some minutes. It is true that man can expose himself to anomalous and unfavorable conditions and endure hours, weeks, years under strains of maladjustment. But the effects of improper environment are often cumulative, and we pay a penalty for spending long periods of our lives enmeshed and entangled in unnatural, abnormal surroundings, such as we now have to face every day.

If we design for long-range survival of the race, we cannot exercise a primitive attitude, as if we were improvising for a mere emergency. In the ever more complicated situations of civilization, we have cause to remain on guard and not fall

victim to a short-sighted awe of and childish adoration for an undisciplined technology, tolerant of all its toxic sequences.

Apart from stimuli eliciting immediate responses, we must be interested especially in subtle long-range effects and what they mean for survival. This leads us into exactly those fields which the active man of affairs interested in quick turnover has so often permitted himself to ignore. Particularly where these fields seem to border on the realm of 'aesthetics,' he is likely to shrug his shoulders and, dodging all such discussions or decisions as insignificant, return to business as usual and to precarious neglect.

27

The designer is often seen as a man who cleverly meets practical problems and embellishes his solutions by a few applications of his aesthetic acumen. He is best appreciated where he deals with machines of production and new-fangled materials. He is the admired wizard of electronically molded wood, modern glasses, plastics—things that have a recent but rich history of development.

But when the designer does anything essential for us, no matter through what extraneous means and materials, he deals primarily with nervous systems, and he caters to them. He may well contemplate with awe and interest the huge number of afferent, the in-bringing, nerve fibers—half a million of them—which enter the 'cord' through the posterior roots of the spinal nerves. They are the sensory reporters which keep us informed of our surroundings through all our life. Nervous systems are the most complex material confronting the designer, vastly more complex than anything in manufacturers' literature.

One needs a vivid imagination to picture the multitude of dispatches and alarms that reach us every moment—all the routings and combinations of sensory impulses. Perpetually, waves of excitation lead to the cerebellum, further to the cortex of the upper brain, and from there outward to mus-

cles and glands. A great many in-flowing stimuli reach lower receiving stations almost simultaneously and act on the cord and its many antagonistic flexor and extensor centers. A vast muscular activity is continuously innervated in us even while we believe ourselves to be at rest.

The state of the relative excitation and inhibition in each stimulated part or center can be called its neural balance prevailing at that particular moment. If a consideration of these nervous phenomena is attempted, any narrow, nineteenth-century mechanistic attitude will lead the designer astray. It will more disarm than help him when he faces his audience of nerves or tries to elicit nervous response, as essentially he always does.

But what are these nerves a designer's life effort is concerned with? What can he learn about them and about their anticipated reactions? What is their response to a stimulus? What occurs in them when impulses travel down the length of their path and hurdle synapses with a measurable speed? Is a synapse, that mysterious connection between adjacent nerve axons, something 'material,' permeable to the nervous current, perhaps a film of the lipoid part of plasms, as some scientists describe it, no thicker than two molecules? Or, as others propose, is it perhaps better conceived as just an 'electromagnetic zone,' sometimes a roadblock, sometimes passable? What might it be according to tomorrow's findings? How does it operate, how is it activated? Discoveries follow each other and under their impact even terminology changes quickly. And yet respect for what objective observation has encompassed is already a gain.

It may be interesting to trace the supply lines and especially the initial sources of nervous events. We find sensory stimuli are the prime movers, and the switches that they operate and activate are senses, the same instrumentalities by which also design first becomes noticeable and effective.

If space design, architecture, environmental planning are, as a whole, 'omnisensorial,' i.e. if they appeal to all senses, perhaps we should here summarize the immense subject of

our sense equipment, to which reference must so often be made.

Points of origin for the vast army of in-bringing, afferent, sensory nerve fibers are the sense receptors, which, though just as numerous, are unequal in number for each specific sense. Compared with the theoretical and abstract client to whom the inadequately equipped Euclidean architect thought of making his merely geometrical appeal, the man with the five senses already had a very rich endowment. Yet this proverbial small and round number of senses is itself superannuated now, somewhat like the world of the past that supposedly was composed of but four conventional elements: earth, water, air, and fire.

Sense receptors have been newly counted and found almost innumerable. Three or four million pain receptors or pain points alone are distributed over the entire cutaneous surface of man. Compared with this mass, there are 'only' a half a million pressure points, one sixth of a million warm points, et cetera—that is, the minute spots on the skin, sensitive respectively to pressure, cold, or heat. The endowment with these senses varies markedly for different individuals and the different proportions of sensibility may account in large measure for puzzling personality differences which the designer is to please.

It is clearer, perhaps, to speak of several purpose-categories of sensory receptors, most of them represented by a vast crowd of sensory terminals or nerve endings. First of all there are 'non-adapting' receptors of pain, which are most significant for survival and are distributed almost throughout the entire body. When they are activated, the alarm normally does not cease, unless we succeed in removing ourselves from the painful attack or else liquidate it in some suitable manner. Then there is an array of adapting receptors, capable of accommodation, an adjustment, an acquiescence to prolonged stimuli. Briefly listed these are:

Proprioceptives—the inner muscle senses, numerous muscle spindles, tendon-sense organs, and, as an important supplement, the gravity and acceleration reporter in the ear. All

these record for us the movements and positions of our body and do it every single moment of our life. When we but turn our head to fix our attention, this type of sensing at once comes into play.

Interoceptives are recording impulses from various visceral organs within the body. Indirectly at least, and vaguely, this group of senses, like all others, may report design failures. Here we are warned of situations due to faulty planning which may affect our generally smooth and even inner functioning.

Surface senses, the cutaneous sense organs, are with very irregular prevalence distributed over the skin surface and record changes in the immediate environment of the body. But, as we have indicated, parts of this environment are much better sensed than others because the various parts of our surface are endowed with very different degrees of sensitivity. These skin senses include receptors for touch, which will record a tiny external pressure of 1/25,000 of a gram, receptors for contact-heat, and many more for contact-cold. Everything from an air heater to the texture of upholstery goods on the sofa or the smoothness of a plastic doorknob speaks intimately to the surface senses.

Teleceptives are concerned with conditions and changes in the more remote environment. The ear, the eye, the nose, and the receptors for radiant heat and cold constitute the teleceptives so far known to us. The nose of man has rather degenerated. Man, according to Broca, is one of the micro-osmatic animals, i.e. those who are under-sensed owing to imperfect olfactorial organs. Nevertheless, we remember that smells mean much to our feelings and elicit strong responses from our upper and lower viscera. A certain faint smell may make a room almost uninhabitable, just as it can render a person distasteful to us. The smell of a natural cedar paneling has a nose significance distinct from that of varnish and paints. Some exhalations and smells increase with the warmth in the surrounding air and our nose thus turns into a thermometer, crude but directly linked to our emotional centers. Here the interesting fact should be

pointed out that a radiant-heat system may appeal to certain of our heat receptors, but keep others, those for contact-heat, more or less idle as it were, frustrated in their function. Although in such a case our body receives its required heat quanta by radiation, we are, at least in an interior, used to having another sense make report on thermal matters, and so we may in a first experience not be quite sure that we feel comfortable with this sort of installation. We can term such a frustration 'sensogen.' To what degree it may be based on habit is hard to say. Somewhat similarly, indirect lighting may call for the forming of a new habit because at first we miss the accustomed glares in our vision field. While suspended or bracketed light fixtures and hot-air grills in the wall may be a nuisance, their visible presence gives a person used to turning their particular switches a certain feeling of assurance, quite apart from actual effectiveness. A substantial fireplace assures us that a room will be cozy, that it is comfortably heatable. But here we have clearly transgressed from the realm of sensation into that of more complex associative cerebration. The boundary line is for practical purposes scarcely one that can be sharply drawn. Habituation and frustration seem to occur on many physiological levels. They affect simple cells, nerves, the involved functioning of the brains.

With the exception, perhaps, of some of the interoceptives, a practical designer is, evidently, engaged to manipulate almost directly the entire and manifold sense equipment with which his client, the consumer, the human species is endowed. Schools that train the student will be obliged to familiarize him with this physiological keyboard on which he must try to play with understanding and harmony.

Individual and social psychology will ulti-
mately merge with BRAIN PHYSIOLOGY, TO
GUIDE THE DESIGNER IN HIS OBSERVATION
AND CREATION OF RESPONSE PATTERNS.

28

Neural events are not outside and be-
yond our space and time. They have been observed to pos-
sess spatial and chronological order and dimension. They
can at certain moments be localized; they can be watched in
their spread. They occur one after the other, always much
more quickly than we could follow their progress in the com-
paratively slow current of verbal expression. It may be noted
that their velocities are measurably different in the various
branches of the nervous system. Neuromental events are
fleeting to such a degree that we cannot adequately accom-
pany them far, even with our most clever and ready intro-
spective talk. This is also true when they can be called con-
scious. We are habitually deceived by our own attention,
which selects and highlights only a few phases of the process.
'Single' neuromental events have so many ramifications that
there actually exists only an over-all entity of nervous hap-
pening. This ever-unified function is perhaps also illustrated
by the difficulty of keeping any portion of nervous tissue
alive and in working order by itself after it has been sur-
gically severed from its total system. Physiologists have better
succeeded in artificially entertaining life and living reaction

in cut-off parts of muscular tissue, even in entire organs such as kidneys or glands. The main cell body of a nerve can hardly be nurtured in isolation, so infinitely subtle and lively are the energy transactions required.

The designer of our physical environment should not lose sight of the fact that he is likely to stimulate our entire subtly organized being, not just a specific sense or a particular organ. Those who dealt with the soul as an inconceivably fine and indivisible entity were closer to these views than the run-of-the-mill materialists. Contrasted with the other organs and organic matter, the entire nervous apparatus could indeed be considered as one organ, of its own kind and on a level of its own.

Nerves and nerve cells have grown. If we seek a truly organic approach to design, we must have the desire to understand some of the implications of such growth.

> Growth as such must be regarded as the expression of an intrinsic potentiality of the cell. It is not exhausted when the nerve cell begins to conduct impulses according to its definitive role. After this the cell continues to grow, and seeks out new realms to conquer. The functional nerve cell is from its beginning a dynamic system reacting to its environment after the manner of a living organism.
>
> Physiological conduction is, so to speak, its accessory or secondary function. If it ever loses its potentiality of growth and differentiation, we do not know when or where.[1]

Neural growth by cellular multiplication is, however, a process that does not go on and on. It stops amazingly early. According to Donaldson and research findings of the Wistar Institute, Philadelphia, there is in mammals no further increase in the number of nerve cells from a time soon after their birth. For the cell accretion in the cerebral cortex of

[1] G. E. Coghill, *Anatomy and Problem of Behavior*, Cambridge University Press, 1929, pp. 85, 86.

a rat, for example, twenty days after birth was observed to be the time limit. Growth after that concerns increase not in cell number but in cell size, and in the amount of inter-cellular material, of axons and dendrites. It is for the most part the coming into play and function of cell combinations, morphologically already in existence or pre-formed.

Growth of our decisive neuromental equipment is not an aimless process of getting bigger. It can, so to speak, be lured hither and thither so as to form a link, close a gap, or make a connection.

Forsmanns has shown that nervous tissue has a capacity to grow *directionally* to meet other nervous tissue of specific affinity or supplementary character. Peripheral and central portions of severed nervous fibers 'find' each other while growing. A peculiar sort of attraction, of chemotropism or chemotaxis, is ascribed to them in the explanation of this phenomenon. Ganglonic brain cells send out, by growth, tentacles that find others with which to keep continuous contact, and, as we have seen, this contacting, this liaison-growth is the principal kind of growth, if not the only one, which continues to take place during life experiences. The 'liaison material' is in fact the bulk of the cortex.

Fine extensional growth and subtle linking of parts miracu-lously produce feats of function from what had seemed a mere inert juxtaposition. In his splendid neuro-anatomic and physiological parallel researches on the *amphibium amblys-toma*, G. E. Coghill has shown that growth of nerve cell appendages over less than one-hundredth of a millimeter 'have profound effect on behaviour.' By such minute growth the animal 'transforms itself from one that must lie helpless where chance places it, into one that can explore its environ-ment in response to impulses from within, or stimulation from without.' And further: '. . . the conception that a neu-rone grows during a certain so-called embryonic period, or period of maturation, and *then ceases to grow* and becomes simply a conductor in a fixed mechanism, is erroneous and *wholly inadequate to account* for the function of the nervous

204

system as a mechanism of learning.'[2] In other words, the 24-hour-a-day, 365-day-a-year stimulus impact of designed environment may perhaps 'physiologically teach,' by molding the nervous make-up even of an adult and the alteration may take place through continuously stimulated neuron extension. Such a feat is certainly accomplished with a child. We ought to ponder this view of 'learning' by induced nervous growth when we try to fathom the potentialities of design.

Apart from growth by ramification of a restricted number of cells, the nervous system has another particular distinction. It is above all differentiated by the dimension, the minimum magnitude, of its metabolism, by the very small quantities of energy that are negotiated within it. These nervous energies have so strange an effectiveness in some of their manifestations that they move societies and civilizations. The required quantity of them is almost infinitesimally small compared with that of the mechanical energies, observed and measured in, say, the simple, muscular activity of chopping wood. *Innervations seem to constitute the very highest exploitation by nature of the tiniest sums of energy.* Here is something that makes them particularly interesting to the designer. He and his enlightened consumers must keep this important fact of minute actions and reactions in mind. They will then fully appreciate the enormous effectiveness and therefore the significance of the many stimuli which the natural environment and the ever-increasing constructed environment continuously apply to all of us. If we look at these minimum energy quanta with the eyes of the practical man in his day-to-day decisions, or even with the eyes of the calculating engineer, they seem negligible indeed. But because of the peculiarities of nervous energy economics, they had better be valued on an entirely different level. As mentioned, generations who led their lives in pre-materialistic times have had obviously less difficulty understanding this special

2 Ibid.

requirement of the sensitive 'soul' than the rough-and-ready mechanists who have for a century or two sprouted along the path of a naïve and popular 'scientism.'

Even a mechanistic interpretation of events cannot overlook certain trigger effects which may change large blocks of our situation. Chancellor Bismarck decided in 1870 to scratch a few ink symbols on a telegram blank. A message went from a health resort called Ems to King William of Prussia. That telegram started a major war and ultimately led to the creation of a troublesome empire to end other empires. The incident has become famous in world history. A diminutive brain action will help to release energies from a vast storage in a specific manner perhaps to upset the balance of mankind for decades. However, forgetting spectacular examples in nerve-dictated world events, if we are earnest in our determination to construct an everyday environment suitable for survival of the race, we must never sneer at tiny neuromental responses. We must neither overlook nor neglect the formidable significance of chain reactions and we must respect the modest stimuli which set them going in sequence, and which sometimes may seem without importance to us merely because we have remained uninformed about their explosive or cumulative character and fatefulness.

A powerful accretion of energy for releases similar to the mentioned trigger effects characterizes the maze of events that go on in the upper brain, the gray matter of the cortex. Many influences, now dormant, now active, are there ready to combine or to become mutually effective.

Anyone who in a creative capacity confronts man—and surely a designer always must do so instead of losing himself in a play with his tools, technicalities and materials—faces, above all, this world of cortical responses. He can no longer depend fully on his intuitive guesses, however splendid. Familiarity with brain matter and function is no less important for design than knowing the properties of steel, concrete, and glass fiber for their successful employment.

206

Certain desired INNER DISTRIBUTIONS OF
FORCE AND STRESS within our nervous system
are THE REAL AIM OF ALL OUTER DESIGN
BALLISTICS.

29

Pavlov, the prominent physiologist,
was Nobel prize winner in 1904. His later work developed,
branched out, and was appreciated for casting a sensational
but systematic illumination on conditioned behavior. G. B.
Shaw, who doubted the accomplishment, wrote ironically:
'My late friend H. G. Wells was so impressed that he de-
clared, that if he saw Pavlov and myself drowning, and only
one life-buoy was in reach, he would throw it to Pavlov and
leave me to perish.' [1] There has been other opposition to
Pavlov's assumptions and his illustrative word accounts.

'If we could look through the skull into the brain of a con-
sciously thinking person, and if the place of optimal excita-
bility were luminous, then we should see playing over the
cerebral surface a bright spot with fantastic waving borders,
constantly fluctuating in size and form, surrounded by a
darkness, more or less deep, covering the rest of the hemi-
spheres.' Pavlov expressed himself in this metaphorical man-
ner in 1928, after founding a solid school of original experi-
mentation and pointedly planned experience with laboratory

[1] G. B. Shaw, On Vivisection, Allen & Unwin, London, 1949.

207

animals. He has never actually been belittled in the one thing that most interests us—his systematic attempt to accumulate an unprecedented body of verifiable data concerning behavior.[2]

Of course, as Menziers stated in 1937: 'It is not justifiable to conclude cavalierly that all conditioning follows the principle of conditioned salivation in dogs.' On the contrary, the field now open owing to these initial and sustained successes is varied most interestingly. The attachment to and evaluation of laboratory methods may even have to be tempered and kept under skeptical control—which is the best part of all scientific approach. Liddell sounds an important warning when he states that the investigator, preoccupied with refined measurements of conditioned performance, may too easily come to regard a living subject as a laboratory preparation curtailing spontaneous natural activity under the test conditions.

There seems little danger, however, that laboratory methods of physiology when applied to design will become burdened at once with an overdose of narrow pedantry. The present danger lies rather in roaming speculation not yet brought down to earth by systematic experimental observation.

Persistent and meticulous research into the energy phenomena, into the physical and chemical circumstances that characterize nervous action, is in continuous progress. It underpins current views and will modify too-daring hypotheses. A feat, for instance, such as the 'accurate timing of neural events to the fraction of a millisecond is an enviable achievement of the present-day neurophysiologist.'[3]

Following the grand array of well-tabulated experimentation, most interesting attempts have been made to interpret the actual processes that go on especially in the cortex. This precious outer brain blanket, when unrolled and unfolded,

[2] See Dr. H. S. Liddell's appraisal in his concluding chapter written for John Farquhar Fulton's *Physiology of the Nervous System*, Oxford University Press, 1943, p. 493.
[3] Liddell, op. cit., p. 521.

is 2000 square centimeters in size and measures 3 to 4 millimeters in thickness. To observe brain processes in terms of time and space is helpful, even if the characteristics of their electromagnetic phenomena or energy transformations are still quite obscure.

In the central, especially the cortical, region of the nervous equipment, events of energy distribution become observable which physiology has described as excitation, inhibition, diffusion, or irradiation, and finally, as induction of nervous events. We may notice that these processes seem to yield, occasionally but not always, products of more or less pronounced consciousness.

Design for human consumption depends in its possibilities on the responsive behavior of the brain. A phenomenon, which we would commonly call generalization, may be considered first. It can perhaps be described as an excitation not fully localized or not fully limited to a specific stimulus. There is response not only to this specific stimulus to which one brain area may have been conditioned by a series of repetitions, but also to any similar stimulus. Or it may mean that a stimulus becomes effective for an entire brain neighborhood instead of eliciting response at one spot. Innervation seems to show a natural tendency to spread, to diffuse, to 'irradiate' into adjacent or connected regions.

'Generalizations' have their psychological implications. If we speak of them in physiological terms, in terms of nervous function, they mean a broadening or 'de-specification' of the original response base. The results are most useful for conduct in general and thus help sustain life. We cannot always deal in singularities. Yet, generalization may well become unjustified and impractical when it makes us jump to wrong conclusions from one specific case, or produces a neurotic emotional pitch out of proportion to an incident. We suddenly may see a dire situation at hand as hopelessly 'typical,' and the entire world turns gloomy.

A sound, a color, a word, or any special incident may elicit an unwarrantedly broad response and misguide our conduct or judgment. The traveler who, during a trip in Sweden,

hastily notes in his diary, 'Waiters in Swedish dining cars are mostly red-headed,' may be acting erroneously but in a manner quite close to usual practice that has its organic causes.

Apart from things said or thought consciously, this physiological brain phenomenon of *spread of response* plays its perpetual role in the silent, subconscious reactions to design. Experimental observation of it in the laboratory is possible. It can be intensified and complicated by other related phenomena that may also be tested in their elemental forms.

A 'dominant' focus of excitation absorbs the energy of other stimulations for its own reinforcement. These minor stimulations fail then to become competitive and to follow up their own careers. And further, a dominant excitation area dulls by 'negative induction' all other cortical areas. Dominance seems to reinforce itself through silencing of competition.

The meaning of dominance as a brain phenomenon effective for life, and design for life, cannot easily be overestimated. Among other things, it means economy that a comparatively small portion, well handled, could be made to dominate the entire scene and satisfy us in spite of it. A long indifferent highway may accidentally become a scenic route in our memories. This is accomplished by the dominance in our mind of only two or three profoundly impressive stretches of a thousand yards each, where we happen to turn a bend or pass a crest between two hills and joyfully behold through the windshield a magnificent vista, easily memorized. If a person says 'New York,' he may think of only two or three spots or overwhelming scenes, such as a glance north from Times Square at theater-closing hour. This particular view, taken in at a particular moment, may dominate over a thousand other drab and insignificant ones which he has seen in the same city but has failed to register so forcefully.

The bearing of dominance on design policies could be developed interestingly. Dominant dramatic effect, shock, and

surprise have always been tools of the designer who wants to stop or alter established reflex arcs or give backbone to his composition.

However, it cannot always be tolerated that our general judgment be overcome by just a few dominant impacts. We must not be swept off our bearings continuously. Concrete life very often needs more equilibrium and finds it in detailed mental reaction. While we are sitting at the steering wheel of an automobile, our life may depend not on generalized notions but on a very minute fittingness of a number of responses and a well-balanced co-ordination. Irradiated and generalized cortical responses alone, as well as dominant ones which absorb all others, would, in the long run, be sure to lack the character of survival aids; in fact, they may harbor danger on many occasions.

What we frequently need is to-the-point precision and specificity. Therefore we are also endowed with another 'mechanism,' an elastic device to focus our responses sharply. We are capable of narrowing them down progressively from their spread so that, when well trained, they turn active only upon a specific stimulation. The reaction then seems to become lodged in a particular spot of excited brain matter and firmly limited to it. This counter-mechanism is called inhibition.[4]

The conflagration first spreading over wide 'association areas' (a term of Flechsig's) is being dimmed down in its outer region by inhibition and dammed back to the point of origin. Thus the original generalization has been partially or fully counteracted by a new pattern of energy distribution.

[4] In the establishment of conditioned reflexes, Pavlov lays great stress upon the part played by the process of inhibition. In his nomenclature, internal inhibition is used to designate that form of inhibition which has long been known in physiology and through which the activity of any portion of the central nervous system is brought to rest reflexly by the stimulus of some other afferent pathways—the reflex inhibition of a sneeze, for example, or of the tonic activity of the vasomotor center. An established conditioned reflex may be inhibited by this method through a sensory stimulus of any kind.

A dog trained by repeated laboratory experiments to a combination of food stimulus and sounding bell will first tend to secrete saliva not only when he hears the customary bell, but also in response to any other abrupt sound. This means that almost the entire central area linked to the acoustical receptor is excited enough to elicit salivation. But by further-continued training, when food is repetitively and consistently denied after other sounds, and when it is again only given upon the one specific sound of a bell, the dog will slowly 'learn to distinguish.' He will do so more and more accurately, salivating only upon stimulation of the bell and ignoring any other similar stimuli. The refinement of this process of conditioning can go on with increasing selectivity in the pitch of the bell until the experiment ends at the threshold below which, for constitutional sensory reasons, the dog can no longer distinguish.[5]

A very significant cortical function, operated through inhibition, is here touched upon: 'differentiation.' It is, so to speak, the antagonist of what was described as generalization. The study of conditioned reflexes has cast light on the problem of differentiation, and it holds some clues to the *differentiated perception of design*—the differentiation of shaded colors, of detailed forms, and their subtle and willful combinations. All judicious consumption of design is evidently based on trained differentiation.

Dr. N. E. Ischlondsky and researchers of the Pavlov school have rendered explanations somewhat like this: distinction and differentiation are response performances that are accomplished when a widening and expanding excitation within the cortex layer is halted and reversed by an inhibitory counter-action. The ring-shaped wall of obstruction which, as mentioned, dams the spreading of excitation, is thrown up by a secondary process of conditioning. Such conditioning is achieved by repeated combinations in time. Through continued practice the ring of the inhibited area is then nar-

[5] Incidentally, at this point, when further tests are forced on the subject, a very irregular 'panic reaction' may set in and what has been called by Pavlov an experimental neurosis is produced.

rowed down to a ringlet and finally the excited area within is reduced to a fine point. *The response is now sharply focused; it has become specific.* This phenomenon of responses acquiring specificity has been observed in higher organisms to evolve by natural life experiences from birth onward, step by step. There is a vast variety of applications for this capacity which is constantly refined by informal or formal training.

Any differentiation once accomplished successfully is obviously an aid to life and survival. We can assume that the capacity for learning to differentiate has developed as such a survival aid by naturally selective processes, because organisms are thus enabled to cope better and more precisely with the exigencies of environment. If design sharpens our nervous tools for differentiation, it proves itself an exercise of vital significance.

The capacity for differentiation seems to be an intimately combined product of maturation and conditioning or learning. Interestingly enough, experimenters have convinced themselves that acquired maturity can temporarily be reduced to an earlier stage. A state of *de-differentiation* can be brought back when stimulation is made to reach the intensity of a shock and, according to some observers, also when the mind is put into what has been described as a state of frustration.

Experimental psychologists have ingeniously demonstrated how a kindergarten child of five, when frustrated in expectations to which he was earlier conditioned, markedly loses his ability to differentiate. In general behavior such a child descends, for the time of this influence, from his level of maturity, or his 'mental age.' He then does not, for example, use his toys with accustomed specificity, but knocks them about as he would have done one or two years earlier, when he was less developed.

Both causes of reduced or reversed differentiation—shock and frustration—are in measured doses very significant to the designer, and he finds means to make use of both.

While a design composition may often require and invite

finer differentiation, at other times devices will be desired to make us less susceptible to differentials or details that the designer may like to suppress from our perception. There are occasions when he wishes, for example, to eliminate from our attention minor irritants and deficiencies in color combination, form, or texture. Strong shock-like overstimulation adjacent to the questionable object, or a strongly felt 'lack of expected stimulation' (which is frustration), will readily help reduce the normal capacity to differentiate. Like a composer of music, the designer can lead us at will into a meshwork of aroused anticipations and fragmentary disappointments or frustration. He also knows how to produce calculated shocks here and there. Thus, by his intuitive gift or according to a plan, he can raise and lower our momentary capacity for sharp distinction.

Any new stimulation is only a fractional change of a total environment to which the totality of our response pattern remains geared. Also our designs and planned constructions must never be conceived as piecemeal, losing sight of the total life while engrossed in detail. Properly understood, plan and design always involve modifications of the environment as a whole.

To picture the effect of our design, we may theoretically assume that there is inner equilibrium in a person before we bring the design into play. When not stimulated by design or accidental circumstance, the entire nervous system is kept in a state of rest or, more correctly expressed, in a *suspended* balance between the inhibitory and excitatory components. These components are perpetually at work in a human being and, in fact, his entire neuropsychic life seems to consist of the manifold shifts of this balance. Whenever the quiet balance is disturbed to a degree corresponding to the intensity of impacts produced by our design, noticeable *resultant* innervations occur at once. These constitute either surplus excitation or inhibition. There will be significant sequences of both and patterns of their combination.

We now return to another operational concept which has

already been alluded to briefly. Disturbances in one region are often caused by an *inductive* influence from another region. This is supposedly similar to the processes of induction which transmit energy phenomena from one electric coil to another or to the induction phenomena discovered for antagonistic muscle groups. Reference is made here to the great experiments of Sherrington, who proved that if we excite the tensor muscle of a leg, the corresponding flexor muscle is automatically inhibited by something like an inductive mechanism.

The inductive effects observed in the cortical region and perhaps in other nervous areas do not seem to occur, however, as 'stabilized' or statically localized. In this they differ from the fixed muscle antagonism. In contrast to these effects they are, so to speak, *temporarily emergent antagonisms*. The phenomenon of 'induction' is quite distinct from that of irradiation, and has intricately different results.

As stated earlier, if an excitation area is definitely dominant, it will succeed in dulling other areas through induction so that other stimuli there become ineffective. If a perception causes a specific excitation which is sufficiently predominant, energy transactions elsewhere become inhibited and brain tissue numbed against innervation.

In contrast to this, irradiation is considered to be the cause for disturbing interference of another kind. A well-elaborated differentiation or, more correctly, a response, well specialized and differentiated by appropriate conditioning, may be made to lose markedly some of its perfected sharpness by the *flooding-in* or *irradiating of another stimulation*. Under such circumstances of confusion the obstructing ring wall of inhibition seems to relax. When it gives way, we revert to more vague generalization. Experimenters have ascertained that the fine inhibitory mechanism of differentiation can be rendered ineffective by induction as well as by the irradiating influence of competitive sensory impacts.

The bearing of all this on design is evident. For example, forms or colors, either simultaneous or immediately successive in the field of vision, will modify each other's impact

and impression. Often they will mutually reduce the clarity of each elicited reaction. Their relationships correspond with the physiological relationships of brain processes elicited by them. Both are actually one to us and will in the end certainly be best comprehended as identical.[6] We arrive at a new understanding of design features through their correspondence with what goes on in our brains owing to their impact. Experiments can probe into the operation, measurements, and intensities of these phenomena, thereby helping us to see the problem more clearly in order to avoid accidental pitfalls and to support our design intention more successfully than by mere guesswork.

Before leaving the vast field of still incipient suppositions on the phenomenon of cortical innervation and force distribution, we should mention an interesting theory which develops the view that inhibition may be set equal to *localized sleep*. This interpretation considers what we commonly call 'sleep' as nothing else but a generalized, far-spreading inhibition, gradually reaching out over larger cortical areas. The velocity with which such a generalized inhibition recedes and a person wakes up is measurably different for different individuals.

The same individual difference in speed of responses—often as much as one to ten—is observed in the small-area inhibitions as well. Therefore, this personal factor holds true also in the differentiation phenomena that were described as produced by a contracting ring of inhibition. In other words, here is an approach to the problem that one person may be capable of distinguishing design subtleties more quickly than another. The phenomenon of *physiological personality* is clearly and quantitatively brought home to us. Indeed, the ability to differentiate and to generalize, and the degree of this ability and its rate of speed, is perhaps a most characteristic trait of mind and personality. Another such

[6] Wolfgang Koehler calls this the principle of isomorphism—structural and spatial likeness *in the relationship* of stimuli to each other and the brain processes, thus elicited, to each other.

very personal trait is pronounced capacity for inductive phenomena. These traits may ultimately define also how *individual personality, within the species, can specifically be served by design.*

It can well be anticipated from the relation of inhibition to sleep that the study of *hypnogene* phenomena and sleep-producing factors may give us a great deal of food for thought-shaping design. Rhythmic and monotonous sequence, even of painfully strong stimuli, have been carefully investigated and measured in their diminishing power to excite.[7] Non-rhythmic and intermittent patterns can do a great deal to revive at once excitation which has failed and can finally be completely overtaken by inhibition under the impact of monotony and sheer repetition.

Original designers have often felt themselves engaged in a struggle for acceptance or in a battle for conquest. If they could grasp more fully all that is involved, the missiles they devise would reach their aims more effectively and their ballistics would be less accidental. They could conquer many a now toughly resistant rampart. They could almost manipulate at will cortical spreads of excitation and inhibition, as well as inductive effects. All this is, of course, not done by an unfailing stark and downright push button control technique. Accomplishment will have to come through empathy as through cautiously gathered judgment and the recognition that elements of design are, after all, somewhat on the order of extremely touchy switches which must be turned on with subtle knowledge in order to elicit the desired processes of response.

[7] Russian experiments of Laporsky, Jerofeeva, Friedman, Schislo, and Solomonoff, Roansky, Petrowa, and others have become known.

ELEMENTARY MOTIVATIONS OF MAN become complicated when conditioned and variously molded in individual lives; they play their role in design as well as in the acceptance of it.

30

Long before the physiologist of today, philosophers and psychologists tried their hand in cataloguing fundamental motivations of man.

Survival is a primary motive, deep-seated, beyond all speculative exercises of the mind. Individual survival and even more, survival of the race, is a normally accepted value in the majority of known societies; most suicides would shrink from their deed if they thought it would extinguish the entire species. The brain physiologist N. Ischlondsky thinks that to react against essential interference with survival, is arch primary to all so-called primaries, those broad bases in which responses have roots and footing. He hesitates to use such evanescent, elusive concepts as basic drives and prefers to speak instead of reflexive dispositions. Designing or furnishing a room seems to bring us right into the thicket of these arch tendencies of response. For a person in the room and exposed to the design, every so often these tendenceis will at least be 'egged-on.' They may even become plainly expressed and manifested by full motor action, accompanied by pronounced emotional response.

218

W. A. Hunt and C. Landis in 1936 perfected earlier experimentation to prove the *startle reflex*, a definite, stable, ever-recurrent response pattern of an involuntary nature. It is called forth when, for example, a shot is fired. Figuratively speaking, a designer has many occasions to 'fire a shot,' to use a startling feature and create corresponding reaction.

A relative or a milder derivative of this bundle of co-ordinated bodily responses, so conspicuous when we are startled by something, is probably the *orientation reflex* which Pavlov described to his students as the 'what-is-going-on' reflex. It can easily be observed when a stimulus of any kind enters our awareness. A noise, a flash of light, makes a dog—and us as well—sit up. The entire nervous system jumps to attention, but the 'where' seems salient here. While receptivity is irresistibly stepped up, the receptor areas are turned for best exposure to the stimulus or in the direction of its impact.

The *defense reflex* may be pointed out next. It watches over survival and secures it by counter-aggression, flight, or protective effort.

Complications appear when the basic response has been associated with secondary conditioned stimuli. Certain contrasting but typical branch manifestations of the defense reflex can serve as examples. From this same reflexive disposition a twofold attitude may derive.

There is natural gratification in feeling visually unimpeded and in being free for action, at liberty, not caged and incarcerated. A person may look at large view windows of a living room with their unobstructed panoramic possibilities, and every time he does so he may feel like taking a breath of relaxation, gratification, and relief. A division bar, a structural post, or a wall pier introduced to interrupt this expanded opening will dim this response and conflict with it. It will interfere with the freedom craved; it will remind him of a 'cage.'

To maintain clear visibility along the approach lines of a remotely possible attack, or for a remotely necessary escape, has been—in minute dilution of the defense reflex—an un-

conscious sub-motive of many a seemingly accidental design decision.

But the defense reflex may involve something else. Another gratification is to 'be protected,' inaccessible to others and to possible enemies—to be screened off from a potentially hostile exterior world. And so another person, differently conditioned, may look at the same wide, unobstructed glass front with anxiety. Division bars give him the feeling of security, of protection against burglary, murder, danger—associations to which the perception of a large window opening invariably radiates in *his* cortex. These associations are in the middle brain linked to negative emotions—perhaps even to visceral or glandular reactions—that may emerge to a marked degree of consciousness. It is obvious that the practical desires and evaluations of the second person are quite contrary to those of the first. As clients of an architect, each will voice his concern, vaguely perhaps, but entitled to his sympathetic 'feeling-in.'

We all can easily comprehend that it is a fundamental defensive attitude which makes us, almost unawares, place value on protective devices in our surroundings. For instance, much of the time we welcome a solid or opaque enclosure, especially a sheltering feature *behind* us. A wall back of our easy chair where we want to relax, or back of our seat at the desk where our concentration shall not be disturbed by our sustained subconscious watching of the rear, has a specific meaning in this respect. And so has the placement of plumbing fixtures. For protection against surprise, we are even not indifferent about how the bathroom door—locked or not—relates to these fixtures. We have come a long way from the original pronounced defensive instinct which prompts many animals to seek a screened and protected place for their natural calls. Yet primeval motivations seem to persist faintly in our designs, and can be traced there.

The cluster of general primary reflexive dispositions, toward defense, toward food intake, and so on, may have varied proportions from one individual to the other. It may become the foundation for a conditioned superstructure of

gradually acquired attitudes that we feel are specifically our own. They may often be manifested in no more than a mental tonus, largely cortical, but combined with a sometimes very pronounced positive or negative emotional accent. This can almost pass as a definition of what we call likes and dislikes, so dear to us and also so conducive to our feeling of being a specific personality as distinguished from our neighbors. Design and the consumption of design often become a conscious personality test, depending to a great extent on all these phenomena that are still too vaguely evaluated.

Individuals are always encompassed by a socio-economic-geographic constellation. A Chinese in the southern province of Kwantung may, by a lifetime of routine, be conditioned to take hardly anything but rice as a gratification of the feeding reflex. In contrast to this, the thought of meat as daily fare will with its quite different sensory appeals start a northern hunter's mouth to water. Similarly, by way of conditioning or 'canalization of response,' the defense reflex can in one person be well gratified, for example, by an enclosing wall of brick. For him this particular structural type has been fixed and attached to the habitual solution of his *shelter requirement*, which can pass as a derivative of the defense reflex. By dint of this conditioning, however, the same person may not feel at all sheltered or protected by the snow wall of an *igloo*, as would an Eskimo, nor by a fair thatch enclosure, which, in turn, is all an Ashanti householder dreams of in his African Kraal. 'I will not live in a glass house' may be the expression of a person who shudders to miss the accustomed feeling he found in his earlier residence that had a few windows less, and in each a few division bars more. But with a proper police department, with heating and cooling provisions of today, and under the impact of current home magazine illustrations, we may gradually become conditioned to an enclosure of glass and movable drapes as against one of immovable brick. Secondary responses can change.

Shelter methods, like diet, are derived from attitudes rooted in primary function. But by repeated experience of

221

combinations, specific stimulus patterns become affixed to a basic response, so that they turn into regular instruments of its unfailing activation. Then the process goes on, with other and more specific conditioned reflex material of second and third degree being added to that of the first until, finally, predilections may become most personal or idiosyncratic. Interior decorators are familiar with this sort of phenomenon. The designer may have to explain to himself and to his client the genesis of all pros and cons peculiarly superimposed on basic themes in order to lift the matter out of the realm of the seemingly arbitrary or again the sacrosanct.

At this turn, the consumership becomes an audience of listeners, to whom a professional analysis is presented. The problem is thus removed onto a new neuromental level, the *verbal* level. In conversation the design is now demonstrated to feature as yet unnoticed but plausible values that have bearing on well-being and survival, and this oral demonstration will often help toward a sound conclusion of the mentioned conflict. Once initial willingness and acceptance are secured, the rest will consist of progressive habituation and adaptation. In other words, a new habit formation may be undertaken by the consumer if he is first helped on the verbal level to discard an older bias.

Having gained a vista into the intimacy between arch motors and design, we return briefly to our parade of primaries. We might refer next to the *control reflex*, which tends toward freedom of our body action and control of the surroundings by our grasp. An urge 'to possess' is but a derivative of this primary.

Another broadly based and regular response is the *precision reflex*. It generally makes any nervously well-developed individual react *negatively* to vagueness or imperfection and *positively* to accuracy. Such accuracy applies to perception and to action as well and shows clearly their close relationship. It is obviously related to the acuity or sharpness of senses and to well co-ordinated motility.

Whenever a gratification of such reflexive dispositions

seems not fully attained, purposeful action may promptly be innervated to attain it. In frustration, an adverse emotional tonus is produced, and this in turn is linked with various measurable vegetative effects which on their part are felt as unfavorable to well-being and survival.[1] We are irritated, disappointed, depressed. None of the basic cravings can be starved without such punishment or a marked feeling of discomfort. Yet we must never overlook how diversified gratifications can be owing to complex conditioning.

It may not be commonly accepted to isolate and speak of arch phenomena, for example the tendency toward control or defense—as certain brain physiologists have attempted—in terms of reflexes. Earlier, this term was reserved for much simpler repetitive nervous events, such as the footsole reflex, which produces its manifest flexing of the toes as neatly as clockwork. Those arch drives, however, regardless of their terminology, often seem to lead merely to new cortical balances, and to other phenomena in the association area, while further palpable consequences may be wholly or partially kept in suspense. The result is not always an immediately flagrant external effect, although measurable inner tensions are produced.

These inner tensions, however, make up the great realm of partly suspended responses that design elicits. They constitute its most significant emotional yield.

[1] The James-Lange Theory claims that emotional experiences are sensorial, that is, vague impressions from our muscles, viscera, and so on.

In THE PHYSIOLOGY OF TRADITION two factors contribute: long habituations and also brief but impressive shocks that become instrumental in the constructive memory of man and the race.

31

The physical shell required by a community or a single family in a given culture shows conditioning of many kinds. There are variations, played on the simple theme of human constants.

How do 'values' come into existence, enter the life of the group, and affect the self-image? How do individual habituation and social tradition, with which design is so closely linked, evolve as powerful factors? Habituation, at the bottom of so many human phenomena, operates on numerous organic and especially neural levels. Living tissue, cells, nerve cells, and entire nervous apparatuses seem to form their habits.

When it rains water diffuses, reaches a rivulet, a canal, and follows it. Observant neurologists have compared this with the flow of neuromental excitation which also spreads and, where possible, discharges through a system that is already in the process of discharging. Any stimulus is believed to have a tendency to contribute energy to outgoing impulses. A newly added stimulus causes responses to follow mostly those paths which are already used in an existing excitation

and which are already effective in channeling nervous energy. When such a canalization is established, a subjective value has been formed, and a social one may be in the offing. Values are potential satisfiers. They produce a chronic, emotional response which will heed all similar signals, even those only faintly suggestive of the customary stimulus. The acceptance of a value seems in itself to diminish protracted inner tensions, which are loathsome.

The growing of a path, or the channeling of responses, is intensified by what Holt has called 'adience'—the principle that any stimulation will cause the organism to act and move toward more of the same kind. Water not only follows a channel but in doing so accrues in quantity and deepens it by erosion. The principle of adience has been considered helpful in explaining the genesis of reflexes and of many response patterns such as inclination to acquisitiveness, gregariousness, and so on. Any vivid experience tends in this way to perpetuate itself, unless through special circumstances a counterconditioning should set in.

A perpetuated response pattern is, of course, what we call a habit. Habit on higher levels may work in two ways. Behavior can be streamlined by it through elimination of earlier complicating responses; the revulsion against a stimulus disappears, wears off. A mortician's apprentice will soon not wince at his job. But behavior may also be relatively amplified and complicated through addition of entire chains of responses and again habit will account for such acquisition. An acquired fixed sequence of actions in glands and muscles begins to unroll, for example, when we sit down at the usual place for the usual meal and begin handling spoon, fork, and knife, followed by salivation and swallowing, all in the usual way.

One thing must be firmly kept in mind. Habituation, habit-forming on all organic levels, cannot really be separated from constitutional growth or maturation, as physiologists call it, since growth is not an isolated phenomenon. It never occurs in a vacuum. It takes place through manifold interaction with concrete surroundings. The child learns

225

while it grows and grows while it learns. A segregation of acquired habit and sheer growth responses or, in other words, an attempt at theoretical separation of nature and nurture, is a most controversial undertaking.

Also, a handy distinction between cultural tradition and innate 'instincts' cannot be established by setting forth brilliant generalizations or preconceptions, but, if at all, only by meticulous observation. A sparrow was observed to abandon his natural chirps and to learn canary call notes when reared in a nest with canaries. After some struggle and delay, he imitated their song successfully.

Habits interconnect into a tough meshwork. Responses of the first order can, by conditioning, be linked to secondary and tertiary responses. The way these various sets cling closely to each other and can, in fact, be made to disappear in entire chains when one of their vital links is broken or made to disappear—these are mechanisms studied with care by reflexologists. The best among them know, however, that the organic regularities which they observe would be sorely misunderstood as *mechanical*. Their studies have been momentous in illuminating the processes of habituation and learning as well as the chances for successful acceptance of design.

'Tastes' depend largely on the establishment of values through the process of canalization. The satisfaction of a drive or reflexive disposition which may be rather general at first is accomplished in the end by one specific kind of stimulus.

At the beginning of a baby's life, a great number of substances put in his mouth cause swallowing. Later, the infant turns choosy. Thresholds have become high for many stimuli which were originally within the generally accepted class of adequate stimuli. A two-year-old, after responding at first to all tones and rhythms, will soon demand certain nursery rhymes for satisfaction.

Among any set of original stimuli, there are, of course, more or less potent ones. By conditioning, however, the

original degree of responsiveness may actually be reversed. It has been proved that acquired tastes may replace sweet milk with bitter beer, a rhythmic movement with a jerky one, gentle combinations of color or sound with what earlier was considered shrill dissonance.

Canalization is the psychological term for a particular type of conditioning: a general, non-specific craving is given an increasing and ever more specific satisfaction. Unlike other cases of conditioning, however, canalization requires no shifting of association to a new or far-fetched stimulus. It involves instead an act of selection from among more or less adequate stimuli to make one of them dominant in the business of eliciting response. In other words, for one particular stimulus, the entrance has been made easy, the threshold cut low, the door left open.

Experimental psychology can teach a designer that canalization is the most promising sort of conditioning he could attempt, if he wishes to be an organic realist. He then goes on, producing the same, 'but more so.'

The designer must also know that it is not possible to become accustomed to everything; one merely adapts himself to stimuli within a certain range of tolerance. Within this range, planned or accidental circumstances begin to delimit responses to a specific stimulus or set of stimuli. An emotional accent is then often produced through the repeated exposure to the same. This has been called 'the pleasure of recognition of the familiar.' The 'ethnocentrism' of the anthropologist, Gidding's broad principle of social unity through consciousness of kind, has much to do with 'the love of the accepted.'

The identification with one's own kind, e.g. where likes and dislikes are concerned, may come first from attachment in infancy to one's parent. Elders may be deified or revolted against, yet generally parenthood is a basic device to preserve tradition. Furthermore, a perpetual self-identification, an identification with one's own cherished ego, calls for maintenance of habitual values. These values are not just pigeonholed, but form a sensitively balanced system that guarantees

one's personality and its continuance. Design and design acceptance thus become eminent instrumentalities to brace the individual by his adherence to himself as well as the group to which he belongs.

Indeed, canalization—preference acquisition—is largely what might even be called the forming of a personality. It is distinctly felt as impairing the personality to give up a once canalized response. To keep canalized responses intact means to keep one's ego defended, its image untainted. 'The insertion of a new value . . . may set up a sense of strain and disturbance, a sense of not being one's self, a sense of pressure to embark on an uncertain voyage.' [1]

Here is a plausible explanation for resistance to innovation in design, and for the time lag in acceptance so well observed by sociologists. It is a problem cardinal to the designer.

No personality is so plastic that it can learn and again unlearn things in a crazily checkered row. Habituation, so intertwined with maturation, is, after all, a life process and such processes are to quite an extent irreversible. It would be unwarranted to predict that patterns of response, conditioned and reconditioned, will follow and replace each other in an endless succession leading nowhere, and reflect only a senseless sequence of offered fashions. The sociologist De Sanctis is convinced that values are formed as the branches of a tree sprout, never to grow backward into the trunk.

The picture of a slow and steady shaping as with a growing tree, may have to be supplemented, however, if we turn our attention to drastic episodes which may and do occur, just as a bolt of lightning which may sometime strike that tree.

Although habituation operates through frequency of exposure, there may also be responses fixated in quite another manner. The shock of intensive emotion linked to the experience of a single strong stimulation may be a decisive and

[1] Murphy and Newcomb, *Experimental Social Psychology*, p. 230.

formative agent. Some very negative fixations may thus be produced by what Freud called a trauma, the Greek word for wound or lesion. But also positive vital experiences can come and be fixed by way of shock, and this the designer must never forget. In fact, great art could never do without sudden impact. One intense delight, like one of mortifying anguish, may become an almost unbeatable competitor to many earlier or later experiences of the mild habitual kind.

A house, then, can be designed to satisfy 'by the month,' with the regularity of a provider. Here it satisfies through habituation. Or it may do so in a very different way, 'by the moment,' the fraction of a second, with the thrill of a lover. The experience of a lifetime is often summed up in a few memories, and these are more likely to be of the latter type, clinging to a thrilling occurrence, rather than of the former, concerned with humdrum steadiness. Here is the value of a wide sliding door opening pleasantly onto a garden. It cannot be measured by counting how often and how steadily the door is used, or how many hours it stays open. The decisive thing may be a first deep breath of liberation when one is in the almost ritual act of opening it before breakfast or on the first warm and scented spring day. The memories of one's youth and of the landscape in which it was spent, seem composed, to a considerable degree, of this sort of vital recollection. There are in each life certain scattered quanta of experience that may have been of small number or dimension statistically but were so intense as to provide impacts, forever essential.

The designer undoubtedly has to deal with both these principles of fixation of memory values: habituation extended in time as well as shock, with its characteristic brevity and singularity. Not only a habit, but any fixation can produce dominance, so that other responses are not only inhibited but, as discussed, come to discharge their energy into this dominant response.

But psychologists have also observed that habituation often terminates in only a partial dominance, and other competitive responses do not really die out but linger on in a

repressed state. Such an internal split and prolonged underground guerilla warfare neurotically impede the organism's activity stream. It produces emotional states usually undesired by the designer, who must be on his guard against them. If he truly wants a design feature to stand out as the essential one, he must make sure that any and all stimuli and responses possibly militating against it are not just repressed temporarily but successfully silenced once and for all. And so the study of repression, the meaning of *incomplete conquest by dominance*, are most interesting to him. Concomitant are experiments on memory concerned with physical forms or other stimulus patterns. It is often the designer's business to stabilize awareness of features deliberately made dominant. But whether conscious or not, it is the *emotional intensity and accent* which seem to fix memory indelibly, and to account for its effectiveness in subsequent attitudes and motivations.

If we have learned to consider environment as the sum total of all stimuli to which a neural system is exposed, it becomes clear how the future development of brain physiology will aid and underscore with factual knowledge the design of a constructed environment. The designer, the architect, has appeared to us as a manipulator of stimuli and expert of their workings on the human organism. His technique is really with the organic matter of brains and nerves, however familiar he should be with the trades of the steel fabricator, the mason, the plumber, devoted to external inorganic tasks. Their outer arrangements, though, may further or harm inner physiological developments. This is so except perhaps where matters seem predestined by heredity. There it is often assumed that things are removed from design influence and determined by constitutional equipment and genes. What seems hereditary, however, is often influenced by the prenatal, the uterine environment, and the condition of a child-bearing mother is not independent of the situations in which she finds herself for the act of birth. Whether she spends the months of pregnancy in a cave, in a nomadic

230

tent, or in a residence with controlled climate and insulation, whether she has her baby kneeling on two stones or after being wheeled from the labor room into the delivery suite of a modern maternity hospital, briefly encompasses the designer's influential contributions to what may be early death of the infant or later appear as its inherited constitution. The limits of these contributions and so the formidable powers of design often seem almost beyond scrutiny.

There are perhaps more severely defined limits to design on purely socio-psychological grounds. Organisms are group phenomena and human beings belong to a society. In altering a tradition or in substituting something else for it, we must bear in mind that new habits or fixations cannot possibly be created in a vacuum but are sedimented by a novel dominance over older, established habits. In general an entirely new response, one utterly different from earlier ones, and one fully detached from a reflex basis, is not in the cards. 'New habits are not plastered on piecemeal; they are assimilated into the dominant pattern of a going concern . . . each new habit can integrate with habits already present; it can, under special circumstances, displace habits weaker than itself (or weakened by its arising dominance); it can be assimilated as a member of a family of responses. . .' [2]

In a child, the assimilation of new habits need not waste much energy on the displacement or remodeling of what went before; and so habits formed at an early age are particularly strong and stable. While adults may have the purchasing power for design, children are, biologically speaking, the principal consumers because they are the most responsive ones. They are easily affected by it for a lifetime. But mature customers of design are especially difficult to serve. Apart from the impediment already explained, they are liable to resent subjectively any deviations from their ways as imposition.

Razran has made clear that human subjects, different from

[2] Murphy and Newcomb, *Experimental Social Psychology*, Harper, New York, 1937, p. 166.

Pavlov's dogs, often show something like an 'attitudinal control' of the conditioning process. They prove capable of influencing or even reversing it by a reaction against the experimenter and a resistance against the conditioning setup itself. Thus tradition may strangely stimulate an individual to rebel against its continuance; or again, a would-be reformer of design may easily induce or reinforce a reactionary attitude of the public against his person and consequently against his proposals.

Tradition could be considered as the social establishment of stereotypes, for which the arch examples are gesticulation, facial expressions, and verbal language made understandable within the group. In the last analysis, all other *meaningful forms* are also derived from self-expression and then *socialized into instrumentalities of communication.*

It seems that a full absence of facial expression and gesticulation is to us socially tedious or even alarming. It is to us like muteness and silence, an intimidating blank, perhaps because it leaves us without information or frustrates our fundamental need for signals. This may be only one case within our more general emotional reaction against emptiness, referred to earlier as a mental horror vacui. Out of the general craving for an interchange of signals, specific sounds, gestures, and facial expressions are canalized into equally specific satisfactions and become socially accepted. They may be only partially understandable within another society, and a Chinese student in an American college or fraternity has to relearn to behave scrutably, not only to speak comprehensibly. Formal expression in design and all the arts seems to follow out of a socialization process similar to the one described here for the organic prototypes of expression, the expression by facial muscles and by general gesticulation, using the members of our body.

A startled look or a baby's smile are probably primary. They form the raw material on which the socialization processes begin to act.

The socially accepted version of look or smile may become so without words and by the suggestive action of the child's

elders. Autosuggestion may soon support the development, and it hardly differs from other kinds of suggestion, except in its origin. In most cases, however, autosuggestion is particularly powerful, as it happens to be free of emotional barriers set up against external influence, and of those attitudinal resistances that are activated so often by authority situations. Perhaps the most profound effectiveness of a tradition is accomplished when it is no longer consciously discerned as such. This occurs when self-identification with it has become so strong through autosuggestion that doubt or acceptance of anything else is felt as a personal affront. An inner emotional evidence, not mere dutiful adherence to tradition, corroborates the conviction as if a spontaneous, very personal choice were at hand.

Our issue has been to highlight the physiology of tradition, the emergence of fixations as well as the processes affecting a modification of tradition or its gradual replacement. Nothing illustrates these processes of social integration and disintegration so concretely as does the constructed environment, the shell which human society secretes through its manifold, system-controlled but often individually initiated, design activity.

The ultimate accomplishment of a constructed environment, fully illuminated by bright biological comprehension, is, of course, still far ahead of us. It will be obtained by degrees only.

Our courage may be bolstered if we remember the meager results of other sciences in their helpless infancy, for example, chemistry two hundred years ago, and if we realize the difficulties that typify any beginning. We may then contrast this picture with the present stupendous applications of these same but now matured sciences to useful design.

A writer in the eighteenth century may have been passionately convinced of the immensity of potential realizations through the physical sciences. Should he have envisaged for the future metal bridges which span a mile, building-skeletons calculated to tower a thousand feet before any enclosure walls are installed, or metropolises housing millions,

with gas, water, sewage, and railroads piped underground, he would have had greater difficulty proving his propositions than we have with ours. We are convinced that patient research, starting from the elementary and progressing to the complex, can indeed gradually remodel the constructed world about us, to reach new levels of organic wholesomeness.

STRANGE IMPORTS AND MISAPPROPRIATION OF
CULTURAL GOOD are general human custom
of long standing.

32

Cultural evolution seems largely the
evolution of habits and comparable fixations. This makes
them worth the study of the brain physiologist but also a
crucial issue for the designer and his consumers. It is in diet
and dwelling that habits are hardest to react against. Moral
attitudes may also have habit character but are less hardy be-
cause they are introduced later in life and are consequently
reflected upon more consciously.

The food our mother fed us as toddlers becomes a pre-
ferred stimulus. The dwelling habits, whether acquired in
the tent of Siberian nomads, in the New Mexican adobe, the
Puerto Rican swamp squatter's hut, or the corrugated iron
shack of a Buenos Aires slum, are taken in by the still
speechless child as unquestioningly as the blue of the sky
and the warmth of sunshine.

Thus architecture, the bias in home building, the lodging
tradition, is the hardest to reform. Certain patterns of re-
sponse have somehow been preserved from cave days to the
present. Mystically inclined conservatives may revere them
as quasi-sacred.

Conservatism, down to the aimless repetition of motions
which have lost their meaning, is a stratified and rather com-

plex phenomenon. Sometimes social tradition is its only sub-floor and it reaches no lower; sometimes it has a strong bio-logical foundation. Essentially and originally, it is a survival aid of the first order, although it may turn nonsensical with the passage of time.

We see a dog go to rest; he begins turning and spirals to the floor until he lies ring-shaped with his nose under his tail. This has been interpreted as precisely the way his an-cestors pushed down prairie grass, formed a little bowl-like berth in which to rest, and protected their noses against swarming insects. But our dog does all this on the firm lino-leum floor of a well-screened kitchen. No grass, no insects. His behavior has become strangely misplaced and is an atavism.

In cultural situations left-overs are not the only strange inserts. When moved from one point of time and space to another, from one constellation into another, anything can become profoundly displaced with regard to its function. Insular primitive society and more or less precultural ages were perhaps less threatened by such strange insertions. These ages may have been more successful in maintaining a healthier, living continuity of habit and tradition than higher civilizations that are wide open to cosmopolitan traffic. Still, a variety of contacts between primitive groups, through the jungle, over mountain barriers, or by paddling over oceanic water from island group to island group, must have brought not only armed combat but also more important clashes of habit and, above all, a controversial borrowing from strange, incompatible traditions. The history of design and design enjoyment is full of such transfer. Ancestral action is re-peated, yes, but strangers can sometimes be imitated enjoy-ably, even without comprehension.

There was, and still is today, much of stimulation in mis-interpretation. Savages enjoy looking around a dime store, although they might misunderstand much of what they see. A Zulu chieftain dons a top hat without possessing the striped trousers; an occidental tourist may love Chinese char-acters so much that after his return home he will hang up

236

in his study a beautifully brushed but puzzling pictograph that in Canton was pinned to a washroom door and, in translation, reads: 'For Men.' Students of applied art will be herded through ethnological museum collections and with pencil and paint learn to exercise that ancient human gift and prerogative of *misappropriating forms and ideas*.

Still, we should hate to miss all of this. Not unlike the primitive society, the civilized one has been increasingly subject to the external influences of interchange and to the lure of misappropriation. Like curious Americans, the Greek tourists Solon and Herodotus traveled abroad, often to pick up misinterpreted formal and ideological souvenirs. Plato, in his *Timaeus*, narrates how an Egyptian priest congratulated Solon on the childlike naïveté of the Hellenic voyagers. Former periods may have given more earnest thought than ours, however, to the systematic benefits of a grand tour. For a student seven hundred years ago, a switch from Salerno to Paris was easier than is switching from Ann Arbor to the University of Southern California today. It was certainly more recommended to scholars, nor did they lose any credits in turning to a new Alma Mater.

Traveling, learning—and misunderstanding—are old human institutions. Since the neolithic days of forested Europe, there has been a lively exchange of mental and physical commodities and controversial contraband.

Civilized Japan was perhaps something of an exception to such promiscuity, since for hundreds of years at a time it was not only geographically but also politically an island. We can repeatedly refer to old Japanese circumstances, because the undisturbed and tight correlation of habits in different fields used to be very striking in that country. The traditional Shinto construction of the dwelling seems to be tuned acoustically to a specific sort of music, dance, manner of speech and poetry, to the indigenous clothes of men and women, and to the peculiar customs in taking a meal or a bath.

A good deal of that clarity of integration may have been obscured earlier by Buddhistic imports, especially the wave

since the sixteenth century. But when Admiral Perry crashed the sea gates of the empire three generations ago, an avalanche of foreign cultural currents rushed in, underwashing the integrated structure. It is significant how things from then on started to cave in, to go out of joint and out of gear. Japan became an example of how tradition totters. French banking and Beaux Arts architecture, German engineering and military modernism, American mass production and commercialism, permeated these traditional islands of 'noble but simple' samurai, and humble and docile rice growers and fishermen. All of them had been accustomed to liking one kind of plum twig and one kind of lyrical roll picture. Soon, almost suddenly, the Japanese themselves turned into enthusiastic transoceanic tourists, kodaks and notebooks in hand. They were bent on enriching their long-marooned islands by pickings and imports.

When, a quarter of a century ago, I followed my first lecture invitation to Tokyo, Kyoto, and Osaka, I heard a girl sing a song in one of those half-and-half American night clubs. On the surface she was not a *moga*, which was then the Japanese term for 'modern gal' and roughly corresponded to a New York 'flapper' of the 'twenties. She was traditionally dressed; for some reason her geisha name signified 'a thousand years' (probably of happiness), although she was only sixteen. The song went on in quarter-tones with chirping, quivering, shamisen accompaniment—a true replica of old-fashioned Japanese lyrics—and the text was: 'Shall we make love and go on drinking tea? Or shall we get out and take the Odiwara Elevated Express? See, just now rises in Shinjuku the famous moon of the Musashi plains, over the roofs of the five and ten cent stores.'

Poetic quarters of ancient Tokyo were soon strangely enriched by a turmoil of neon signs to compete with that famous moon. The sexes danced together (to the horror of the old-fashioned), tapping loudly on hardwood floors. The department of education prescribed that school girls dress in airy occidental clothes and sit on benches so as not to become bow-legged by resting on their heels; during the war, female

bus drivers and street car conductors were proud to wear breeches and high-laced boots. Multitudes began swarming on bicycles along Tokyo streets studded with millions of telephone poles, or crowding the subway train Asakusa-Ueno.

Far from the metropolitan hustle, at the seashore of Kama Kura, the giant Buddha statue Daibutsu still sat calmly, but not much longer. A world's fair traffic developed all around it, and near-by, under the native warped pine branches, expanded a fashionable modernistic beach club with upper-class week-enders relaxing in the Fabrikoid upholstery of chromed metal chairs, sipping American drinks on the view terrace while inside a pianist, supported by saxophone, intoned syncopated sound loveliness to reach the distant bathers through a powerful loudspeaker.

The breaking and supplanting of habits, the glory and downfall of tradition are best understood by an unbiased outsider, and it is by this token that we find distant Japanese circumstances more revealing than corresponding trouble in our midst.

We have spoken of pianos and leather shoes versus sound-absorbent floor mats. The one uproots the other; they do not go together. But there is always a whole string of causes upsetting the applecart of a once steady and lovely tradition. Leather shoes with thin soles are themselves concomitants to bicycles and automobile gas throttles that are hard to pedal with thick, wooden-soled sandals. Closets are made to hang occidental pants and evening gowns whereas this mode of storage was never applied to kimonos, which are always laid flat. Chairs and tables are introduced for wearers of those pants and gowns, so unsuitable are the new Western garments for sittting on one's heels and eating from a tray placed on the floor. All the interlocked structural and functional standards started to go overboard, together with the simple floor mats from which these and all uniform elemental dimensions were derived. Everything seems lost in the shuffle of a dissolving past and in the novelties of the present that call for installation by a host of new-fangled

specialists, such as plumbers, tile setters, glazers, electricians, steel-sash contractors, heating and ventilating engineers.

The ancient Japanese carpentry builder as a prototype of well-conditioned human functioning has grown sadly obsolete. He used to lay out and execute everything by himself, from wooden bathtubs to paper-covered screens. Now he is contra-indicated and baffled. He does not know how to work from these accursed but venerated blueprints, and less how to co-ordinate eighteen or twenty subcontractors for trades unfamiliar and unknown to him. He never could quite turn his personality into that of a many-sided entrepreneur. Befuddled, the old man prepares to sink into his economic grave.

Technical civilization rushes on. But a finely spun human brain clings more tenaciously and painfully to its previous conditioning than a magnetic wire recorder that is promptly voided and refilled by every new microphonic impact to come along.

An intensely interlinked complexity of causes and effects may ultimately succeed in effacing neatly established neuro-mental patterns. On occasion, and now more than ever, habits and tradition seem to be blasted to bits and the table is speedily cleared for a new game.

CONSCIOUSNESS MUST NOT BE OVERESTIMATED, as so much occurs in our being unawares. Still, to direct awareness remains a paramount task of the designer.

33

A most practical question arises ever again: How, and how drastically, can design and the individual designer operate on such a sociological product as tradition, stiffened as it has become. How tenaciously will the consumer cling to it? Certain illuminating case histories will have to help our understanding.

It should go without saying that the methods to recondition a sufferer of any maladjustment must not entail brute force such as locking up the cocaine, the opium, or the addict himself. On the contrary, police power very characteristically tends to fail here. An order to be useful must seep in and find 'volitional' or spontaneous acceptance. A proposed environmental change through design must be carefully prepared for such acceptances. This is often achieved by preconditioning through verbal explanation or what has been called enlightenment. It works through a frequently repeated intellectual appeal that must be accompanied by one of emotional nature and is best introduced wtih judicious gradualness.

Yet, we deal with the brain phenomenon of automatic association, and conscious control here is only minor. A *de-*

signer's arguments on a conscious level will therefore never be completely effective but will remain precarious. At many a turn we have to consider the restricted powers of consciousness.

We said that layer upon layer of conditioning must be placed to build up our habit structure. Like the earth added in the site improvement for a building project, each layer must be compacted to form a firm terrace. It must be tamped repeatedly and stabilized until higher reflex structures can rise without danger of collapse.

Conscious affirmations seem to come frequently *post factum*, not as ground work. They are rarely decisive at the beginning and are often hardly more than the additive satisfaction of final solidification. They appear *after* little accounted-for emotions have already established a strong attitude, pro or con, toward a design. At any rate, our responsive contact with a design often operates in a more direct physical manner, such as actually sitting on a designed chair. Mere abstract meditation—just thinking about it—does not even begin to exhaust our essential relation to a design.

A great many of the simple and co-ordinated reflexes are as unconscious as they are involuntary. Even the initial sensory reactions involved here are accompanied by a consciousness that is frequently very limited. Visual and auditory sensations are often clearly differentiated, but the multitude of our inner and muscular sensations are for the most part vague and beyond the orbit of consciousness. The smallest dental surgery or repair suddenly alerts in us a brand-new awareness, formerly quite unsuspected. Only now do we learn that the position and exact shape and surface texture of every tooth had evidently been known to the tip of our tongue, and every bit of strain which the tooth exerts on its socket while we chew had obviously been minutely recorded. Sensory reports have been coming in always, but now they happen to be different in a few tiny details, which are at once noticed exaggeratively. There is a similar experience in store when we sit down on our favorite upholstered chair

and find it almost a stranger even with only one of its springs broken.

Sense impressions have a resistance that is graded against eclipse from consciousness. Their peculiar hardiness in this respect is something to ponder. It is well demonstrated in increasing anaesthesia or when we fall asleep. On such occasions these sense activities, not all at once but one after the other, lapse into oblivion—with the auditory sense usually enduring to the last. Even in our slumber we retain a bit of hearing.

Consciousness, or lack of it, in the sensory realm is intertwined with that of reflex life. Yet to be aware or not is by no means the vital issue that decides well-being and survival. The warning can only be repeated that, as designers and as consumers or users, we must guard against any over-evaluation of consciousness. And the warning is extended to include here the world of conditioned responses as well. These, too, are largely characterized by unawareness of the processes that generate them. A man may become attracted to a certain musical selection by hearing it repeatedly during leisurely vacation breakfasts at a pleasant resort hotel. He may later recognize the music with similar pleasure, but not remember the casual incidents of becoming first attracted to it. It may, of course, be different when this same music first came to him on a significant boat ride in the moonlight with the young lady he adores. In such a case, the event of linkage may always remain spotlighted. Likes and dislikes, once acquired, may be rationalized in many ways, but circumstances of which we are completely unaware are often connected with their acquisition. We can never be certain whether those likes and dislikes are originated quite by accident or whether they are essentially valid and deserve to be abided by. They are always fateful even though sometimes rather ridiculous considering their genesis. To permit acquired likes and dislikes to govern design of consequence, without screening and interpreting them skeptically, is more than hazardous.

Of course we do not favor only such decisions that are made in the limelight of consciousness. On the contrary, we

should become convinced of the overwhelming importance of minimal values in sensory and neurocentral energy transactions. Stimuli below the threshold of awareness are our daily fare; they move us continuously. Such subliminal impacts and conditionings may account for what we call intuition. They may make for our greatest wisdom. Certainly the best judges of personality, and an architect should be one to serve it, seem to work through intuition and in exceedingly short periods of time, on the spur of the moment, not knowing exactly how.

Our deep faith in intuition, however, must not prompt us to disdain the research that aims at objective yardsticks so as to insure against the most appalling detriment and waste in cases when false or faulty intuitions are trusted—and fail.

No matter what was said on behalf of the subconscious, awareness remains a great issue to the designer. He has to acquire a vast operational knowledge of it and must learn that, according to experiments, awareness of almost anything can be strengthened or blocked out if appropriate means are used. He may often have to wield these means. It is up to him to distribute highlights, emphasize essentials, and obliterate distractions.

It is in this era of brain-physiological research that the designer, who wields the tools of sensory and cerebral stimulation professionally, can perhaps be recognized as a perpetually and precariously active conditioner of the race and thus acquire responsibility for its survival. He acts, in a way, as a guardian of such survival, and students, as practitioners, will gain in moral stature when they come to consider what is entrusted to them.

Seen from this vantage point, any short-range commercial role of the designer appears not 'practical' at all. His practice reaches down so deeply that to look at it as a mere business proposition is foolishness. He is not just a caterer to already established responses, he is a grower of responses and even of the plant itself which can be cultivated to respond. The fact is that certain pathways for nervous impulses

grow *and can be made to grow*. Such pathways can at least be 'facilitated' functionally during an individual lifetime, not only during that of the species.

Golt's experiments with animals, whose life he succeeded in maintaining after removal of their upper brains, give a practical demonstration of the simplified and more predictable psychic material a designer would have to deal with and to cater to if the vast assortment of acquired conditioned reflexes could simply be set aside. But it cannot and will not be set aside. If the functions lodged in the upper brain render the picture complex, *we must gladly accept this complexity in spite of any puristic, aesthetic creed*. As it is, the designer will, in the richer human world, have to employ consciously the involved responsibilities of his job as a gardener of nervous growth. The amount of good or harm he can do to mankind is staggering. The potentials have not yet been exhausted in the curriculum of the industrial art school or the college of architecture.

The designer will be most useful to his consumership if he does not let himself be side-tracked into reduced sub-human, merely sensory aesthetics. To aim at mere impressionism is by no means normal. On the contrary, it is abnormal and artificial to relegate oneself to a sort of primary perceptual abstraction. It takes self-denying exercise to do it. To be all eye for light and color and bring them onto the canvas was just such an abstraction and was, for a time, a wonderfully refreshing theory. The common man never went along with it, in spite of its superb accomplishments. It may be dangerous to let such interesting indulgence in sophisticated primitivism lead us astray. It cannot do so for any length of time. Nature cannot be overcome. Nervous excitations travel at a velocity of eighty or ninety feet per second from peripheral receptors to cortical centers. We cannot intercept them at will or easily cut off their later associative involvements and enrichments. Upper brain processes and sensory events interact continuously. That is fundamental human nature and you cannot be 'all eye.'

Impressionists beware: upper brain processes can even cancel out sense impressions. An elaborated conditioned reflex, secondary as it is, has often proved in experiments to be more powerful than a fresh and primary sense stimulus. A dog trained to run, upon hearing a bell signal, for his dish of food in the corner of a room will do so even if there is plainly no food to be seen in that corner! We may lift the left hand with a silly stare at its wrist, although it is perfectly visible to us that our watch has been transferred to the right hand. The acquired reflex is not simply neutralized or eliminated by a mere sense check-up of circumstances. If this were possible, the sense impression would expose the particular action as patently useless and consequently inhibit it.

To be sure, the planner or designer has to manipulate sensory stimuli, but he must deal and must learn to deal with upper brain phenomena which are, in terms of practical physiology, the true correlates of important human adjustments, whether or not they actually emerge into consciousness.

'CONTROL' CRYSTALLIZES IN OWNERSHIP. The map of towns, architecture, and the entire constructed and fabricated environment have actually been dyed in the wool by ownership.

34

We consciously register ourselves as the helpless victims of surroundings that are not controlled by us. Without control of environment, our actions seem submerged in helplessness and passivity. This is a situation on which we always tend to place a negative emotional accent. The 'space behind,' for example, that space outside of our visual control, has just such a negative character. The space near the grip of our right hand, or in full view, has a definitely positive, emotionally satisfying character because it is under our control.

Portions of the constructed environment that we are physically able to modify, and later, those that we have *the right* to modify or to make use of at will, have pleasurable associations.

Through practical experience, humans and animals high up in the evolutionary scale have further developed what has vaguely been called the 'instinct of possession' and, when concerned with latent or less-used property, 'the collector's drive.' But in simplest words, *ownership means control* if it means anything at all in rational terms.

It is characteristic of architects to speak of their clients as owners. The question of ownership of buildings, which are

the most significant part of constructed environment, opens a vast field of discussion. How and to what extent have attitudes of ownership influenced and penetrated architectural production through past history? Here architecture turns into a gauge and a demonstrative expression of socio-economic systems and controls. What interests us even more, it deals with matters of socio-psychological significance, which may have become almost divorced from truly practical economics.

The natural precedent for ownership is perhaps the conscious 'possession' of our bodily and mental faculties. First, we have a naïve way to divide our truly indivisible person into parts: hands, feet, a head. Then we say, 'This is my head, these are my feet, my hands.' If a hand becomes paralyzed or is amputated, the assumption is upheld that it is still the hand *belonging* to a certain individual; when we are speaking of higher organisms, there is of course psychological justification for this assumption. Had man remained as regenerative as lower animals whose cut-off member can reproduce itself and even has the capacity of adding on an entire new 'individual,' our so-called possessive instinct might well have developed in a strange and different way, or be less marked.

When human beings began to provide tools to supplement their physical faculties, and in general to produce commodities for their use and consumption, they obviously extended the concept of possession further, to include these products. In a transcendental way, they extended their own egos, their self-images, into them.

Apart from 'phantom pictures' that we may retain of lost limbs or belongings, however, it is evident that the primary concept of possession is a functional one and clearly refers to actual use, or at least the freedom to use. Permanent absentee ownership of an empty house can only mean that its use by the owner, while not actual, is possible.

But beyond this simple beginning of the ownership concept lies, added, a vast psychological development into less and less functional meanings of possession, which have tended to endow it with an almost mystical character.

248

Long before human beings, nesting birds staked out and violently defended claims to their hunting grounds. In nature, however, this seems to be merely a use claim of the first comer and is often restricted in time to the breeding period only.

We humans condition our children by handing them goods as gifts on a long-awaited festive day, telling them: 'They are now yours!' This magic phrase and ritual connotes a transference not merely of use but of ownership which undoubtedly is deeply impressive to a mind in the formative stage. Strictly physiologically, it seems incomprehensible, and such transference is merely a symbolic act. The presentation of use rights proper becomes inextricably intertwined with this rather mystical rite of transferred ownership, and only adds to its emotional complexity.

A mental picture of possession is thus far from being rational. It is marked by a magic extension of the individual ego beyond its natural boundaries, beyond its time limits, and even beyond the grave. As a further matter of mystical fact, possession of a granite tomb, or of volatile fame, is felt to insure continuation of existence in some occult way. And finally, possessions, buildings, and furniture are conceived as falling to heirs; they are *inherited like organic properties*, like physical and mental qualities. They are also seen as agents that have the power to bridge time and bind it together for us.

In the family group, a possessive extension of the male ego over its mate and offspring existed for a long time. Later, together with other related concepts of ownership, it was partly dissolved but not fully liquidated by tribal communism of a prehistoric age.

The concept of ownership has reflected the various socio-economic systems developed by man to fit varying types of production. It has acquired certain colorings during the more recent stages of feudalism or of industrial capitalism, and these colorings are significant because, although slowly fad-

ing perhaps, they continue to characterize to a great extent the currently prevalent picture.

Designing a building means inherently dedicating it to specific controls. But man has claimed ownership of various parts of his natural surroundings as well. A great portion of them—the land, the water, the woods, if not the clouds—'belong' to an individual, a community, a nation. Especially constructed, man-improved environment is a crazy quilt of belongings. This is very apparent when one flies in a plane over France, Guatemala, or Canada, and finds the land division pattern in each case strikingly different. It became what it is as a result of multiplied specific ownerships and design-dedications.

With the spread of purchasing power, and its concomitants, mass production and supply, the picture changes further. Developments such as prefabrication of houses, based on collective rather than on individual design-dedication, profoundly modify the situation. First- and second-hand ownership, for example of an automobile, become less distinguishable when the owned commodity has been designed for no one in particular, but rather for general use.

Also, that ingredient of the ownership concept which derives from origination, *authorship rights*, will undergo marked change when choice and design do not tend to any singularity of initiative, but to multiple manufacture. Ownership and authorship cannot but change in an increasingly prefabricated world.

In architecture, however, the concept of 'title by authorship' has in the past been cloudy to start with. Medieval anonymity of creations was preceded by doubtful ascriptions of authorship in antiquity. The architect as an 'author' might then have been the building manager and contractor. Individual inventing was comparatively infrequent and usually not emphasized. Also in our day, the balance between authorship and ownership is not untroubled in architecture. Ownership and authorship titles seem somehow to conflict and appear occasionally inimical to each other. Home owners, perhaps justly, often like to claim that they were really the

250

authors of their home designs and seem to begrudge author-ship rights to an architect, because they sense that these rights are somehow competitive with their full enjoyment of ownership and basically infringe upon it. There is unques-tionably at least an element of physiological truth in this curious feeling. A substantial design control, a domination of shape and forms to live with, cannot well be relinquished if one wants to own them.

Many complications of this theme and a variety of views occur in fields other than architecture. A piece of music *belongs* to the composer. In the Andaman Islands a song may receive applause and find popularity but no one has the right to sing it except the inventor. Later on composers trans-fered rights to publishers. Now, finally, a song is a packaged commodity which can be traded to many, a neatly micro-grooved prefabrication to be enjoyed in an identical perform-ance on a million record players while royalties flow to the composer. Such commercial provisions and legal definitions of an author's possessive right are to this day quite vague in architecture. In music, they go back no more than three or four generations. As recently as the lifetime of Philip Emanuel Bach or even young Mozart—in fact, throughout the entire eighteenth century—scores were habitually pirated like building design today. Yet in that same period, a piece of chamber music might also pass by *dedication* into the own-ership of a patronizing prince without his holding any com-mercial monopoly.

Quite apart from an artist's signature or the willful trans-ference of his product to an owner, however, a possessive earmarking of building and architecture is the custom and its beginnings are lost in the most distant past. Beyond com-parison with any other, this art and its companion, design of cities, are indeed deeply permeated by ownership concepts. Ownership of buildings is almost as old as the hills which, themselves, early turned into 'property.' Aside from personal-use considerations, this has most strikingly colored design procedure and appreciation, much more so than is thinkable in any other art.

251

THE 'ETERNAL' CHARACTER OF A MONUMENT IS ADMIXED TO ARCHITECTURE, MAKING IT A TOKEN OF GLORIFIED DEDICATION AND BELONGING. Fixing this idea over ages is all the function a monument is expected to have.

35

A building can be dedicated by design to a specific function, which again is characterized by the palpable use that the owner makes of it. Or it can be intended as a symbolic monument which has no practical function but mystically, by its mere existence, means something.

These two extremes rarely occur in their purest form. On the contrary, most designed buildings contain both elements, but in a widely varied proportion of mixture. It seems quite involved, but dedication, or belonging, never fails to be part of the mixture. A man might also dedicate a building to the guardian spirit of the place, the *genius loci*. 'Joint control' and a more practical co-ownership may nevertheless be retained by the builder or granted to another party. For example, a tire factory in Los Angeles, may on practical terms be assigned to the latest type of tire production that is introduced to this locality by a concern from Akron, Ohio, where rubber is at home. The building, however, is symbolically dedicated by design to the new home-site in California, and so, queerly enough, is made to have the outward appearance of a Franciscan Mission. Dynamic function and a be-

longing to an assumed or revived cultural background are fused here in commercial innocence. A regional community is given some mystic—in this particular case even mystifying—partnership claim to the building; the legal and practical ownership, of course, being retained by the Ohio concern. Nevertheless, California is granted some co-ownership; the *genius loci* is given a specific share of influence and control.

The triumphal arch has only a restricted and short-lived dynamic function; in fact, it was developed as a structure for use on a single occasion. In Rome, such an arch might have been erected so that King Jugurtha, or the surviving captives from destroyed Jerusalem, could drag themselves through it before being put to death. Once this dynamic and functional event was over, the arch was retained as a commemorative symbol and exacted its main effect by mere static existence as one of the monumental paraphernalia of the Roman Empire which owned it and had its official monogram, SPQR, most conspicuously stamped upon it.

There are other and varied cases of such ownership by design-dedication—the burial structure of a Pharaoh; a temple consecrated to Apollo, Vishnu, or Buddha; a church belonging to Our Dear Lady, the Queen of the Angels. There is the Circus Maximus and the Thermae dedicated by Caracalla 'to the people,' that is, the former electorate or, later, the political mob of metropolitan Rome. This bathhouse particularly appears much more as a conspicuous property than is simply explicable by its mere function of providing showers, sweating compartments, and pools. It is one of those gigantic toys, ownership of which was presented as a demagogic love token and paid for by the exploitation of far-off provinces and the booty of devastating colonial campaigns.

There are countless types of control and belonging, and an almost unlimited number of shadings of the concept of ownership, ranging from the kind exercised by an entire community, to the one of Mr. and Mrs. Jones, or that of Louis XIV who was France. They have grown with and

through the body of architectural production of all times and completely permeate it.

For purposes of clarification, one may well endeavor to differentiate between the prestige of ownership, with its conspicuous representation of investment and the expression of well-controlled use or specified function that the owner may rightly expect from a building. In the first case, the emphasis rests on a static aspect, in the second on a kinetic-dynamic, or operative, one.

The distinction will remain serviceable as long as we confine the concept of functionalism to things strictly outside of human nature. There functions have a physically operative meaning. Mystic or symbolic connotations may also be functional, but on quite a different level. They remain a matter of specifically human interpretation.

We have tried to characterize human motivations in the field of ownership as brain-physiological phenomena. They are difficult to break down into their basic constituents. The most basic of them has been described as the control reflex, or the automatic response attempting control of the situation around us. But the freely controlled use of a property has often degenerated into a few rudiments, such as the mere prevention of trespassing. If ownership does not imply operational availability and actual usage, it appears without organic precedent in the extra-human world and, in such isolation from facts of nature, it possibly impairs the survival of the design in question. Anything that seems to have turned anorganic, unelastic, and calcinated demands close scrutiny. Our environment is in need of careful, biologically keyed planning to aid our own survival. It must be guarded against permeations of dead matter which remain outside of vital circulation.

At any rate, devices expressing or celebrating possession per se are something foreign to nature's architecture, which does not rest on static significances. They rather appear as supra-functional elements in man-made design. Sometimes they are very prominent, sometimes receding, but they are

almost omnipresent in historical monuments such as can be found among the illustrations of architectural textbooks. The most remembered and discussed products of past architectural design derive their significance at least partly from just such a static character and from the original display of a now often long outdated dedication and ownership. Their message to us seems, by this token alone, definitely beyond the mere expression of sheer operative function.

In the age of income tax, it seems predictable that individual patronage or a conspicuous private-ownership dedication can hardly be the grand theme 'with variations' and the favorite inspiration it has been to architecture and planning of the past. A physiologically sound, dynamic integration of the constructed environment now often appears hampered by it. At least, it is known to clog urban rehabilitation, which the individual owner himself longs and hopes for when he happens to live in a district blanketed by blight. An economic deadlock produced by blight—perhaps we can call this typical condition 'blight lock,' to coin a term for something common to our cities—must often be resolved by condemnation of such helpless, obsolescent ownership. Mere magnitudes and the ever more powerful industrial trends have veered very noticeably toward a new relativity of belonging, and design cannot help but express it.

The ingenious mass economies of engineering and the comparative ease of toilproof technology tend to transgress both the practical and spiritual confines of the ancient ownership principle. Nevertheless they can be most gratifying to the combination of responses to which the term *control reflex* has been applied.

The erection and upkeep of structures by masses of exploited humanity no longer add to the dedication of a building and are presumably fairly foreign to future architecture. They were obviously unavoidable in bygone days and thus have characterized and flavored many monuments of the past. Imitation of such monuments would indeed be a spiritually impoverished and meaningless performance today,

when the related sacrificial toil and production scheme has come into disuse.

The Cheops pyramid erected by electrical derricks would, we have felt, be but a shallow offering to the gods. The dedication to eternal divine ownership would remain unconvincing. In order to be awe-inspiring, such piled-up monumentality of deadloads has to crown a construction period of awful backbreaking effort, or else it becomes a mere miscarriage, emotionally misplaced, as it is, in the scheme of current events.

We realize very well that to touch off associations valued by the individual, the community, or the race, physical structure—buildings dedicated to commemorate desired and esteemed concepts—will remain in demand as important objectives and design programs. But while concentration of power and mechanized effort are now stupendous as regards operational potential, they are also too impersonal and fluid to lend themselves easily to connotations of static dedication or eternal belonging. Monumentality will have to be truly of our own version to prove successful in an age which has such different and staggering time perspectives into the infinity of past and future.

Gigantic fossils are impressive. Once they may have, alive, fitted their scene superbly and owned it, but their strength declined. Their chance of survival vanished. They are no memento to eternity. On the contrary, they prove to us the implacable passage of time, which like space is no one's parceled possession, but our physiological playground of perpetual change.

We no longer cherish treasures kept buried and in abeyance, our choice is a continuous handy control of what we need; OUR BELONG-INGS SHALL BE OURS AFTER THE FASHION OF OUR WELL-EXERCISED LIMBS, and we hate atrophy, decked out and splendidly draped.

36

Ownership, glorified by formal design, is not merely a keynote for the impressive exterior of palaces or the spacious mansions built to please the old—or the newly rich. It permeates and determines also the interiors of even modest dwellings. With the possible exception of the barrel that sheltered Diogenes, the cynic philosopher of self-chosen absolute poverty, abodes are conceived as containers not only of inhabitants but also of their belongings.

Storage requirements to fit possessions are not merely secondary subjects; from the start, the architect has to discuss them at length with his clients. Properly understood, possessions reflect the individual's personality, his personal biases, and those generally current at the time.

A list of storage requirements, as to quantity and diversification, is highly illuminating. Completely voiced by each member in a family group, it implies an analysis of the life of all the partners, their contribution to the pattern of total activity, and their proportionate influence.

When father, mother, and children speak up before the

architect who seeks to learn something about the family he has been commissioned to house, when they begin at once to advance and to argue their storage rights, or when either husband or wife seem to grow resigned and fall silent while the other party subtly or brutally asserts predominance, a lively and eloquent family portrait is unrolled.

Where housing projects or rentable apartments must be designed for anonymous tenancy, the architect is most likely to go wrong on this point of differentiating and proportioning storage facilities, since he has no chance to give a hearing to the multitude of his unknown individual consumers and must often decide on an oversimplified solution of his own. 'The tenant in the abstract' is a nebulous client.

The storage of possessions and the role of furniture in this connection have their own expressive history. During the more recent part of this history, mere ownership—ownership with a supra-rational, mystic tinge—has receded, while handiness for usage has tended to prevail. Control asserts itself.

Listing man's movable belongings, one cannot but notice that they have, generally speaking, increased in number but decreased in permanency, in replacement value, and in specific bulk. The *daily use* of all personally owned articles seems to have a markedly upward trend.

In former centuries, a dresser in which clothes were stored over generations by nobility, burghers, and peasants was usually kept locked and was opened only on special occasions. Treasured books, family silver, or china were preserved by the wealthy in safe and ornamental compartments, and at times proudly exhibited or exposed behind leaded glass for an admiring glimpse. Every article reflected the primary, treasured value of a *statically possessed* object, and was given a psychological accent accordingly.

The feeling of having, of owning, things was very conscious and permanent, while use (the act of putting them into operation) was rarer and more intermittent. To have inherited or acquired such belongings was what was coveted. It gratified more the *possessive instinct* and certain repre-

sentational needs than it yielded frequent functional enjoyment.

The storage containers themselves reflected exactly this attitude in various periods of design. Tall, sculptured dressers with conspicuously elaborate locking devices indicated the value of the treasure behind the doors. Carved linen chests, ornate china closets, closed book cases with transparent fronts were cherished monuments to possession and, at the same time, inaccessibility to strangers and guests was often played up to emphasize ownership.

To our generation, these artistic documents of permanent ownership are flavored with a wistful quaintness. We must admit that possession has become less enduring, more fluctuating, and in more and more cases it tends to be superceded, even obliterated, by the idea of use. There is a long way from treasured family china to cardboard picnic dishes and Lily cups, from grandmother's linens to paper napkins, paper handkerchiefs, and perhaps paper underwear discarded after a single use. There may well subsist an ingrained aversion against such pronounced impermanence. Yet this tendency to impermanence is unmistakable and seems unavoidable in a civilization of inexpensive, mass-produced commodities.

The compensation offered for the abandonment of permanence, however, is carefree and abundant use with less subsequent toil to restore, to repair, to clean. Our ideas of cleanliness are broader, more scientific, and more intricate than those of any former period, but we want to spend a minimum of time and energy in achieving it. We discard rather than labor to clean, we detest dirty work and time-devouring chores, although some of us may become embarrassed at the problem of how to utilize the time gained by the increasing simplification of our household duties.

Concealed chutes for refuse and soiled linen; easily washed receptacles; smooth, impervious interior surfaces; letter files and waste compartments to hold an unprecedented amount of largely insignificant mail and 'literature' on its way to the incinerator; diversified and adequate storage space within

arm's reach for neckties, cosmetics, mouthwash, magazines, typewriter ribbons, pipe cleaners, pajamas, and recorded music; revolving hat racks, ventilated shoe closets, dumps for cigarette ashes—all these were not found in the palaces of the past. They are *desiderata* of the contemporary home-dweller and in time may become a matter of course in even a modest housing scheme.

Significant statistical curves of commodities produced and consumed, as well as of resulting waste matter consequent to consumption, can be plotted for the last hundred years and projected into the future with astounding results. In each subsequent period, more shirts, more pairs of shoes, more hats, socks, cans of preserves, anthologies of detective stories, dictionaries, hot-water bottles, perambulators, tooth brushes, automatic pencils, collapsible bridge tables, golf clubs, skis, and fishing tackle must be allowed per head of population—but static ownership per se, possession pure and simple, is dwindling in importance.

We like to see belongings change to usables, to life tools, and habits are geared to this change. In the past, possessions were significantly *buried treasures*, kept in a cave, or even secured, like the ill-fated Rhinegold, at such an unhandy place as the bottom of a river. Treasure-and-storage psychology then dealt with irreplaceables; to gather unique objects and to preserve impressive quantities was itself a pleasure and a gratification.

Thus a mansion or palace appeared as a collection of suites and expensive rooms, filled with splendid, statically arranged furniture and possessions. If, however, the floor area of a small future house for the many is no more than a limited number of square feet, well and conveniently planned, its usefulness will have to be tested by the intensity of easy, logical, flexible usage of each part of this floor area during the day. So-and-so many 'square foot hours' of usage per diem will be its livability index, an index of dwelling value. The bigger the better seems to us for many current reasons a fallacious maxim concerning a house, a city, and almost any other article. The original *physiological*

factor of handy and sensitive control counts, the factor of actually and frequently putting to use every item in our collection—be it a public museum, a library, or merely an arrangement of diversified cooking pots.

In the same way, present and probably future generations are committed to a sportsmanlike interest in the systematic exercise of their own human bodies. Atrophy of muscle groups as a result of failure to practice them is dreaded. We all are less content than were the Victorians merely to own our body and to drape it for dignified presentation.

ONLY THAT MEAL IS 'OURS' WHICH WE CAN
DIGEST; a house, a neighborhood, a huge
megalopolis, all beyond our organic controls,
are not our house, our neighborhood, or our
city.

37

'The bigger the better' seems a falla-
cious maxim in scaling the value of an owned object. To be
owned in a physiological sense, an object must be assimilated
organically. There is a limit to bigness if we want to keep it
within the possible capacity of nervous and generally organic
assimilation.

A dinner cannot have innumerable courses and still be
digested and controlled by our gastric juices. A megalopolis
may be too gigantic to be wholesome for the nervous con-
stitution of its individual inhabitant. A vast quantity of bric-
a-brac in a Victorian room is heavy, over-rich fare compared
with a sparingly furnished Japanese room, making one plum
twig in a simple vase its only decoration.

The capacity to assimilate, to control nervously, may of
course be impaired by many factors other than that of sheer
bigness. But in all such cases of indigestibility, ownership is
merely *claimed*. Food is not *my* food if I am physiologically
incapable of eating it. We are reminded of Balzac's mad
pawnbroker whose back room contains a gruesome agglom-

eration of many platters and dishes with rotting fish, meat, and fowl, which he gluttonously collects but never eats.

All objects can and must be considered as food for our nervous consumption. Indigestible, unassimilable, they can never be ours in any workable way. An ownership that is not organically operational is fictitious. The safest way to achieve belonging would seem to design our environment with a fine sense of our ability to assimilate it with a degree of nervous comfort. At least, we must try to control design with this aim in mind.

A suit of clothes that we order from the tailor to fit our requirements and measurements exactly, and which we control during production by repeated fittings, thus becomes, in a physiological sense, our own suit of clothes. The increase of nervous comfort and effective co-ordination caused by well-fitting clothes and shoes is measurable and beyond doubt. Men and women engaged in sports are distinctly aware of the fuller control over their bodily properties when dressed to suit their particular sport. The articles of clothing they wear are thus owned by them in a deeper sense than merely because they bought them in the sporting-goods store and paid cash.

Ownership in architecture, home ownership, for example, is, as has been discussed, a symbol that comes down to us from earlier periods when it did mean a full-fledged control over design, layout, and specification. Louis XIV *did* own Versailles, because he actually and truly expressed in that project his will and requirements. Moreover, through the construction and through his selection of talent to execute it, he created a style and a distinct architectural school as well as the entire manufacture of glass, furniture, and tapestries to serve his purpose. He drew on no given market for any of the articles, permitted no financial agencies to tell him how or where to modify his original intentions. He went so far as to discard existing surroundings and to create new ones imperiously. In fact, he produced a region of his own every time he chose to build anything. Ownership here was indeed the last word in self-expression. The frugal

263

American pioneer in his forest clearing owned his humble cabin in very much the same way.

In contrast to this, there is the home ownership of a person who has the limited choice of a fifty-foot lot in a standard, previously established subdivision. He has to have his house built from standardized, marketable materials, with plans approved by the building department, and an appearance dictated by the bank appraiser and loan insurance agency, all of whom are already considering a resale after the 'owner's' anticipated default and eviction. Such home ownership has indeed shrunk to an almost empty verbal symbol. There is little spiritual content and no exciting nervous appeal to its dry legality, only the ever recurrent irritation of meeting financial obligations connected with it.

An owner of this sort merely acquires the privilege of carrying capital charges and amortization over twenty years, a period so long that under contemporary conditions of general insecurity, and in view of the flimsiness of the house, final possession is but a dim promise. A mere word, though cunningly adapted to minds long conditioned by this stimulus, ownership approaches downright fiction in such a new context because from the very beginning the loan is granted under the mute proviso that the owner's self-expression through this project be kept negligible, that he conform strictly to the financial guardians' idea of standard remarketing and ready repossession.

Any attempt at reselling Versailles at its original cost minus depreciation would be as successful as selling the moon. But the house of today is often designed from the start with the idea that the owner will make place for an unknown successor.

In the current world, home ownership has in many cases deteriorated like other symbols, ornaments, and trappings superficially borrowed from periods in which princes and pioneers could find self-expression in a building activity that they themselves truly determined from the bottom up. Ownership has now become, semantically, a confusing word and

misnomer. It connotes an idea that must be reanalyzed to be at all constructive and fruitful for physical design.

A comparatively small, ever-dwindling number of persons may remain who build with their own funds and so do not have to dread rejection from the Federal Housing Administration, the moneylenders, and intermediate mortgage peddlers. A still smaller minority try to employ an imaginative designer of their own choice who is invited to create a minute miracle on a fifty-foot lot; the execution of his plans is then entrusted to commercial contractors and subcontractors who often enough may have to bewail their loss of profit in an individualized job to which they are not geared. Such a phenomenon, such home ownership, if it ever comes to pass, remains an erratic block in the general scene. The appraiser, the realtor, the neighbors shrug their shoulders; people in passing automobiles shake their heads in amazement. And the two adjoining buildings may still go up cloaked in the shreds of standard style, English cottage, or modified French provincial, with their bathroom windows giving on the breakfast room of our homeowner. Individual ownership is pitifully pinched in such a helpless and self-contradictory situation.

Still, in spite of frustration the word 'ownership' retains its magic power. It has a psychological impact dear to millions. Governmental policies reckon with this conditioning of our minds and even contribute to it. They claim it is a stable factor in the midst of an economic order of fluctuating employment markets and a shifting population. Yet contrary to all the advertisements, buying your home on the monthly installment plan is not *like* paying rent. It actually *is* paying rent, plus, however, the added responsibility of maintenance, which commonly would not be the tenant's burden.

'Full' ownership, after twenty years of payments have been endured, and even when no economic shift or accident has interfered, often proves illusory, we have already hinted. In the meantime, the structure has become obsolete long before amortization is completed, so that the chances of equitable sale will admittedly have evaporated unless some abnormal

housing shortage gives fictitious value even to decrepit shacks. Self-expression, the only thing that could possibly survive vulgar obsolescence, has in the vast majority of cases been blocked from the very start, precisely in order to produce that drab commercial value of a certain date and datedness. The whole matter is ridiculously complicated by the loan agency's insistence that the speculative builder avoid repetition and achieve a sort of pseudo-individual expression by varying, from house to house, windows, doors, porches, roof configuration, and the synthetic coloration of asphalt shingles.

The number of people in the United States who in normal times have sold their jerry-built houses for a profit is microscopic, as every expert will testify. War booms and devaluation of money may falsify this picture just as they do with everything else. Those who have seen their property become burdensome and depreciated by undesirable neighborhood developments are legion. But again, men do not necessarily live by actual experience; more frequently because of early conditioning, they respond to what looks or sounds like a magic formula.

Generally such neuromental conditioning represents a greater problem to designers and planners than all the technical difficulties or resistances of physical material. It can be changed by gradual retraining, but hardly by argument.

At the speaker's table of a housing convention, years before the last war, I was seated beside a nationally known labor leader who explained that American workers cannot wholeheartedly embrace the idea of rental projects. 'In their souls,' this speaker concluded—and his poetic expression was profoundly justified—'they carry the nostalgic longing for a home of their own.'

In my heart I wondered whether the speaker had in words of the past oversimplified the involved circumstances of the present, and when asked to express my thoughts, I answered essentially in this vein: 'We do and should deeply respect this longing for a setting that gives anchorage to the soul. We must also understand and respect a love for the words,

the revered symbols, and esteemed and cherished ornaments of a bygone day—which at a distance we are often inclined to interpret as a better day. But let us in fairness consider the following quite common and current example, although there may be notable and more ingenious exceptions to the rule.

'A new industrial plant is nearing completion; employees' families will be attracted in great numbers and—it is statistically plain—will find no dwelling places ready. So, several hardboiled and fiercely competitive subdividers rush site plans for row upon row of small lots for approval by the city planning commission, borrow or secure humdrum stock plans worth less than twenty-five dollars apiece, variegate them in appearance with blue, green, and maroon roof shingles, try to lower specifications to any permissible minimum—and, often without competent contractors, execute things as much below that minimum as they can, short of detection and trouble from the authorities. They obtain maximum bank loans to cover practically all construction cost, and are backed by obliging officials of a government that is supported by other taxpayers to insure this speculative scheme.

'There may be notable exceptions. But commonly everything in such an involved transaction is done for the quickest possible turnover, and, anything else lacking, the houses are actually sold like fresh doughnuts. Each small dwelling with its ridiculously detached garage is a double speck in the landscape, within a crowd of other double specks. It pretends to be an "individual" home, owned, like a diminutive castle by an independent man who happily looks up at *his* supply wires descending from *his* own dear power pole placed by the utility company on an easement in *his* rear yard. He hardly understands the complex legalities of the situation when he signs up for *his* down payment.

'The subdivision burdens him with the paving of over-dimensioned and costly 50-foot wide public traffic streets paralleling each other in a heartless grid at intervals of 250 feet to intersect obnoxiously and dangerously with the noisy

boulevard on which the sales project, for more convincing commercial value, abuts.

'Without all these concessions to rigid routine there would be no prompt promotion, no loan insurance, no rushed subdivision, no cheap dwellings. This is a wonderfully scientific, systematic age, and we know things beforehand. We know the percentage of yet unborn children who, by law of accident averages, are doomed to die under wheels or be crippled on this sort of street system after a brief roller skate through life, unless these children can be conditioned to play unnaturally, each in isolation on his father's "own" lot, between his "own" gas meter and his "own" garbage can that is waiting for the municipal collection truck.

'Commercial subdividers—even when willing—cannot easily provide recreational area, however small, because they see no ready way to its maintenance. And why bother about it anyhow? The developers rightly want to be out from under when they have sold the individual parcels. They usually cannot afford to create an unsalable patch of green, nor, if they are wise, do they laboriously try to file a dedication to the municipality or the county. These local governments shun like the plague the liability of a little park crowded with tots. It would call for supervision. And the upkeep of a somewhat isolated bit of landscaping by their staff of maintenance crews is cumbersome. The general run of voters would be stunned, the politicians say, by the cost of such new-fangled neighborhood play lawns and spray pools maintained for others. Why, practically no old established taxpayers enjoy such provision for their own children. How could they be expected to bear the cost of such luxuries for recently arrived families of laborers who contribute little to revenues, but mostly burden the budget?

'No, these new houses are not built by "owners." If they were owners, they would want to protect themselves more carefully against leaks in the cheap plumbing fittings, or in the flimsy flashings of their roofs, unnecessarily but picturesquely intersected to catch a prospect's eye, or against the hundred and one other repair items that are bound to crop

up as time goes on. These houses are crammed down the throats of people who, willy-nilly, are promoted to being owners on rather weak financial legs. The devil take the hindmost, that is the fellow who, after a few repossessions, will by chance "own" the property, and will do so at a time when those repairs are liable to mount up every month to a most uncomfortable outlay. And if toward the end of amortization, the whole dilapidated subdivision degenerates into a slum, it is the funeral of those unlucky ones who then happen to be the owners.

'Summed up, it is ownership in quotation marks; it is as far from the real thing as a "Mexican ranch" in Hollywood, California, is from a real Mexican ranch.

'In contrast to this depressing picture, let us look at the tenants of a unified project conceived and managed as a truly integrated human neighborhood. In addition to the psychological misappropriation of a word and the application of cold financial instrumentalities, other creative and more biological considerations have been at work and have yielded a lovelier product, not for turnover but for the permanence of lasting life. The homes are arranged about a central park in the core of a well-landscaped super block, kept free from rolling traffic, with recreational facilities for all age groups, with day nursery, kindergarten, pool, and picnic grounds, built through a blanket loan or other over-all scheme of financing. If, by their payments, proportional-benefit tenants acquire a share, a vote, and a say-so in the neighborhood community, they can decide and keep in mind a wider setting beyond their restricted four walls. Are they not more justified in flattering themselves with the idea of ownership, a true and contemporary sort of ownership, because, it again spells influence on one's environment?

'To be sure, it would not be the ownership with potential speculative profit that is so often promised and so rarely realized. But it would be an ownership with natural teeth in it, so to speak; that is, with neighborhood control—a control and a nervous protection that even fairly wealthy owners of individual property today can no longer enjoy. We could

then speak of modified, mutually insured, mutually conditioned ownership, such as seems the only possible one for the many in this age of pronounced interdependence.

'Leaving aside economic terms that have ceased to describe correctly the facts of life, the natural, physiological terms of symbiosis (or living together for wholesome survival) can apply to such a scheme and such a design for a well-fused neighborhood. Biologically studied and restudied, this design will probably grow to be more assimilable and digestible for human beings and their nervous equipment than what we now try to swallow and absorb of surroundings that are often very hard to take.'

THE PROBLEM OF DESIGN ACCEPTANCE IS
BASIC FOR HUMAN EVOLUTION and foreign
to evolution in nature. Nevertheless, natural
laws do govern what minds can assimilate;
there is no use lamenting these laws but
much use learning about them.

38

Conservatives are rightly worried by
novel design. Designers always add something to the natural,
the organic equipment of man; *something that is outside of
it* and extra-organic. By contrast, the shell of a snail, the wax
constructions within a beehive, or the mud structures of
beavers are considered to be, in a certain sense, organic, and
the result of reflex actions. However one may express and
value such a distinction, one thing seems clear. Only man
applies some degree of what could be called *individual initia-
tive* in form of design, and the practical difference between
animal and human products can be grasped readily enough.

For human production one distinct rule holds true: there
are frequent innovations, and they seem to originate with
individuals. Newly modified patterns, pieced together from
various sources by an associatively gifted brain, are—after
typical resistance—taken over ready-made, imitated, or ac-
cepted by the rest of us who are non-inventive, at least so
far as the particular subject in question may be concerned.
Only faint precedents for such a phenomenon exist in the

animal world, and proof of them may be interesting but difficult to give when they are rigorously judged.[1] A peculiar and pointed drama of design is being acted out on our human stage alone. An individual serves as the protagonist, the mass of consumers is the critical or accepting chorus.

At any rate, an immense number of devices, contraptions, and conceptions are in current use within the typical human environment. Yet the overwhelming majority of those who constantly use these things have taken no initiative in their creation, except perhaps by acceptance. What is equally striking, structural understanding of an automobile, of electric power supply, of the intricacies of financial operations, is not at all necessary or common with those who drive a car, turn on the domestic washing machine, or play the stock market. As the anthropologist Hooten says, perhaps uncharitably: 'Contraptions are termed "foolproof" because they are intended for the injudicious use of morons.' Anthill and beehive are foolproof, but without an ingenious effort to be so, without inventive protagonists, without acceptance problems cropping up around novel design.

The division of the human species into producers, percentually perhaps a shrinking group, and consumers, less and less able to grasp production methods behind the scene, is strikingly and specifically non-animal. Even early in the game of civilization, there was a tendency to close the shop, to exclude the bulk of consumers, the *hoi-polloi*, from certain secret procedures, and thus to stimulate and increase their awe for the marvels of professional and creative practice. Some mysterious and exclusive magic and secretiveness characterize the methods of ancient producers.

Constructed human environment reflects the conflict of two initiatives. First, the initiative of production and producers, often enough individuals not at all working in unison. Second, the initiative of acceptance, wielded by a fre-

[1] Ernest Thompson Seton, observer of wildlife, describes modifications of hunting methods used by wolves and prairie dogs, as originated by one superior specimen and imitated by the pack. This would foreshadow the role of the leading designer.

quently amorphous, non-organized mass of consumers. This second group is for the most part so inert that the term 'initiative' seems badly chosen. Nevertheless, consumers do *act*, in various degrees, from a flagrant yielding when faced with the dominant, compelling force of authority, to something that looks like convinced consensus. Often it is more the unconscious tuning-in on a powerful new constellation—mere acquiescence. Rejection and resistance are more frequent, however, and indeed they sometimes take the form of very vociferous initiative. Cultural evolution or progress is thus infested with a continuous struggle, hardly ever fully conscious, between two unequal but complementary agents without analogy in extra-human life. Perhaps we can now better understand the friction that every progressive step in arts, science, technology must overcome. It is a basic phenomenon in the evolution of design, in the intertwined lives of designers and consumers.

Bernhard J. Stern, in a well-documented study, 'The Resistance of the Adoption of Technological Innovations,' [2] analyzes general receptivity to inventions and reformative proposals. He adduces an overwhelming array of carefully analyzed cases to illustrate an opposition that has its roots entirely outside of technology proper, and reflects that antagonism between creative producers and the mass of potential recipients.

In 1762, Galvani was trying, with his experiments on the reactions of frogs' legs, to take the first steps toward an understanding of electricity and a mastery of its immense potentialities that have won such common application in our day. 'I am persecuted,' he said, 'by two classes, the scientists and the know-it-alls. Both call me "the frogs' dancing master." Yet, I have discovered one of the greatest forces of the universe.' This last sentence must have sounded like that of a madman in an asylum. Yet it was a brilliant appraisal by a genius of a new scientific vista.

[2] Technological trends and national policy, including the social implication of new inventions. Report of the Subcommittee on Technology to the National Resources Board, June 1937.

Two generations later, Fulton, the inventor of the steamship, wrote: 'As I had occasion daily to pass to and from the shipyard while my boat was in progress, I have often loitered unknown near the idle groups of strangers, gathering in little circles, and heard various inquiries as to the object of this new vehicle. The language was uniformly that of scorn, sneer, or ridicule. The loud laugh often rose at my expense; the dry jest, the wise calculation of losses and expenditures, the dull but endless repetition of "Fulton's Folly." Never did a single encouraging remark, a bright hope, a warm wish, cross my path. Silence itself was but politeness, veiling its doubts, or hiding its reproaches.' [3]

Catherine Bauer quotes an English socialist as saying: 'All new proposals go through the same process with pundits: Firstly, it is said, the thing is impossible. Secondly, while it is practically succeeding, it is pointed out as being against the holy scripture. Thirdly, when it has jumped the hurdle and is honored for its general usefulness, the experts make clear that they "always told you so." '

Our purpose here, however, is not to joke or complain about the 'stupidity' of people who opposed a break of habit and a threat to vested mental or financial interests. Rather, we want to make it clear that the unequal struggle between the creator and his public is physiologically sound, unavoidable, and fundamental. An original designer in his harassed life may well draw comfort from the recognition of this truth instead of quarreling with his contemporaries. Cultural or technological progress is not achieved by means of intellectual persuasion; rather its fate is determined piecemeal by the laws of nervous economics which underlie affirmation, acceptance through habituation, and resulting emotional gratification.

The friction concomitant to the human way of advance can be followed back into neolithic times. Still, whoever is in the heat of battle commonly ignores its physiological back-

[3] George Iles, *Leading American Inventors*, New York, 1912, pp. 60-61.

ground and typicality. This subject is so overwhelmingly important for the story of design and invention that exemplification should be instructive. If practical inventions come to be accepted slowly, by force of habit, rather than as a result of rational argument, how much more must this be true for the formal, 'impractical,' aspects of design, which are less easily argued. It is proof for our contention that we must also here strive for new objective yardsticks instead of expecting placidly that logic will solve acceptance problems.

When, in the Stone Age, metals were first discovered and the attempt was made to introduce them into general use, an uproar must have risen and split men into the few who accepted and the many who rejected. Argument and hesitation have continued for a long time; almost up to this very day, we can perceive the faint reverberations of the struggle. According to the Biblical story of the building of Solomon's temple, the sound of iron tools was not heard,[4] and the Mormon temple at Salt Lake City had still to be built without iron. No bolts of iron were permitted in the repair of the Publican Bridge across the Tiber as late as the fall of the Roman Republic.[5] Stone knives were used by the Jews for circumcision and by Egyptians for embalming long after they had become familiar with iron. The first successful cast-iron plow, invented in the United States in 1797, was rejected by New Jersey farmers on the theory that cast iron poisoned the lands and stimulated the growth of weeds.[6] Metal chairs have still not found an acceptance comparable with that of chairs made of wood. A new material, a new energy, or source of energy, a new principle of operation is very disquieting. The opposition encountered by an inventor or designer of a useful improvement is of an intensity which subsequent generations, having seen the success of those proposals, often find incredible and quaint. Still, the contemporary scene is infested with exactly the same type of

[4] I Kings, 6:7.
[5] E. W. Burgess, The Function of Socialization in Social Evolution, Chicago, 1916, p. 16.
[6] Bernhard J. Stern, op. cit.

opposition, the same type of bitterness and ironic 'humor' directed against the protagonist.

In England, resistance to the railroad was largely from the landlord class which, with its feudal privileges, arrayed itself against the aggressive industrial bourgeoisie. The temper of the opposition is to be seen in the remarks of Craven Fitzhardings Berkeley, a member of Parliament for Cheltenham, pointedly dwelling on sensory stimuli and conditionings that affect his own emotional tonus: 'Nothing is more *distasteful* to me than to hear the echo of our hills reverberating with the noise of hissing railroad engines running through the heart of our hunting country, and destroying the noble sport (fox hunting) to which I have been accustomed from my childhood.' It was in protest against the mounting spirit of industrialism that Ruskin, rejecting the 'nonsensical' railroad, drove through England in a mail coach.[7]

Anticipation of trouble is typically elicited in us whenever something new threatens to upset our balance of neuromental economics. Subjectively judged, both moral and physical safety seem then in dire jeopardy.

'Twenty miles an hour, sir! Why, you will not be able to keep an apprentice boy at his work! Every Saturday evening he must have a trip to Ohio to spend a Sunday night with his sweetheart. It will encourage the flightiness of intellect. All conceptions will be exaggerated by the magnificent notions of distance. Only a hundred miles off! Tut, nonsense, I'll step across, madam, and bring you your fan.'[8]

In England, Nicholas Wood, whose position was that of 'railway expert,' said that Stephenson's claim of a possible speed of twenty miles an hour was absurd, and added, 'Nobody could do more harm to the prospects of building or generally improving such coaches than by spreading abroad this kind of nonsense.' In Germany, it was proved by experts that if trains went at the frightful speed of fifteen miles an hour on the proposed Rothschild railroads, blood would

[7] Ibid. Quoting Emil Ludwig.
[8] Bernhard J. Stern, op. cit.

spurt from the travelers' noses, mouths, and ears, and the passengers going through tunnels would suffocate.[9] As late as 1834, the average rate of speed on railroads was not much greater than that attained by horses on good roads, so that mail contracts were sometimes given to stages for making better time.[10] Almost universally there was a stress on hazards and imperfections, and a failure to realize the potentialities of the railways. In Germany, for example, it was not until 1860 that the use of railways for the transport of troops in case of war was considered. The derogatory attitude toward the locomotive is reflected in the bantering designations given it, such as 'hell on wheels,' 'devil wagons,' and so on.

Each improvement in railroad equipment and organization has been marked by opposition and delay, especially when it involved costly equipment rendering the older stock obsolete. Commodore Vanderbilt dismissed Westinghouse and his new air brake with the remark that he had no time to waste on fools.[11]

Sir Goldsworthy Gurney's steam coach made regular trips between Cheltenham and Gloucester in the 1820's, and although it was financially successful, it was abandoned because of the opposition of landowners, stage coach proprietors, and the breeders and users of horses. All animal lovers were marshaled in defense of the horse by vested-interest groups.

It is interesting to see how the resistance skillfully availed itself of lobbied legislation. In 1865, a drastic act was passed requiring three drivers for each vehicle, one of whom should precede the carriage at a distance of 60 yards, carrying a red flag by day and a red lantern by night. Speed was reduced to 4 miles an hour for the country and 2 miles an hour for

[9] E. C. Corti, *Das Haus Rothschild in der Zeit seiner Bluete*, 1830-71, Leipzig, 1928, tr. Brian & Beatrix Lunn as the *Reign of the House of Rothschild*, New York, 1928, pp. 77, 94.

[10] Bernhard J. Stern, op. cit.

[11] Hornell Hart, *The Technique of Social Progress*, New York, 1931, p. 631.

the towns, and the local communities were given the right to tax the operation of vehicles and to prescribe the hours of operation—which they did in a discriminatory manner. With such restrictions, not repealed until 1896, the steam carriage was doomed.[12]

As late as 1896, A. R. Sennett read a paper before the British Association for the Advancement of Science, in which he maintained that the steam engine rather than the internal-combustion engine would prevail and that petroleum propulsion had to improve a great deal before heavy loads could be dealt with or passengers conveyed 'free from excessive vibration and offensive exhalations and with a degree of luxury at all comparable with that which we have come to identify with horse-drawn vehicles.' He likewise contended that horseless carriages could not be widely used because they required great skill, inasmuch as the driver 'has not the advantage of the intelligence of the horse in shaping his path.' [13]

Lord Montague vividly describes the prevalent hostile attitude toward the early motorist: 'Among our friends we were considered mad. In the press we were held up to public derision, sometimes as fools, sometimes as knaves; and every accident that happened, even remotely connected with the motor car, was attributed to the "new Juggernaut," as it was called. The papers were almost without exception hostile.' [14]

Songs such as 'Get Out and Get Under' had a match in 'My Merry Oldsmobile.' European monarchs delayed long before they admitted that an automobile was dignified enough for them. Emperor Francis Joseph I of Austria, who died in 1916, never entered an automobile.

The financiers exaggerated the numerous mechanical imperfections that existed in the early cars, stressed the absence

[12] F. B. Hunt, 'Self-Propelled Cars Sought 500 Years Ago,' *The New York Times*, 27 April 1930, p. 11.

[13] Quoted in L. H. Robins, 'Old Cry "Get a Horse" Echoed in the Sky,' *The New York Times Magazine*, 23 Dec. 1928, pp. 4, 13.

[14] Robins, op. cit. p. 4.

of good roads, were deterred by litigations and quarreling over profitable markets.

Changes in the automobile that would increase its sales possibilities by making its use simpler and its power greater were accepted slowly. The self-starter was invented in 1899, and installed on one make of car in 1902. It was impossible, however, to get manufacturers to spend money on such refinements, and by 1912 less than 5 per cent of the manufacturers were offering cars with self-starters as standard equipment.[15]

Bernhard J. Stern shows how the resistance against the railroad, steamship, and automobile was matched by that against the airplane only a few years ago. There is an almost equal opposition from inside and outside vested interests, from inside inertia and outside friction. The owners of existing transportation services, the railroads, steamships, and bus lines, as well as automobile manufacturers, have propagandized against the extension of air routes. Not long ago in Alaska, the drivers of dog teams and those who sold them fish were vigorous in their opposition to air mail service.[16]

The opposition of what is called vested interests may easily be interpreted as 'selfish,' meaning emotional on a narrow score. Yet, in order to appear warranted, to succeed, and not to die down as fallacious and against the common interest, this opposition must undoubtedly find deeper and broader resonance. However ridiculous it is in certain instances, there exists the fundamentally sound attitude that unless an innovation in design is *assimilated into a well-integrated order*, it may upset the entire applecart and be a threat to survival. The individual designer seems less interested in fending off such a possibility than he is in his own pet invention and this is natural. There is, though, a dim public consciousness—which our argument wishes to develop and to stress—of the need of objective criteria to

[15] R. C. Epstein, *The Automobile Industry*, Chicago, 1928, pp. 105-7, 110.
[16] *Business Chronicle*, 1930, vol. xxx, p. 1.

judge all newcomers in design and help to absorb them safely.

The roots of such a public attitude are found in that basic physiological conservatism where inertia equals the most coveted good, nervous economy.

Strange as it may seem to us in retrospect, people who used to hand-crank their motors did not at once recognize that suspicious-looking, new-fangled self-starter as a nerve-easing device. On the contrary, nerve-easing was found in the daily dozen of hand-cranking motions which otherwise were somehow missed every morning. A *new habituation* must be the first objective of any pioneering in design. It has been shown that inventions, obviously operational, do not convince in themselves. Yet revulsion and rejection may testify more against the injudicious methods of introduction than against the design product. All its chances rest in happy integration and assimilation. It will take a harmonious fitting of the new elements into existing patterns of neuromental operation. A carefully arranged training by exposure to the novel elements, a slow feeding of new or improved dishes into our 'total diet' is the true means for a planful forming of habits.

The pioneering designer, therefore, will always have to engage in a series of steps rather than in just one design, or disclose its new features and consequences gradually instead of in one stroke. There is no need to point out how much this applies to the physical facilities of a human community so much in need of contemporary renewal.

THE 'VESTED' EXPERT—'WITTY' OR JUST
SOUR—RISES AGAINST INNOVATION more often
than the common man. On the other side,
innovators frequently have one-track minds,
and cannot comprehend all the doings of
their own brain children.

39

It is often assumed that the chief ob-
stacle to progress is the inertia of the so-called common
people. The fact is, however, that the man in the street is,
as conservative leaders are likely to say, gullible enough to
be swayed by even the most novel programs and designs. He
may open the door to poor developments as well as to quite
magnificent and constructive ones. This is particularly true
when the proposed innovation is not in conflict with his
own operative set of habits, although it might be with those
of the expert or specialist. Old salts of the sailing era natu-
rally resented the steamship more than common landlubbers.
A conservative connoisseur or art critic may react to a new
ism as if it were a direct personal insult.

Soon the proponent of a new design will find himself un-
easily face to face with reputed, often ponderous personages.
Their prestige, so typically instrumental in human cultural
developments, is of course utterly foreign among the broad
forces found effective in the evolution of the natural scene.
Sociometric graphs have shown how complicated human

groups are in their psychological constitution, and how values are formed owing to leadership and followings. The leader of opinion, more than anyone else, is sensitive and skeptical when an innovation comes before his eyes. He acts with reluctance even without any specific vested interest—except perhaps the one of the recognized expert who considers himself entitled to imprint his stamp of oracular approval and, where necessary, to exercise in rejection a celebrated and caustic 'sense of humor.' Many artists and men of technical design ability may suffer at the hands of a renowned special expert or, in fact, any grand and generally accepted authority whose established mental patterns and imagination are weighted backward rather than forward. When illumination by gas was first discussed, the great romantic Sir Walter Scott wrote to a friend: 'There is a madman proposing to light the streets of London—with what do you suppose—with smoke!' Lighting with candles and torches was lauded as picturesque. Opposition to gas lighting was not restricted to England, but arose in some degree in all countries. 'Napoleon characterized the idea as *une grande folie* and when Paris finally attempted to introduce the new system in 1818, it met with little favor. Later on, of course, gaslight was again tenaciously clung to when electricity threatened to break in; dim gas streetlighting was characterized as romantic as contrasted with the glare of electric lighting, and the lamplighter was sentimentalized.' [1]

Sentiment, emotional habit, more than rational reasoning, is kept active and thus effectively mobilized for resistance against any novelty. A continuous emotional accompaniment to upper-brain response drones on like the undercoloring of a *basso sostenuto*. The history of writing and printing casts a vivid light on the nature of this emotional resistance to the unfamiliar.

Writing as a conserving instrument is in itself extremely conservative. Scripts acquire highly emotionalized attachments and have become identified with cultural and national-

[1] Quoted by Hart, op. cit. p. 629.

istic symbolism. The result is that styles of writing and alphabets become tenacious. The ancient and medieval scripts prevailed for over five centuries, the Gothic for over eight centuries, and was being revived in Nazi Germany. Even when one script displaced another, the older form persisted in use for special purposes. Organized resistance has been made to changes in alphabets, as when the elimination of three letters from the Bulgarian alphabet in 1922 provoked the resignation of two ministers.' [2]

'The same conservatism is evident in numerical notation. In 1229 an edict was issued in Florence forbidding bankers to use Arabic numerals, and Roman numerals are still widely used, especially for ceremonial purposes.' [3] Opposition to the enforced or even optional use of the metric system of measurements in the United States has been based on sentimental appeals to a poetic tradition and postulated superiority of the English system as well as upon arguments based on the costs of the change.

As we have seen, such conservatism often represents, to use popular expressions, a mixture of selfishness and of unimaginative impatience with the necessarily imperfect beginnings of every innovation. The end of the world as a result of such innovations has been predicted on innumerable occasions, also merely on moral grounds. It was feared that starting the ball rolling would upset all stability.

The introduction of printing was delayed for twenty years in Paris by the hostility of the guild scribes. The first printed books were considered mechanically crude, costly, and inferior to the artistic work of the skilled calligraphers of the guilds, and the resistance is therefore easily explicable. A widespread sentiment against printing was expressed by Governor Berkeley of Virginia, when he said in 1670: '. . . I thank God there are no free schools, nor printing, and I hope we shall not have them these hundred years; for learning has brought disobedience and heresy and sects into the

[2] B. I. Ullman, *Ancient Writing and Its Influence*, New York, 1932, p. 121.

[3] Isaac Taylor, *The Alphabet*, London, 1883, vol. 2, p. 263.

world, and printing has divulged them and libels against the best governments.' [4]

Innovators often unwittingly violate old taboos, and thus their proposals acquire a symbolic significance that the innocent designer may not have foreseen.

Questions of the status of women and of etiquette became involved in the controversies over the utilization of the typewriter. The girl typist rose to be a symbol of woman's emancipation and aroused responses accordingly. As for etiquette, it was and still is in some quarters bad taste to use the typewriter for personal letters.

Emotional attitudes have acted especially as a brake on the progress of architectural design and delayed acceptance of useful innovations. To quote again from Stern's excellent study: 'Architecture has always been conservative. When the early dwellers on the Alpine lakes descended into the Italian plains, they continued to build pile dwellings, even when they settled on hilltops. Churches and public buildings still cling to ancient and medieval forms.' [5] We have seen that 'there was long delay in using iron in building, and when it was used it was either hidden or, when unavoidably shown, employed with no idea of its esthetic possibilities.' According to Giedion, steel construction as evolved in the nineteenth century had to follow devious channels until it was honorably received by the official architectural fraternity. The quaint proceedings of the London Architectural League one hundred years ago—the time when Charles Dickens wrote his humorous passages on an architect's office in *Martin Chuzzlewit*—were recently unearthed for a centenary celebration. They throw light on this fierce struggle against metals as design element. As a rule, new materials are allowed to worm themselves into an established architectural canon when they preserve forms—which are the most stable of all things that

4 Quoted in A. M. Simons, *Social Forces in American History*, New York, 1911, pp. 47, 48.
5 V. Giuffria-Ruggeri, 'A Sketch of the Anthropology of Italy,' *Royal Anthropological Institute of Great Britain and Ireland Journal*, 1918, vol. XLVIII, pp. 99-100.

are stable with consumers. Many a 'practical' inventor has, as consumer, not seen or believed in the aesthetic possibilities of his own design and has volunteered to conceal its intrinsic features.

Not only did it seem revolutionary and inappropriate to utilize new material media, but the public was made to believe that certain items of the new environment were altogether outside the province of aesthetic treatment or architectural design. The commercial profit-making drive of the railroad builders did much to augment the revulsion of the agricultural groups to this symbol of industrialism, for its pushing executives were not concerned with remedying its ugliness, smoke, and grime. When a famous artist volunteered to paint a mural in a railway terminal in London, his offer was refused on the ground that art had nothing to do with machinery. Utility had, unhappily, become divorced from beauty, and the two engaged in independent careers.

Appliances and equipment wrought into buildings have gradually taken a place equal in importance to structural elements. But until very recently any attempt to integrate such 'utilities' with the structure, and to see their problems combined for mutual benefit, was rare. Architects took a less lively interest in plumbing facilities than did politicians and moralists. In the 1840's, the bathtub was denounced in the United States as an epicurean innovation from England, designed to corrupt the democratic simplicity of the Republic. The story has been told that when President Fillmore installed a bathtub in the White House in 1851, there was an outcry against it as a monarchical luxury that could well be dispensed with inasmuch as former presidents had got along without them.[6]

In conclusion we might say that those who have made it their trade to back industrial enterprise and building involving design soon see their investments tied up in more or less obsolescent objects. They naturally hate to have this obsolescence quickened by the introduction of other and newer de-

[6] *The New York Times*, 21 November 1926.

sign ideas that upset a precarious equilibrium. 'Bankers regard research as most dangerous and a thing that makes banking hazardous, due to the rapid changes it brings about in industry.' [7] Bankers, seen at close range, simply partake in a common human denominator. Although 'men of facts and figures,' they, too, are prompted by their emotions and by the craving to have their lives simplified and prolonged through a nervous economy that flows most easily from the *status quo.*

[7] Stern, Report of the Sub-Committee on Technology, National Resources Board, June 1927.

THE GRAND, GODLIKE ORIGINATOR MUST
THROUGHOUT CIVILIZATION DESCEND MORE
AND MORE into a merger with a co-operative
team which then reveals its own peculiar
physiology of production.

40

Sociologists and historians of technology have pointed out that there is a regular and fairly predictable time lag between the conception of a new idea and the acceptance, i.e. application, of it. There are no doubt numerous causes of this time lag; we shall briefly discuss one in particular, the design acceptance by co-workers. It is the basis of creative co-operation and the collaborative process, and tends to assume increased importance as our technological equipment becomes more complex. In early periods, designers were relatively independent; their work required a minimum number of co-workers and auxiliary subdesigners. The producers of the Stone Age flint implements may have been isolated individuals, but the number of people who must collaborate in the production of a television transmitter, an airplane carrier, or a fully equipped prefabricated house is, of course, incomparably greater and more highly differentiated. Inventors, draftsmen, shop superintendents, skilled workmen of many kinds, must, in their collaboration, each accept and utilize the services and finished products of the

others. Only in this manner can they implant their own contributions in the common pattern of advance.

Within the framework of this productive process, a man may play a passive, receptive role at one moment, only to become an active producer the next. It is a chain of responses and creative events. And the whole series of contributors and contributions must be visualized in advance of the process and during its progress. Thus successful design can hardly be divorced from production planning. To make clear the mental workings of a creative team would be a most significant example of sociometry—the graphic, illustrative study of productive human group relations.

The history of architectural design and its realizations is therefore much more complex than a history of art, in which great originators are singled out and cited for their independent creations. The fanciful tales of individual art heroes, such as Giorgio Vasari's, probably falsify the record of architectural accomplishment even in his period, although for various reasons the exuberant hero worship that prevailed during the Italian Renaissance was then less contradictory to fact and more genuinely characteristic of the time.

This Renaissance myth of genius, which has colored much of the subsequent writing on the history of art, reflects the recognition that true initiative of production is not a common property of the human species. Many mythologies let ingenious inventor-gods usher in civilization and teach its skills to ordinary mortals, who do not themselves have to be inventive.

The latter-day originator, however, has little opportunity for such godlike freedom and solo creation. His supreme gift consists rather of anticipating realistically the necessary chain of collaborators, and also the trying tests of acceptance that his product will have to meet, first in every succeeding stage of production and, finally, in the market place.

No such limitations are imposed on the creator in the Book of Genesis; but we are told that even God soon met with the disappointment of the innovator, that customary lack of acceptance and co-operation on the part of his public.

288

Because of this failure a new start was undertaken upon cleansing the earth by the Deluge. To shallow critics, this seems a surprising turn after the self-assurance of the first seven days. Yet how true it all is to life. And it sounds equally true that, in spite of his saddening initial experience, the Lord in the next attempt firmly adheres to his original design. What he decides to improve is not his design of the world but the consumership of his product.

We really have here the archetype of the tragedy that envelops creative man himself and innumerable incidents of his history. Through many and all disappointments a creator must stick to his guns, and in the last analysis he will always come to grips with the difficult problem of reconditioning his consumers. Mass extermination of those who were reluctant to accept and follow did not really help when it was tried. Also, with a new crop of mankind, God found it necessary again and again to send forth eloquent prophets to warn, persuade, educate the indifferent and the resistive. His great patience was often almost exhausted, but being himself father to all creative genius, he naturally could never descend to opportunistic concessions. Although the Renaissance, in some of its protagonists and works, was rather pagan or agnostic, and sometimes treated the naïve medieval faith with irony, its image of the great designer and producer is patterned on the God of the Scriptures as Michelangelo painted him.

Generally, profound faith was invested in great heroic individuals, their insufficiencies were retouched and purged, and their portraits were glorified after the method of revered ancient biographers, such as Cornelius Nepos or Plutarch. The artists and the public of the Renaissance rebelled against the anonymity that was so characteristic during the Middle Ages. They felt that great creative achievements are unlikely to arise from a nameless collectivity. Instead progress seemed begotten of free, super-normal, godlike individuals. Descartes states with emphasis that great and worth-while action always emanates from one personality.

In our own age, which is so much committed to both industrialism and collectivism, and also is advancing in a knowledge of physiologically based psychology, we shall have to rectify this picture of heroic independent creation by humbly investigating the interlocking chains of group stimulation and reaction. It is precisely these sequences of nervous events, mutually sparked, through which complex design is originated and executed, and on which especially its reliable survival value will depend.

We must therefore consider first the productional activity through which a building is designed and eventually constructed, assuming that the plans have met the consumer's requirements, at least for the time of programming. But a single building never encompasses all our life. From the first worried telephone call for the obstetrician to the final one for the funeral director, we have increasingly come to depend on many communal facilities outside of our own four walls. When in the end we turn to the human aspects of comprehensive actual usage we shall consider as a telling illustration of a finished product the neighborhood and the entire community around our dwelling place. For this is probably the most significant package of designed environment in which our life must be lived—through all its niceties and vicissitudes.

41

On Ceylon, I once had occasion to observe a native architect at work. He was a yellow-robed Buddhist monk sitting on a field stool in a clearing of the tropical forest. His project, a large temple, had been under construction for thirty years—with no schedule or budget in evidence. Things may be interrupted when funds run low; or, when collections are taken up successfully, the old man will go on directing. He holds a stick or baton in his hand like a conductor, and without being very vocal, manages his philharmonic crew of working people. Sometimes, for their lack of co-operation or understanding, I saw him beat helpers over the head with his bamboo baton, a controversial practice, one that would be unacceptable in the West to contractors' associations and labor unions alike. But in fact it seems a less cruel method than ours of subjecting collaborating performers to often hair-splitting specifications. Contracts full of legalistic intimidation often drown creative participation in anxiety or bring out trickery to get even.

Our Buddhist architect sat for thirty years, from sunrise to sunset, facing his project under the tulip trees, while their shadows were lengthening and shortening, while the clouds overhead were following prevailing trade winds. He knew

291

his site, he knew his men and materials, as we are never permitted to know ours.

Historically speaking, drawings and blueprints are a rather recent development. In past periods, the originator of a design usually communicated his idea directly to his working crew, and clarified it by *showing* them what to do. His success in effectuating his design depended also on the imponderables of personality. Musical productions long followed a similar pattern of immediate transference. The first full score of a composition, leaving almost nothing to be filled in and 'ornamented' during the execution, is only about two centuries old.

In building especially, the need for a settled budget and time schedule evolved the custom of definite contractual agreement before work was begun, and has imposed ever stricter preparation and specific fixation of a plan.

Paradoxical as it may seem, alterations came first. They came long before anything was built from the bottom up. Existing caves were fixed up for homes and, according to the French architect and thinker Violet-le-Duc, leaves and vines, first artificially interwoven to form a catenary foliage fabric and then stretched over tree branches, became the first roof construction. Piecemeal patchwork preceded over-all plans.

Comprehensive over-all planning means prebudgeting of space, energies, and funds. But 'spending along' was also here first, and the world is studded with monuments to afterthought—bright and otherwise. Afterthoughts are extremely natural. In fact, brain physiology would indicate that there are no thoughts, only afterthoughts in endless sequence.

Up to the end of the eighteenth century, the architect's most important client was a prince often accountable to no one except God—and that later, perhaps on the Day of Judgment. The prince procured the funds necessary for building by taxing his subjects or waging predatory wars. The state was his collateral and he mortgaged it to the hilt; such were his methods of financing. Although we have records of precise bookkeeping on construction operations dating as far back as the fourteenth century, there was not much real cost

planning. And if there was such a thing as a budget it was often blithely overstepped—all too often right onto the toes of suffering subjects. When taxes and impressment of labor became too severe, an underground grumbling was heard, and a catastrophic end came to princely projects when revolutionary discontent finally swept the old order away.

As the age of democratic rule made its appearance, parliamentary budgeting, corporate financing, and building loans were based on the exact requirements of the projects. All these things are interrelated and have affected architecture fundamentally. Advance cost survey became a special necessity, although it runs counter to the natural inclination both of the artist and of the autocratic owner. In architecture, absolutism has given way to complex interdependence, and therefore, by necessity, to an attempt at anticipating what lies ahead.

But even advance calculation was easier and a little more feasible when undertaken piecemeal. The need and desirability of full integration was often discounted. Thus, instead of becoming a harmonious whole, the man-made environment has turned largely into a jumble of separate productions, expediently thrown together.

It is rather unnatural to precalculate all effort, every ounce of material, and every detail over long stretches of work. Here is a basic difficulty in our make-up which we can only gradually learn to overcome. Very slowly, we manage to extend the techniques of planning over a wider field, to team up with an array of assorted collaborators, and to forecast the interaction of a multitude of prearranged factors.

The absolutism of a leader has a mystical accent and is somewhat fashioned after the Biblical story of how all things began and came to pass. Creation is often pictured, at least officially, as quite unconditioned by any sort of collaboration. Adolf Hitler was publicly credited with having evolved many a design single-handedly. And this autistic behavior is generally at the root of the accepted image of the individual assumed to be creative. But also, according to his own introspection, he who creates feels deeply isolated. There are hap-

piness and loneliness in this feeling. It seems to flavor the profound and wistful tales of solitary world-builders which have come to be told in so many mythologies.

But current processes that mold our environment militate in many ways against isolation. Constitutionally governed society has left patrons, artists, and architects increasingly deprived of omnipotent positions. Above all, a newer custom of financial accountancy and our present economy have brought about a highly significant change in the training and availability of that always-required supporting cast of crafts-men and mechanics.

The absolute potentate, upon the advice of his autocratic designer and with scant concern for cost, established and commandeered his own working crews and manufactures. Stone quarries, brick kilns, woodworking and glassmaking shops were put in operation solely to supply His Majesty's projects, which then constituted what there was of tangible progress in the world. There was little or no general market for these manufactures. They were at first not organized with a view to financial gain, since there was no purchasing power to speak of in the land except that of the prince. A Louis XIV chair was so called very properly because only Louis XIV could afford to have one, and it had not been designed and made for distribution to any other consumer. The rest of France often sat on rock bottom, while the courtiers did not really sit at all, except on edge. Most of the time they were standing up in a circle around the throne or at the *grand levée*, that is, in attendance on the King's breakfast, which he took in the baldachined, carved, and guilded fourposter of his royal bed chamber.

At that time, all the links of the production chain, all the craftsmen and specialists, all the collaborators of the court architect belonged, as did the architect himself, to the rigidly organized retinue of the monarch. They had passed through apprenticeships that fitted them for the execution of established designs; they did not have to worry about a multiplicity of architects' offices, each with different ideas on specification and practice. Nor was there a many-headed

294

public to please. The royal designer communicated an idea or a technical requirement to the royal overseers of the various manufactures and shops; his instructions were somewhat like inter-office communications. Every kind of abbreviation and simplification was permissible and comprehensible. Directions had almost the brevity and explicitness of an officer's command to his men in the royal cavalry or bodyguard. Drill and training were sufficiently unified to make any private understand at once. Only later, when production had to be geared to manifold markets with ever more varied demands, and when the training of artisans had gradually lost its helpful uniformity, did minutely detailed designs and blueprints become necessary.

By the time the Victorian era dawned, production rested on a pyramid built up of commercial entrepreneurs, manufacturers, contractors, and subcontractors, who hired and fired foremen, and workers, all of them drawn from the newly created and rather mottled free-labor market. The architect, often himself a free-lance professional working on percentage fees for a variety of clients and no longer for one permanent patron, had to conceive of his work in terms of building contracts. They were signed only on the basis of accepted competitive bids of contractors and subcontractors. Whatever the limits of his own knowledge, he had to learn to formulate the specifications of twenty-odd trades and to transform their vernacular into multigraphed verbalizations and legal language, black on white. He had to train himself to visualize technicalities theoretically and on paper, to enjoy and read the blueprints of his own making, and he often naïvely expected the men on the building sites and in the shops to do the same. His obligation and chance to train someone for the task had ceased.

Meanwhile the *nouveau riche* consumers, the captains of industry in need of a showy emporium or of a rent-producing tenement block, kept one eye fixed on the grandiose past of princely architecture and, ignoring the profound change in the psychology of production, expected a service like that of bygone days. It was hoped that a maze of blueprints and

farmed-out, unrehearsed subcontracts, a hurly-burly of hirings from the street and dismissals, or finally a Philadelphia lawyer's litigation when men or matters went wrong would all yield stylistic results equal to those assured by the rigid organization of training and employment that had governed things earlier. But somehow Humpty Dumpty could not be put together and up onto his wall again. All the King's men were dead. And all the King's columns revived in pressed sheet metal, all the plaster-cast caryatids, the staff-molded astragals and pilaster caps failed to do the trick, however painstakingly they were now preassembled on the new-fangled blueprints.

Not that human design ability had dwindled or that the individual nineteenth-century brain had deteriorated organically. The truth of the situation was that a fundamental material and thus a psychological transformation of the whole process of production had alienated it from old established goals as well as potentials. Unless consumers can be led to be cautious in bestowing love on static forms and understand at least the fundamentals of productive procedure and performance, they, above all others, are bound to suffer disappointment and frustration.

Person-to-person explanation and demonstration of a creative scheme stimulate the working personnel because these means of appeal are addressed to many senses and because they supply both intellectual and emotional impetus. They help the participants to overcome their inner resistances and blockages. The typewritten formalistic verbiage of our specifications, our carefully dimensioned details may have advantages as regards precision and 'scientific' objectivity when conveyed impersonally to the executing workman. But unfortunately, it is difficult to adjust them to the varying mental levels of that chain of performers and artisans. Teamwork is impeded by the mass of involved terminology packed into instruction sheets and blueprints, often more suited to the courtroom than to construction sites.

If all the collaborators, from the original designer to the

last helper, were on the same psychological level, there would perhaps be less difficulty of this sort. It is no accident that in reality these men are so different from each other. How else could they supplement each other's work? If they were all alike, they might only compete with each other and be quite unable to co-operate.

In the pre-industrial era, successful communication of design ideas depended on leaders able to adjust their understanding to the various levels of emotional and rational capacity represented by their working crews. They made little use of abstractions. High-brow or academic expressions did not enter into their vocabulary. In personal contact, it was possible for them to explain a given point in various ways, according to the mentality of the man addressed. The facial expression and the behavior of the worker were in turn a valuable and practical guide to the instructing designer. He could see immediately whether he was making himself understood and whether his words served to induce pleasurable and purposeful response. He could correct his procedure at once if he saw his workman becoming confused, frustrated, or hostile owing to the complexity of his orders. We might say that neural friction could at once be lubricated by neural means before a perniciously unco-operative attitude had been established.

The free-lance designer preparing plans to be submitted to competitive bidding is in an entirely different position. He does not know what sort of crew he will have, or how well it will grasp his ideas, or the psychological factors with which he may have to cope in obtaining the needed, willing teamwork. He is almost deliberately trained to disregard such subjective contingencies. Stenciled specifications are couched in a mock-scientific language, stylized to safeguard, after failures in execution, a clinching presentation before judge and jury, and to be argued in cross-examination. In writing these contract documents, the architect practically anticipates a legal aftermath. The best possible craftsman reading it all is promptly scared off, and only the shrewd businessman, forti-

fied by ingenious legal counsel, can tackle a contract of this kind with the necessary confidence.

Thus it is that 'free contracting,' whatever its advantages, tends by very natural selection to eliminate certain types of creative men who were able to function constructively in former periods, and assures dominance and survival of other types who perhaps were never before found in the field of building a human environment.

The results reflect this difference in personnel. It is in short the difference between column caps individually carved out of individually selected stone by creatively motivated workers, stimulated to their tasks by a designer who assumes personal direction, as against column caps cast businesslike in stereotyped molds, patterned from intricately detailed drawings and assembled without benefit of a single spoken word or encouraging smile.

Quite generally, however, even if no substitution of one method by another can possibly produce the identical result, there is still no reason to despair of our situation. We have merely to understand the limitations of the less personal method and to content ourselves after evolving the best values it can produce. We must hope that while certain values have been irretrievably lost, others may have been gained.

Progress is always accompanied by an element of regret; it is known to wise adults that we cannot eat our cake and have it. Our attitude, however, must be not only resigned but also constructive. It is desirable that the processes of communicating design ideas should not voluntarily be dehumanized and mechanized any more than is absolutely necessary. Any de-personalization or freezing of these processes tends to inhibit the living evolution of design itself.

The monuments of medieval culture may have been largely anonymous productions because there were no signed plans, but they were in actuality the handiwork of individual designers and workmen in organic association, with intimate nervous contact among all participants. It

was a living group accomplishment. The chain of designers-producers was neurally linked and almost free of mechanistic impediment. In our present-day of blueprints and elaborate contract documents, we have built up a veritable system of such extraorganic interpositions. It matters little that we try nominally to preserve that Renaissance tradition of crediting a great architect with the design and with design leadership. In reality, the very conception and mental projection of our designs are bound to be mechanized by the methods of collaboration and transmission.

At present, the canon of transmission of our architectural ideas is largely planimetric presentation; that is, the drawing of floor plans, elevations, and sectional layouts of a house or any spatial concept on a flat piece of paper. This imposes unavoidable and grave limitations on the concept itself. It will have to be simple enough to be understood by those expected to execute the plan. Many spatial concepts cannot be represented intelligibly by these particular means.

Means tend to influence ends. Mechanically applied, the metric system will influence us to think in proportions other than those convenient under the system of inch and foot. The common fraction one-seventh may often have been favored by ancient designers or builders because it was easily kept in mind, whereas the equivalent decimal expression, 0.14285714 . . . , would hardly have attracted them.

To the geographer, of course, the world does not really change whether he uses Mercator's projection or some other cartographical system, or whether he computes distance in miles or in kilometers. But we must not forget one thing: he is merely recording, he does not design under the impact of these systems.

Designing is a nervous procedure par excellence. It will always be highly dependent on the mode of formulation and transmission, the means used to make the idea comprehensible. These means are virtually immanent in the idea. The powerful economics of mind transaction is effective long before such an idea becomes even dimly visible.

In the year 1900, Adolf Loos started a revolt against the practice of indicating dimensions in figures or measured drawings. He felt, as he often told me, that such a procedure dehumanizes design. 'If I want a wood paneling or wainscot to be of a certain height, I stand there, hold my hand at that certain height, and the carpenter makes his pencil mark. Then I step back and look at it from one point and from another, visualizing the finished result with all my powers. This is the only human way to decide on the height of a wainscot, or on the width of a window.' Loos was inclined to use a minimum of paper plans; he carried in his head all the details of even his most complex designs, and prided himself on being an architect without a pencil.

One day one of Loos's clients who was greatly devoted to him had to abandon a project for unforeseen reasons. He intended to compensate his architect for the paper work done to that point with what he thought was an adequate remuneration. But Loos convinced him that the design work already done was a hundred times as much as was shown or possibly could ever be shown on the few sheets of drafting paper he had presented. And he received his fee in full. It may be seen, however, that Loos was not a professional designer of the particular age in which he lived and did not act like one. His very human method of bringing design to realization was an anomaly—so was his fee and the fact that he could collect it.

INCREASING SHOP FABRICATION MAY REVIVE
THE HUMAN TIE BETWEEN DESIGNER AND
WORKING CREW, a contact that was sorely
lost in the bewildering fog of an age only
partly mechanized, an age of paper specifica-
tions and competitive contracting, of foot-
loose free-lancing in design, and of plodding
along on construction premises.

42

Any lay person who undertakes to de-
sign by himself a little addition to his quarters—to contrive
a rumpus room in the basement, for instance—proceeds in
a manner not unlike that of Adolf Loos, the great pioneer.
He acts as he does because, as we have already pointed out,
it is psychologically normal not to fix everything by rigid
plan at once but rather to visualize one step after another
in a *sequence of alterations.*

The training of the contemporary architect in this aspect
of his work enables him to telescope several steps of trial
and error by means of one visualization. For this he has
learned to use paper and pencil. And these tools may even
become important stimulants to set his mind working. Then,
once he has made his final decision about how to proceed,
he employs a complicated set of symbols to transmit the fin-
ished idea to others. His most useful equipment, however,
consists of such gifts as he may possess for envisioning all of

the desired relationships, in space, in time, in function, in form and color.

In making paper presentations, the good architect never falls victim to his training of draftsmanship. Scale drawings and sketches of perspectives are to him effective methods of making himself understood—not so much to himself as to clients, bankers, contractors, foremen, and building inspectors.

Just as he is helpful to all of these people through his drawing, they are helpful to him in the realization of the design; and this they can be only in the same measure as they are enabled to grasp and visualize his intention and enter into it with an emotionally favorable attitude.

School training in mere precision and in legalistic verbiage alone does not do the trick. A man may be able to express himself concisely, and yet be unable to make friends or enlist co-operation. On the other hand, it is possible, by use of the proper intonation and phrasing, to establish direct emotional contact with one's collaborators, who will recognize an attitude as friendly and helpful and respond helpfully on their part.

Working drawings with their instructions can indeed be agreeably systematic and appealing in form and content, or they can be as confusing and careless as the sort of speech that remains ineffectual because it offends or defeats the attempt of others to grasp it. We must never forget that, rightly or wrongly, there is a class difference between workman and designer. The man who works in the field in the cold wind and the drizzle harbors a basic ill feeling against the boys who allegedly enjoy the comfort of a downtown office and either fail to deliver or spew out details and blueprints without end to harass the worker on the job. The contract is similar to that between the front-line soldier who storms steep hills in face of a shower of hand grenades and 'the bunch of push-button officers back there' who are always pictured as telephoning their orders between dinner courses in the luxurious mess hall of headquarters.

This hostile feeling arises easily whenever there is sharp

differentiation between field and office work. Shop work is marked by less psychological division and antagonism. It isolates the designer less than field work does and may actually improve human relations. Its expanding role in modern building is therefore a wholesome trend. Construction work done under one roof of a shop may be nervously as wholesome as it was when, once upon a time, work and design were executed close together in the field. But where shop work is not integrated with the job done in the field, the office man or the drafting-room architect builds by correspondence. In that case he must at least be an appealing letter writer and ought to have an almost tender consideration for the outside helpers to whom he addresses his blueprint symbols.

During the construction of San Francisco's Golden Gate Bridge, the chief engineer took me up to the south bridge tower, then already soaring some six hundred feet above the waters of the bay. We donned steel helmets, which were scant enough protection against the red-hot rivets that, occasionally missing their destination, came swishing down like bullets. Two workingmen, blueprints in hand, made the ascent with us in the dangling, doorless wire-mesh cage of the construction elevator. At sea level, the weather was rather calm; but we seemed to be climbing slowly into a raging storm as our little cage, swinging to and fro, rose ever higher through the red-painted steelwork of the tower, and the foam-capped waves below became tiny and insignificant.

At a height of five hundred feet the elevator reached a heavy diagonal bracing of the gigantic structure and made an intermediate stop. Here our two companions got off; they were riveters and had a four-hour job ahead of them at this hazardous station. There were other men at work on the slanting brace in front of us. They shoved out a heavy board, cantilevering it toward the elevator cage, which seemed to me to sway more violently than ever in the high wind.

I clutched the wire-mesh enclosure with both hands as the two riveters jumped onto the plank. I saw them, blueprints always faithfully in hand, crawl up the steel girder to the iso-

lated foothold where they would have to work for long hours, all alone between sky and sea. There would be nobody to ask questions of; their only link with the world would be their crumpled rolls of drawings. I saw them looking at these as the elevator moved upward. I hope that in these documents the designing engineer was speaking to them with a voice that was comforting and reassuring in the storm and the danger.

Construction men lie on their backs or bellies, perch on swinging scaffolds and roof trusses, gasp for air in the obnoxious fog of the spray gun or in foundation wells deep underground—and always they consult blueprints, drawings, schedules received from a man whom they have never seen, and whom they visualize as an office functionary wearing a white collar and often an artistic necktie.

In the shops of an airplane factory the relation is different. The intellectuals are more intimately part of the picture there. Occasionally, they come walking out of the drafting room in their working smocks to check, confer, and explain. Designers, like ordinary people, meet directly with production engineers, who in turn consult with foremen in the assembly shop. They can perceive each other as human beings laboring in companionship. Although these men have different jobs, each knows the other and appreciates the other's training. Departments can remain in touch. The individual worker does not necessarily depend on blueprints alone, however plentiful they may be. And here blueprints are likely to specify production details even in easily understood perspective rendering. There are full-size 'mock-ups' and models to help in visualizing the most complicated spatial relationships. And above all, there is familiar conversation—human voices which even under the worst conditions of noise and haste remain a reassuring influence. Men in a shop are not scattered as they often are in the field, where they must puzzle out their problems in isolation.

A basic fallacy of lay literature has been that it depicts prefabrication and shop work as soulless, and the man in the factory as sour faced compared with the carpenter or mason

gaily singing on his job. Workmen enjoying the companionship of the shop are probably less grouchy than those consigned to solitary tasks in detached stations of the field, but chained by paper directives.

If construction must be planned on a mass scale—as it often must in our time—then field work has little of those merits of individual initiative or freedom from care. It has become just a function of carrying out written orders. And mere written orders, almost necessarily abbreviated and skeletonized, impose more nervous strain than does day-to-day contact with the designer, at least whenever new problems are being handled. Roof configurations complicated merely to be interesting, all kinds of picturesque irregularities in fenestration, and other special details did not bother the spirited carpenter on the job as long as all these forms sprang from his own initiative as they did in the olden days. Whistling, he sawed, fitted, and joined as he thought best. If nowadays he is required to produce similar effects working from blueprints and in compliance with trick details, he stops whistling or singing and, when sufficiently puzzled, begins to curse.

Whenever a large portion of the work is shop-prepared, those picturesque irregularities—formerly often the accidental result of spontaneous, carefree work in the field—become meaningless, incomprehensible, bothersome anomalies. Prefabricated simulation of spontaneity, prefabricated English cottages and Mexican farmettes negate the very nature of the current process that brings them forth. From a technological as well as psychological point of view, they are a contradiction to the natural laws of survival. New ways of gratifying demands of form must and will be developed under the mutually changed conditions of mind and construction process. The old satisfactions and values degenerate into cheap and troublesome mimicry, and hence must perish from the earth.

We have dealt with misuse of forms and processes as a complicating factor even in primitive civilizations. With cultural advance and increasing communication it becomes a

serious blight, because it substitutes the crazy quilt pattern of hybridization for a normal and genuine evolution.

In modern times, printing and printed matter, easy distribution of design reproductions merely enlarge the problem. The illustrations of current magazines of 'decoration' and 'design' are in a way only the contemporary version of the folios of ornament cuts which, since the late Renaissance, have been flooding the Western world. It was the Paris publishers of the eighteenth century who first deliberately hired artists, often famous painters, to devise sheer ornamental forms for sale. This art exercise, dissociated from any specific material or tool except the needle of the engraver, was intended to fertilize the brain, 'furnish inspiration' for cabinet-makers, stucco workers, forgemen, wood carvers, jewelers, baked-biscuit artists, landscape gardeners, and what-have-you. All the craftsmen who earlier had maintained their own traditions of workmanship in close relation to specific materials were now warned that they would fall out of fashion if they did not take their ideas from the portfolios of a metropolitan commercial publisher's trade of designs canned for mass consumption. It was the advent of the cliché.

The Albertina in Vienna and many other European museums contain vast collections of those delicately engraved but ominous sheets of ornamental patterns once sold at high prices to artisans of all kinds—designs overloaded with rocailles, fretwork, gingerbread, late eighteenth-century parlor rusticity, chinoiseries, monkey scenes.

Commercially derailed 'fine artists' undermined the artistic prestige and initiative of the artisan and the shop. Pattern sheets wiped out normal tool-bound design concepts safely founded on shop practice rather than on dexterity with the pencil.

Lost for a while in the fog and steam rising over new power production, we are now again sighting the bearings of indigenous 'trade-and-tool wisdom.' The new shops of fabrication may regain a realistic initiative that has too long been obscured by detached draftsmanship.

306

LIFE'S NEEDS ARE THOROUGHLY INTERLINKED BUT THIS LINKAGE IS RARELY OBSERVED WITH CARE. Neither speculative thought nor overbearing piecemeal technology can make up for such essential carelessness.

43

Through the ages, man has labored hard, both physically and speculatively, to devise instruments for improving his environment. Himself he has largely taken for granted and known for the most part by accidental introspection. The fresh goal of our discussions is to stimulate interest in objective physiological data as guides in constructing and in judging human environment to fit man, properly appraised. The first task will be at least to hint at programs of purposeful experimentation. The labors of many a researcher will be required to isolate and solve problems, roughly pointed out by the practitioner.

For many years, I have been concerned with finding a good start from which to evolve concrete research in this vast field of design and to learn from attempted investigations what we ought to know of its biological effects. The experimental design of elementary classrooms in Texas may serve as an example. It represents an attempt at such investigations that has prompted similar efforts elsewhere.

Dr. D. B. Harmon, who began with a physiological interest in primarily optical environmental influences on the develop-

ment of school children, penetrated—whatever the detail validity of this work may be—deeply into the problems of biological oneness. Into this oneness each and every particle of sensory behavior or sense-determined action flows and is absorbed. 'We do not see to see,' said Dr. Harmon, 'we see to act.' Seeing, taken as an example, most generally affects all our active and passive living. When we are children, moreover, it can make us grow up into healthy normalcy or into stuntedness and distortion.

An interprofessional commission was formed for the state of Texas—composed of physicians practicing internal medicine, dentists, orthopedists, educators, illumination engineers, color, paint, and optical experts—for the purpose of studying the light and brightness distribution in elementary classrooms and all factors that thereby influence the growth, health, behavior, and learning performance of 160,000 Texas school children. Tentative exemplary measures were then taken to correct a few sample classrooms in visual matters.

Brightness contrasts were diminished not to exceed one to five anywhere in the binocular field. The effects of this simple but newly established balance were stunning. Of a huge number of well-established refractive eye difficulties, supposedly correctible by glasses only, 65 per cent had disappeared after six months in the properly illuminated and colored classroom, which had been specially treated for proper brightness distribution.

But what to doubters is even more striking and astounding than specific eye welfare is the fact that 47 per cent of malnutrition symptoms were reported to dwindle out of existence when energies were preserved by eliminating muscular strain caused by malposture and growth difficulties due to visual trouble. Diet had not been changed at all during this half year. Forty per cent of chronic infections, nose, throat, and ear ailments, and deficient functionings, we are told, were eliminated without any specific treatment of these deficiencies, but by general improvement of visual hygiene.

Were it not for the official endorsement and scientific character of this commission, one might easily suspect and

mistrust such new findings as illusive. But parallel work has been undertaken by the Bureau of Child Study of the Chicago Board of Education, the Yale Clinic on Child Development, the University of Toronto, and, apart from all statistical detail of the findings, at least the tendency of promising research was here ineradicably established. This is even more important for our purpose than immediate results or their accuracy. It appears to be of overwhelming significance that methods are being invented and slowly perfected to test objectively the broad, profoundly influential, and ramified effects of each type of sensory stimulation.

To emerge from the realm of guesswork may help design generally to rise above the empire of likes, dislikes, and tastes. It may, at least in part, give the designer some of the objective status that practical men and politicians have learned to grant the planners of health measures.

As stated, systematic studies on thousands of school children were concerned with the effects of traditional classrooms. Classrooms were visually improved, so that improper distribution of brightness in relation to various tasks and to the total classroom life was reduced. Results were carefully tabulated. The entire reflex chain set into motion by *action under visual stimulus* was identified, observed, and illustrated through the medium of motion pictures. Stills were excerpted from this flowing record and interpreted. The positioning of all bodily members was appraised in relation to subtle determinants from the field of vision, particularly in relation to the visual stimulation by brightness differentials existent in the room. The posture pattern under this influence and during a special localized visual task was compared with desirable, normal, undistorted posture. The visual adaptation to this task and the adaptation to it of the whole body appeared intimately fused. It was recognized that wholesome normalcy and free play in the total bodily action followed from visual ease and relaxation. This would of course best result from bringing, without impediment, the kinesthetic plane of comfortable manipulation—the object in our hands—to coincide

with a suitable visual plane of acuity and eye comfort. But the visually guided action must also happen without undue lateral optical interferences that originate off center. Offensive or distracting brightness and sharp contrasts to it in the broad binocular field surrounding the focus of active attention must be well controlled.

Where such controls were not exercised, malpostures promptly occurred. They had to be interpreted not only 'geometrically' but also 'dynamically,' i.e. in muscular tensions that were evidently produced by the reflex positions of head, jaws, neck, spine, arms, and so on. This led to methodical electric measurement of muscular innervation with careful comparison upon tabulation, and to anthropometric studies repeated over a long period in order to record results of specific habitual strain on the muscular and bone structure of growing children.

While all these studies started specifically with circumstances of vision and extended over into various consequent effects connected with it, similar and corresponding research may get under way on the physiological basis of acoustics or thermal problems. Yet even when a single sensory realm is the starting point, findings can finally lead to novel architectural design of classrooms, and of school buildings.

Comparing traditional with visually corrected classrooms, biomicroscopic investigations revealed that the physical architectural shape and character of these rooms corresponded to equally characteristic eye deformations of the children who lived and worked in these rooms. Noticeable morphological and histological changes of the living sense organ itself proved startling and intimate consequences of the architect's design. This had to him been also very largely 'eye-determined,' only in a more traditional sense.

The research tended to branch out over a much broader field, however. Chemical tests were made on the children; quantitative analyses of blood samples, urine, feces, the end products of glandular activity, were statistically compared. Fatigue studies of many kinds concerned themselves with

cardiac conditions, sampling certain modifications in heart sounds, and with neurological effects of visual activity, by checking on typical changes in all principal normal reflexes and in the respirational pattern. The experimenters also became attentive to strictly cerebral phenomena. A further step, therefore, was the recording and measurement of what is called the disintegration pattern of the basic encephalographic sinus waves. In simpler words, brain-wave recordings were made of children while in visually stimulated action, under both ordinary and corrected classroom circumstances.

Naturally, also psychometrics were applied to gauge comparative mental achievement in detail and learning performance in general. This in itself is a tremendous field of experimental elucidation of classroom design through functional results, to which, after all, classrooms are dedicated.

Having once recognized that a sensory stimulation such as the one producing vision does not simply end there, we can appraise with awe the complex investigations into all parts and layers of the physiological being and entity that will be possible and perhaps unavoidable in deciding on the merit or demerit of a formal and technical design.

Dr. Harmon, originally interested only in the vision of school children, comes to state in the course of his studies that 50 per cent of dental trouble due to faulty jaw positioning (malocclusion) may be attributed to forced general posturing caused by a wrong and troublesome distribution of brightness levels in an elementary classroom.

That vision, posture, and dental decay may have a hitherto unsuspected relationship can help to exemplify for us the complex responsibilities of design. When we follow the successive stages of redesign of classrooms—their fenestration, illumination, color schemes, and general equipment, down to slant and reflectivity of desk tops—we can foresee that what has long been treated under the rule of innocent inertia or reckless guesswork may be based to a degree on provable knowledge and cautious balance of valid considerations. Even where design failure would not immediately threaten us with grossly pathological consequences, architecture seems

to ascend to a new order of motivation, and design may have to answer a new and less arbitrary consumer attitude.

If, for example, we introduce such a thing as nationwide facilities for the daily exercises of public education, it means in more than one respect potential collision with long-consistent natural circumstances. It may actually mean a new pathology, a cluster of new physiological difficulties as by-products.

We may conclude by demonstrating how one specific physiological investigation may demolish design patterns of long standing. It can lead to serviceable differentiation more fitting for both the individual and the human natural equipment in general. There have been in the past too many fallacious generalizations on the one hand, and exaggerated beliefs in super-individualized response to aesthetic stimuli on the other.

In a traditional grade-school room with several windows in one of its long walls, the children are regimented. They are seated parallel to each other at fixed desks placed in straight rows, all directly facing the blackboard. The light comes from the left. The studies of Dr. Harmon have proved the physiological fallacy of this simple geometrical arrangement and have shown the urgent need to give individual attention to the placement of each single seat. For each seat and for each row of seats, the left front corner of the room— that is, the corner where the bright window wall intersects with the much darker blackboard wall—is optically the decisive point. And it is differently situated in relation to each child. The angle between the line of vision directed toward this corner and the line toward the center of the blackboard is naturally different for every seat in the room. Assuming that the difference in brightness between the left and the frontal portion of the field of vision should be reduced to a minimum to obviate eye strain, Dr. Harmon arrived at a most unusual arrangement of the seats in curves, fanning out and nonconcentric. Here each child is turned differently in order to have the same visual benefits. The novel and interesting design and layout is governed by physiological

312

optima. It improves not only conditions of vision, but, as a consequence, also general performance of body and mind, and fosters growth without distortion. Children are indeed observed and aided by the designer to act and to grow under the directive influence of light, almost as plants do in a greenhouse in following their basic heliotropism.

As we said, a design innovation of this kind may, on the one hand, introduce interesting individualization and a differentiation, too little considered in the past. On the other hand, it allows again for important physiological constants to counteract lawless views in favor of a pseudo-individualization. We have been suffering in our time from a roughshod and arbitrary individualism that interferes with the kind of harmonious setting other cultures have enjoyed. But we may in our designs come closer to a true and new understanding of the individual and its nature, engaged in a profound interplay of inner and outer circumstances.

DESIGN, never a harmless play with forms and colors, CHANGES OUTER LIFE AS WELL AS OUR INNER BALANCES.

44

Architecture is a social art. It becomes an instrument of human fate because it not only caters to requirement but also shapes and conditions our responses. It can be called reflective because it mirrors a program of conduct and living. At the same time this art of a planned environment does more, it also programs our daily conduct and our entire civilized life. It modifies and often breaks earlier established habit.

We have keenly felt the need to probe into the general background of design and to search for the methods that ought to make its activity safe and sound for its vast consumership.

The primary interest is in what seems to remain 'constant' in these human consumers; it will be reckoned with as firm ground. From there our curiosity proceeds to what may be modifiable in human make-up and to what possibly should and could be changed in everyday requirements. Their steadiness is often only *supposed* to be legitimate and reliable.

It is strange that human beings have hardly ever been studied with regard to their vital needs and care, the way rooted plants are studied in order to aid the agronomist in

his work. Little information of this kind has been collected in practical handbooks printed for the architect and the designer.[1] The sort of investigation spoken of here is not at all revolutionary in itself. Only its application to design has so far been rather fragmentary. The most specifically human endowment to be studied is a nervous system fused to an upper brain of extraordinary volume and complexity.

Officially, 'physiological psychology' dates back to Wundt. The measuring of nervous responses received great impetus from Feré and his psycho-galvanic scaling of their intensities in 1888. Since this work, acoustical intensities and pitch, tactile impacts and pressure, gravity pull, and so on, have been investigated in their role as stimuli and measured in an orderly fashion. There is no reason why all influences of our surroundings—be they accidental or of our own design—should not become gaugeable similarly, as, for instance, the effects of the thermal and other physical or chemical properties of the air that surrounds us are measurable in physio-

[1] Professor Lee R. Dice of the University of Michigan has called attention forcefully to the "importance of co-operative studies of the biology of man," and indicates that "no investigation or group of investigations now in progress is in my opinion sufficiently comprehensive to secure anything like a complete picture of man the animal, as he exists in this constantly changing world."

'Professors Brozek and Keys of the University of Minnesota have called attention to the Laboratory of Physiological Hygiene which exists at their institution and the importance of "interdisciplinary research in experimental human biology."

'No proposal to study human beings scientifically and comprehensively has as yet received any substantial public support. In spite of all the moves that have been made and all the ideas and proposals that may have been entertained or set forth, we can say that to date there has never been developed a study of human beings which even remotely approximates comprehensiveness.

'. . . we may assert without fear of argument that human beings are incomparably more complex than wood. Yet success in the field of wood technology has required the work of large laboratories with well-trained staffs for many years. If we are to understand human beings—a problem incomparably more important—we must be prepared to put the requisite amount of money and effort into the task. Fortunately we can reap benefits as we progress.' *The Human Frontier* by Roger J. Williams, Harcourt, Brace & Co., New York, 1946, pp. 171-174.

logical terms. We have to breathe air continuously and we have to suffer the harms that come from its pollution. But air is only the prototype for that over-all agent, the much more complex, ubiquitous, and perpetually effective agent that we call our physical environment. This environment of ours is largely an artefact. In our technologically advanced state of affairs, it is a pile of often incoherent fabrications and constructions interfering with life processes and adulterating them.

Systematic observation and legislation tend to govern the traffic in foods and drugs. But the effectiveness of design in all kinds of small and large single commodities and in constructed environment as a whole is powerfully at work on senses and nerves. It often reaches down as close to the core of our life as the diet, the stimulants, and patent medicines that we swallow under the pressure of clever advertisement.

The far-reaching influence that a new biological knowledge must have on design is quite obvious. While such research would perhaps have seemed fantastic a few decades ago, it is now common enough to be put into the service of the consumer. It will enable us to receive a fairly clear picture of the pathology of design, of the ill effects caused by design miscarriage, even if they are not conspicuous or easily detected. Through the sensory functions or irritations that design elicits, it often disturbs many inner balances and thus manifestly affects our individual well-being. It has its meaning for the development of a generation of growing, still pliable children, and particularly through this circumstance, for the survival of the race. The investigation may, as said, lead to an appraisal of injuries due to design that are as yet unknown to the designer himself. The potential consequences of such a state of ignorance may well make us feel uneasy.

A great many general disturbances due to sense impacts are measurable and have actually been measured. They range from metabolic troubles and irregularities in the distribution

of oxygen to deficiencies in the production of endocrine substances and enzymes.[2]

A vast array of normally balanced inner phenomena seems to be potentially and mediately affected by sensory impulses conducted toward the brain. These do not simply terminate in our perception but they become trans-brain influences with greatly ramified flow lines and effectiveness.

A striking example of this has been given in D. B. Harmon's research, which takes its start well confined to the visual conditions in the classrooms of school children, and from here diverges broadly to many phases of life, growth, and handicaps. Unfortunately, a study like this is still a rare event in architecture, and human beings are usually not granted this much attention by those who undertake to construct their surroundings.

A high organism such as ours stands in a subtle relationship of sensory response to what happens outside. It has always been known that our 'vegetative functions' are not truly and fully removed or isolated from those of the senses. They are not really autonomically governed by a special nervous system. Their connections to the spinal equipment and the brain are so manifold that a mutual influencing is perpetual.[3] For instance, since Cannon's work of 1915, the

[2] Types of general disturbances derived from sensory sources concern such widely diversified or intimately connected phenomena as oxygen deficiency or diminished supply affecting brain-cell chemistry and degeneration of brain tissue; the incomplete combustion and the lactic-acid content of the blood; the creatinine-phosphate-sugar and urea equilibrium between plasma and lymph; the glandular production of mutually activating endocrine substances; enzymes; various catalyzing processes of inner chemistry in both directions, or toward the attainment of equilibrium and a median level; hormones; the modifications in urine formation and chemistry; the speed rates or velocity constants of various secretions and absorptions; the curdling or coagulation of blood.

[3] According to Langley, the nerve fibers efferent or leading out from the seemingly segregated string of sympathetic ganglia have their special job. They supply the plain, involuntary muscle tissue of heart, viscera, and glands, and are engaged in those processes that formerly were called vegetative and later automatic. But a great deal of preganglionic fibers, rami communicantes, and other conductive bridges intimately connect the central spinal system and this autonomic system to make it really one interdependent unit.

317

effectiveness of emotional states on all vegetative functions has been scientifically confirmed.[4] The gall bladder, liver, and intestines have long been known to be affected by what is seen and heard and our feelings about it. Everyone is aware that shocks, such as a frightening sight, may upset intestinal functions.

Cannon's studies, which show the sympathetic system as an *instrument of automatic adaptation to routine change of* the environment, are highly interesting to the designer because he is perpetually concerned with what adaptation to his design an individual or the public as a whole can accomplish. Such an adaptive process will rarely be conscious and voluntary.

We must not forget that 'aware and willful' activities are relatively few and are directed from the motor areas of the frontal lobe. *Through design, however, man can, mediately or by a planned roundabout way, extend willful events to his innermost realms where responses were formerly almost uncontrolled.*

We must get over the notion that design deals only with external objects. Once we recognize that a product of upper brain power called design affects ever-greater portions of the innermost human being, related responsibilities begin to loom before us.

First with curiosity and later with more profitable absorption, the designer will follow information about how the inner equilibria, such as distribution of venous and arterial blood, the pressure in and the dilation of our vessels, and so

[4] These influences have been found to be mediated through centers in the spinal cord and the diencephalic region, called hypothalamus. Stimulation of it evokes adrenalin secretion, a consequent rise in blood pressure, cardiac and vascular effects; in short, meddles into everything that traditionally ought to be 'autonomous.' For example, detailed observations leave little doubt that emotional disturbances caused, say, by sensory stimuli will actually hasten bowel movement or again dull and retard the rhythmic contractions—regularly six per minute or so—of the little muscular projections called villi, which line the lumen, the hollow of the intestines, and, according to Brucke, act as minute pumps to suck in and absorb nutritive juices.

on, are measurably affected by outside stimuli that man himself can devise. While at this point the topic may be highlighted only briefly by mentioning a few general physiological test objects, it will become clear again and again that sensory stimulation is no innocuous play with forms and colors, but that it has a great many important extra-sensory consequences.[5] Since the inner physiological equilibria are so significant for these life processes and for survival in general, they must be patiently observed. They must be checked under all possible impacts of experimentally imposed sensory stimuli. Under such exposure, deviations from the normal must be quantitatively noted in proportion to the measured magnitude, frequency, or duration of these stimuli.

Certain businesses have become interested in this field of benefit or harm to well-being. For example, producers and sellers of heating and ventilating equipment found it profitable to invest in careful studies and experiments on subjective comfort, physiologically analyzed. A ventilating engineer now knows that a two-year-old child, in proportion to its body weight, uses up three times the quantity of oxygen an adult would need. Computed on the basis of skin surface, the rate per unit is one and a half of what the grown-up consumes. The anesthetic effects of various air pollutions, the humidity of air, its relationship to temperature, its passage over our perspiring skin surface covered with minute moisture particles secreted by each innervated sweat gland, and

[5] There are such equilibria worth watching when sensory stimulation is added. They are of many and various kinds. Frequently they are functionally and specifically linked, such as that of venous arterial blood distribution and pressures in connection with items of, say, the general cardiographic investigation already mentioned. Further items may be observable as vascular effects, perhaps dilations of capillary diameters; changes in permeability of tissue in cellular partitions, in unbroken maintenance of colloid osmotic pressure; of plasmatic viscosity; of concentration in hemoglobin perfusates, inactivation and oxidation of internal adrenalin by a number of significantly elicited and developed enzymic systems, and so on. The good work already done in general physiology and in specific fields of it is immense and grows daily. The forecast is safe that coming decades will still greatly multiply and refine its methods and objectives.

so on—the sensory concomitants of all this have been carefully examined and interpreted for practical application. Yet, where subsidized research is involved, as in this case, it may always be necessary to keep a close watch for the borderline beyond which intentions of more lucrative trade may begin to color the results.

For 'natural' ventilation that happens not to require the purchase of a mechanical contraption, desirable data, circumstantial interpretation, and guidance will come to the designer much less easily. There he will find himself promptly foiled by the commercial sources of instruction. Often enough he is left with his own subjective sensory experience, with such of his feelings and such scraps of inner evidence as he can muster by himself. Much less data seems readily available here and, of course, there is no manufacturer to mail us a free handbook when we send in a request stub in response to his national advertisement. *Natural ventilation is no subject for such an ad.*

There may be nothing to sell, nothing to advertise, and still there may be a maze of significant facts to know and to investigate. Let us take an example that is somewhat removed from our own scene, so complicated and biased by expensive gadgets. But even in the face of comparative simplicity, strange quandaries will be caused by the intimate interlocking of varied and devious design arguments that no specialized salesman or manufacturer would worry about. This complexity is nevertheless the order of the day in conceiving a serviceable building anywhere and so may be described as generally characteristic for the process.

I was called in to devise the layout and structure for simple, rural classrooms on a tropical island. Obsolete ordinances, borrowed from the Continent many years ago, required a legal 'minimum' of static air storage per child in the room. Most of this stored air consisted in a volume stagnant under the ceiling, while the windows were ordinarily placed much lower down, all on one side of the room, with disregard for cross-ventilation. Warm, moist air, practically

stationary, saturated with airborne bacteria, and recirculated through many lungs, had made tuberculosis endemic, spreading from one child to another in the locality.

On the one hand, rigid economy was exercised by keeping the floor area small and crowded. On the other hand, attention and money were expended on making the school building high and on providing a vertically extended store of air. But tall classrooms with a small floor area create special problems of construction, especially when the forces of high winds, hurricanes, and earthquakes have to be taken into account. Walls and footings must be reinforced more heavily, and in order to lend added strength to the walls, the most useful and refreshing openings, windows and doors, must be reduced in width so that the amount of dead masonry can be increased for a greater lateral resistance. The result of all this is that costs go up far in excess of being merely proportional to the height and bulk of the building.

Cost, structural safety, and pathology, the manifest spreading of disease, are, however, not the only things we cope with through design. We are also concerned with sensory comfort and with general well-being—concepts badly in need of physiological understanding. West Indian sultriness, an object of complaint, can be mitigated by opening up the buildings and orienting them into the very steady trade winds, which are equally West Indian and a glorious asset to the climate. We must give the air a chance to pass over our skin, where it dries the millions of precious tiny sweat droplets and causes a delightfully cooling sensation. It can be shown that this is really more important here than reducing the chemical pollution of the air.

Severe economic limitations may not permit us to increase the cubature or the structural bulk of a building. This does not defeat us. We can save money by making the edifice less tall if only at the same time we think of turning it into the breeze and opening it to the great outdoors—to all the natural blessings free of charge.

And so we did proceed. The structural concern about elevating the building high, up into the dangers of occasional

heavy wind attack, was reduced. Yet ventilation by salu-
brious breezes was increased through orientation and open-
ing. Wisely taking stock of natural circumstances, instead of
working against their grain, turns them into helpful agents.

My design solution assumed a normal 100-feet-per-minute
velocity of air currents in the direction of stable trade winds.
Such a velocity is very small and proved available during
practically all school hours. It produces an impact on the
forehead and face which is hardly more noticeable than if
one were to pace slowly up and down in a fully protected
room. While on a really hot day we might yearn for speedier
passage of air, even this velocity, almost below the threshold
of awareness, nevertheless gives us about *four changes of the
entire air volume per minute* for a 25-foot-deep classroom,
whose ceiling may be no higher than the window height. It
is an effect of amazing magnitude if one remembers that
costly artificial ventilation may furnish no more than ten air-
changes *per hour*, or one twenty-fourth of what we accom-
plished naturally. The air moves in freely from one broad
open front and makes its exit through the other. Airborne
bacteria no longer hover in the classroom but steadily move
sideways and are spilled out into the sun. Expectoration dries
promptly, quickly diminishing in contagiousness, and all the
while evaporation cools the skin.

The most difficult part of the assignment was to overcome
the ordinance in force and to deal with habituation and the
established bureaucratic forces backing it. But after all, class-
rooms are for children and for education; with this concern
in mind our new layout offered a great many advantages.

It must not be called a mere accident if in the process of
our design the relation of child to classroom, the child's
'feeling' in the allotted space, improved steadily. While
working on all those other problems, I remained aware of
the fact that a lower room under the tall tropical trees may
be, as a shelter, in much better scale with the child's stature
and in more suitable proportion to it. Projecting roofs and
broad fold-up doors now helped to extend the room outward
through a wide opening onto a classroom patio and aug-

322

mented the floor area for the horizontal expansion and activity that is so welcome to normal children as well as to modern teaching processes. And all this was possible when air storage was replaced by air passage.

A very involved combination of motives and considerations, from cost to earthquake loads, and a way of learning by doing, went to produce our decisions. Healthfulness, practical size, and outward expansion of schoolrooms were accomplished without a corresponding increase in price, so as to fit an over-all capital improvement program of an entire system of Public Education.

The design problem of a schoolroom has been used as an example earlier, but there purely from the point of view of vision. Here it serves equally well to demonstrate how various problems may be unrolled, starting with ventilation. These two approaches are of course not mutually exclusive but rather in need of correlation. They have to be brought into harmony with a great number of other considerations. Not least, they have to be reconciled with social complications—tradition, habits of the community, prejudice. Formal elementary education, where a novelty, is not immediately convincing. Even if it were successfully accomplished, it is first doubted by poor share-cropper parents in rural backwoods—and not just in tropical ones. It needs gentle introduction without social irritation and complaint. Disease spreading through the school may lead to just that and in fact may prove in any circumstance too high a price to pay for education.

We have dwelt here on an exemplification of how complex design motivation tends to become as our technical and social purposes increase, and how little orderly and convenient literature exists to guide us on the primary physiological level.

One fact already stands out in the total scene of mixed design considerations: a 'timeless,' static sort of design concerned with space alone will be an error. In the instance of a classroom it became clear what air flow reckoned in time

must do for living beings who themselves are physiological clocks also operating in time. Our kind of ticking is the pulsing of our blood, our breathing or inhalation-exhalation cycle, and all the many rhythmical processes that go on simultaneously within our bodies. It is through these processes—much in need of accommodation in suitable space-time—that we live and survive.

OUTLINE OF A MANIFOLD EXPERIMENTATION
that may point to greater wholesomeness in
the design of our general setting for life.

45

In the light of our discussion so far, we may attempt now to formulate the designer's professional task in terms of valid requirements of the human organism. He must attempt to strike a happy medium between those physiological imperatives that are the *constants* of life, on the one hand, and on the other, the *acquired* responses, which by his professional judgment he finds possible to include in a wholesome scheme. He should pledge himself to serve wholesomeness honestly. If physicians take such a humane oath, the designer must too.

But apart from his concern with every one of his products, he has a long-range objective. He works from design to design on a progression of stimulative constellations, carefully fitted to our capacities. The human organism must be enabled to perform a successful habituation while the designer and architect must aim at nothing less than the steady improvement of man-made environment in the direction of an enhancement of all, even the finest biological values.

Adjustment to planned change is essential for our survival as a billion-dollar technology advances headlong, often threatening to overwhelm life itself.

In *The Conditioned Reflex, Neuropsyche and Cortex*—

written from the point of view of a neurologist—N. E. Ischlondsky gives a comprehensive picture of living, of acquired responses functioning in rich variations over the base of primary reflex patterns. The variations arise first from the countless accidental conditioning experiences of man's life in the natural scene. At the top of evolutionary growth, however, civilizations flourish under the conditioning effect of *human plan and design*. *Deliberate plan and design thus take on the character of potent and final physiological instrumentalities*. The conditioned responses that a designer must take into account or work for are often very complex; nevertheless, it seems feasible to devise simple laboratory experiments that will gradually throw light on many of the problems involved without distorting them into 'oversimplified caricatures in the name of empirical science.' [1]

As we have said, conditioned responses are always superimposed on primaries, and our illustrations of what this may mean to the designer can be attached in every case to one of these primary—or arch—responses.

Let us consider, for example, the *orientational response*. It is in its effect almost similar to a tropism and consists of an involuntary *turning for reception*. The individual lets his current preoccupation, whatever it may be, lapse and automatically turns his body and sensing areas toward the source of a suddenly or newly offered stimulation. The stimulus may be simple or complex.

It may hold interest for our discussion by consisting, for instance, of a pattern *statically organized about a center*, a pattern commonly called symmetrical. Or, it may be an arrangement that embodies *dynamic direction*, which, however, does not necessarily coincide with the direction in which we orient our senses. For example, the object of our attention may be a train in motion or one merely standing ready to move, in which case the observer faces something that in itself is not centered and on the contrary has a dy-

[1] Douglas N. Morgan, 'Psychology and Art Today: A Summary and Critique,' *The Journal of Esthetics and Art Criticism*, December 1950.

namic 'sideways directedness' of its own. Such an object is called asymmetrical.

In the case of symmetrical objects, exemplified by innumerable famous—and also infamously shallow—designs, the eye focuses easily on the axis, already automatically established as part of the orientational response; there is restful coincidence. But the situation here becomes also more complicated when, for example, colors are added in one or the other way. They will incite changes of focus as the eye turns to them, owing to the physiological impossibility of responding with an equal lens accommodation to a variety of color stimuli. The ocular muscles are in such a case repeatedly innervated for successive focusings, as if the eye were following a moving object. And so a motor phenomenon is produced in the eye itself, although the outer objects are really fixed. In such a case internal stimuli bring forth a cortical response, as if external motion had been evidenced. Outer and inner worlds are confused, flow into each other; they are really one—an ancient truth.

Let us now analyze our effort of orientation if an object is asymmetrical and actually in motion. A train, close to us while moving through our field of vision from one side to the other, stimulates our outer eye muscles to action.[2] The eyes follow and jump, follow and jump, for an ever-new binocular focusing on the center portion of the field and again on parts of the object that are forever gliding outward from this field. We face a situation that is clearly not without conflict for the orientation reflex. This conflict acquires

[2] The unequal and progressive distribution of receptors in our retina strangely governs our turning of the organ when stimulated. 'It will be noted that while in the fovea there is almost a one-one correspondence between the rods and cones and the fibres of the optic nerve, the correspondence on the periphery is such that one optic nerve fibre corresponds to ten or more end organs. This is quite understandable in view of the fact that the chief function of the peripheral fibres is not so much vision itself as a pick-up for the centering and focussing-directing mechanism of the eye' (emphasis added). Wiener, Norbert, Cybernetics, Technology Press, John Wiley & Sons, New York, 1949, p. 158.

at once an emotional accent of its own so that our total attitude differs noticeably from one that accompanies a more simple and static orientational satisfaction.

A conflict not dissimilar to this, and perhaps reminiscent of it, occurs even when a resting, not a moving, ribbon or series of forms and colors is before us. The orientational response here is somewhat handicapped and more complicated than when we view a serenely centered symmetrical object. The row or ribbon calls for our sustained motor exertion and a greater expenditure of nervous energy. In other words, if supposedly sheer visual impressions occur in sequence, they are actually accompanied by inner muscular sensings that are concerned with repeatedly orienting and directing the visual receptor organ. This combination of original visual experience and experience rooted in the motility of the organ is beyond doubt cortically fused and emotionally evaluated as a whole. Thus what has been called simply perception of a formal arrangement or design takes on a highly complex character. It needs to be at least somewhat appreciated in its complexity, both by those who wield it and by those who may be victimized by it.

A man-designed world has come to surround us on all sides. Patient experimentation with both simplified and ever more involved cases will instruct us about our natural reactions. To sketch a merely tentative method of progressive investigation, let us continue with the orientational response. It is basic and primary and comes into play, we know, each time a single stimulus or a group of stimuli is presented— accidentally or by design—in a location toward which the eye can turn. To arrive at a more precise understanding and comparison of effects, the next step will be to make the response measurable. This has been done for human subjects by numerically checking for instance, the *galvanic skin reaction* which accompanies an act of attention and perception. It is always concomitant and in proportion to the active response in question. By tests these minute changes in

the electric conductivity of the skin can be followed and tabulated.

More striking results are perhaps obtained by linking the orientational response with the *food reflex*. Since Pavlov, this is a more generally known technique. A dog is chosen as a subject and his salivation is exactly measured in the test tube. Caution must certainly be exercised in interpretation and in concluding from animal experiments on more complex human conditions.

The object with which the dog is confronted initially may be a dish of food and later any other object strongly associated with it. To investigate the significance of *relative location*, the object is placed at various heights, requiring a tilting *up* or *down* of the subject's sense organs in various degrees. The maximum and reduced amounts of salivation for certain angles can thus be established. There may appear borderline cases in which salivation ceases altogether with increased difficulty of orientation. Repeated quantitative measurements of the responses are tabulated for all observed cases and subjects. Orientations upward and downward are, for most natural reasons, characterized by different effort and are of different valence, emotionally as well as physically.

The experiment is then modified: it is required that the sense organ turn *sideways* in order to face the stimulating object, and the magnitudes of these lateral angles and of the responses are again carefully recorded and compared. Results may differ interestingly from the up-and-down tests, and right turns may be well distinguished in emotional significance from left turns.

In further investigation, the original object is accompanied by others of the same size *in symmetrical arrangement* and in varying distances from the center object—one, two, three feet, and so on. Naturally, these positions correspond to certain angles under which the accompanying objects appear in relation to the main line of vision. As always, the measurement of varying responses is tabulated for each condition.

The *sizes* and *brightnesses* of the accompanying objects

are then varied to a specific degree so that they are smaller or greater than those of the center object. Again, responses are measured and tabulated to clarify how, apart from sheer distance, the proportionate *prominence* of lateral elements affects the impact of a symmetrical composition. Finally, *colors are changed* symmetrically on both sides, in different selections, combinations, and so on. A symmetrical arrangement with asymmetrical colors may give most informative test results.

But for all these cases of symmetry and its modification, experiments can increasingly illuminate peculiarities of the studied response. Subjects, human or animal, will generally show a primary, and perhaps further a secondary, receptivity to certain 'organized entities.' Such receptivity may, by sufficient repetitions, be produced as a result of training, and show the manifestations of a conditioned reflex that proves durable. For each case the number of repetitions required to form such a lasting combination will be very characteristic and, through comparison, most instructive.

This entire series of experiments on the effects of the stimulation induced by a symmetrical arrangement may be followed by others, devised to investigate the responses to *asymmetrical arrangements*, and further by stimulus situations in which objects move or seem to move (a) *sideways*, and (b) *toward* or away from the subject. In each test series, the effects of introducing the above-mentioned variations in proportion and color should be observed.

Finally, there will in this context be experiments that would make it possible to evaluate the effects of *competitive stimulation*, i.e. of placing two distinct arrangements in the field of vision—say, something comparable to a row of windows in a building front, behind a row of differently spaced telephone poles, a situation common enough, but often ignored by the designer. The experimenter might also study the responses to two or more different symmetrical arrangements viewed simultaneously. Thus we should learn what really happens to the beholder when a designer unwittingly sets up a composition with two conflicting rhythms or axes.

330

It is disconcerting, for example, to contemplate the wall of a room that presents not only a centered mantelpiece as a focus of orientation, but also independently at its side a window with symmetrical drapes offering a stimulus that tends to a rather equal dominance. When faced with two majesties, one enthroned here, one there, it is hard to make one satisfactory bow to both.

The mechanisms of nervous induction and irradiation seem to play such a vital role in the cortical innervation elicited by competitive stimuli that practical examples turn up in great numbers every day.[3] In the foregoing discussion we have merely suggested ways of investigating the orientational responses by means of experiments that can be progressively refined. The intention was to indicate generally the need and method of replacing guesswork and subjective inferences with a more concrete objective research into the subtleties that arch responses in action may show.

We have become aware of the significance these responses hold for design, and have listed some of them earlier. Perhaps their formidable definition, the elusive conception of them as basic *drives*, can be made more understandable when we state as clearly as feasible what it is we are 'driven to.' In this attempt, of course, nothing more can be accomplished than to describe the scope of such arch responses by characterizing the particular type of gratification toward which they seem to tend. If the examples of popular paraphrasing should sound a little too 'purposive,' it may be remembered that we try only for a dramatic illustration. The words used here are meant to yield a conscious record of what is, of course, mostly subconscious, but very effective when we arrange our surroundings for actual life, design a room, or furnish it.

The following responses may thus be expressed by simple sentences rendered in the first person to give a vivid picture

[3] N. E. Ischlondsky, *Brain and Behaviour. Induction as a Fundamental Mechanism of Neuro-psychic Activity*, C. V. Mosby Co., St. Louis, Mo., 1949.

of their often intertwined tendencies. Manifest motor action may follow these tendencies, or appear in rudiment, just slightly 'egged-on.'

Orientation Response: I am ready to act or am already acting to gain a position so that I can be fully aware of a particular event which I must face. I raise or turn my head or my whole body. I dislike anything that is interposed between me and the source of stimulation.

Defense Response: (a) Escape: I am alerted to flight, should it become necessary. I have quickly checked by general perception that I am not surrounded by an obstructing enclosure or any other obstacles impeding escape.

(b) Protection: I like to be fully protected, should any circumstance require it. I have checked by perception that I am well surrounded by an enclosure to shelter me safely.

Control Response: I desire to be at liberty, free of shackles and impediments, in order to have full control of my limbs and of all objects or tools that may be required for the gratification of my intentions, whatever they may be. I have checked by perception that everything I might want to make use of is handy. None of it seems to be out of reach, nothing and no one is positioned to interfere or stop me.

Precision Response: I am acting to get everything in which I am interested clear, sharp, and distinct to my senses. My perceptual check-up shows me that I have succeeded in eliminating all vagueness, all blurred uncertainty from my sensuously accessible surroundings or from their impressions on me. I want to be satisfied that everything I intend to pay attention to is well in focus and defined.

Whenever any one of such gratifications seems not fully attained, purposeful action may be promptly innervated to

332

attain it. Or, in frustration, a negative emotional tonus is produced. Such an adverse emotional tonus is in turn linked with various measurable effects in the vegetative system, which on their part are felt, either plainly and pointedly or just vaguely, as unfavorable to well-being and survival. We are irritated, disappointed, depressed. No basic response pattern can be subjected to prolonged frustration, none of the basic cravings can be starved, without such punishment or a marked feeling of discomfort.

An essential task confronting the designer is that he familiarize himself with regularly recurrent responses, which can be considered basic or universally dependable. The next problem is that of furthering or eliminating, as the case may be, conditioned reflexes that have become associated with basic responses through habit or tradition. The designer will need to gather objective information about which responses are wholesome in a given situation, and he will also have to be ready to account for his own goals in the same spirit. In order to understand the motivations he wishes to manipulate, he must be patient to compare their functioning in carefully arranged situations of gratification as well as of frustration. He must call to his aid the experimental psychologist and permit him where possible to introduce safe quantitative methods of verification, where formerly connoisseurs referred to *intangible* qualities and *imponderables*. It will not bespeak true interest in the 'organic approach' if its important findings of today are ignored by the artist of design and swept aside by the many technicians who quite innocently doctor up our ubiquitous fabricated and constructed surroundings.

If the reliable findings of which we speak at first come trickling in slowly and in small numbers—compared with the formidable flood of full-page advertisements often so irresponsible as far as true life needs are concerned—they will nevertheless become in time a much more trustworthy guide in helping us toward sounder decisions of design and acceptance.

333

Broadened, the objective research suggested will serve a number of ends:

1. To ascertain the force of *influences of environment affecting the organism generally*, not through the senses. Special consideration will be given to stimulations that are man-made or modifiable and therefore within the province of the art of design.

2. To clarify data on *specific sensory responses*, to show how the many senses work, singly and in 'stereognostic' combination.

3. To study the *relation of such sensory stimulation to an inner somatic equilibrium*, which is fundamental to our immediate well-being and our ultimate survival.

4. To study with care *conditioned and associated responses* elicited in our brain by *simple design elements*.

5. To investigate with ever-greater refinement and dependability the *interrelations of all responses*, their superpositions, their colligations, configurations, and mutual interferences.

The *subjects* on which experimentation is undertaken may be both animal and human. Psychologists observe how mice react to mazes, which after all are a complicated sort of architectural interior, a puzzle made up of partitions enclosing a space that is to be evaluated. More simple design features combining, for instance, elementary light, color, sound, and form stimuli can be tried on animals before we proceed to men, women, and children of various ages. An involved stimulation is more appropriate to human subjects, and these should include some of average endowment as well as exceptional and even pathological cases. Aberrations sometimes illuminate, by contrast, what we appreciate as normalcy.[4] A

[4] A most interesting category of research is foreshadowed by Paul Shilder in *The Image and Appearance of the Human Body*, Kegan, Paul, Trubner and Co., London, 1935. The book deals with abnormal self-images which patients produce under normal stimulation of their

check on idiosyncrasies caused within the 'normal range' by 'physiological individualism' will be of great benefit to the designer when it can be objectively verified.

The test *objects* used in such experimentation may be classified in three groups:

1. *Specific properties of sensory significance.* Shapes, colors, textures, consistencies, and the like, considered in their function as *singled-out stimuli.*
2. *Materials.* Substances with which our combined senses habitually deal as *complex stimuli* such as occur in our constructed environment.
3. *Arrangements and compositions.* Over-all stimulus combinations, such as a room designed for a specific use, thus involving optical, acoustical, chemical, mechanical, thermal, and other factors. The play on our sensory and central nervous equipment, as well as on our general physiology, occurs for the most part in enlarged and fixed combinations of many ingredients.

It is clear that experiments stressing objects of the third group will often draw heavily on the findings derived from work with the first and second groups, which contribute elements for composition. But in some instances, the experiments turning on the third group may yield independent results that could not have been obtained by any other means or on an elementary level. After all, the human organism reacts as a whole and responds to the environment as a fused totality, in which any one stimulus is hardly separable from the rest. Design is perceived and specifically planned not as a sum of design elements or of separate stimuli but as an integration of such stimuli. At the same time, recognition of this fact and of the great need for skilled integration should not deter us from analytical exploration as far as the current state of information permits.

affected or surgically changed bodies. Experimental brain specialists can generally throw fundamental illumination on responses to form and design.

Using all available means, we may hope to design and build more soundly for the multitudes of human beings who cannot extricate themselves from the confines and the vastnesses of contemporary industrialized environment. Step by step, we may thus erect a safe stairway leading to more wholesome and more spacious levels of man-conditioned existence—even if the topmost landing and a panoramic view to reward the long ascent may never come into our sight during our own brief span of life.

COMMUNITY PLANNING is an art, but one in need of a large scientific advisory board, CHAIRED BY AN EXPERT IN BIOLOGY.

46

The epitome of today's industrialized environment, as well as *the* grand problem in practical human biology, is our present city.

To look upon any form of urban existence as unnatural has become an almost common attitude. It is an attitude similar and probably related to that which condémns the machine. It will be difficult, however, to determine exactly at what point an aggregation of human beings, or of the tools they use, may be deemed unnatural or antinatural.

We might safely surmise that the food-gatherers and hunters of the early Neolithic Age were appalled when some innovators—probably considered crackpots at first—began to till the soil. We can imagine how the conservatives of that time talked about the pernicious novelties of agriculture— the burning down and clearing of God's good forest, which had nourished their forefathers so well, the frightening away of game, the unnatural scratching of mother earth's skin with cruel implements and the forcing of her to yield crops. Above all, the reactionaries must have been more than skeptical of a mode of living that crowded people together in areas much smaller than could ever have sustained a clan of hunters. It was all running painfully counter to most in-

grained custom. The food-gathering Shoshone Indians, for instance, had to roam and commute ten or twelve hours a day over the hot chaparral-covered hillsides of Southern California just to find their routine livelihood of nuts, berries, and roots. They could not exist except as a sparse population.

In the light of more ancient ways of living, the idyllic existence that romantic poets have ascribed to the tiller of the soil and to the tender of cattle is highly unnatural. The inventors of agriculture and its new economy may well have seemed to be crafty and dangerous exploiters; and, of course, with their spotty, piecemeal planning, they were. Raw surgery was ruthlessly imposed by them upon the natural environment that earlier generations had known and revered. The hunting nomads must have seen with annoyance how herds of cattle were driven in and corralled on what had been pasture for nothing heavier than slender deer. The hoofs of heavy cows trampled the meadow at the stream until a ravine—first narrow, but ever deepening—was eroded, into which the entire bottom of the lovely green valley crumpled, gradually to be washed down and out of sight forever.

The old-timers of the primeval open spaces may have been appalled by the crowd and the morals of the first agricultural villages, very much as country people now are by the denizens of Manhattan, their jammed buses, subways, metallic herds of taxicabs, and by their way of life in general.

Cities, as far back as we can trace their patterns, fall into two categories: those that appear to have been 'planned,' and those that seem to have arisen without a conscious effort. As an example of the first, we may use the star-shaped city of Washington, D. C.; of the second, any number of medieval towns in Europe that 'just grew' about a pre-existing center of gravity, such as a Romanesque monastery or a good church site on the hill.

Some observers have been inclined to designate these towns of more or less irregular appearance as *natural*, and to contrast them with towns created by *rational initiative*, which came into being, for instance, when a prince ordered his architect-henchmen to lay out a city and glorify his might.

Now such a differentiation will become less telling if we realize that conscious 'planning' of cities has often been and certainly can be something very different from a planimetric Euclidean manipulation of the very simplest kind. This is an unfortunate identification. The soldierly geometrical order and planning ideas to be executed with the snappiness of the drillground were possibly borrowed from martial layouts, such as the temporary *castra*, the Roman fortified camp, and other subsequent army engineering. The checkerboard for Philadelphia laid out by William Penn's surveyors about 1680 was contemporaneous, almost to a year, with the last Turkish invasion of central Europe, and with the Sultan's war tents standing in famous military discipline, row upon row, before Vienna. But similar schemes of easily measured and staked-out rectangularity date much farther back. Twenty-two hundred years before Penn, the palm of success and the title of city planner went to Hippodamos, a surveyor, who laid out an Ionic city along gridiron lines. He did so on an irregular peninsular site, and in spite of it. This same uninspired sort of planning has been applied, we know, from Miletus to metropolitan Manhattan, and to a thousand Gopher Prairies. It has probably most benefited the surveyor himself by simplifying his paper work and speeding up the job of his field party, who staked out the urban fate of coming generations.

But people sometimes got very bored with it all, and proposals to lay out a city in the form of a star, or of a wheel with spokes, or to plan a house in hexagons instead of squares, seemed refreshing. One could furnish a neurological interpretation for this phenomenon of refreshment by breaking routine, and for its bearing on cultural evolution. Such rebellions often revert to purely abstract ideas and forms, which have their appeal to the human brain.

Whether more novel or conventional, it is Euclidean abstraction, and especially the two-dimensional one, that may block design for living. Obviously even a city built on a level plain has a decisive skyline for eyes to behold, and at least a conspicuous dimension in height. But most impor-

tant, a city is—physically and physiologically—a phenomenon within a four-dimensional continuum. Its life processes develop in time and continually erode a cherished planimetric scheme, until, sometimes, the early hard formal logic is soundly contradicted or can no longer be even traced. The basic difference between strongly pulsating life and a life thinned out into an arbitrary game of abstractions has been repeatedly emphasized in these essays. The useful designer of our day will know better where to direct his curiosity and how to apply constructive attention to the delicate needs of survival.

Every city is a complex of solid and liquid bodies and gaseous exhalations, teeming with several populations. The two most prominent are the human and perhaps the bacterial populations. There are, however, several others: entomological (bugs and termites), lower mammalian (rats, cats, dogs), vegetative (from lichens in basements to boulevard greens and a few trees in lucky backyards). In order to achieve a successful symbiosis—an ecological balance, a productive living together of 'desirable' elements, always with marked preference for humans—large-scale planning must be applied. But the stage needs always to be set for a physiological and four-dimensional spectacle. The Euclidean contestant entering the arena with his static paraphernalia of T-square, triangle, and compass will look from the start a bit hopeless and forlorn. Biological balance is not easily housed in our gridiron towns even when they are garnished with a few special geometrical gems; a lack of human dimension in daily behavior has been forced upon us.

Thirty years ago, when I tried to give a name to my attemps at *regaining the vanished biological balance*, I called the entire series 'Rush City Reformed.' At the outset, I thought of avoiding geometric and mechanistic terms in the words I chose, describing to myself and to others the organism of a livable city.

St. John's 'In the beginning was the Word' profoundly anticipated semantics. Our very vocabulary and the metaphors within which our minds happen to operate predetermine a

good many of our practical methods and conclusions. 'Mere' words effectively slant and deflect our views. An idea for a new design almost *has* to be of a certain kind if the terms of thinking are mechanistic, and design initiative was quite different when, for example, concepts were animistic. If we call a city a complex machine in perpetual production of various other mechanistically conceived items, such a city will clearly come to conflict with the serene geometrical idealism and dignity of Capitol Hill, from which radiate classical avenues, flanked by ministries and secretariats in colonnaded rows. Both of these planning phraseologies, however, the geometrical and the mechanistic, will by necessity be foreign to still another, where we start to speak of organic growth, articulation, exfoliation, degeneration, blight, and fatigue. We may continue on our way into a new and perhaps better sort of urban world as our metaphors and comparisons will be drawn instructively from the organic sciences of living, biology and physiology. Neighborhood boundaries will then be likened appropriately to synapses between nerve cells, which are boundaries only in a sense but at the same time planes of contact, electro-chemical transmission, and subtle but vital energy exchange. We may observe in our cities something like the osmotic pressure of organic fluids against, not really separating, membranes, or open diffusion from sector to sector, and we may find situations which remind us of 'arborisation,' branchings, or of 'anastomosis' and 'syncitia,' the characteristic growing into each other of living parts—in short, phenomena that have been minutely observed elsewhere in nature and named by patient scientists of a nonmechanistic breed. All these fertile concepts of organic realism can become valuable loans granted by histology, morphology, or operative physiology.

'Observational methods alone, without a bit of experimental interference with the observed processes, are bound to remain more or less static,' said Samuel R. Detwiler, professor of anatomy at Columbia University, in his outstanding work on neuroembryology. He maintained that this realization 'has gradually transported the embryo into the

hands of those who are subjecting living embryos to such alterations . . . in environments as are pertinent to an analytical study of the dynamics of the developing organism.'[1] Would it not, then, be interesting to alter also that 'postnatal' environment, i.e. the neighborhood, the community in which dwell the infant, the adolescent, and the never quite finished adult?

This physical environment, the neighborhood, the town itself, can be observed as an organism. According to Detwiler there are 'many lines of experimental study dealing with the nature of forces underlying the development of normal *architecture* in both central and peripheral systems.' Such study will be concerned with the much-needed 'knowledge of the interacting morphogenetic agencies.'

All this may seem rather doctrinaire to the practical planner who is forced to be a politician when he finds himself up to his ears in opportunistic 'spot-zoning' to please business interests here and there or when he has to struggle against the superficial aestheticism of an amateurish lady or gentleman on the planning board. What can the statements quoted above mean to him?

If properly grasped, they can be eye openers. It is indeed possible and fruitful to speak of 'morphogenetic agencies' in relation to the physical growth of a human community. We have here a splendidly pointed expression for *form-creating forces*. Science has, in many cases by means of objective observation, established *influences that determine the emergence of forms*, and thus a recognized scientific term signifies a known and fascinating phenomenon. In architecture, the idea is still rather muddled—that is to say, in the architecture of architects, not the 'architecture' of embryos and organisms in general of which anatomist Detwiler speaks, and which has been so meticulously investigated by men like him.

'Through studies upon regeneration and, in recent years, by the methods of surgery on the embryo and penetrating

[1] Neuroembryology, Experimental Biology Monograph, Macmillan, New York, 1936.

explanation, many interesting and highly significant facts have been discovered. From these assembled data have emerged various hypotheses regarding the role of . . . agencies underlying normal architecture in the nervous system.' [2] If the physiologist does so readily and repeatedly resort to architectural allusions, perhaps the planner may in turn cast his glance on natural prototypes and be well advised to profit from physiological terms. After all, physiology has precedence in studying the interrelations of forms and functions. But on another level, this is also the job of the architect. And so a physiologically minded planner may discover useful hints in terms as well as in certain practical methods of research developed by physiologists. Analogous ideas will indeed suggest themselves to him, while the possibilities inherent in such methods are not likely to come to the mind of one who speaks and thinks of a city in static geometrical terms.

For example, an anatomic-histological-physiological procedure has been developed to study and control flow patterns and the dependencies of a conductive system such as a system of nutritive distribution. This procedure consists of cutting that system once at this, once at that point. The observer then tabulates what happens. This is done while the system is actually functioning, in order to study its degeneration, its devious, interrupted, and abnormal operation under specifically selected conditions.

The traffic system of a city might be similarly cut or blocked here and there for repeated short test durations as part of a well-planned act of research. This should give the planner a chance to observe the resulting difficulties (degeneration) as well as any undirected, spontaneous tendencies toward rerouting (regeneration).

Or, to give another illustration: the method of 'staining' is quite commonly used for purposes of physiological observation, especially the staining of a flowing medium when the study concerns the pattern and speed of a living circulation.

[2] Ibid.

This method might be borrowed for telling experiments in the field of city planning. For instance, on a certain test day all trucking traffic entering a specified section of a city might be required to display flags of certain prearranged colors, which would designate points of departure or of destination. The measure would make possible a quantitative and qualitative source analysis of particular categories of heavy traffic and their characteristics in mingling with the rest, crowding it, or avoiding it.

Organisms tend to progressive differentiation. They may start with a mere 'metabolic gradient' within the plasma body—a simple gradation of the capacity to exchange substance and energy. Later, as evolution progresses, organisms go on with further articulation. The physical accommodations of man's life are or ought to be an organic extension of this life and should pass equally through a process of increasingly refined differentiation.

Similar to the original all-purpose cave of the Paleolithic Age is the multi-purpose communal area, such as the open ritual, civic, and sports ground in neolithic Machu Picchu of the Peruvian mountains. The first *Forum Romanum* with its over-all use grew into a more articulated cluster of fora, piazzas, and piazzettas, endowed with buildings appropriate for various purposes. Differentiated organs and special facilities are evolved and acquired step by step, but sometimes growth can undo its own benefits.

A relatively evolved organism may also revert to a pitiful state of amorphousness. By this we mean a state without an organic logic of form, with undifferentiated texture and monotonous over-all characteristics—unfit to serve specific functions. Our own cities have, during recent generations, often shown this tendency toward indifferent shapelessness. In the hands of surveyors and other sometimes simpleminded but powerful practitioners they have reverted to, or been arrested in, a hopeless amorphous state. The civilized part of the world is unfortunately now dotted with such crippled cities. They are not at all stunted as regards brutal growth, which is sometimes dinosauric, but they are lacking

in more intelligent articulation and sensitive differentiation, on which their continued life will depend. And an overdose of rigid, elementary geometricity is no substitute for functional orientation, on the contrary.

Geometrical grids have been mentioned as blanketing many a city and in fact obstructing development. Yet, a city such as Penn's Philadelphia, among others, may also serve as a hopeful example of how no checkerboard can hold out against the upsurge of life processes. Ultimately it is dynamic life, not the initial T-squaring, that determines growth and shape. Around 1800, the visceral traffic, as we might call it, of underground utilities serving vital needs, the newly piped water supply, radiating from pump stations and reservoirs, reconcentrated Philadelphia's already fast-spreading body of dwellings into rows, assembled them first around public fountains, then along water mains with privately connected taps and tubs. A few years later, gas intensified the communal clustering around the supply of this new utility and the process of functional adaptation continued and pressed against the limitations of the first merely geometrical conception of a rigid checkerboard. 'Epidermic circulation' and surface traffic also exerted a similar influence. The massive motor age grew to maturity. Velocity, volume of flow, and pressure increased and eventually broke up the senseless rectangularity. Fairmount Parkway, the impressive 'arterial vessel,' now runs at a sharp slant recklessly through the grid, just as the Diagonal Norte, similarly an afterthought, does in Buenos Aires. Of course, these late-introduced diagonal avenues, again rather geometrically conceived, must intersect with the over-all checkerboard at impractical acute angles, difficult for traffic and monotonously repetitive to the eye. Today's freeway plans follow much more *liberated flow-lines* on their own separate level.

It is not quite correct to say that the city founders could not possibly have foreseen the subsequent development of traffic requirements, and that this alone accounts for the later failure of their plan. In a way the failure occurred sometime before the blueprint was dry. Old age is used too often

345

for explaining and excusing, on grounds of senility, a constitutional incompetence that age has only served to camouflage.

Inadequacy or maladjustment attributable to aging may of course be a normal organic phenomenon. But Penn's plan for Philadelphia happened to be only a little older than Admiral Oglethorpe's layout for Savannah, Georgia. Oglethorpe, no more than Penn, could anticipate the Fords and Chevrolets of two hundred years later. Yet, the Savannah pattern of many refreshing green squares, *entirely segregated from rolling traffic lanes instead of being painfully permeated by them,* is good to this day. It was, to start with, more than a geometrical idea. It dealt and deals humanly with life, operating in space and time.

Monotonous stacks of rectangular city blocks have been made to climb up hillsides or run blindly into river bends and across irregular peninsulas. Geometrical regularity gloried in the utter oblivion of natural terrain. In Baltimore, Brooklyn, or Manhattan, rows of dwellings were at first built of frankly repetitive brownstone or brick. Later, artificial relief was sought. It was looked for in the diversity of the elements rather than in the comprehensive framework, and so each and every house in new suburbs got its particular skin-deep style treatment.

In nature, on the other hand, the process is an entirely different one; one might say, in a sense, it is the reverse. An irregularly spreading oak tree, with all its branchings, grows according to a pattern little expressive of formal geometry; rather one can easily see how sap flow and circulation have shaped the frame, basically and in every diversified detail. Yet the entire tree has very uniform oak leaves, nothing but oak leaves of characteristic sameness connected with branches and twigs by identical stems to serve almost uniform venous layouts. On some plants the leaves are left elastically free to turn and orient all their frontal surfaces in the one direction most favorable to their function of photosynthesis, the assimilation and nurturing process of green growth.

While nobody ever seems to have lamented the monotony

or uniformity of a tree, our rigid residential neighborhood is found in need of being enlivened, 'relieved of monotony.' What must correspond to the interesting organic form of a tree trunk is here, in the majority of cases, a bare rectangular Euclidean framework, indifferent to vital orientation. On this primitive support we hang our often forced variety of building forms. It is like assembling palm leaves, oak leaves, and maple leaves on the same branch, which itself is just a straight stick. These building forms are borrowed from disparate sources and soils and made to grow monstrously together into one street organism. The strange, synthetic chimeras of the surgical biologist look like child's play in comparison. He produces horrible 'Xeno-plastics' through experimental grafting tricks only in order to learn something about nature from unnaturalness. We have cut from their organic base and fused together Swiss-chalet, Moorish, and Norman 'styles' and tried to live happily ever after with the combination.

By contrast, a sound uniformity of orientation and of little dwellings hanging on a residential street like the repetitive leaves on a twig simply annoys people whose minds have been conditioned by Hollywood variety. It is even considered 'unnatural' that two-bedroom houses harboring families of similar size, composition, and nationality, all within the same climate, should themselves be similar. If they nevertheless turn out essentially similar, the fact must be hectically concealed. The truth is, however, that such small homes in one setting, if they are to serve their purpose, cannot differ much more in design and construction than the leaves of a tree. For a sound fulfillment of life's purposes, elements such as these, I have found, may often be healthily and pleasingly sub-grouped, but they cannot be turned at will in all directions, regardless of the sun or prevalent wind, nor can they be given arbitrary shapes that ignore natural determinants.

As a matter of fact, trees are commonly called beautiful not in spite of this basic uniformity of their leaves but because of it. And real-estate subdivisions are usually beautiful to the degree to which they contain trees. Trees cover up

the dreary geometry of sidewalks and telephone poles and cast their lovely swaying shadows as well over the frozen, lawless variety that, with all stylistic wrinkles, has unsuccessfully tried to 'relieve' all these houses of their essential monotony.

The tight medieval city could seldom afford trees. Streets then had no space for planting. Man's early mastery over nature consisted largely of excluding her from the human stage of living and acting. The city of the Middle Ages had a circumvallation and occasionally molted it, like the growing grasshopper its chitinous casing and our growing little boy his pants. Growth in such cases calls for intermittent reaccommodation. But normally the old city would develop inward, into ever-greater density until the suffocation point seemed reached.

In many parts of the world, the pattern of ownership of agricultural land has, because of division through inheritance, tended to become atomized and extremely, even ridiculously, complicated. Analogously, city lots have been subdivided again and again and households nested one within the other, until places like Spalato, Dalmatia, or San Juan, Puerto Rico, turned into teeming ant hills or inhuman box-within-a-box establishments. Most natural survival aids and health factors, available perhaps in the initial layout, were lost by the sheer clogging density of accumulated population.

On the other hand, a new, thinly spread, traffic-crazy town such as Los Angeles is threatened with a different kind of disaster—something like elephantiasis—endless outward expansion and dragging bulk of little vital advantage. For purposes of simplifying commercial transactions, silver has been minted into dollars, all of equal weight and dimension. For similar reasons, the landscape has been parceled, and city lots have often been made uniform, say, fifty feet wide in Los Angeles, ten yards in Buenos Aires. They are rectangular wherever possible, and they are strung out in endless rows, easy to look over, like stock for sale. Such lots can then be readily exchanged for dollars, but organic values—anchorage

in landscape and community—are much less easily negotiated.

The medieval piling up of humanity was a phenomenon of aging through hundreds of years. It entailed increasing atomization, chopping up of physical footholds, shrinkage of physiological standing space for each individual or family, but *at least no loss in sharing communal benefits.* There was a focus to the old town and a social area serving the entire citizenry, workdays and holidays. A cathedral contained assembly room of liberal dimensions, providing for the increase of population in centuries ahead. Drawing for auxiliary space on the graveyard around the church—which was itself economically operated in rotation and every so often emptied of the bones and skulls of bygone citizens into special silos—the grand Cathedral could, for the quick and living, accommodate medieval mass attractions such as the field day of famous mission preachers. When Juan Capistrano or Bernard de Clairvaux came to town promoting a crusade, the overflow of audience found their grandstand on adjacent rooftops if nowhere else. Civic gravitation has hardly such an actual centerpoint in our current cities.

And our post-Victorian parceling and subdivision of the landscape deserves even more to be called atomization than the in-finite medieval holdings, though perhaps in a curiously qualified sense. Unlike real atoms, which are each well differentiated to form in interesting configuration shapely molecules and thus are strongly tied into a total communal structure, our atoms of architecturalized real estate seem, in the same vicinity, almost all of equal weight and valance in spite of their bit of sham variety. They have no effective 'affinity,' no specific formative attraction or relationship. No higher molecular structure ever comes to pass in these tiresome subdivisions beyond subdivisions. Human society, the community, is not benefited by a clear center of gravity and seems broken down into an indifferent multitude of elementary particles without cohesion, without that dynamic give and take which alone yields something like 'postured grouping.' We mean the grouping of a team in co-operative action,

where each individual posture complements the others, and no soulless, mere side-by-side prevails.

In our humdrum cities there is lack or poverty of gravitational centers—and they often seem of doubtful character, location, and permanence. They are occasional jumbles of mercenary places of recreation, night clubs, dine and dance spots, and the retail markets with haphazardly assorted commercial service facilities around them. Even the motion-picture houses, once rallying places of the chewing-gum and popcorn age, have fallen into atrophy. On mild evenings, skipping a TV program perhaps, the adolescent boy meets girl in front of the drug store's magazine rack or soda fountain, or at the good-will bench on the sidewalk which Woodhead's Lumber Yard has put up for advertising purposes and, incidentally, to mark the bus stop. The common use space or the communal gathering area of our towns has shrunk disastrously, although pavement may amount to as much as a deplorable 35 per cent of the total urban ground. Traffic area shows a fantastic increase over the Middle Ages when people had a different notion of apportioning land to its various uses. Crowded as these places were, they had both a cultural focus as well as a 'nature reserve' just beyond the city gate a few hundred steps off. Attic windows of their houses—and minds as well—could look over the city walls into a landscape of natural functioning.

An hour's rowing distance off the east coast of Puerto Rico, there lies in the Caribbean sea a small crescent-shaped lonely island with coconut palms leaning over its beaches. On the map it is officially named Cayo Santiago. Popularly it is called 'island of the monkeys,' and it swarms with several hundred specimens of macaco rhesus that serve as laboratory animals for the Institute of Tropical Medicine in San Juan. Perhaps nowhere have animals, rather close relatives of humans, been so well observed under almost natural conditions. There is found on this monkey island little of social promiscuity or of accidental, indifferent side-by-side.

The caretaker of the picturesque realm once related some

interesting observations on the animal community to me when I was commissioned to plan certain laboratory facilities on this secluded tropical spot. The large population is racially homegeneous, but it habitually splits into a number of more comprehensive 'tribes,' with neighborhood areas claimed by each one, and in each there arises a sort of civic organization headed by a 'president,' 'first vice president,' and other leader-substitutes, all honored in a strict hierarchy. Male monkeys, after spending two years or so in their mothers' care and within a group of mixed age and sex, withdraw then into a bachelors' club. From this pool of eligible young males, they advance to one of the tribes, the one with which they choose to establish themselves in mated life (mates do change, but only within the same tribe). Convention requires that bachelors first cautiously approach the group that they have chosen to join. Paralleling it for a while, distantly on its single-file walks through the bush, the patient applicant for membership reduces the distance between it and himself a little each day, and finally he is 'accepted.'

Primitive human society is even less a promiscuous crowd. Leadership by consent engages in suitable administration. There is subtle articulation according to age, skill, contribution to communal life, and sharing of it. The physical setting used to express all this. Amorphousness and indifference about size, scale, and distinct character have only lately overtaken man's cities, and in our days we have come to call a town what is really a shapeless agglomeration of subdivisions, in monotonous blocks, streets, and lots.

It is clear enough that different categories within a population should be accommodated differently: there should be provision for single persons of both sexes, for young couples, and for old people who are no longer raising children. It is also clear that a family is a growing, aging organism and has in each, the first and the second decade of its life, a different make-up, a different set of living needs, different 'symbiotic' requirements.

In those early studies of 'Rush City Reformed,' already mentioned, such a biological age-grouping of families around

351

corresponding nurseries, kindergartens, elementary schools, adolescents' recreational facilities, was (then perhaps without much precedent in systematic planning) kept a guiding principle. Apart from convenience, I expected a more harmonious and neighborly relationship to spring from this important and sympathetically valued consideration of 'family age.' Apartment buildings with club-like facilities were projected for single persons, no longer or not yet attached to a family. Other multi-dwelling structures were dedicated to beginners in matrimony, serving them perhaps up to the time when their first child would be walking and would begin to crave the self-expression that seems to derive naturally from this new skill. Specific accommodations like the ones described were assumed to play their role in the neighborhood plan.

What can be called a *neighborhood* has an optimal size that will not change greatly so long as phases of infantile development, human stature and gait do not change. Man is still the measure of things, as was proclaimed thousands of years ago. Modern means of traffic may extend settlements and shrink the planet; but we repeat that within a neighborhood, humanly conceived, they should not be allowed to cause significant dimensional changes. And there are also reasons for this other than pedestrian musculature. There are significant limitations to human brains and nervous systems.

The social psychologist Cooley experimented with what he calls the face-to-face group. He demonstrated that members of such a group, sensorially linked, can achieve a wholesome mutual adjustment of behavior, identification with each other and the group, and social integration much more readily than members of mere ideological groupings spread over wide geographical areas such as the nation, the state, or the mammoth city. The neighborhood, therefore, with its human contacts unimpeded by metropolitan mechanics has a true physiological significance. The desirable social development that will aid in the survival of the community and the race under ever-changing circumstances depends to a considerable degree upon the neighborhood.

For decades I have concerned myself with neighborhoods of this type, for which I wanted to muster all natural health factors as aids to survival. Layouts of this character have now, at least theoretically if not in fact, found widespread acceptance. A central face-to-face area for recreation, green, clear of disconcerting and dangerous commotion, with elementary school, neighborhood assembly and play space, a public health service unit, a branch library, and a few scattered day nurseries for toddlers and children of kindergarten age, are all to be accessible over pleasant promenade walks that do not cross lanes of rolling traffic at any point. A small arboretum and a bird sanctuary, for a little daily show of native flora and fauna, and perhaps even a small model farmyard to demonstrate and teach a bit of animal husbandry and gardening, may be helpful to a town child's experiences. All this might far surpass what we can dream up to enjoy in the neighborhoods in which most urban dwellers must live today. Yet interest in such organic and recreational influences close to our children may bear future fruit in balanced minds.

Low-rental and low-cost housing for the many, designed with clear premeditation and in a grouping that truly suits human traits, does not have much of a history from which solutions could be reliably deduced, nor are there many systematic precedents for the increasing number of communal provisions that go with housing, well done in grand scale. In fact, carefully located and distributed public parks, public schools, and health centers are comparatively recent innovations. Their harmonious and subtle integration into the city body and into the menu of daily civic fare is still rather novel. The pre-Christian civilizations and model democracies of antiquity hardly conceived anything like the regular social service of a public hospital to care for the sick, and the first structures for preventive medicine and public health service in New York, Chicago, and Los Angeles were built only a few years before the Second World War. Their design and especially their location were very much open to question. To this day health facilities are by many city ordinances relegated and cramped into commercial zones. Such institutions

gradually emerged as mere afterthoughts and as such they were often haphazardly grafted into the plan of the obsolescent 'paleotechnic' city. Now these facilities, although dependencies of an expert central administration, are slowly moving into the focus of an articulate and intimate neighborhood grouping. This is happening against considerable resistance. After a period of technological concentration on showy, bigger-and-better institutional buildings, these comparatively new communal facilities conceived on a more human scale—the small park or green area, the small neighborhood school—are still considered administrative headaches. They have often been discouraged by 'practical' budget politicians and prevented from appearing even on the tracing linen of a master plan.[3]

The huge institution, the mammoth consolidated school, the gigantic hospital, the colossal park were for a while declared to be the 'economical solution' because of lower initial cost per unit, easier maintenance, control, and management. Monuments to this faith can be found looming from Montevideo to Marseilles, and, when done with great gifts, have an impressive power of their own. They may indeed embellish the megalopolitan skyline and the grand civic panorama.

The biological cell, the face-to-face group, is, however, too easily disowned in such a tendency toward gigantism. Especially institutions not fully identified with neighborhood populations as their communal property never really fuse with human needs. Vast school buildings or their chain-link-fenced play fields, for instance, have been opened to the populace at given off-hours; at most other times they are kept locked up—again to simplify maintenance and administration. The manager's, the principal's, the superintendent's jobs of supervision and direction, and the ease with which these jobs can be done, are sometimes more carefully considered than the general human advantages of having these

[3] The economics of a separate 'school town,' an area of grouped-together schools, supplied by bus traffic to cheap virginal land, as now discussed in New Orleans, were explored and a design of this nature discarded by the author a quarter of a century ago.

facilities function liberally right in the midst of the people and emotionally close to their hearts. Frequent and spontaneous use of communal areas, a daily rhythm in this use, serves the subtle cohesion of what we have called a neighborhood, and thus vitalizes the community as a whole. Huge remote 'institutions' are deprived of this deeper biological usefulness and the function of eliciting day after day socially wholesome neuromental responses.

In an age of predilection for traffic, Mohammed can be readily prevailed upon to go to the mountain that has failed to come to him. The population, the patients, the school children are being transported long distances to reach these super-institutions.

Concentrated human accumulations, earlier unheard of, are by-products of industrialized technology and inconceivable without it. But this same technology can now be utilized also to recapture more natural conditions. *Control from a distance* is in the ascendant. Aside from bodily traffic, it is the other great invention to shape our destiny. An old dream, distant control, is now being realized. Napoleon could stay farther away from the battle than Hector of Troy. Even in a battery of artillery pieces a generation ago, the commanding officer no longer walked about the emplacements to aim over every gun barrel, and with the aid of modern devices a school principal may be able to see each one of his classrooms and speak to children and teachers and janitors without having them all concentrated about him in an oversized building. A well-organized system may be composed of detached units, each of reasonable scope and easily accessible to those it serves.

The good old walk to school may be resurrected and embellished as a promenade path through a park. I have long liked to promote this walk to establish by its physiological span neighborhood sizes and related dwelling densities of reasonable scale—and all this in a setting lovely to behold and safe to pass for even a little toddler. Communal-service facilities such as are suitable for neighborhood units will best help to articulate and dimension organically these living

cells of a city, in Bangkok a neighborhood clustered around a temple ground at the canal, in Venice around a 'campo' with church and convent of the local patron saint.

But there is the great problem of total city size. How many boroughs can make up an urban entity or a regional whole conscious of its communal unity? This is a complex socio-psychological issue. Of course it has many technical and economic implications, but what interests us here especially is the degree of a city dweller's cultural gratification and emotional satisfaction or frustration that seems so markedly related to the size of the community in which he lives.

Young people growing up in a small town, alert people who have to spend their lives there, frequently show signs of disappointment and restlessness. They seem to feel that they are missing something of the potentialities that the metropolis has to offer. Just what constitutes a metropolis as a source of such potential gratification, however, varies from one period to the next. There is in this sense not an absolute but only a historically relative optimum size for a city. As the specific weight of atoms is at the bottom of chemical compositions and their properties, so one could somehow refer to the specific size of communities that will have weight in a culture and lend characteristics to its substance. It is thought-provoking that the specific size of cities that can offer corresponding and comparable cultural rewards to their inhabitants should itself be so different through the ages.

The Nuremberg of 1550 may have had a population that today would constitute only a moderate-sized town. But every cultivated individual who lived there at that time could share a cosmopolitan outlook, available within its walls and hard to find anywhere outside. The Paris of 1850 could justly feel itself to be a center of the world, with a population that perhaps did not greatly exceed that of Buffalo, New York, and its motorized county lands a hundred years later. The proud spirit expressed in subway ads—'It is great to be a New Yorker'—seems to have existed in various ages, for communities of varying but characteristic magnitudes. The specific metropolitan magnitude for each historical moment

would be an instructive subject for detailed study. Present trends seem to indicate that in the future cultural gratification will depend less on dense 'conurbations' of the traditional type and may well be found in surroundings that are biologically more bearable. Cities will not have to be gigantic—or at least it will be possible and desirable to articulate them into humanly scaled neighborhoods, which, however, will retain all possible mutual cohesion.

There is something like a magnetic field of influence about a communal entity. Such a field is perhaps theoretically boundless, but with increasing distance from the core, effectiveness dwindles in geometric progression. That field, it has seemed, may have to be voluntarily limited, together with the size of the community itself, to maintain a fit physical operation and psychological identity. Yet this limitation should not be an obnoxious barrier, that is, one that imprisons.

No doubt, the imagination of the nineteenth century and its biggest child, the United States, was fired by 'unlimited possibilities' and unrestricted accumulations. While sheer deadweight diminishes practical returns, we must not overlook that it has through the ages had its grand monumental connotation and undeniable appeal to human minds. And so, *the bigger the better* has also characterized the core of Rome, which expanded from that *one* original Forum of human size, where you could be sure to find your friends, finally to a vast system of extensive monument-studded forums, where you could not find a soul in the loitering crowd or milling mob.

The great American city has no public squares in which to loiter and be impressed by a magnificently planned setting. The really monumental thing about this city is its traffic and traffic jams, which are not only a nuisance but, perversely, also its pride, and for long used to pass as its cherished expression of vigor. Our metropolitan turmoil is the monumental example of the amazing and pernicious length to which the power of habituation and of daily conditioning can go. Only our self-annihilation stops them and threatens—

or, should we say, promises—to put an end to city life of this kind.

But mechanized traffic cannot be called off, even though it is an organically troublesome imposition, especially on the more peaceful life processes that were once expected to succeed in the traditional core of a community. However we may admire the serene plaza of Latin cities, we unfortunately find ourselves rather confronted with a primary need for traffic loops and fluid passage, enormously dimensioned to take care of rush hours. In our case, huge sums must be budgeted to facilitate traffic flow, and vast paved spaces must accommodate those armies of parked automobiles from which human beings emerge only to return after the shortest possible pedestrian itinerary. Also, when people swarm out from old-fashioned subway or new-fangled monorail stations, they will head straight for other mechanical traffic devices of escalators and elevators, because any attempt to centralize in the core of our city offices, courthouses, hotels, department stores, or what have you, makes verticalism and multi-level arrangement the usual way out of the dilemma of mass access. This dilemma has as its other horn, horizontalism. But a horizontal spread of the core spells more nerve-wrecking concentration of street vehicles in sluggish motion, ever looking for temporary storage, so hard to provide. Only slowly the idea dawns that square feet of shopping floors exploitatively piled up are lesser determinants of value than the number of shoppers per day to whom these floors are accessible—the consumership delivered per square foot and hour.

All of our choices are far removed from that old, peaceful, dignified plaza, piazza, forum, agora, where minds met in easily audible conversation, and the eye was pleased by a stable, long-cultured setting. But verticalism, the soaring up past many floors, the towering over fumes and crowds, seems to capture the imagination better than the protracted parcel-carrying and dreary walk back and forth along fronts or flanks of cars, once one has been lucky enough to find and capture a parking space. The luxury of a monumentally embellished

pedestrian core, to serve a metropolitan region in a traditional sense as its centerpiece, now seems almost beyond all means, owing primarily to the need for its vast accessory, the sheer utilitarian traffic space to be cleared and dedicated around it. But even with this price paid, the scale would be inhuman; approach and departure would turn into an ordeal, like that experienced on leaving the vastness of the Hollywood Bowl and its carparks after listening with twenty-five thousand others to a Brandenburg Concerto, which we could better have heard and enjoyed in a hall of human size.

If there is a choice between endless colonnades and dizzy towers, probably the towers will win out. Conditioned as man is to mechanical traffic, he finds the towers now less fatiguing, with purchase collection service in their basement garages, but they still have their striking eye appeal and, as of old, are likely to touch off inspiring associations.

Perhaps the true alternative is to emancipate the satisfaction of a communal core from metropolitan overcomplication and keep it liberated from gigantism. It may well be that we can seek and find the best of that satisfaction closer to home and to human scale and grasp. A focus of communal living existed and functioned in moderately extended Siena, Luebeck, or Athens. It may have to be modified today and be not one but a whole array of splendid cores, each elevated over its level of rolling traffic beneath, that can adorn a galaxy of boroughs and neighborhoods with individual life and interest. The comprehensive civic idea of a metropolis will glory in the mutuality of parts and retain its best expression of magnitude and linkage in a network of wonderful parkways sweeping through the scene. By coherent and diversified vistas, they may invite frequent visiting between these affiliated part-communities, each with its own refreshing face, pattern, and appeal. A picture of the new great city as a whole can at any rate no longer be enjoyed by a visitor or by a citizen standing still at any one spot, but mostly in far-spanning unimpeded motion, by flying over these township-articulations in a garden landscape. We enjoy its perspectives while swinging over the wide, ris-

ing curves of modern road interchanges that command a sweeping view, and are themselves the grandest, most flamboyant plastic forms of our new urban scene. The plan for a metropolitan region will place great emphasis on these connections, which are much more than utilitarian, on the continuous communal contact they facilitate, and on the frequent and speedy social refreshment they yield.

Animals differ from plants primarily in their much more pronounced capacity for movement. The brain equipment of man has placed many specific rational and emotional accents on motion. Undoubtedly there is such a thing as an essential urge for locomotor self-expression that is intimately related to our biology. Over this organically legitimate base, however, cancerous hypertrophies have developed in our day of grand technology. An obliging accommodation of this wild growth may not be justified and may itself grow out of all sensible proportion. In fact supertraffic threatens the survival of the community and is to the individual the most common hazard of the land.

A measure to be recommended on the basis of physiological considerations is undoubtedly far-reaching separation of traffic rolling on wheels from the pedestrian who slowly shuffles along. It should be an acoustical separation as well as an optical one. Apart from the pedestrian's obvious and general sensory annoyance near an automobile road, there are generated thought-associations that lead to a secondary but general displeasure with good, healthy walking. When the walker sees himself overtaken every few seconds by a speedy vehicle, he cannot help pondering that it reaches its destination or a distantly visible landmark in a few minutes, while he himself will still be crawling toward it half an hour hence. His emotional perspective on the use of legs becomes biased just as the language he is inclined to adopt. A bitter word always reinforces a bitter attitude; a man who 'crawls' feels humiliated. To make walking a pleasure again, the man who walks must not be forced to compete visibly with speeding automobiles. If there is a valid sensorial and brain-

physiological basis for segregating categories of traffic, their pernicious cross-influence is actually open to concrete tests.

We ought to favor the rehabilitation of the human walk wherever possible. It is *the original medium* of that loco-motor self-expression for which biological significance has rightly been claimed. It will never, without harm, yield this priority. Besides having neural benefits, walk also happens to be one of the healthiest forms of general muscular exercise, stimulating to many visceral and glandular processes. The segregated pedestrian routes in the neighborhood must be well landscaped and made most attractive for day and eve-ning strolls, instead of investing funds all-out on road width and easy grades to favor blindly and promote profusely roll-ing traffic everywhere.

Originally settlements were limited in extent by walking distances; walking distance remains the standard of human scale for a neighborhood. We have held this to be true, no matter how much the over-all municipal region may be ex-tended by speedier private vehicles or common carriers. And we should never forget that also with Americans, half the population are non-motorized children, and all the customers of our school administration walk if schools are properly spotted. However foolproof future vehicular traffic may be made, it is evident that man must attain a certain degree of competence before he can control, direct, or even board such high-velocity vehicles and ride them safely. A fairly steady walk and a degree of motor co-ordination are attained by most children after the second year of life. At that age, if their path is made reasonably safe, they are soon able to walk a certain distance to a day-care center, just as they used to swarm freely through an old-time Ashanti kraal in Africa or through a Slovakian village, before the advent of the auto-mobile.

The nervous implications of rearing children appear to have changed considerably since automobiles, buses, and other machines began to rush through the human ant hill. Parental irritation, exhaustion, and anxiety that comes from having to overprotect the young were at a minimum in the

361

old community. They must again be reduced to a minimum in the modern neighborhood; this would be a revival not so much of the old-time village as of the serene quality that villages once possessed, and the outcome of a psychiatric respect for it. Freedom from fear and a certain security of life and limb, at least intramural security, must be planned for and restored. We must get back to that feeling of ease that once distinguished the neighborhood where people used to grow up and raise their children without apprehension about being overtaken by whirlwind death right in front of their huts.

Speed may be considered necessary, or even idolized. Physiologically it is of little benefit or harm to us. If we wish to redesign traffic so as to eliminate irritations and thus aid survival on a neural level, we must never forget that through our senses we actually experience *only the accelerations, retardations, and stoppages*; it is primarily these interferences with fluidity and rhythm that count in neural economics. An over-all harmonization, an elimination of stoppages and bottlenecks, is, from a neuro-physiological point of view, much more urgently needed than mere increase or facilitation of speed. It becomes absurd to think only in terms of unco-ordinated speed. Shooting along in rocket ships should not be combined in one pattern with standing in a tiresome line at ticket windows and customs counters.

A billion-dollar program of speedways on the work reserve shelf of an American metropolis is nothing unusual these days and will calmly proceed to condemn private property for many miles of public rights-of-way. Yet blighted areas through which we rush for many worthless miles have rarely on any comparable grand scale been rebought by a community for the obvious and sensible purpose of clearance and healthy redevelopment. Oddly, there seem to be far fewer political and budgetary blockages when it comes to acquisition of impressive ribbons and vast patches of land for the needs or vagaries of traffic. Large-radius and flat-curvature speedway interchanges might soon replace the 'clover leaves,' already old-fashioned because they consume twenty seconds

362

more for a left-hand turn. Such super-technical progress from the new to the very newest is flagrantly out of balance with gross backwardness and neglect of truer life necessities.

In opposition to an overevaluation of mere traffic velocity, we may also point out that in a well-planned speedway system it should never be necessary to make more than one or two turns to the left or right while traveling through an entire metropolitan region. Furthermore, the route interchanges that occasionally occur between the straight top-speed runs could serve as natural nerve-soothing slow-downs. *Generous landscaping will give commuters' travel recreational accents at these points.*

The interchanges might be combined with branch-offs that permit smooth and safe inflow of local traffic, which, after all, is perhaps the most subtle kind of traffic for urban humanity.

For reform—as I dreamed of it in the 'Rush City' studies of long ago—the area of rolling traffic within the neighborhood proper was to be reduced in the proportion to which self-contained livability would increase there. Traffic, apart from its local branchings—those fine capillary ramifications—was planned as steady speed traffic, passing *between* these neighborhoods, not *through* them. Slightly sunken roadways, judiciously screened by naturally grouped trees and shrubs, would form the well-segregated, insulated, 'sheathed,' and concealed vascular system connecting individual boroughs or sectors of the greater community. In this connecting system mere distance was to mean little. It was always to be reckoned in terms of a time equivalent for actual access to the goal. The aggregation of the boroughs formed a loosely knit, well-articulated urban region, with much cultivated nature to be enjoyed in passing and, as stated, commutation itself might thus claim relaxation value. All this now sounds much less revolutionary than when it was first drawn up and written down, and when 'parkway' was not even yet a popular word. But one's courage flags if one contemplates the number of places where developments have materialized

very thickly since then without the least heed to such ideas. How much has been spoiled meanwhile beyond recovery.

Services requiring a considerable amount of daily traffic and trucking, retail stores, markets, restaurants, theaters, dance halls, as well as repair and maintenance establishments from overhaul garages to branch lumber yards, were to be situated so as not to encumber the quiet, restful core of the neighborhood. I thought they should be placed strategically, again *between* residential neighborhood cells, straddling and bridging the here deeper depressed speedways, and the upper level of local lanes that branch off along ample customer parking facilities. The motorized commuter may as well be given the chance to pass and review on his way home an array of clustered commercial units which compete for trade or offer metropolitan diversity and distraction against small-town boredom.

A bridge thrown from neighborhood cell to neighborhood cell constitutes indeed something like a synapse, to use this physiological simile to designate a dynamically significant contact feature. *Articulations* as well as *linkages, absorptive* and *discharging surfaces*, not boundaries or enclosures, are the most significant phenomena in all physiology and organic assemblies.

Three-way links are established at those points where a borough's artery passes between the entries of two neighborhoods. All such links help to make of the larger community an associative organism, not a mere aggregation of parts, each remaining in isolation. Coghill, studying the embryonic development of nervous systems, warns against the expectation that a mere aggregation of locally evolved parts could ever result in a true individual. There is no reason for sheer bigness if there is no cohesion or co-ordinated function accomplished. A similar view may well apply to city growth. At those crucial points in question, our elementary city cells will share in a rhythmical circulation, in the beneficial effects of a systole and diastole of the regional heart, however remote.

A shopping center in the described position serves a much

more far-reaching purpose than do the many confusedly dispersed local stores of yesterday—and today. The local trading establishment will tap a sufficient purchasing area so that competing stores, or, better, stores of a similar kind but qualitatively differentiated and grouped together as best serviceable, find their place within the short radius of a serene and rationally routed shopping walk. There is also business to be picked up from cars after they have easily filtered into local traffic lanes, and from passengers who for an intermission may get on their legs while changing from express buses to locals. Night trucking for stock deliveries to this trading center can make use of the costly speedway during off-hours without disturbing residential night rest and that periodical recovery which is biologically so much required for all flesh and nerves. Landing space for air traffic, especially the kind that can hover before descent, and parking areas near the shopping center are made readily accessible to all long-distance, local, and neighborhood travel, to avoid disfiguring the core of a residential area with a panorama of endless formations of vehicles. The space parked cars take up is not allowed to swell unduly the walking distances within the cell of residential character. Where accumulated parking areas become unavoidable, the green foliage of tall border plants and interspersed shade trees counterbalance and conceal the loud colors and blinding specular reflections of duco finish and shiny metal, massed in this age of chromium. Perhaps one day cars will be designed to be less gloriously conspicuous in the landscape.

For many years I have attempted to analyze the meaning and the distribution of the hectic activity and traffic that flood the newer urban scene and cover such a large part of it. I have tried to show the fallacy of expecting an abatement of traffic jams from a sheer thinning out of the metropolitan spread of cities, which remained essentially centered. On the contrary, this diluted, uniform expansion, especially when based on private means of transportation, overtaxes the inner vascular system by bulky centripetal and centrifugal traffic peaks when all suburbia moves downtown in the

morning and returns home at night. In fact, the greater the spread of such an urban area, the wider and more numerous must be the streets in the inner portion to take care of the accumulating traffic, be it fluid or in suspense when cars are parked. The aggregate cross-section of inner road-vessels ought to increase with the square of the city's radius. But to speak in more organic terms, every major current of traffic created downtown, and its outlet avenue, may be likened to a tree-trunk that is rooted in the central area nourishing this traffic. It has its ever-finer ramifications outward and finally its capillary branchings of ultimate distribution. The sheer mechanics of *sap circulation will make the trunk's diameter grow with the crowning spread of the tree.*

But we must remember that in a city every employment market, every shopping center, every spot for mass recreation naturally gives rise to a secondary traffic growth—and by the very nature of things it is impossible that the root areas of various traffic should coincide with each other. Our 'trees' multiply and, in fact, take on shapes like those of the bewildering tropical species in the botanical gardens of Trinidad or Colombo, where we see branches droop and again sink roots of their own in many new spots. The orientation of this kind of intertwined growth can become very complex in an urban region. As a matter of fact, the traffic rooted in after-work or week-end playgrounds most often tends to move in a direction opposite to that of the traffic that has its roots in daily employment.

When several such traffic organisms get into each other's hair, then startling, complicated time-space situations develop which are indeed very hard to predict, and experimental observation, such as biological research favors, will be much superior to speculative prophecy. All true fluidity may easily be lost, and turn into heavy viscosity. The final result is the crystallization of a perpetual traffic jam and every so often the painful catastrophe of a thrombosis.

Added, of course, to the troubles in moving along must be the almost immeasurable parking problem, right there where space is made most precious by too much convergence

of life, foolishly conducted to its own frustration. There are also here instructive physiological parallels in vascular layouts, in pathology of circulation, in organic systems in which a flow *not only circles* but reaches finely detailed areas to *sediment its cargo of needed substances or to serve vital energy exchange.*

Certain categories of traffic undoubtedly constitute a most necessary life function. They are essential and logical, while others can no doubt be attributed to an extraneous influence and the temporary post-Victorian traffic craze that has overtaken our generation because it happened to witness the stupendous development of private automotive vehicles and was lured into installment buying by high-powered advertising. We may have lost sight of other sounder common carrier solutions. The private motor car has greatly accelerated the decay of communal cohesion, although on the other hand it has increased to an unprecedented degree the common interest in a mighty mere-traffic-area, well paved, signaled and policed.

We have alluded to night trucking on speedways or parkways. During daylight hours, these same roads may be reserved for a continuous flow of passenger cars on two or three center lanes while an intermittent movement of express buses takes place on the outer lane, with stops accessible to the pedestrian. In such a dual or mixed dedication, we have, then, an example of *design both in time and in space.* It is necessary and has all natural precedent.

The successful use of multishift systems in a factory is not only a matter of managerial skill. Full usage of an expensive device, whether it is a tire factory, a speedway, or a commercial block under joint management, calls for precisely conceived design, thoughtfully applied from the very start to multiple operation that must be foreseen in every phase. *It is not just managerial skill that permits a green plant to change its metabolism from day to night; it is rather the plant's basic design that enables it to do so.* Design and management must be recognized as a twin problem: in nature the two are simply one, and so they must be approached

also in human planning. Not even a preliminary sketch, whether for a private kitchen or for an international airport, has any promise unless modes of handling, administration, and maintenance are thoroughly anticipated and agreed upon beforehand. Design is good, bad, or indifferent not in itself but always relative to management.

In nature's economy, multiple use and multiple purpose in a single organ are quite common. Often organs are enriched by a few subtle touches of differentiation to enable them to meet specific requirements as they arise periodically or occasionally. In planning for communities and their improvements, this particular merit of dual-purpose proposals often is a means to silence the clamor against wasteful expenditure.

Waste is what is not used up in the allotted time. And the dynamics of time considerations have, ever since we spoke of traffic, rightly been introduced into the subject of city planning, which has too long been merely a matter of geometry.

Yet dire biological wastefulness and organic economics that should be primary in communal planning are often disregarded in favor of monetary ideology. Habitually, the predominating thought is just to get investments amortized. We worry a good deal that remnant credits be liquidated to a happy end. Equities in old sewers and disposal plants, in obsolete and offensive street lighting, which blinds eyes and puts street signs into eternal night, overhead power service, or what-have-you, all must be used up to the bitter end. We dread tax increases and new bond issues more than daily stabs into the sensitive tissue of our healthy living. If those old 'improvements' are rotten, they may have to go, and indeed ought to in any event, whether they are paid off completely or not. The true biological requirement is to wipe out those outmoded installations, and not to let slowly dwindling interest and amortization payments dominate administrative minds, which should be responsible for much more than finance. The most multiplied penny wisdom can

368

hardly outweigh an improved knowledge of the factors that aid or harm survival. It is against the spirit and proper pace of this advance in scientific knowledge to let changes wait until senile ideas have duly reached their budgetary retirement age.

The Second World War, like all wars but more so than any of its predecessors, has speeded up obsolescence. It has become increasingly plain that plans are made and needed more to guarantee future investments and returns than to assure the continuation of the status quo. A leaf can here be taken from living nature and its wastefulness, which is as proverbial as its economy and perhaps profoundly identical with it. Even a slight sign of obsolescence or unsuitability is here often and quickly followed by abolition and a natural 'plowing under.'

An accelerated superannuation and speedy retirement due to scientific revaluation may raise anxiety in those who wish to carry on business as usual even in the face of catastrophes such as war destruction and revolutions. But business has hardly ever been 'as usual' for a sufficient length of time to merit that expression. Monetary scales deserve no preference over biological scales, because they rarely hold true over the protracted periods of slow communal development and its need of long-term appraisal.

All systems of economic indexing and comparing become controversial when applied over extended intervals of time and space. For example, we look at a tabulation showing, from decade to decade, how food prices rose in England, taking the level in the year 1500 as 100 and continuing to the end of the seventeenth century, when they had reached the numerical value of 682. We may be more used now to such changes of the economic scenery, yet the effect was then nevertheless bewildering, and an all-round interpretation of what happened between those figures is far from easy. Still one thing is clear: those two hundred years were but a comparatively brief phase in the life and organic evolution of a long-lived town such as London.

The particular tabulation mentioned is taken from a study

on the medieval building trades.[4] It appears that communities were perpetually—even though with a varying density of employment—engaged in improvement projects that sometimes took centuries to finish. Meanwhile, if there were budgets they toppled over and over again—together with the stout and proud time schedules and evaluations of business as 'usual.'

The truth is that, whether or not we can, in a dim historical perspective, distinguish such investments as 'good' or 'bad,' large-scale building itself has in many periods been an approach to economic welfare and thus, in a measure, to biological welfare. These matters remain tightly interrelated, and public-development projects have remarkably *fed back* into the system and kept amazing percentages of the population busy, earning, eating, and nursing healthy offspring.

To quote Knoop and Jones, in those long, bygone, 'pre-industrial' days, 'the public building industry, in fact, stands out from the contemporary activities of more or less independent master craftsmen in their little workrooms, as the towers of a cathedral or the battlements of a castle stand out above the houses huddled about their base.

'Beaumaris castle at one period, admittedly a time of exceptional activity, found employment for 400 masons, 30 smiths and carpenters, 100 unskilled workers, and 200 carters (medieval truck drivers)! The meaning of these figures will be understood if it be remembered that the population of London, in 1377, was probably no more than 35,000, of whom, when deductions have been made for women and children, perhaps 10,000 or 12,000 were adult workmen.'[5]

For periods that through long stretches of time have turned disparate, it is indeed equally difficult to compare the individual economic gratification of workers, the civic gratification or the merits of public works programs, and the amounts invested in them. The common denominator, the proper gauge of value, lies ultimately in *biological returns*, *i.e. the*

[4] Douglas Knoop and G. P. Jones, *The Medieval Mason*, Manchester University Press, 1933.
[5] Ibid. p. 4.

*aids and harms to the survival of a given community and
its organic membership.* Such aids and detriments are much
more relevant for a possible appraisal of specific and vital
stability. The expression 'standard of living,' when soundly
understood, has all these connotations.

Yet so far it is harder to analyze ecological implications of
this kind and to weigh biological benefits and blunders than
it is simply to make the taxpayer feel bad in terms of dollars
and cents by telling him that a costly thing like an 'improve-
ment' which has not yet been paid off must already be
scrapped.

Quite another eternal trouble with economics, clogging
civic brain action, is that things continue to pay their way
into a gloomy future long after they have been amortized
and almost everybody—except the few lucky payees—has no-
ticed their threat to health, happiness, and survival. Diver-
sified slums that prove veritable gold mines for their absentee
owners are a bad drain on the community's well-being and
an awful biological liability to their occupants. The original
investment has long ago been paid back in full, in some cases
three and four times over, and all income derived now is net
profit. No healthy regeneration takes place. Maintenance
expenses and the bother of repairs are kept almost to zero;
why worry?—nothing is expected but ever-continuing dete-
rioration, which we could call asymptotic. It never reaches
the happy point of annihilation. This sort of investment is
the ultimate example of a budgetary boon; a realtor of the
older school might call it a 'peach.' At the same time it is
not at all digestible, but a foul fruit. It is degeneration,
pampered by economics. Biologically it may be a cancer on
the surface and in the depth of the community with a threat-
ening possibility of metastasis. It is eating and swelling its
way into the heart and inner tissues of society, which also
must be understood as an organic growth. Yet financially the
costly new cannot easily compete with the dead and cadav-
erous which keeps on paying handsomely. And so to make
a change has sounded crazy to many a 'practical' man.

371

Where for a thousand years pigs and dogs had done scavenger service, plans for public garbage collection, incineration, and elaborate sewage disposal first appeared as doctrinary, idealistic dreams conceived in a vacuum of any possible 'financial facts,' and altogether devoid of practical sense. As long as only aesthetic frowns of distaste were directed against malodorous open sewer trenches and the refuse heaps behind the back door, nothing was ever remedied. Science had to step into the void with physiological facts, which spread the fear of God in a materialistic age. The discovery of bacterial threat did it, and then the huge expenditure to effect the necessary salubrious changes slowly gained the support of public opinion. Once such a stage had been reached, an immediate, immense destruction of age-old deadweight began to take place. The unprecedented and 'incredibly costly' installations became a matter of course within a very short period of time. The entire metropolitan underground was perforated with fantastic systems of pipes and canals, all minutely calculated to drain toward distant disposal areas. The most ordinary sewer systems of today would have seemed like black, fantastic nightmares to the taxpayers of only one hundred years ago. And all this may again be readily obliterated by further developments based on newly emerging informations and convictions.

Considering traditional methods of geographically relating human dwelling and production, we notice that in old established rural regions, the cultivated land and area of production activity is often uniformly spread and permeates the dwelling area up to a degree where the two become practically one. Each farmer is surrounded by the soil he tills. His home is part of his landscape of activity and his life-setting. The psychological impact of this state of affairs is obvious. But communal expression is not easily superimposed over this kind of living, working, and getting together. Church, parish house, and inn must hold a more or less arbitrary position in such a scheme of things.

In other regions of Europe, or of China, we encounter, however, a type of village in which the extensive agricultural production area is detached from the individual dwellings and surrounds the community as a whole. The worker of the field with his implements, the herdsman with his flock *commute*. This type is in a way the forerunner of urban agglomeration. The thought of increased common defensibility and fortification has contributed in large measure to this arrangement. Even in small Chinese villages we find a well-built wall as protection against marauders.

Within this old type of walled city or village, however, commuting distance is minimized for most people; in fact any journey to the working place is done away with. The baker sleeps near his oven, the smith at night closes the forge to join his family in the back room, and all owner-tradesmen dwell right within or adjacent to their own production plants, somewhat like the early pioneer farmer who kept goat and cow under the roof of his home. And hired helpers live with their employer. Undoubtedly it is a scheme that has a psychological bearing on the behavior pattern throughout the day and throughout a lifetime.

Later, by a series of advances, the culture based on individual production and craftsmanship and on a corresponding mentality begins to deteriorate. With it degenerates also the city of the craftsmen. The advent of mass manufacture, by hand or with simple tools tended at home, is first accompanied by a farming-out scheme. After a while this is superseded by the big workhouse, on which the laborers converge and to which they again have to commute, but in a new way and in ever-larger numbers. The centralized workhouse offers certain economic advantages. Here hand and machine tools can be placed in easily supervised rows; thus the workers' behavior may be closely watched, and the period of skill acquisition can be considerably reduced.

The workhouse would logically seem to belong in the middle of the city, surrounded by the dwellings of the workers and supervisors. But as this workhouse is a late addition to the old city, central sites have long been taken

and are solidly occupied at the time the concentrated method of production is introduced. It may be for this physical reason that the workhouse is merely grafted onto the fringe of the urban area. But perhaps there are still other reasons and motivations of a social psychological nature.

In olden times, the rows of workshops operated by artisan-guild members—chandlers, joiners, bakers, potters, or violin makers—were the pride of a city. These lively shops were its psychological and material anchors, whether in Cremona, Italy, or in Canton, China. Consequently, they were best located right in the heart of the town and under the eyes of everybody. Together with their products, these shops and their busy, brainy, skillful craftsmen were pointed out with pleasure to stranger and visitor. The workhouse, on the other hand, was ugly and lacked respectability. Even its laborers were emotionally conditioned against it because the work there was not spontaneous but more or less commandeered, and it was calumnied by the organized guildsmen. These men of a threatened craft lobbied in a long and losing battle for all possible legislation against it. When a workhouse could no longer be kept out of a burgher's town, it was relegated to the peripheral area near the city wall, together with houses of prostitution. The operators of workhouses first found their labor supply not from within the city, but among runaway serfs and country yokels, who were ridiculous to the city dwellers because of their speech, behavior, dress, and poverty. These people often had to live outside the walls and commute daily through the city gate. The guards were instructed to lock the door behind them at night.

It is perhaps because of these socio-historical beginnings, and the train of associations they have evoked—not because of any intrinsic 'physio-logic'—that later industrial plants were from the outset often also relegated to neglected peripheral locations. They are still striving for a rational place in the body of the urbanized region.

Natural logic calls for a more median site on which workers can converge with ease for their hours of productivity

and from where they return to their various residential neigh-hoods for recovery from fatigue. This would also eliminate the peripheral obstructions by which industrial development often threatens to cut off the natural outward expansion of dwelling areas.

The city dweller should be pleasantly conscious that contacts with an expanse of natural surroundings are unbroken and easy for weekly, if not daily, recreation. This great benefit should be impeded and infringed upon as little as possible, and exfoliation of residential zones into the open landscape should not be curbed.

This growth obviously cannot be inward or centripetal in character. Ever-increasing masses of foliage must develop outward and in a direction opposite to that of a growing root-system. Similarly the growth of a residential section, we have noted, is centrifugal, away from the productional and industrial area from which the population draws its sustenance.

A large encircling industrial belt which blocks the way into the country so that outbound traffic may perhaps only filter through between tiresome grimy factories and warehouses can be judged a Victorian heritage of divorce from nature. It is not in itself convincing but minds have been conditioned by habit to a pattern of prejudice, called economics, that makes them see fatalistically if not with approval conspicuous exploitation and pyramiding of urban land values within the interior, and look for cheap industrial land out where wooded grounds can be denuded, streams polluted, and generally the community's dirty wash handled out of sight.

A series of parkways constructed to pierce the stifling ring around a city and to permit occasional sorties of the beleaguered dwellers seems only a palliative, and an expensive one.

Moreover industrial-employment geography imposes current requirements, and expresses the possibilities and aspirations of today. Manufacturing management has perfected techniques of quickly training new workers to certain skills, but fluctuation and drifting-off are also common phenomena.

375

Employees are no longer predominantly or invariably specialized craftsmen. They want to range freely over the entire employment market of a region. They would feel economically and psychologically cramped if they were holed up in specialized neighborhoods, adjoining specific plants or trades, say, sheet aluminum workers here and synthetic rubber workers at the diametrically opposite side of town. It should prove hard for a worker's family to follow round a 'ring' of diversified industrial employment so as to match every occasional change that might occur at will or under economic pressure. A steadiness of lodging, the anchorage of home ownership, would then certainly be neither plausible nor practical.

Assuming that the future city and its production facilities will not expand beyond control and may be pre-limited to a wholesome size, the way the size of higher and the highest organisms is limited by nature, we could well conceive the principal production equipment assembled along something like median lines of the urbanized region, forming its supporting spine, as it were. Under certain conditions of topography it may of course be advantageous to have such production areas rather develop into several limbs that branch in various directions. In a neo-technic age, these industrial strips or ribbon zones will be carefully managed and regulated to make sure that all biologically obnoxious conditions are eliminated—from noise to pollution of water or air. A manufacturing plant will be kept from encroaching on other plants near by, and the whole productive establishment may again become the visible pride of a town and region, as it has been so often in the past. According to the conviction for which we plead, the dualism between a drab and dirty 'practical' ninety per cent hidden away on the outer fringe and the idealistic, lovely, 'aesthetical' ten per cent played up on the limelighted civic stage has no precedent whatever in nature, which is a whole—undivided into such defeating contrasts.

Our discussion of urbanism has recalled designs for the reform of 'Rush City,' which reach far back into the author's early career. Today more than ever, urban reforms cannot be

missed by citizen or taxpayer. Over-all principles and detailed schemes will have to be subtly suited to the needs of human nature, and design proposals assimilated to a knowledge of these needs. New knowledge is required and can be bought only at the price of patient and systematic investigation.[6]

To seek such knowledge is undoubtedly to face a panorama of difficulties. Yet it is hard to see how a mere retouching of precepts, vague and vaguely motivated, will bring us the city that will not be a threat to the race; the city that does not simply chew up what vital force the non-urban areas produce; the city that is not an enormous amorphous and anorganic agglomeration but has its proper magnitude and is articulated on a human scale.

Scientific statements are neither authoritarian nor, like taboos, pronounced for eternity. As new knowledge evolves, they may well undergo changes in time, but for each historical moment their objectivity offers the best available base to build on, with all the intuition and moral stamina a human community can muster and employ to be loyal to its potentials and its period. In the realm of recent urban development, bank appraisers and realty investors of long standing but sometimes of short and shallow insight have been more honored than physiologists—or well-trained planners who would heed their findings. A new vital conception of cities and homes may liken them to healthy greenhouses and flower pots, designed and mass-fabricated with the best technical ingenuity of today to serve and support the eternal organic life, which must go on sprouting, branching, and blooming.

Banks are usually interested merely in what sort of homes, subdivisions, improvements have sold and paid off in years

[6] Lewis Mumford has long ago used the interesting expression 'biotechnic age' for this new era on which he sets his well-reasoned hope, as 'Life which always paid the fiddler now begins to call the tune.'

'The sort of thinking [referring to the *Rush City Reformed* studies of a quarter century ago] should now be resumed, and perhaps public competitions should be held to enlist the imagination of the younger generation of architects and planners. . .' Lewis Mumford, *The New Yorker*, 8 Jan. 1949, p. 60.

past, and it is this type that they favor with a loan and sponsor for production. But up-to-date industries act differently, whether they produce washing machines, ladies' hats, or lawn mowers. An approach into a successful future by a detour into dusty statistics of the day before yesterday is also controversial for housing or for planning residential neighborhoods, schools, street intersections, or suitable facilities of any kind. In the past frequency of occurrence was often coupled with frustration and suffering. It is in itself no criterion for a decision to model the future.

Living human cohesion, healthily and well maintained, shall be the principle of coagulation to a community, not the flimsy fiats of wholesale commercial promotion and pay-off. Nor can it be abstract, timeless geometry.

The architects of medieval England were simple masons but they harbored erudite aspiration and called their rule 'Constitutiones Artis Geometriae Secundum Euclidem' (Regulations of Geometrical Art according to Euclid). Nevertheless, being practical people, these planners quite often deviated bluntly and very humanly from the precepts of their patron saint. The new planner who took over from them, when the Great Fire turned to ashes the London of the Middle Ages, was Christopher Wren, a well-gowned professor of mathematics and astronomy at Gresham College, Oxford. 'Indeed he was not only untrained as a craftsman; he was untrained as an architect; and if there is any link between him and the medieval mason architects, it must be his profound capacity in the art which they, little as they knew of it, took to be the foundation of their craft,' i.e. geometry. It developed from a utilitarian practice to a most meritorious inquiry and then almost into a rite. Finally it turned into a very superficial satisfaction. Douglas Knoop and G. P. Jones, in speaking of the end of medieval masonry and what superseded it, define town planning as the 'purposive grouping of structures to produce a satisfying *impression* of a harmonious whole. . . It is indeed true that Wren and others who possessed such a capacity were not given oppor-

tunities to use it fully; the practice of such an art requires more public control of land and regulation of building than was possible in Wren's day, or in the period of industrial change and individualist enterprise which followed.'

It seems, then, that also in the seventeenth century—the period of absolutist grandeur that was simultaneously a great triumph of mathematics, when princely geometry projected gardens, formally cut, far into the country, and arbitrarily patterned new cities—planners suffered, as they do today, from incomplete control of land and private building.

Even in their heyday those grand geometrical schemes often remained largely on paper. Nevertheless, the questionable influence of that *ancien régime* of thought, taste, and detrimental distance from natural, wholesome life lingered on beyond all political revolutions.

And the distance from life was not all of an 'aesthetic' mathematical kind; some of it presaged, early and ominously, latter-day shoddiness and commercialization of land. Exploitative scheming began to succeed right under the eyes of the monarch and his *carte-blanche* planner. Roger North, a contemporary witness, speaks of one Nicholas Barbon, whose father (evidently a 'political contact' and go-between, very useful to him) was a prominent member of the Parliament of 1653. Barbon abandoned his first trade, the venerable medicine racket, so flourishing in Molière's time. He found in the rebuilding of London after the Great Fire another field through which to attack health and survival, and a better market for his abilities. He had no technical training or vision whatever, and all the vaults collapsed in one of his earlier ventures, 'Mincing Lane'; houses he had built came down 'most scandalously.' 'But,' says North, 'he was the inventor of this new method of building by casting of ground into streets and small houses, and to augment their number with as little front as possible.' Although he managed his creditors and the opponents of his schemes magnificently, lack of cash and his many irons in the fire finally defeated him. This practical man and builder had many imitators, however, who

continued to further 'the superfetation of houses about London.' [7]

The influential but chilly arts and practices of geometrical formalism and commercial exploitation have competitively or co-operatively dominated the city ever since. For the planning of the future other arts and sciences, and more than one or two, will be needed. Among them—again this is our hope—a basic understanding of human life, its implications of mutuality, its social conditions and dependencies, will have preference.

To achieve all this and arrive at practical applications, it may be necessary to make available a more liberal supply of land for re-use from scratch, as some of the war-devastated countries have been attempting, and as our own recent legislation does for an urban redevelopment on a grand scale. At any rate in this age we must guard against giving once more a free hand to plan-makers like the Geometer Royal, or to abstract formalists and grand symmetrists (heirs to André le Notre, garden architect to the King—and a splendid talent of his day), or to builders, very busy for a time and bankrupt in the end, like Barbon, who remains a classic example of the kind of rushing exploiters who should *not* have a hand in city building. The public, the electorate, the people must learn of it: the historical moment has dawned when a host of physiologically and sociologically informed and inspired professions, planners, architects, social workers, all trained in team effort, shall be encouraged to advise sound developers and development, and reconstruct an environment that will be an aid instead of a handicap to the survival of the race.

[7] Related by Knoop and Jones, op. cit.

THE ART OF DESIGN can associate itself with scientific skill, and do so WITHOUT AN INFERIORITY COMPLEX.

47

Throughout this book, which seeks to point into a future of happier living with and through design, I have stressed my conviction that the task of constructing the many things that make up a human environment and should assure the survival of the race cannot be accomplished well without the use of current and available scientific knowledge. Before concluding, however, I should like to do away with the implication that the designer in his functioning can be wholly governed by *scientific attitude* or *methods*, or should aspire to be a scientist himself. He sometimes accomplishes his most important work in fractions of a second, as fast as a human brain can live time. He must continue to rely on intuitive insight often telescoped almost into an instant—just as the physician who practices the art of medicine must often act for the greater good of his patient, on the spur of the moment, in order to answer the emergencies of life. Neither can have the laborious slowness on which the scientist prides himself. Obviously, art, the art of design, which is a part of the art of living, cannot be replaced by science or technology. While science is proud of its infinite methodological deliberateness, of its indifference to momentary and personal exigencies, and even to moral issues, the art of de-

sign, whether we are concerned with goals or with practical procedure, has none of these far-reaching freedoms.

We are touching here perhaps on a crucial issue of our time. The belief that science is above all issues humanistically and religiously tinged, or that eventually it might even do away with 'idealistic' ethical norms, with any moral or intuitive 'bias,' and with all the arts, was a half-conscious expectation that characterized the mechanistically inclined 'scientism' of the nineteenth century. It commands less credit today. At any rate the reasonable promise of the sciences shall not be further abused through misclaim or exaggeration. There were times when scientific detachment had to be especially extolled and firmly established, as authoritarian governments and churches persecuted and suppressed the advocates of freedom of inquiry. But such detachment is justifiable only as a means, not as an end in itself. When this truth is forgotten, when scientific attitude absorbs all else, cool indifference together with prolific inventiveness may breed disaster.

Not long ago, totalitarian governments set up their concentration camps for calculated extermination of human beings, and scientists were engaged to practice with detachment human vivisection. After the Second World War they were tried and executed—obviously not on purely scientific grounds. Atonement is, for example, no scientific concept or procedure, but together with other moral necessities it has not yet been abolished.

Especially since the advent of the atom bomb, our top-ranking scientists—Einstein, Millikan, and many others—have found it necessary to awaken the world to the fact that something quite different from scientific aloofness is needed to prevent the destruction of humanity. They have begun to speak in the name of universal human brotherhood—which according to diversified anthropological data may not be a scientific concept either. But it is precisely such an insight into the oneness of the human species, its characteristic properties, and its world-wide problems that must guide the work of the designer of our time into a feasible future. Conscious

of his instrumental position, he must aim to contribute to the growth of the smaller organic community within arm's reach, as well as to suit the now evolving planetary society of man under the conditions of this last half of the twentieth century. The current technological accomplishments, after they have been carefully sifted, must be shared universally for the true benefit of the human race, and for peace on a shrunken globe.

While the individual incident of art performance, owing to its million subtle variables, may long remain 'beyond science,' for the broad practical purposes of prudently producing and judiciously consuming a culture-constructed environment in this industrial age, physiology, the science of life, can well be tapped and gives great promise.

That new and growing knowledge will above all be invaluable as an aid in programming. It will support us in arriving at a truly contemporary set of objectively valid criteria for determining the requirements of the consumer, the users of appliances, vehicles, equipment, buildings, and cities. Whether the project in question is the construction of a small home or a large hospital, an extensive housing development or the campus of a college, those who will occupy the facilities and pay the cost must insure themselves against being victimized by designers pledged to obsolescent convention, or to mere novelty. Ultimately, the consumer himself must insist on security rendered by men of the right training and information, so that an environment conducive to wholesome living and survival is achieved.

Such security is never absolute, and we may expect that new data and changing interpretation will continue to mark the advances in biological research. References to current scientific findings in the course of my discussion, here and there, have relevance to the problematics of design. They were included only to exemplify my belief that systematic biological investigation, when carefully correlated with organized policies of design, will redound to the benefit of a broader human consumership. It will be of equal benefit to the designer himself as he tries to deal selectively with ma-

terials, surface textures, forms, space itself, and combines all in arrangements of purpose, useful to humans. Everything here, whatever specific usefulness it may otherwise be interpreted to have, operates and activates, first of all, our neuromental being. Up to now, the designer has too often motivated his selections vaguely, by taste alone, or his basis was a checkered mixture, but hardly a fusion of 'aesthetics' and 'practical considerations.' He must learn to respect science as a base and corrective, but as an artist he will not use it in cold blood. He must allow its ever-advancing inspiration to permeate his mind and must sleep over such information with profit. Upon dormant periods of slow ripening may one day suddenly follow the fertile chain outbursts of genius, with all its reverberating consequences to yield a new and wondrous scene.

Through a day-to-day experience of creating plans for construction and fabrication, and through an ever more urgent need of interpreting them convincingly to the users, I have been led gradually to adopt a friendly, observant, physiological attitude of design and to forget more speculative terms. Thus these collected essays trace some of the peregrinations of a designer's mind and point up dependable approaches and conclusions to which they have brought him.

In building-work, as well as in putting these thoughts to paper at odd moments, it has been in all humility my endeavor to render a small contribution to human welfare. An architect, like any other artist, can never *prove* things—strictly speaking. They must slowly prove themselves to others. He must be content if in his brief and crowded lifetime, fate accords him the privilege of stimulating younger men to carry on in turn, for the sake of life itself.